Kazimir Malevich 1 8 7 8 - 1 9 3 5

Kazimir MALEVICH

1878-1935

Published by The Armand Hammer Museum of Art and Cultural Center
in association with the University of Washington Press

National Gallery of Art, Washington, D. C.
16 SEPTEMBER 1990 – 4 NOVEMBER 1990

The Armand Hammer Museum of Art and Cultural Center, Los Angeles
28 NOVEMBER 1990 – 13 JANUARY 1991

The Metropolitan Museum of Art, New York
7 FEBRUARY 1991 – 24 MARCH 1991

This exhibition was organized by the National Gallery of Art,
The Armand Hammer Museum of Art and Cultural Center, and
The Metropolitan Museum of Art, following an initiative by
Dr. Armand Hammer. The exhibition is supported by an indemnity
from the Federal Council on the Arts and the Humanities.

The exhibition has been made possible by
Philip Morris Companies Inc. at the National Gallery of Art

by
Occidental Petroleum Corporation at
The Armand Hammer Museum of Art
and Cultural Center

and by
IBM Corporation at The Metropolitan Museum of Art.

Additional support has been provided to the Metropolitan Museum
by The Murray and Isabella Rayburn Foundation.

Editor: Jeanne D'Andrea
Designer: COY Los Angeles / Steven Rachwal
Printed by Anderson Lithograph, Commerce, California

Copyright © 1990.
Published by The Armand Hammer Museum of Art
and Cultural Center
10899 Wilshire Boulevard, Los Angeles, California 90024
All rights reserved. First printing.

Library of Congress Catalog Card Number 90-082093
ISBN 0-9626953-0-0 (paperback)
ISBN 0-295-97066-9 (cloth)

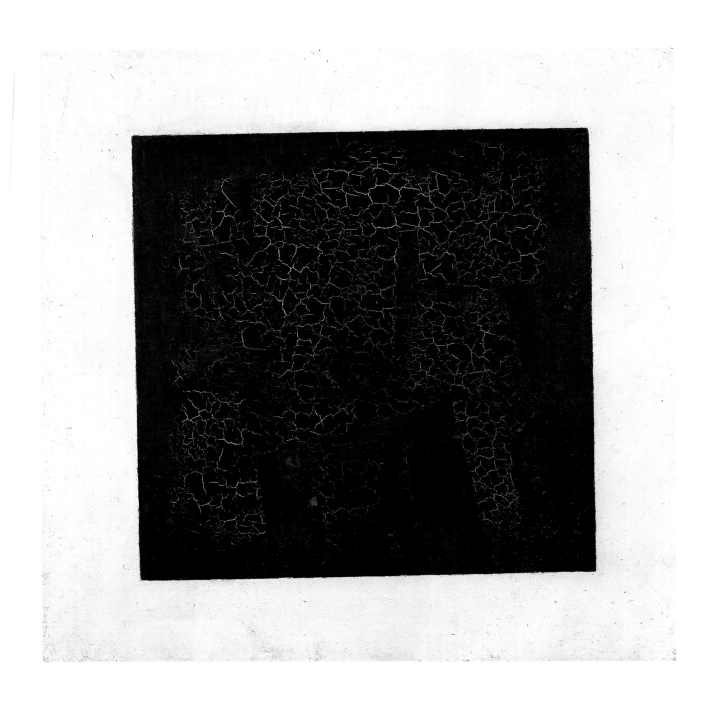

CONTENTS

I am pleased to extend my congratulations on this historic exhibition of the art of Kazimir Malevich. For the first time, Americans from coast to coast will be able to view a major retrospective of works by this renowned Russian artist, the founder of Suprematism and a father of Modern Art.

It is significant that this exhibition is the result of multinational cooperation, coming as it does during a time of renewed hope for world peace. The State Russian Museum in Leningrad, the State Tretiakov Gallery in Moscow, and the Stedelijk Museum in Amsterdam have all contributed to making this tour possible, and I thank everyone involved for their efforts.

Fine art transcends differences in language and culture, providing a bridge between peoples that fosters better understanding between nations. The creative forms of Kazimir Malevich may be as complex and varied as the range of human emotions, yet they unite us in our appreciation for his talent and vision. It is my sincere hope that all those who view this exhibition will gain a deeper understanding of the dreams—and the timeless truths—that form a common bond among members of the human family.

It is fitting that this showing of Malevich's works will be the first exhibition at the new Armand Hammer Museum of Art and Cultural Center; Dr. Hammer has long been devoted to furthering greater understanding between the United States and the Soviet Union. I salute the Center's staff and all those at the National Gallery of Art and the New York Metropolitan Museum of Art who strive to preserve great works of art and to share them with the public. You perform a valuable service for our nation.

Barbara joins me in sending our best wishes for a successful tour and exhibition.

George Bush

I would like to welcome visitors to this exhibition of works by the preeminent Russian painter Kazimir Malevich, a remarkable man of complex destiny. He was one of the greatest and most original spokesman of the entire Russian avant-garde, a movement that had such a deep influence on twentieth-century art.

Malevich's artistic quest was an attempt to comprehend the warning of approaching world tragedy. Today it is incumbent upon all of us, and especially our two great nations, to rid this world of its mortal dangers and together explore an avenue that will lead to a new era in the history of mankind. To this end, it would be indeed enlightening to penetrate the artist's conceptions and premonitions.

I would like to extend my appreciation to Armand Hammer, who with this exhibition has made still another contribution to better understanding between the United States and the Soviet Union.

I share your joy in connection with the forthcoming opening of the Museum in Los Angeles this year. It is pleasant that the opening of an exhibition of Kazimir Severinovich Malevich coincides with this event. I see new evidence of your many years of effort to improve mutual understanding between the Soviet and American peoples. You must surely know that these activities are respected and fully appreciated in our country.

It is my sincere wish, Dr. Hammer, that your Museum will become the center of Los Angeles culture.

With warmest regards

FOREWORD BY ARMAND HAMMER

In this last decade of the twentieth century we are witnessing a profound transformation in the social fabric of our time. As I look back over my life, I realize that I have been not only a witness but also a fortunate participant in the world events that have shaped our century.

One enduring legacy of the past stands out strongly in my mind: the constant search for the renewal of the human spirit. With this in mind, our inaugural exhibition at The Armand Hammer Museum of Art and Cultural Center is appropriately a retrospective of the work of Kazimir Malevich, a pivotal artist who strove to capture that very quality. Building on the past, his fertile mind incorporated the pictorial concerns of Cézanne and Matisse into the rhythms of his own work.

Earlier this year Raisa Gorbacheva shared my joy over the coincidence of the museum inauguration and the opening of *Kazimir Malevich, 1878–1935.* "I see new evidence," she wrote, "of your many years of effort to improve mutual understanding between the Soviet and American peoples. You must surely know that these activities are respected and fully appreciated in our country."

Capable and ingenious members of Occidental Petroleum Corporation have helped me to make this international exhibition possible: Ray Irani, president and chief operating officer, worked with me on all of the complex diplomatic and financial maneuvers; Gerald M. Stern, executive vice president and senior general counsel, resolved the various legal ramifications of the undertaking; Florence Ajamian, who heads my staff, spent many long hours across several time zones in communication with all of the people involved, and particularly with Nina Vlassova, office manager at Occidental Petroleum Corporation-Moscow. International arrangements were facilitated by the staff of Occidental International Corporation-Washington, D.C. Headed by William F. McSweeney, president, and Robert M. McGee, senior executive vice president, they assisted the exhibition teams of the three American museums and their agents for the Soviet Union and The Netherlands.

We are especially grateful for the support of President Mikhail Gorbachev and Mrs. Gorbachev as well as that of President George Herbert Bush and Mrs. Bush. Their letters are a fitting introduction to the importance of this exhibition. The two distinguished heads of state have been guiding forces in warming the international atmosphere, which in turn enabled me to arrange for the exhibition that will be the centerpiece of our Museum's opening and to procure the right to publish a catalogue commemorating this historic event. I thought it only fitting that this great artist's work should be shown in our nation's capital at the National Gallery of Art as well as at The Metropolitan Museum of Art in New York City so that people across America will have the opportunity to explore Malevich's contribution. This was not an easy proposition. Alfred H. Barr, Jr., former director of The Museum of Modern Art, once admitted to a curator that he had to put aside a retrospective exhibition of Kazimir Malevich for six to eight years because he "could not find anyone with adequate discipline as an art historian and at the same time someone who knew Russian and preferably German too." Mr. Barr was never able to realize that exhibition. Malevich's work has been out of favor with Soviet governments for sixty years, but he is now one of the supreme figures in modern art. As the doors to individual freedom begin to swing open during the last decade of this century, it is especially appropriate that his works be exhibited.

Caught up in elements that were meant to abolish individuality, Malevich created a world of people completely enmeshed in their environment. His involvement in the search for a perfect art form had led him to a new way of seeing. Malevich's participation in the Futurist opera *Victory over the Sun* also fascinates me, because it was written to signify "an end to all future wars." In designing the opera's stage sets and costumes, Malevich was unable to see what lay ahead for our world. But his revolutionary art clearly testifies to the changes that stirred the human spirit, for that year was 1913.

I believe that all the arts are universally connected and that they reach each of us in our own particular way. As you visit this museum and cultural center, I hope you will see this structure not just as stone and mortar but as a worthy environment in which to continue the search to renew the human spirit.

An exhibition of Malevich's work is especially appropriate today, not only because the works of art are original statements, but because they are little known in the United States. In inventing Suprematism, as Malevich designated his new style of painting, he and those he influenced successfully challenged the established traditions first of painting and then of architecture.

Painters over the centuries had concluded that the illusion of space depends largely on diminishing the color and scale of objects to convey a sense of depth. But Malevich wished his pictures to be "nonobjective," and thus to be devoid of objects. How could he then solve the problem of space? From a study of color, he found that black against white gave a suggestion of space. Thus, at least in theory, to create the visual illusion of space it was necessary to arrange certain colors—often white, black, red—in a particular manner. This became a basic tenet of Suprematism. Later, his involvement in architecture paralleled his studies in painting.

In 1915 the *0.10* exhibition opened in Petrograd. In it thirty-nine Suprematist paintings by Malevich were shown for the first time. The public was bewildered, but the exhibition attracted many young followers. It also ratified Malevich's position as a pioneer of the Russian avant-garde.

As innovator Malevich disclosed new artistic theories. Suprematism embodied a fundamental change in the entire concept of artistic creativity. A reaction to nature remained basic, but the ability to reproduce it mattered less. Instead, it was the artist's sensations that counted. The sensation of flight, for instance, or the sensation of telegraph transmission. These sensations extended the range of figurative art in a fundamental sense, by placing within its reach phenomena invisible to the eye but accessible to reason and experience. Malevich called Suprematism "The New Painterly Realism" and insisted that the new style rested on real foundations.

In 1918 Malevich's proposal was chosen unanimously from twenty-eight cover designs for a report of the committee on rural poverty. The bright red rectangles and circles call to mind red flags. Individual letters vie for freedom in the cover text, a Suprematist formulation. Most of Malevich's disciples had not taken part in the early Cubo-Futurist arguments, and for many of them Suprematism was the basis for solving all the problems offered by the "New Art."

And solutions were badly needed. The Revolution had wiped out the czarist regime, but people's lives remained much as they had been, despite a nationwide desire for change. The revolutionary politicians wanted to alter the aspects of towns as quickly as possible; and those artists who sympathized with the Bolshevik regime were eager to express the new experience in works of art. Among the radicals who wished to transform the old academy were the Suprematists. Numerous master-artists shared in the preparation of revolutionary images to decorate the streets and squares of Petrograd for the first anniversary of the October 1917 Revolution. Many of the new artists began to design for factories, clubs, and public spaces. In their desire to change everything, they designed monuments, interiors, clothing, and even official seals. Malevich, however, realized that the new art had outstripped the understanding of those for whom it was intended and that teaching was a major obligation. He was a professor at the Free State Art Studios in Moscow and Petrograd in 1918–1919 and director of the Free State Art Studios in Vitebsk from 1919 to 1922. In 1923 he directed the formal theoretical program of the Institute for Artistic Culture in Petrograd.

The Suprematists gave primary attention to architecture. Malevich was vividly aware of the unlimited architectural opportunities offered by the new space and color solutions of Suprematism. Town planners of today who are inspired by Malevich and his disciples have moved away from traditional gridiron street patterns to more picturesque schemes. Suprematism also influenced the innovative typographic designs of Malevich's pupil El Lissitsky, as it did the design and decoration of white porcelain produced by the state factory in Petrograd.

At the end of his life, Malevich painted a group of portraits in the style of Cranach and Holbein. He continues, however, to be greatly admired for creating Suprematism, which has had a wide influence throughout the Western world as well as in his own country.

A. N. Radishchev State Art Museum, Saratov
Busch-Reisinger Museum, Harvard University, Cambridge
Institute of Russian Literature, Pushkin House, Leningrad
Kuibyshev Art Museum
Leningrad State Museum of Theatrical and Musical Arts
Musée national d'art moderne,
 Centre national d'art et de la culture Georges Pompidou, Paris
Private collection, Leningrad
Solomon R. Guggenheim Museum, New York
State Russian Museum, Leningrad
State Tretiakov Gallery, Moscow
Stedelijk Museum, Amsterdam
Sverdlovsk Art Gallery
The Museum of Modern Art, New York
Yale University Art Gallery, New Haven

The critically acclaimed exhibition of Kazimir Malevich, mounted in 1988–1989 by the State Russian Museum in Leningrad, the Tretiakov Gallery in Moscow, and the Stedelijk Museum in Amsterdam, was an occasion of historic importance. Drawing from their own unparalleled holdings of Malevich's art, these institutions reunited works long separated by politics and history and, for the first time since the 1930s, brought one of the most influential artists of this century to the attention of the Soviet public.

We owe a great debt to our Soviet and Dutch colleagues who generously agreed to help us present a version of this extraordinary exhibition in the United States. Further enhanced by key works from five additional Soviet institutions, four American museums and the Musée national d'art moderne in Paris, the United States tour of *Kazimir Malevich, 1878–1935* constitutes the largest and most comprehensive retrospective of Malevich's art ever seen in this country. In an era of *glasnost* and ever-growing cooperation between cultural institutions in the Soviet Union and the West, a project such as this affords a unique opportunity to study in depth works that, for the most part, have never been exhibited in an American museum.

Building upon the strengths of the Leningrad-Moscow-Amsterdam presentation, the American exhibition offers a somewhat different perspective. It reduces the number of works from the beginning and end of the artist's career and includes additional significant works drawn from Malevich's most intensely original and creative phases, thereby allowing for an unusually concentrated understanding of his overall achievement.

With works from various periods juxtaposed for the first time in more than six decades, the complex problems posed by the dating of Malevich's work can now be addressed in a way that had not been possible earlier. As will become clear from the installation of the works and from the catalogue that accompanies the present exhibition, the dating and sequence of much of Malevich's work has now undergone important revision, and with the extraordinary cooperation of a number of scholars inside and outside the Soviet Union, a tentative new chronology is offered.

Malevich scholarship is clearly at a moment of creative transition, as much new information comes to light and opportunities for discussion have grown. Because this exhibition affords the opportunity to see and study an unprecedented number of this seminal artist's most important works assembled in one place, it is our hope and expectation that a deeper understanding of his career and hence important new scholarship will develop from this presentation.

Our deep gratitude goes to Dr. Armand Hammer, without whose initiative this project would never have come to fruition. Dr. Hammer's diplomatic skills and his enthusiasm for Russian art and culture are legendary, and it is only fitting that this Malevich retrospective will be the opening exhibition for The Armand Hammer Museum of Art and Cultural Center in Los Angeles. The Museum has also been responsible for the publication that accompanies the exhibition. Throughout the planning and execution stages of the exhibition, Dr. Hammer enjoyed the full cooperation of the Soviet Ministry of Culture, and we are immensely grateful to Nikolai N. Gubenko, Minister of Culture, Genrikh P. Popov, Chief of Administration of Fine Arts and Preservation of Monuments, and his colleague Andrei Anikeev for their willingness to help at every stage.

Truly a collaborative effort on an international scale, the organization of this exhibition necessarily involved a number of colleagues around the world. From the beginning, the American organizers received the warm and generous support of fellow professionals in Soviet museums. At the State Russian Museum in Leningrad, Vladimir A. Gusev, director, and Yevgenia Petrova, deputy director, could not have been more generous in committing virtually every work requested. At the State Tretiakov Gallery, Yuri Korolev, director, and Tatiana Goubanova, head of the foreign department, generously extended every professional courtesy to their American collaborators. Our colleagues at the State Museum of Theatrical and Musical Arts and at The Institute of Russian Literature, both in Leningrad, were also unusually responsive to our requests for loans. Elena Basner, senior research curator at the State Russian Museum, together with senior research curators Tatiana

Mikhienko and Irina Vakar at the State Tretiakov Gallery, contributed in innumerable ways to all aspects of the enterprise; together with other Soviet colleagues whose roles are acknowledged elsewhere in this publication, they participated in probing discussions that led to the revised chronology of Malevich's work presented in this exhibition and catalogue.

Over one-fourth of the works in this exhibition and catalogue come from the collection of the Stedelijk Museum in Amsterdam, a collection acquired with remarkable foresight in the 1950s by then director Willem Sandberg. We are profoundly grateful to the present director, Wim Beeren, as well as to deputy director, Rini Dippel, for the generous loan of the majority of their Malevich holdings.

Finally, it would have been impossible to present the exhibition as presently conceived without the understanding, cooperation, and generosity of the American lenders, for whose participation we are deeply grateful.

The indispensable connecting link between all of these various institutions and scholars was Angelica Zander Rudenstine who functioned as consulting curator of the exhibition at the National Gallery of Art. For her seemingly infinite energy, unwavering attention to detail, and profound knowledge of this complex period we are deeply indebted. Mrs. Rudenstine, who selected the show and is responsible for its concept, worked closely with numerous collaborators around the world. In addition to many Soviet colleagues, she benefited especially from the collaboration of Joop Joosten, formerly of the Stedelijk Museum, and of Troels Andersen, director of the Silkeborg Kunstmuseum in Denmark, whose pioneering scholarship on Malevich provides the fundamental basis for any discussion of the artist.

At the National Gallery in Washington, deputy director Roger Mandle skillfully engineered the many administrative, contractual, and logistical aspects from the earliest stages. He was assisted by several members of the department of twentieth-century art: Jack Cowart, curator; Marla Prather, assistant curator, who acted as coordinator of the exhibition at the Gallery, assuming innumerable responsibilities for the realization of the exhibition and executing them with consummate skill; and Amy Heilman, exhibition secretary, who efficiently provided administrative and clerical assistance throughout. Other members of the Gallery's staff who deserve recognition here include D. Dodge Thompson, chief of exhibition programs, and Trish Waters, exhibition officer; associate general counsel Elizabeth A. Croog, who attended to the many complex contractual arrangements between institutions; corporate relations officer Elizabeth C. Weil and Elisa Buono Glazer of her staff; information officer Ruth Kaplan and Katie Ziglar of her staff; and Gaillard F. Ravenel, Mark Leithauser, and their staff in the department of design.

An undertaking of this scope would have been inconceivable without the generous support of Philip Morris Companies Inc., who sponsored the exhibition at the National Gallery. We express our profound gratitude to Hamish Maxwell, chairman and chief executive officer of Philip Morris, and Stephanie French, director, cultural and contributions programs. We also thank Marilynn Donini, specialist, cultural affairs and special programs, who was extremely helpful throughout this project.

The exhibition at The Armand Hammer Museum of Art and Cultural Center could not have been realized without the generosity of Occidental Petroleum Corporation. We gratefully acknowledge the assistance of Gerald M. Stern, executive vice president and senior general counsel.

John E. Bowlt's comprehensive knowledge of the Russian language and the Russian avant-garde has made him an indispensable advisor in the development of the exhibition catalogue at The Armand Hammer Museum of Art and Cultural Center. Dr. Bowlt is also a contributing author and the translator of several of the catalogue essays. From the outset, Hilary Gibson, director, development and planning, has devoted much time and energy to the exhibition. She deserves a special mention for her untiring enthusiasm for this project. Jeanne D'Andrea has astutely edited and actively guided the catalogue's development through several mutations and has perceptively helped to shape its final form. Ms. D'Andrea is also responsible for the design of the exhibition in Los Angeles. Paula Berry, assistant to the director, fine arts, has skillfully attended to the numerous organizational details of the catalogue. She has been constantly responsive to the many demands and requirements of its implementation. Mary Ann Sears, executive secretary to the director, fine arts, has facilitated essential communication among the lenders, participating museums, and the Museum's staff and consultants.

The Metropolitan Museum's presentation of the exhibition is made possible through the generous

support of IBM Corporation. We express our deep appreciation to John Akers, chairman and chief executive officer, and we wish to recognize the assistance of Richard Berglund, director of cultural programs, and A. N. Scallon, director of corporate support programs. In addition, the Metropolitan Museum extends its special thanks to The Murray and Isabella Rayburn Foundation for its important support of the exhibition in New York.

At the Metropolitan Museum of Art, Marion Burleigh-Motley, head, office of academic programs, collaborated with Angelica Rudenstine and conceived and organized the colloquium/workshop of scholars and conservators. Lowery Sims, associate curator in the department of 20th century art, acted as coordinator of the exhibition at the Metropolitan Museum. Sharon Cott, assistant secretary and associate counsel, ably handled many contractual matters. Other members of the museum staff who should be acknowledged here are Daniel Kershaw, exhibits designer, and Norman Keyes, Jr., public information officer.

We gratefully acknowledge the United States Federal Council on the Arts and the Humanities, which granted a government indemnity for this exhibition.

J. Carter Brown
Director
National Gallery of Art

Stephen Garrett
Director

Alla T. Hall
Director, Fine Arts
The Armand Hammer Museum of Art
and Cultural Center

Philippe de Montebello
Director
The Metropolitan Museum of Art

Troels Andersen
Director
Silkeborg Kunstmuseum

Natalia Avtonomova
Deputy Head
Department of Late 19th and
Early 20th Century Art
State Tretiakov Gallery

Nina A. Barabanova
Senior Research Curator
State Russian Museum

Elena V. Basner
Senior Research Curator
State Russian Museum

W. A. L. Beeren
Director
Stedelijk Museum

John E. Bowlt
Professor of Slavic Languages
University of Southern California

Elena M. Fedosova
Research Curator
Leningrad State Museum of
Theatrical and Musical Arts

Tatiana E. Ganina
Senior Research Curator
State Russian Museum

Elena Grushvitskaia
Curator
Leningrad State Museum of
Theatrical and Musical Arts

Joop M. Joosten
Research Curator
Stedelijk Museum

Evgenii F. Kovtun
Senior Research Curator
State Russian Museum

Alla Lukanova
Assistant Research Curator
Department of 19th and
Early 20th Century Painting
State Tretiakov Gallery

Tatiana Mikhienko
Senior Research Curator
Department of Soviet Painting
State Tretiakov Gallery

Dmitrii Sarabianov
Professor of Art History
Corresponding Member
Academy of Sciences, USSR

Tatiana V. Sventorzhetskaia
Curator
Department of Pre-Revolutionary Drawings
State Russian Museum

Irina A. Vakar
Senior Research Curator
Department of Late 19th and
Early 20th Century Art
State Tretiakov Gallery

Milda Vikturina
Senior Research Curator
Department of Techni-
Technological Study
State Tretiakov Gallery

Julia M. Zabrodina
Section Head
Department of Pre-Revolutionary
Prints and Drawings
State Tretiakov Gallery

Even the general acceptance of *glasnost* and *perestroika,* Mikhail Gorbachev's two concepts for reform, cannot bring about a new climate overnight. Countries that empathize with this process of renewal have a solemn duty to take appropriate action but without attempting to direct its course. Although cultural *perestroika* and *glasnost* did not automatically give birth to a Malevich exhibition, clearly the decision had been made in the USSR that the postrevolutionary avant-garde could once again play a public role at home and abroad. In no way did this mean that Malevich's oeuvre in itself would spur reforms. Nonetheless, the freedom allowed to the Ministry of Culture and several museums in the Soviet Union to work on a Malevich exhibition signaled a democratization of cultural life. At the Stedelijk Museum in Amsterdam, we had already invested considerable hope and faith in such an exhibition. And although we lacked many of the crucial components, such as a good overview of the relevant works available and information on the state of research in the Soviet Union, we were able to act quickly. With a minimum of delay, we came to an agreement with our Russian colleagues on a clear framework for cooperation and responsibility.

But the story begins much earlier. From 1965 to 1971 I was senior curator at the Stedelijk in Amsterdam. When I arrived there the collection of Malevich drawings and paintings had been at the museum for just seven years. During this period the Danish art historian Troels Andersen was at work on his catalogue raisonné of the Malevich exhibition of 1927, which was part of the *Grosse Berliner Kunstausstellung* that year. Andersen had been commissioned by the Stedelijk's former director Edy de Wilde, successor to Willem Sandberg, who had acquired the Malevich collection for the city of Amsterdam. Troels Andersen's work was published in 1970. Understandably, those years had made the work of Malevich a daily reality and an object of fascination for me.

When I was appointed director of the Stedelijk, in January 1985, this background may well have prompted me to talk of a Malevich exhibition from both Dutch and Russian collections, an exhibition covering not only the Suprematist and Neo-Primitive periods but also the later return to a figurative style. Looking back, it was a rather daring suggestion to have made. But no bluff was involved — rather there was hope and confidence — a confidence based on the 1979 Paris-Moscow exhibition. This was the first example in years of this kind of East-West cooperation, of exposing the avant-garde to the light of day. And, of course, there was the Malevich exhibition organized by Jürgen Harten in Düsseldorf in 1980. Even though its realization was impacted by international political incidents, it clearly showed that mutual trust, close contact, and great commitment could bring about cooperation on previously sensitive subjects.

In 1986 I began preliminary discussions on the possibilities of a Malevich exhibition. I approached our Prime Minister and the ministers of foreign affairs and culture. This put the exhibition on the agenda for regular negotiations on the Dutch-Soviet Cultural Agreement in 1986. The initiative did not meet with immediate success, but it did bring a small delegation from the Russian Ministry of Culture to The Netherlands. The purpose was general orientation. While there was interest in a wide range of initiatives, a Malevich exhibition was not a priority. The first communication between colleagues had been made, however, and this would later prove significant. From then on feelers went out in a number of directions. The Soviet Ambassador to The Netherlands, Anatolii Blatov, and his staff listened to us sympathetically. Particularly encouraging was the visit to Amsterdam in 1986 by a delegation from the Supreme Soviet. The Stedelijk Museum figured prominently on the itinerary of that visit.

Late 1987 saw the roles reversed. The Union of Artists of the USSR decided to hold Malevich exhibitions in Moscow and Leningrad. The Union informed us through the Soviet Ministry of Culture that our cooperation would be welcome in this tribute to their countryman. Discussion followed in Moscow in 1988.

It soon became clear that both sides shared a passionate wish to do Malevich full justice with a comprehensive exhibition that would display the various facets of his oeuvre. Conservation issues, speed, practicality, and financial constraints led to

the decision to base the exhibition exclusively on Russian and Dutch collections. Emotional factors also were involved. The cultural screen had been breached; events and developments in the European avant-garde of the early decades of the century were visible once more. Undoubtedly, the exhibition would symbolize the restoration of the close bonds that once existed among the revolutionary artists of Europe. Also contemplated was a second exhibition elsewhere, perhaps on other continents, to introduce Malevich more widely, but only after the works had time to rest.

A preliminary protocol of intent was signed, followed by a full-blown contract signed in Amsterdam and Moscow on 18 May 1988. But the Stedelijk's task had already begun the previous year, primarily as Joop Joosten (the Stedelijk's chief curator of research and documentation) and I became acquainted with the collections in the State Tretiakov Gallery in Moscow and the State Russian Museum in Leningrad. Meanwhile, the Dutch contribution to the joint effort had been agreed upon: this would comprise chiefly the writing, production, and printing of a Russian/English and a Dutch/English catalogue. The Russian curators were to supply articles and information for a scholarly catalogue of works. The Dutch curator was to compile the artist's biography, write the history of the Amsterdam collection, and describe the methodology of Malevich's teaching system. Works would be chosen jointly, within conservatorial parameters. The Soviet museums and the Stedelijk agreed to be equally generous in making works from their collections available.

From April to November 1988 we worked night and day to fulfill our tasks. Our opposite numbers in Russia worked on their part of the organization and together with a large number of their associates provided the research data for the catalogue as well as several essays. To have found so many new colleagues and to be able to establish meaningful understanding in record time was indeed a matter of intense satisfaction. I believe this occurred largely because we all shared a common Europeanness and happily recognized familiar traits in each other.

A Russian/English version of the Malevich catalogue — written, produced, and printed in The Netherlands and published by the museums of Leningrad, Moscow, and Amsterdam — was delivered to Leningrad on 10 November 1988,

the day of the exhibition opening. The Amsterdam alderman for cultural affairs, Minnie Luimstra, officially opened the exhibition.

That works of art are spread across the globe, rather than confined to their lands of origin, has been an accepted fact for centuries. Even so, it is quite exceptional that so many works by Malevich belong to a Dutch museum. This major group of paintings and drawings forms part of the collection Malevich took with him when he left for Warsaw on 8 March 1927. He would show a small part of his work there and then the full selection — half of his oeuvre — at the *Grosse Berliner Kunstausstellung* from 7 May to 30 September that year.

Malevich returned to Leningrad, on 5 June 1927, having entrusted his work to the architect Hugo Häring. Malevich also left a package of manuscripts with his host, Gustav von Riesen, formerly of the German Embassy in Saint Petersburg. Although he would have been able to take this material back with him to the Soviet Union, there were clearly good reasons why he did not. We cannot be certain of Malevich's plans for the works he left behind — whether it was for temporary storage in anticipation of their sale or of his return for an exhibition, or indeed to await his permanent move to the West. Whatever the case, he took great care in distributing them, using cultural circles he knew and could trust from afar. The work was stored in what was then the Provinzialmuseum of Hannover, where it also found a temporary home before 1930. The museum's director, the progressive Alexander Dorner, had commissioned El Lissitzky to set up the "Abstract Cabinet" there in 1928. In 1933 Germany's new National Socialist regime attacked and then banned the new art. In 1935 Alfred Barr, director of New York's Museum of Modern Art, was planning the exhibition *Cubism and Abstract Art* for the following year. He visited Dorner and arranged with him to bring about twenty loan works from the Malevich collection to the United States. Among them were paintings, drawings, and five theoretical charts. Four of these works Barr purchased at that time for the museum's permanent collection: two Suprematist paintings and two architectural drawings.

As it became increasingly risky for Dorner to keep the works in his museum, he sent the Malevich collection back to Berlin. Hugo Häring took them under his wing. When he left Berlin for Biberach in southern Germany, in 1943, his

crate of Maleviches went along. During the week of 28 April to 5 May 1951, Willem Sandberg and Hans Jaffé (then director and deputy director, respectively, of the Stedelijk) were able to view the collection. At the time they were organizing a De Stijl exhibition.

Prolonged negotiations followed. After a long silence from Häring, contact with Sandberg was resumed through the good offices of Naum Gabo, Ludwig Hilbesheimer, and others. It was decided that the works would be loaned to the Stedelijk for an exhibition to be opened on 29 December 1957, following restoration of the works by the museum. Häring, who was now owner of the collection, was to be paid an annual fee for this loan; and the collection, which Häring wished to keep together, would become the property of the Stedelijk after twelve years. On his death in May 1958, the remaining ten annual payments were settled by the Stedelijk Museum with an additional grant from the city of Amsterdam. And so, at a time when this work enjoyed no honor in its own land, from either the people or the government, and when Western Europe was indifferent to it, it passed into an environment that did justice to the ideas and oeuvre of Malevich.

As the years went by the collection was shown in Braunschweig, Brussels, Bern, London, Humlebaek, Linz, Vienna, Leverkusen, Winterthur, New York, Pasadena, and Paris. However great the significance of this collection, however eminently important Malevich's representation in the collections of the Museum of Modern Art and the Solomon R. Guggenheim Museum in New York, however important the various exhibitions in the Soviet Union (in Moscow in 1919 and again in 1929 at the State Tretiakov Gallery, and then later moved to Kiev), the uncompromising division of the works prevented the artist from ever being shown in his full glory. Even the academic art-historical interest, with all its inherent bias, could not achieve reunion. And here lies the great import of the 1988–1989 exhibition. A historically valued artist was presented anew and the expected miracle occurred: he simultaneously clarified a historical performance and— after so many years had passed— inspired our time and our contemporaries with work that is as timely as ever.

As for history, it must be clear that all of us who live in a country that has known the heroics of the avant-garde would wish to see — or to weigh — the links between what has happened at home and the great events in csarist Russia and the Soviet Union. This is also true of Italy with its Futurism, of France with its basis for Cubism, of Germany with its Bauhaus (visited on one occasion by Malevich). And it is very true of The Netherlands with its innovations in architecture and painting as best expressed in De Stijl—a style known to Malevich. Just as we compatriots of Mondrian had to wait for a long time to see the full significance of his work (after World War II and with tardy appreciation), so Malevich's fellow countrymen are overdue in learning to appreciate his full meaning. It is all so late. And we need more time if we are to place avant-garde movements in their historical frame of reference.

But here, meanwhile, is the oeuvre, and the exhibitions that make it accessible. These works exude an energy that has lost nothing over the years. This same energy also attracted our American colleagues, and Dr. Armand Hammer in particular. (Magnetism had acted.) Their interest in the exhibition has made it more comprehensive, with the addition of works from American collections. It has allowed Malevich to rise again in a new guise.

The three European exhibitions had already provided potential for Malevich's transfiguration. His own persona and spirit still clung to the State Russian Museum in Leningrad. The State Tretiakov Gallery in Moscow welcomed him into the present with an exhibition in contemporary style. Amsterdam shed Holland's light on Malevich. Russian and Dutch colleagues empathized anew and with emotion. Now we wait eagerly to see what form our American friends will give to the exhibition of Malevich's work.

■ W. A. L. Beeren

Translated from the Dutch by Anthony Fudge

3

■ **Joop M. Joosten**

Dates before 1900 in the Russian context are in the so-called Old Style and are twelve days earlier than those in the Western calendar; dates between 1900 and 14 February 1918 are thirteen days earlier. Western dates are in parentheses.

After the outbreak of World War I, in August 1914, Saint Petersburg was renamed Petrograd. This name was retained until Lenin's death, in 1924, when the city was renamed Leningrad.

Titles of associations, exhibitions, publications, and works of art are transliterated in the Catalogue of the Exhibition.

1878 On 14 (26) February (recorded by some scholars as 11 [23]), Kazimir Severinovich Malevich is born to Severin Antonovich (1845–1902) and Liudviga Alexandrovna (1858–1942), at the

Figure 2

Malevich in Kursk,
ca. 1900

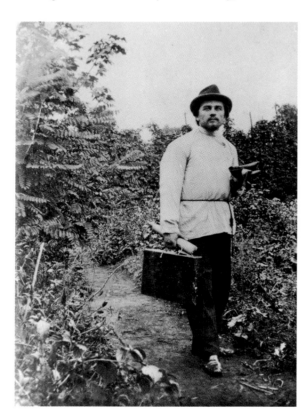

house of his aunt, Maria Antonovna, in Kiev, the capital of the Ukraine. Both parents are of Polish descent. Malevich's autobiographical notes state that his father worked as a manager at various Ukrainian sugar refineries in the vicinity of Kiev.

1889 With his family, Severin Antonovich moves to a refinery in Parkhomovka, near Belopolye (district Kharkov), and then, about four years later, to another refinery in Voltchok, near Konotop, between Kiev and Kursk.

In Parkhomovka, Kazimir completes the two-year program at the agricultural school. Attracted to farm life and nature, he teaches himself to paint his surroundings in a simple peasant style. For a time he is in Konotop, where he comes to know Nikolai Roslavets (1880–1944), later a Futurist composer.

From Konotop, Malevich goes to Kiev to contact the well-known local Realist painter Nikolai Pimonenko (1862–1912), who makes it possible for him to attend classes at the Kiev School of Drawing. Malevich dedicates himself entirely to painting and produces his first finished work.

1896 The Malevich family moves to Kursk.

Kazimir meets his first wife, Kazimira Ivanovna Zgleits, eight years his senior. Two children are born of this marriage: Galina and Anatolii. The latter dies of typhoid fever early in childhood.

Through reproductions, Malevich becomes acquainted with the work of Ivan Shishkin (1831–1898) and Ilia Repin (1844–1930), well-known Realist painters who belong to the group known as the Wanderers. He considers it his mission to represent nature as faithfully as possible.

In Kursk, he meets art lovers and amateur painters with whom he sets up a cooperative studio and forms an association. Among this group are two artists with academic training, from whom he learns about the particular characteristics of the Moscow art schools and the Saint Petersburg Academy of Arts. With one of these artists, Lev Kvachevsky, he often works outdoors. Malevich's work becomes

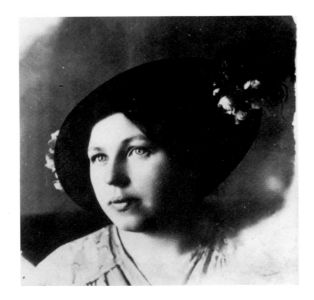

Figure 3

*Sofia Mikhailovna
Malevich*

increasingly impressionistic. He feels an urgent need for academic training and decides to seek it in Moscow. To pay for his stay there, he takes a job as a technical draftsman for the railroad.

1904 In autumn Malevich goes to Moscow.

1905 "Bloody Sunday," 9 (22) January, marks the beginning of a year of political and social unrest. Beginning in Saint Petersburg with the armed breakup of a peaceful demonstration by working-class people for improvement of working and living conditions, it concludes with the Battle of the Barricades at the end of the year in Moscow.

Malevich returns to Kursk in the spring and continues to paint outdoors; his work takes on a neoimpressionist character. Returns to Moscow in the autumn.

In December participates with striking workers in the Battle of the Barricades.

Between 1905 and 1910 he works in the studio of the Moscow painter Fedor Rerberg (1865–1938).

1906 Malevich produces some Symbolist designs for commercial products.

1907 Malevich moves permanently to Moscow with his mother, wife, and daughter.

In March he shows twelve sketches in the fourteenth exhibition of the Moscow Association of Artists, the earliest recorded publication of his work in a catalogue. Other participants include Vladimir Burliuk (1888–1917), Natalia Goncharova (1881–1962), Vasilii Kandinsky (1866–1944), Mikhail Larionov (1881–1964), Alexei Morgunov (1884–1935), and Alexander Shevchenko (1882–1948).

The exhibition in April–May of the Moscow Symbolist artists' group Blue Rose, sponsored by the painter and art collector Nikolai Riabushinsky (1876–1951), makes an unforgettable impression on Malevich.

1908 In Moscow, early in the year, the brothers David (1881–1967) and Vladimir Burliuk organize *Wreath,* the first in a series of exhibitions to be held in Moscow and Saint Petersburg with Goncharova, Larionov, Aristarkh Lentulov (1882–1943), Georgii Yakulov (1884–1928), and others.

The first *Golden Fleece* exhibition, held in Moscow in April–May, includes not only the work of Russian artists such as Goncharova and Larionov but also a large section of French art, including work by Bonnard, Braque, Cézanne, Derain, van Dongen, Gauguin, Gleizes, van Gogh, Le Fauconnier, Matisse, Metzinger, Redon, Signac, and Vuillard.

Malevich takes part in the fifteenth and sixteenth exhibitions of the Moscow Association of Artists, the latter at the end of the year, with several studies for fresco painting (cat. nos. 6–9).

1909 In January–February four Cubist works by Braque, among others his *Nude* of 1908, are shown in the second exhibition of the Golden Fleece, together with works by Derain, van Dongen, Le Fauconnier, and Matisse.

Malevich's first wife leaves him.

Together with the artist V. Petin, Malevich decorates the church in Mstera.

Malevich meets Sofia Mikhailovna Rafalovich, daughter of a psychiatrist, and enters into a second marriage.

At the end of the year he participates for the last time in the exhibition of the Moscow Association of Artists with four works: *Picking Flowers, Village, Promenade,* and *Ride.* Among the other participants are Lentulov and Morgunov.

1910 Becomes acquainted with Goncharova and Larionov. Concerned with giving their Late Impressionist, Fauvist work a more definite Russian stamp, they increasingly seek inspiration in primitive Russian folk art and icon painting; the work that results becomes known as Neo-Primitive. Malevich becomes especially interested in the work and ideas of Goncharova.

In December, Malevich is invited by Larionov and Goncharova to take part in the first exhibition of Jack of Diamonds, a collaboration of the new generation of innovative artists: the Russian-oriented Neo-Primitivists, such as the Burliuk brothers, Goncharova, Larionov, and Malevich; the Parisian-oriented "Cézannists," such as Alexandra Exter (1882–1949), Robert Falk (1886–1958), Petr Konchalovsky (1876–1956), Lentulov, and Ilia Mashkov (1881–1944); and the Expressionists who had settled in Munich, such as Alexei Jawlensky (1864–1941), Kandinsky, and Gabriele Münter (1877–1962). Among the participants from abroad are Gleizes and Le Fauconnier from Paris. Malevich shows three works: *Bathing Woman, Fruits* (see *Still Life,* cat. 14), and *Maid with Fruits.*

In December the Moscow art collector Sergei Shchukin (1851–1936) acquires Matisse's monumental paintings *La Danse* and *La Musique.*

1911 At the first *Moscow Salon,* in which Ivan Kliun (1873–1943) also participated, Malevich shows three series of works, the Yellow Series with representations of saints and angels (see cat. nos. 6–9), the White Series, and the Red Series with representations of bathers and bathhouses (see cat. 18).

In April–May, Malevich takes part in the second exhibition of the Saint Petersburg group Union of Youth, together with fellow Moscow artists David and Vladimir Burliuk, Goncharova, Larionov, Morgunov, and Vladimir Tatlin (1885–1953),

the last introduced by Larionov; Malevich shows four works.

1912 Larionov and Goncharova dissociate themselves from the Jack of Diamonds association, because they feel excessive attention is given to western European, and especially French, developments at the expense of characteristic Russian art. Simultaneous with the second *Jack of Diamonds* exhibition (March), they organize their own exhibition, *Donkey's Tail,* together with a group of sympathizers, including Malevich, Morgunov, Shevchenko, Tatlin, and the newcomer Marc Chagall (1887–1985). The exhibition is the climax of as well as the last important event in the history of Neo-Primitivism. Malevich shows a large group of works depicting peasant life in a Neo-Primitivist style (see cat. nos. 15, 16, 17, 19, 20).

In the second *Jack of Diamonds* exhibition, Fernand Léger (1881–1955) shows his *Essai pour trois portraits* of 1910–1911.

The Saint Petersburg painter and composer Mikhail Matiushin (1861–1934) visits Moscow with Olga Rozanova (1886–1918) and other members of the Union of Youth to bring about a collaboration between the Moscow and the Saint Petersburg avant-garde. The meeting between Matiushin and Malevich marks the beginning of a lifelong friendship.

In April eight members of the Donkey's Tail group participate in the third exhibition of the Union of Youth. Malevich shows four works that were also in the *Donkey's Tail* exhibition (see, for example, cat. 16).

At the end of the year he places five works in the first *Contemporary Art* exhibition in Moscow: *Man with Scythe, Peasant Woman with Buckets and Child* (cat. 21), *Reaping Woman, Peasant's Head,* and *Harvest.* At the same time he takes part in the fifth exhibition of the Saint Petersburg Union of Youth, with works including *Harvest, Man with Scythe, In the Field* (fig. 6), and *Portrait of Kliun* (fig. 5). Among other participants from Moscow are David and Vladimir Burliuk, Goncharova, Larionov, Shevchenko, Tatlin, and Ivan Puni (1894–1956), a new member.

In the works shown in both exhibitions, his earlier natural forms have given way to cone-shaped, apparently "metallic," denaturalized forms. In the catalogue of the fourth *Union of Youth* exhibition late in the year, he describes them as *zaumnyi realizm* (Transrational Realism).

In December, David Burliuk and the writers Alexei Kruchenykh (1886–1968) and Vladimir Maiakovsky (1893–1930) launch their own manifesto, "A Slap in the Face of Public Taste," asserting the poet's right to create new words by making use of arbitrary and derivative words.

1913 On 3 (16) January, Malevich is enrolled as a member of the Union of Youth, along with David and Vladimir Burliuk, Morgunov, and Tatlin.

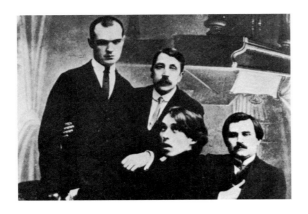

К. С. Малевичъ.—«Портретъ Ивана Васильевича Клюнкова».

In February, Malevich tells Matiushin that the only meaningful direction for painting is that of Cubo-Futurism.

On 23 March (5 April), a day before the *Target* exhibition opens in Moscow, Malevich speaks about contemporary art at the first of two panel-discussion evenings organized by the Union of Youth in Saint Petersburg.

Participates in the *Target* exhibition organized by Larionov in March–April. While Larionov and Goncharova exhibit their interpretation of Italian Futurism, which they call Rayonism, Malevich's interpretation of Futurism suggests movement by breaking cone shapes into almost unrecognizable forms: *Morning in the Country after Snowstorm* (cat. 24), *Peasant Woman with Buckets* (cat. 25), *Dynamic Deconstruction,* and *Knife Grinder/Principle of Flickering* (cat. 27).

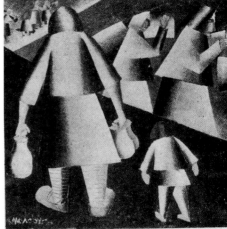

К. С. Малевичъ.—«Въ полѣ».

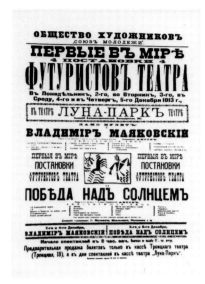

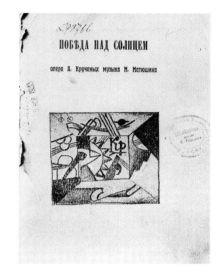

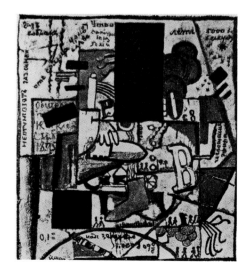

(The work titled *Dynamic Deconstruction [Dinamicheskoye razlozheniye]* is possibly *The Woodcutter* [cat. 23].)

In July, Matiushin invites Malevich to help create an opera (together with Velimir Khlebnikov [1885–1922] and Kruchenykh) for the Saint Petersburg Union of Youth. From 18–20 July (31 July–12 August), Matiushin, Malevich, and Kruchenykh assemble at Uusikirkko, Finland (now a Soviet collective farm "Victory," ten kilometers from the railroad station Kanneliarvi, north of Leningrad), for what they call the First All-Russian Congress of Poets of the Future (Poet-Futurists) (see fig. 36). They conclude the project with a manifesto announcing the opera *Victory over the Sun*. The manifesto goes on to advocate destruction of the "clean, clear, honest, resonant Russian language," the "antiquated movement of thought based on laws of causality," and the "elegance, frivolousness, and beauty of cheap artists and writers who constantly issue newer and newer works in words, in books, on canvas and paper."

Malevich produces lithographic illustrations for a number of books, some in cooperation with Rozanova, written or published by Kruchenykh: *Explosion* (Vzorval), *Let's Grumble* (Vozropshchem), *Piglets* (Porosiata), *The Three* (Troje; see fig. 48), and *The Word as Such* (Slovo kak takovoje).

On 3 and 5 (16 and 18) December *Victory over the Sun* is staged at the Luna Park Theater in Saint Petersburg (figs. 7, 8, 9) with prologue by Khlebnikov, libretto by Kruchenykh, music by Matiushin, and costumes and decor designed by Malevich (cat. nos. 112–133).

In the concurrent seventh and last exhibition of the Union of Youth, Malevich shows two groups of works: one from 1912–1913, of his figure compositions made up of cone-shaped, "metallic" forms, described as Transrational Realism. Although some works had been shown before (e.g., *Peasant Woman with Buckets*, [cat. 25]), the *Perfected Portrait of I. V. Kliun* (cat. 29) and *Face of a Peasant Girl* (cat. 26) are new. The second group, of 1913 works described as Cubo-Futurist, includes *Samovar*.

Figure 10

Jack of Diamonds,
Moscow 1914
From Moscovsky
Listok.

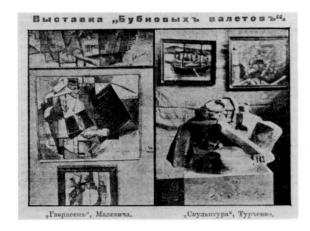

Figure 11

*Alexei Morgunov
and Malevich
Demonstrating at
the Kuznetski,*
Moscow, 8 February
1914

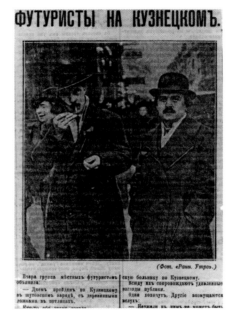

Sergei Shchukin, who already owns an extensive collection of early Cubist works by Picasso, acquires two works of 1912 and four of 1913; the next year he will add three works of 1914. The papier collé and synthetic Cubist works became especially important to Malevich and other artists.

1914 At the end of January, Malevich sends work to the fourth *Jack of Diamonds* exhibition. New participants are Liubov Popova (1889–1924) and Nadezhda Udaltsova (1886–1961). In addition to the three works in the installation photographs (fig. 10), Malevich shows *Portrait of the Composer M. V. Matiushin* (cat. 33).

In the last week of January, Filippo Tommaso

Marinetti (1876–1944), the father of Futurism, arrives in Russia for a two-week visit. As a Futurist, Larionov suggests that they greet Marinetti with rotten eggs, but the Futurist Malevich condemns this provocation.

On 8 (21) February, Malevich and Morgunov hold a Futurist demonstration in Kuznetskii most, a downtown area of Moscow; both have red wooden spoons attached to their coat lapels (fig. 11).

On 21 February (6 March), again sporting a red wooden spoon, Malevich protests at an evening of discussion on modern art organized by the Jack of Diamonds.

In March–April he shows three works at the Salon des indépendants in Paris. Puni and his wife, Xenia Boguslavskaia (1892–1972), who are living in Paris, arrange for the inclusion of Malevich's work as well as that of Vladimir Burliuk and Matiushin.

On 21 February (6 March) he and Tatlin resign from the Union of Youth.

Tatlin has a studio exhibition of his first "Painterly Reliefs," 10–14 (23–27) May.

19 July (1 August): Germany declares war on Russia; Austria follows on 24 July (6 August). On the day war is declared, the German-sounding name of Saint Petersburg is changed to Petrograd.

In the first months of the war, Malevich makes six anti-German propaganda lithographs in the style of the Russian folk print *(lubok),* his contribution to the government-assigned series of propaganda posters and picture postcards intended to win support for the war against Germany and Austria. Other artists who produce posters include David Burliuk, Larionov, Lentulov, and Maiakovsky, author of the captions.

1915 In March–April, Malevich takes part in the *Futurist Exhibition: Tram V* in Petrograd, organized by Puni and Boguslavskaia. He shows *Aviator* (cat. 37), *Lady at the Advertising Column* (cat. 40), *Lady in a Tram* (cat. 35), and *An Englishman*

in Moscow (cat. 38). The other participants are Rozanova from Leningrad; Kliun, Morgunov, Popova, Tatlin, and Udaltsova from Moscow; and Exter from Kiev. At the opening, all participants wear red wooden spoons.

In May, Malevich proposes that Matiushin help him write a definitive essay on new developments in his work, which some months later he is to call Suprematism.

After his unexpected visit to Malevich's Moscow studio in September, Puni reveals information to the outside world about the newest work, which Malevich intended as a surprise to the public at Puni's second Futurist exhibition in December.

At this second Futurist exhibition, *0.10. The Last Futurist Exhibition,* organized by Puni in Petrograd in December, Malevich exhibits a total of thirty-nine completely nonrepresentational works for the first time, presented as the "new painterly realism." Even though he is specifically asked not to call this contribution Suprematism, to avoid antagonizing the public with yet another new term, the word *Suprematism* appears on the wall of the installation (see fig. 38). For the exhibition Malevich and his first followers (Boguslavskaia, Kliun, Mikhail Menkov [dates unknown], and Puni) issue a short statement as part of the manifesto, and exhibit a collective painting. Malevich publishes a brochure entitled "From Cubism to Suprematism in Art, to the New Realism of Painting, to Absolute Creation." During the following year the statement is used as an introduction to another brochure "From Cubism and Futurism to Suprematism. The New Painterly Realism." The other participants are Natan Altman (1889–1970), Vasilii Kamensky (1884–1961), Anna Kirillova (dates unknown), Vera Pestel (1886–1952), Popova, Rozanova, Tatlin, and Udaltsova.

1916 On 12 (25) January, on the occasion of *0.10,* Malevich and Puni, as Suprematists, give a "public popular-scientific lecture" on Cubism, Futurism, and Suprematism and a demonstration of "how a drawing from nature is done according to the methods of Cubism and Futurism."

In March, Malevich participates in the Futurist

exhibition *The Store.* Organized by Tatlin and held in a Moscow store, it is made up entirely of Cubo-Futurist works. Among the thirteen participants are Exter, Kliun, Morgunov, Pestel, Popova, and Udaltsova. The newcomer is Alexander Rodchenko (1891–1956), introduced by Tatlin. Four of Malevich's works appear under the heading "Alogism of Form, 1913": *Cow and Violin* (cat. 32); *An Englishman in Moscow,* (cat. 38); *Aviator* (cat. 37); and *Chess Players.*

Malevich is ordered to report for military duty in July and is sent to Smolensk.

During this year Alexander Archipenko (1887–1964), Natalia Davydova (dates unknown), Kliun, Malevich, Matiushin, Menkov, Pestel, Popova, Rozanova, Udaltsova and others form the group Supremus and plan a publication by that name.

In November, Malevich and his group participate in the fifth *Jack of Diamonds* exhibition in Moscow. His entry in the catalogue simply states: "140–199 Suprematism of painting."

In December, Malevich receives orders to go to the front.

1917 The February Revolution breaks out: 23–27 February (7–12 March).

2 (15) March: Czar Nicholas abdicates, ending the Russian monarchy. A provisional government is formed, followed in July by the Coalition Government under Alexander Kerensky.

26 March (8 April): Malevich speaks at the "First Republican Evening of the Arts" at the Hermitage Theatre, Moscow (together with the poets Kamensky, Maiakovsky, Vasilii Gnedov [1890–1978], the composer Roslavets, and the artists David Burliuk, Lentulov, Tatlin, and Yakulov).

Malevich assists in designing decorations for the May Day parade in Moscow.

Malevich joins the Left Wing Federation of the newly founded Moscow Trade Union of Painters.

Elected deputy director of the art department

Figure 12

Matiushin's Studio at the Academy of Arts, Petrograd 1918 (Malevich, second from left)

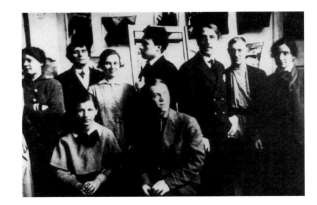

Figure 13

Sergei Maliutin (1859–1937) *Portrait of Malevich,* 1919 Oil on canvas Presumed lost.

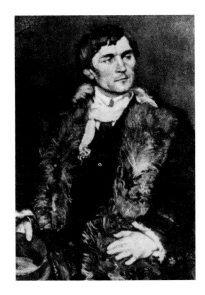

of the Moscow Soldier's Soviet in August, he immediately proposes the organization of a People's Academy in Moscow and Petrograd. His program for art schools, made public in October 1917, is the first proposal for the kinds of schools later established as Free State Art Studios (SVOMAS).

25 October (7 November): The October Revolution establishes the Soviet regime.

In the first days of the Revolution, Malevich is appointed Commissar for the Preservation of Monuments and Antiquities (especially in the Kremlin) by the Military-Revolutionary Committee.

In November the People's Commissariat for Enlightenment (Narkompros) is established under the jurisdiction of Anatolii Lunacharsky (1875–1933).

2 (15) December: Lenin signs the armistice with Germany and Austria at Brest Litovsk, ending Russia's participation in World War I. A peace treaty follows on 3 March 1918.

Malevich again contributes Suprematist work to the sixth and last *Jack of Diamonds* exhibition.

1918 29 January (11 February): a Department of Visual Arts (IZO) is established within Narkompros, headed by David Shterenberg (1881–1948). Malevich is elected a member of the Moscow Division, headed by Tatlin.

1 February (14 February): introduction of the Western calendar replaces the old style of dating.

12 March: the central government moves from Petrograd to Moscow.

Malevich begins to advertise his teaching program on modern art for workers.

In a series of short articles in the magazine *Anarkhiia* (Anarchy) in March and April, he takes a stand against the attempt by conservative pre-Revolutionary artists to preserve their power in the art world by opposing avant-garde artists who consciously support the Revolution. Some of the articles are reprinted in 1919 in the new journal *Iskusstvo kommuny* (Art of the Commune) (Petrograd) on the initiative of Narkompros and with the support of Maiakovsky.

Dissatisfied with the working methods of Shterenberg, the head of the now Moscow-based IZO, Malevich and Tatlin go to Petrograd.

In October SVOMAS open in Petrograd and Moscow. Malevich has a studio in each place. In Moscow he also has a textile studio, which he shares with Udaltsova.

In collaboration with Matiushin, Malevich designs a large wall decoration and a portfolio for the Congress of Committees on Rural Poverty, held in November at the Winter Palace in Petrograd (cat. nos. 134–136).

Malevich designs the sets for Maiakovsky's massive production *Mystery Bouffe,* dedicated

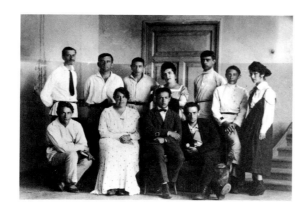

Figure 14

UNOVIS Staff
Vitebsk, ca. 1920
Standing (left to right):
Ivan Chervinka,
Malevich, Efim Raiak,
Nina Kogan, Nikolai
Suetin, Lev Yudin,
Evgeniia Magaril; seated:
M. S. Veksler(?), Vera
Ermolaeva, Ilia Chashnik,
Lazar Khidekel

to the Revolution and performed in Petrograd in November, on the first anniversary of the Revolution. The director is Vsevolod Meierkhold (1876–1940).

1919 Throughout this year and 1920, the Civil War is fought on several fronts, giving rise to extreme economic difficulties for the new republic. A war economy is introduced to address the problems.

On 9 February 1919 Nikolai Punin (1888–1953) publishes a letter in *Iskusstvo kommuny,* asserting that Suprematism is "flourishing all over Moscow" and that the "the day of Suprematism has really come." But he also suggests that the movement is losing its "creative significance."

Malevich joins the newly formed Union of Art Workers *(Rabis).*

In February he attends the meeting at which it is decided to establish Museums of Artistic Culture (MKhK), museums intended solely for contemporary art. In the February *Iskusstvo kommuny* he questions the validity of traditional museums of older art.

Returns to Moscow. Among the artists working in his studio there are Ivan Kudriashev (1896–1972), Gustav Klutsis (1885–1944), and Sergei Senkin (1894–1963).

Malevich contributes sixteen Suprematist works to the *Tenth State Exhibition: Nonobjective Art and Suprematism,* held in Moscow in April. The other participants are Davydova, Kliun, Menkov, Popova, Rodchenko, Rozanova, and Alexander

Vesnin (1883–1959). Malevich's entry includes a recently developed series of "white on white" compositions (see cat. nos. 59–61), answered by Rodchenko with "black on black" compositions.

In June, Malevich completes his first long theoretical essay, "On the New Systems in Art: Statics and Speed," printed and published by El Lissitzky (1890–1941) at his SVOMAS studio in Vitebsk.

At Lissitzky's suggestion and on the invitation of Vera Ermolaeva (1893–1938), rector of the school, in late October or early November, Malevich starts to teach at the Popular Art Institute in Vitebsk, reorganized by Chagall early in the year. At the newly instituted free art studios, Malevich's intention to introduce a new style of art education rapidly becomes evident; all art forms are to be developed on the basis of Suprematism and integrated into a universal system. He receives the full support of Ermolaeva; Nina Kogan (1887–1942), head of the preparatory studios; and Lissitzky, head of the graphic and architecture studio.

The Sixteenth State Exhibition in Moscow (December 1919–January 1920) is devoted entirely to a large retrospective titled *K. S. Malevich, One-Person Exhibition. His Way from Impressionism to Suprematism* (see figs. 44, 45). (Very recent research indicates that this exhibition probably opened early in 1920.)

1920 14 February: in two lectures Malevich explains his ideas about collectivity in the creative process.

In April the new form of training is put into effect within the academic organization of Vitebsk. The principle of collectivity is fundamental to the execution of this plan, named Affirmation of the New Art (UNOVIS). His leading pupils are Ilia Chashnik (1902–1929), Ivan Chervinka (dates unknown), Anna Kagan (1902–1974), Lazar Khidekel (1904–1986), Mikhail Kunin (dates unknown), Evgeniia Magaril (1902–1987), Efim Raiak (1906–1987), Nikolai Suetin (1897–1954), Lev Yudin (1903–1941), and Solomon Yudovin (1892–1964) (fig. 14).

20 April: daughter Una (1920–1989) is born.

Figure 15

UNOVIS Members
Depart for Moscow
from Vitebsk, ca. 1920

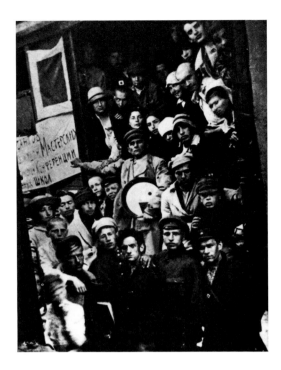

In early June, Chagall goes to Moscow to participate in the conference for fine art managers and never returns. Ermolaeva succeeds him as director. The Department of Visual Arts of Narkompros publishes Malevich's pamphlet *From Cézanne to Suprematism. A Critical Sketch.*

In Petrograd, between March and November, Tatlin, with the help of his students and colleagues, builds the model of his *Monument to the Third International,* shown in Petrograd between 8 October and 1 December and then in Moscow.

In December UNOVIS publishes Malevich's book *Suprematism: 34 Drawings.*

1921 In Moscow, in January, Konstantin Medunetsky (1899–1935) and the brothers Vladimir Stenberg (1899–1982) and Georgii Stenberg (1900–1933) organize an exhibition of their work titled *The Constructivists.* All three are members of the Society of Young Artists *(Obmokhu),* founded in 1919.

21 January: Malevich visits the Institute of Artistic Culture (INKhUK) in Moscow, established in May 1920, to attend the session "Cubism and Suprematism," at which two of his paintings

are discussed. This is one of numerous theoretical debates conducted to clarify the distinction between composition and construction.

28 March: a one-day UNOVIS exhibition is held in Vitebsk (no catalogue).

With the introduction of the New Economic Policy (NEP), allowing for a partial return to the free enterprise system, the government tries to revitalize the stagnant economy.

September: in Moscow the exhibition *5 x 5 = 25* signals the end of painting and the move toward Constructivism. The participants are Exter, Popova, Rodchenko, Varvara Stepanova (1894–1958), and Vesnin—five artists, each showing five works of art.

A growing dislike of the new method of training within the Vitebsk academy as well as the stance of the municipal government force Malevich to find other accommodations for UNOVIS.

In December the Vitebsk INKhUK group, headed by Malevich, visits Moscow, where he lectures at the Moscow INKhUK. By this time the differences between the Constructivist group around Rodchenko and Malevich's Suprematist group are considerable. The suggestion that the Vitebsk group become an official branch of INKhUK is postponed, ostensibly "because of financial implications" but clearly for more complex reasons.

1922 Malevich's last independent publication, the book *God Is Not Cast Down,* is published by UNOVIS in Vitebsk. He begins a major philosophical text *Suprematism. The World as Non-Objectivity,* which occupies him until the end of the 1920s.

12 February: Malevich writes to De Stijl follower Chris Beekman (1887–1964), "dear fellow innovators in Holland," in response to their vain attempts to make contact with Russian innovators. One of his comments concerns "the growing pile of manuscripts that cannot be published or placed in any newspaper." He expresses negative views about Constructivism.

Figure 16

*Collective UNOVIS Entry:
Works by Petrograd
Artists of All Trends,*
Petrograd, May 1923
From *Krassnaia
Panorama,* no. 4, 1923

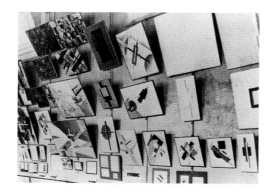

In Moscow in February the forty-seventh exhibition of the Wanderers, whose founders championed Realism between 1860 and 1890, has notable official and public success. Some members of this group, pronounced opponents of the avant-garde leftists, defect and found the Association of Artists of Revolutionary Russia (AKhRR) to rally forces against the dominant role played by the avant-garde since the Revolution. They declare that art should provide an accurate, documentary, realistic image of contemporary everyday life in Russia as well as of the ethnographic differences among the lives of workers throughout the country. The group supports "heroic realism," depicting events of the Revolution and the Red Army's revolutionary contributions.

Malevich gives two lectures in June at the Petrograd INKhUK. Participating with other UNOVIS members, he shows Suprematist works at the exhibition *Survey of New Tendencies in Art,* opening on 15 June at the Museum of Artistic Culture.

Participates in UNOVIS exhibitions at INKhUK, Petrograd.

At the *Erste russische Kunstausstellung* in Berlin in October–November, Malevich is represented by one Cubist and four Suprematist works, one of the latter a "white on white" painting. The American collector Katherine Dreier buys the Cubist work *Knife Grinder* (cat. 27) for her museum of modern art, the Société Anonyme. The exhibition travels to the Stedelijk Museum in Amsterdam in April–May 1923.

December: the Union of Soviet Socialist Republics (USSR) is established.

1923 28 February: Malevich delivers a lecture "On the Artistic Basis: On Color, Light, Pointillism in Space and Time" at the Psycho-Physical Laboratory of the Russian Academy of Artistic Sciences in Moscow.

Malevich contributes to the collective UNOVIS entry in the exhibition *Works by Petrograd Artists of All Trends, 1918–1923,* held in May at the Academy of Arts of Petrograd (fig. 16). On this occasion he announces his "zero" manifesto, "The Suprematist Mirror," in the journal *Zhizn iskusstva* (Life of Art).

In collaboration with the Petrograd Lomonosov Porcelain Factory, he and other UNOVIS members develop designs for new forms and decorations based on Suprematist principles.

He investigates the possibilities for a Suprematist architecture in design sketches of the so-called planits (cat. nos. 156–160).

In June, Pavel Filonov (1883–1941) makes a proposal to convert the Petrograd Museum of Artistic Culture (MKhK), founded in April 1921, into a scholarly institute for research on the culture of modern art. In its September session the museum commission resolves to attach four scholarly departments to the museum and elects Malevich its temporary director.

Malevich's second wife dies. He continues to use her dacha in Nemchinovka, near Moscow, for the rest of his life.

In October he begins the reorganization of MKhK.

1924 21 January: Lenin dies. Malevich writes a long essay in praise of Lenin.

26 January: Petrograd is renamed Leningrad.

2 February: Malevich publishes an article in *Zhizn iskusstva* opposing the artistic direction of AKhRR.

The Leningrad MKhK is closed and replaced by the INKhUK, which as GINKhUK receives the status of an official state institute in February 1925. In addition to the museum, the institute

Figure 17

*Malevich's Daughter
Una,* born 1920

Figure 18

*Representative
Exhibition of the
GINKhUK,*
Leningrad, June
1926

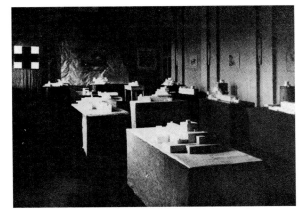

consists of five scholarly departments: painterly
culture, the formal-theoretical department, under
Malevich's direction; organic culture under the
direction of Matiushin; material culture under
Tatlin; the experimental department under Pavel
Mansurov (1896–1983; active at the Petrograd
SVOMAS since 1919); general methodology,
first under the direction of Pavel Filonov and
later of the art critic Punin. Malevich chooses
Ermolaeva, Khidekel, and Yudin as his assis-
tants. New students in his department are,
among others, Anna Leporskaia (1900–1982)
and Konstantin Rozhdestvensky (born 1906).

Participates in the Russian section of the
fourteenth Venice Biennale (April–October);

he shows six *planit* drawings (see cat. nos.
156–160) together with *Black Square, Black
Cross,* and *Black Circle* (cat. nos. 62–64).

1925 Meets the filmmaker Sergei Eisenstein (1890–
1948) and argues with him in two articles in the
film journal *ARK* (1925–1926; of the Associa-
tion of Revolutionary Cinematography).

10 March: delivers a lecture "The Theory of the
Additional Element in Painting" at the Psycho-
Physical Laboratory in Moscow.

In May–June, at the first representative exhibi-
tion of INKhUK, Malevich presents a series of
thirty-two charts that develop his theory of the
"additional element."

In summer Tatlin leaves Leningrad to teach at
the Kiev Institute of Art, where he becomes
director of the department of dramatic, cinematic,
and photographic arts. His post as the head
of the department of material culture is given
to Suetin.

Together with Chashnik and Suetin, Malevich
works out his ideas for a Suprematist architecture
in a series of models, described as arkhitektons,
using rectangular blocks of plaster and wood
(cat. nos. 167–170).

The museum section is shut down and its
collection transferred to the State Russian
Museum and various other museums.

At a meeting attended by Malevich, Matiushin,
Punin, and Suetin, the formal-theoretical
department is renamed the department of
painterly culture.

Marries Natalia Andreevna Manchenko
(born 1902).

In December a decision is made at the Main
Directorate of Scientific Institutions (GLAVNAUKA)
to stage an international exhibition; failing that,
provisions should be made for department
heads to travel abroad. Malevich writes the
proposal on 19 December, signing it along with
Boris Ender (1893–1960, assistant to
Matiushin), Punin, and Suetin.

1926 In February, Malevich shows four *planit* drawings at the International Exhibition of Modern Architecture in Warsaw.

In June he shows a large number of his arkhitektons at the representative exhibition of the Leningrad GINKhUK of this year (fig. 18). The exhibition is attacked by GINKhUK opponents, who by now include members of AKhRR, in an effort to demonstrate the politically questionable status of GINKhUK and to bring about its closing. The argument for its closing is made by the critic G. Seryi in a review, "A Cloister at the Expense of the State," published on 10 June in *Leningradskaia Pravda* (Leningrad Pravda).

16 June: Malevich presents his "Theory of the Additional Element in Painting" at an interdepartmental session at GINKhUK. The publication, dated 3–7 July 1926, goes no further than printer's proofs.

15 November: Malevich dismissed as director of GINKhUK.

At the end of the year GINKhUK is dismantled by merging its staff and departments with those of the State Institute for Art History (GIII).

1927 The transition is clearly not smooth: the work of Malevich's collaborator, Leporskaia, is interrupted ("until the questions concerning the visiting faculty are solved"). She is not admitted to the institute until 1 November 1928.

In connection with his trip to Germany, he completes (with the help of his students Leporskaia, Rozhdestvensky, and Yudin) a series of twenty-two explanatory charts to be used as visual aids in his lectures on the significance of "the additional element" and its usefulness in relation to art education.

On 8 March he leaves for Warsaw, where he stays until 29 March; he shows Polish artists some of the work he has brought with him, delivers a lecture, and attends a banquet in his honor at Hotel Polonia.

Stays in Berlin from 29 March until 5 June. Tadeusz Peiper (editor of the Polish journal *Zwrotnica*) travels with him from Warsaw (fig. 19). He finds lodging with Gustav von Riesen, an engineer who had worked in Moscow before 1914. Von Riesen's son, Alexander, acts as interpreter for Malevich.

On 7 April he visits the Bauhaus in Dessau with Peiper; there he meets Walter Gropius and László Moholy-Nagy. The latter sees to it that Malevich's introduction "Suprematism and the Additional Element in Art" is published in the series Bauhausbücher. Through an association of progressive Berlin architects, Malevich is

Figure 19

Malevich with Tadeusz Peiper, Berlin 1927

Figure 20

Malevich's Will, Berlin, 30 May 1927

Figure 21

Malevich and Una,
1927–1929

He works out ideas with Chashnik and Suetin for satellite cities near Moscow, based on Suprematist concepts of the organization of space.

On 1 November his works are included in the regular *New Tendencies in Art* installation at the State Russian Museum in Leningrad, organized by Punin, who had become a curator of the museum after the closing of INKhUK.

1928 Between April 1928 and October 1930 Malevich publishes a series of twelve articles (in Ukrainian) in the Kharkov monthly *Nova generatsiia* (New Generation on new developments in art since Cézanne.

His manuscript "The Cinema, Gramophone, Radio, and Artistic Culture," submitted for publication, is returned with the criticism that it does "not coincide with the journal's aesthetic ideology," which testifies to the escalating ideological polarization.

1929 April: the First Five-Year Plan is inaugurated at the Sixteenth Party Congress (to be launched retroactively in October 1928). With this the drive begins toward rapid industrialization, collectivization, and the eradication of widespread illiteracy. To establish the creative uniformity that would allow Soviet art to be effective in supporting these goals, the All-Union Cooperative of Artists is established in Moscow as a central agency for supervising commissions, supplies, travel, and so forth. Artists henceforth are to depict the establishment of a socialist society.

The Novembergruppe invites Malevich to exhibit in Berlin, but the proposal comes to nothing.

Appreciation of his research among art historians of the State Institute for Art History steadily decreases. In 1930 Malevich and his department are expelled from the institute.

He is given the opportunity to work two and a half weeks a month at the Kiev Institute of Art.

In a retrospective exhibition of his work at the Tretiakov Gallery in Moscow, in November, he shows new works that recapitulate subjects first depicted in 1912–1913, but in an entirely new

given a separate space to show his work at the *Grosse Berliner Kunstausstellung* of that year (7 May – 30 September) (see figs. 28 – 33). Discusses the idea of making a film on Suprematism with avant-garde filmmaker Hans Richter and writes a short illustrated text.

Upon his departure on 5 June, Malevich entrusts to his host, von Riesen, a package containing theoretical writings; to the secretary of the architectural association, Hugo Häring, he entrusts the works he has brought with him and the series of explanatory charts together with a similar series by Matiushin.

During Malevich's absence from home the political situation in the arts has deteriorated further. In spring 1927 the Commissariat of Education and the Science Administration come under increasing pressure from the Communist Party Central Committee's agitation and propaganda section to abandon their support of artistic pluralism.

After his return from Germany, Malevich proceeds with his research at the State Institute for Art History in Leningrad.

Figure 22

Art from the Imperialist Epoch, State Russian Museum Leningrad 1932

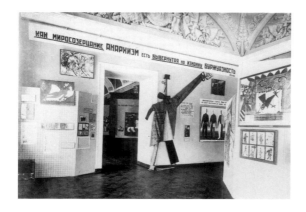

style. The works carry dates such as 1909–1910 (see, for example, cat. 70).

After closing, the exhibition is transferred to the Kiev Art Gallery, but as punishment for organizing an exhibition of the work of the "bourgeois" Malevich, the director, Fedor Kumpan (1896–1970), is given a long sentence. It takes Malevich two and a half years to retrieve his paintings.

1930 Malevich gives a course on painting theory at the House of Art in Leningrad.

Between the end of September and the beginning of December he is interned and questioned "about the ideology of existing trends." "I, as theoretician and ideologist, had to offer interpretations of all trends. I was asked whether there are any right or left tendencies in these movements, any deviations" (letter to the artist Lev Kramarenko [1888–1942], 8 December 1930). As a precautionary measure, friends burn a number of his manuscripts.

From November 1930 to March 1931 he is registered at the Union of Art Workers as unemployed.

In July two of his works are included in the Berlin exhibition *Sowjetmalerei,* organized by the Freunde des neuen Russland. Though the works are dated 1913 and 1915, the perceptive review by Adolph Donath *(Berliner Tageblatt,* 9 July 1930) makes it clear that they are recent figurative paintings of stiff, faceless puppetlike figures and flat landscapes: "One recognizes in these works the 'machine' into which man is being forced—both in painting and outside it."

The exhibition *Russische Kunst von Heute* in October, in Vienna, includes one painting by Malevich, *Soldier.*

Alexander Dorner of the Provinzialmuseum in Hannover, Germany, one of the few museum directors in Europe interested in abstract art, takes custody of the collection of Malevich's works left in Berlin and exhibits several of them in his museum.

1931 Malevich designs a scheme, which is carried out, for the painting of architectural elements in the interior of the Red Theater in Leningrad.

Malevich works on a book titled *Izology,* apparently based on his article in *Nova generatisiia.* In a letter to a friend in Kiev, Lev Kramarenko, he makes a distinction between the "World of Art" as the "world of nonobjectivity" and "Soviet art" as a "symbolic art, and not a naturalistic or realistic art."

1932 April: all official art groups are dissolved by government decree, to be replaced by unions for writers, musicians, artists, and other creative groups.

Malevich is given a basement space at the State Russian Museum for carrying out his research (see fig. 40).

His work is included in the exhibition *Art from the Imperialist Epoch* (fig. 22). The late painting *Sportsmen* (cat. 75) is presented as an example of pre-Revolutionary "bourgeois" art.

He is extensively represented in the exhibition *Fifteen Years of Soviet Art,* held from November to May 1933 at the State Russian Museum and subsequently in Moscow under the title *Artists in the RSFSR over the Last 15 Years.*

The forced collectivization of farms results in a disastrous famine during winter 1932–1933.

1933 Malevich applies for permission to maintain his workshop at the State Russian Museum.

Participates in the *Exhibition of Works by Touring Artists* (no catalogue), in the Scholar's Club in Leningrad.

Figure 23

Malevich in 1935,
During his last illness.

Figure 24

*Malevich Lying in
State in His
Apartment,*
Leningrad 1935

Figure 25

*The Arrival of the
Funeral Procession
at Moscow Station,*
Leningrad 1935

Figure 26

*Una and Natalia
Andreevna at
Malevich's Tomb in
Nemchinovka,* 1935

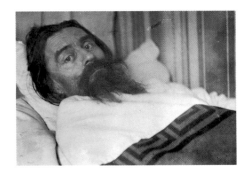

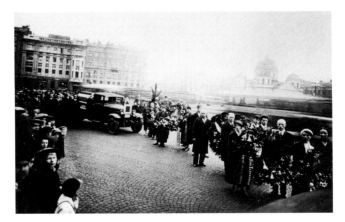

1 December: Malevich draws up a will that specifies that he is to be cremated and buried at Borvikha (now Nemchinovka). Kliun and Suetin are executors.

At the end of the year Malevich delivers the typed text of his "Chapters from a Artist's Autobiography" to the young writer Nikolai Khardzhiev.

1934 Chaired by Maxim Gorky (1868–1936), the First All-Union Congress of Soviet Writers meets in Moscow and concludes by advocating Socialist Realism as the exclusive style for Soviet writers and artists: "Truth and historical concreteness of the artistic depiction of reality must be combined with the task of the ideological transformation and education of the workers in the spirit of Socialism."

Participates in the exhibition *Woman in Socialist Construction* in Leningrad. Two works are listed in the catalogue: *Head of a Young Girl, Sotsgorod,* and *Female Portrait* (cat. 89).

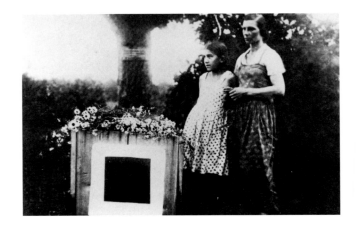

1935 April: with four portraits of 1933 and 1934 (including *Self-Portrait* (repr. *Art in America* [Sept. 1989]: 176) and *Male Portrait* (cat. 90), Malevich participates in *The First Exhibition of Leningrad Artists.* It is the last presentation of his work in the Soviet Union until 1962.

On 15 May, Malevich dies in the presence of his mother, wife, and daughter after several months of illness. Suetin makes a death mask and cast of his hands. In view of his contribution to the art world, the City Council of Leningrad decides to pay the burial costs. After lying in state at his apartment in the former GINKhUK building (fig. 24), his body is placed in a "Suprematist" coffin, executed by Suetin according to sketches

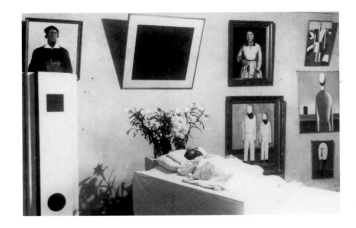

by Malevich but without the cross on the lid that appears in one of the sketches. The coffin is brought to the House of the Artist for mourning, and then a long procession of friends and colleagues follow it to the Moscow Station, to be taken to Moscow by train (fig. 25). After the cremation the urn of ashes is buried in the open field next to the dacha in Nemchinovka. The site is marked with a white cube and a black square, designed and made by Suetin (fig. 26).

2 June: Alfred H. Barr, Jr., director of the Museum of Modern Art in New York, selects a number of Malevich's works in Hannover, from the relocated Berlin collection, for the first large retrospective exhibition *Cubism and Abstract Art,* held in New York in 1936.

1936 March: Malevich is represented with seven paintings and six drawings in *Cubism and Abstract Art* at the Museum of Modern Art.

A large part of Malevich's estate is taken into custody by the State Russian Museum, though still the property of his family. The works are not shown for decades. In 1977, however, they are officially incorporated into the permanent collection by order of the Ministry of Culture. Apart from the collection in the Museum of Modern Art, works by Malevich are not shown again, either in Russia or the West, until the *Exhibition of Russian Painting,* in Palm Beach, Florida, in 1945.

In the late 1950s the large collection now owned by the Stedelijk Museum arrives in Amsterdam from Germany.

GROSSE BERLINER KUNSTAUSSTELLUNG

1927

VERANSTALTET VOM
KARTELL
DER VEREINIGTEN
VERBÄNDE BILDENDER
KÜNSTLER BERLINS E. V.
IM

LANDESAUSSTELLUNGSGEBÄUDE
ALT-MOABIT 4 BIS 10 AM LEHRTER BAHNHOF

VERLAG VON G. E. DIEHL / BERLIN

In 1927 Malevich traveled from Leningrad to Poland and Germany with a large retrospective exhibition of his work (see Bibliography A2 and A3). In Warsaw the exhibition was held in the Hotel Polonia, and in Berlin it was presented as a separate one-person exhibition within the annual *Grosse Berliner Kunstausstellung.*

Few records of the exhibition remain, and it is not known exactly how Malevich came to be invited or by whom. Clearly, the progressive German architect Hugo Häring played a leading role on the German side as did Henry Stażewski in Warsaw. The Berlin exhibition catalogue contained no list of works, but when four installation photographs came to light in the 1960s it became possible to develop an idea of the nature of Malevich's presentation.[1] The four photographs published here (figs. 28–31) are accompanied for the first time by precise indications of the present locations of the fifty-five works reproduced. Fifteen of these seem to have been irretrievably lost; of the other forty, twenty-four are now in the Stedelijk Museum in Amsterdam, three are in private collections, seven in the Museum of Modern Art in New York, four in other museums, and two, formerly in private collections, are now unlocated.

The four installation photographs, however, did not cover the entire scope of the work Malevich brought to Berlin. Figures 32 and 33 present an additional group of fifteen paintings that can be securely identified as deriving from the exhibition. There was also a large group of drawings (see for example cat. nos. 144–151 and 157–166 in the present exhibition), an unknown number of architectural models, and twenty-two charts prepared by members of the Formal Theoretical Department (which Malevich headed) to explicate the theoretical work of the Institute of Artistic Culture in Leningrad.

Since 1935 five of the theoretical charts have been in the collection of the Museum of Modern Art. The remaining seventeen are in the Stedelijk Museum, acquired from Hugo Häring together with the paintings and drawings. All twenty-two were published in detail by Troels Andersen (1970, nos. 115–136).

On 5 June 1927, four months before the Berlin exhibition closed, Malevich returned to Leningrad, leaving his work in the care of Hugo Häring, with explicit instructions that they not be sent back to the artist. Malevich apparently had hoped to return the following year and exhibit his work in other Western cities. He even seems to have considered settling in the West. But none of these plans materialized, and before he died in 1935, having lost all contact with his German colleagues, Malevich assumed that the entire contents of the exhibition had been destroyed.

The fate of these works has now been documented to a considerable extent, and although fifteen of them seem to be definitely lost, the remainder can be traced. Almost all were initially crated and stored with the shipping agent Gustav Knauer in Berlin. At some stage the crates were

Figure 27

Poster for the *Grosse Berliner Kunstausstellung*
7 May–30 September 1927

transferred from Berlin to the custody of Alexander Dorner, the director of the Provinzialmuseum in Hannover, who had long been interested in the innovations of Russian art and may have planned to exhibit Malevich's work. In February 1933, however, when the Nazis came to power, it became impossible to consider exhibiting or even handling abstract art. At considerable personal risk, Dorner concealed the work in his basement.

In 1935 Alfred H. Barr, Jr., director of the Museum of Modern Art, was traveling through Europe in search of works to include in his *Cubism and Abstract Art* exhibition of 1936. In view of Dorner's reputation and their acquaintance, Barr decided to start his search in Hannover. But the discovery of the Malevich collection was entirely unexpected. Barr managed to borrow six paintings, a gouache, five drawings, and five of the twenty-two theoretical charts. He also purchased two Suprematist paintings and two architectural drawings for the museum's permanent collection. He successfully brought the works out of the country and included them in the New York exhibition. After the exhibition closed, it was clearly impossible to return the loans, which would have been confiscated instantly and destroyed by the Nazi authorities.

Meanwhile, Dorner no longer felt that he could safely keep the rest of the collection in Hannover: in 1936, 270 works from his museum had been seized by the Nazis and sold as "entartete Kunst" (degenerate art). The entire modern movement was at risk in Germany, and Dorner decided to transfer the precious Malevich works back to Häring, who courageously stored them, first in his house in Berlin, and after 1943, when he left Berlin for good, in his native town of Biberach in southern Germany.

In spring 1951, Willem Sandberg, the pioneering director of the Stedelijk Museum in Amsterdam, traveled to Germany with his deputy Hans Jaffé. Their ostensible purpose was to arrange an exhibition of German Expressionism, but in fact it was to find the man whom they knew had a collection of works by Malevich in his care. They located Hugo Häring, who showed them the works still remaining at that time. Fifteen of the original group had inexplicably vanished. Joop Joosten has suggested (Bibliography A3, 50) that since most of these fifteen works were large they may have been packed in a separate crate in 1927; but instead of being sent to Hannover, the crate was left at the Knauer warehouse, then forgotten, and ultimately destroyed.

Although Häring seemed interested in Sandberg's proposal for an Amsterdam exhibition, no committment was made. Only when Naum Gabo and Mies van der Rohe intervened several years later did Sandberg succeed in rekindling Häring's interest. In 1957 the works were sent to Amsterdam, where they were purchased in 1958 by the Stedelijk Museum with an additonal grant from the city of Amsterdam.

Numbers in parentheses refer to the present catalogue.

Figures 28–31

1. *The Gardener* (cat. 17). Hugo Häring, Berlin and Biberach; Stedelijk Museum.
2. *Greenhouses (Carrying Earth)* (Andersen 1970, no. 4). Hans von Riesen, Bremen; private collection.
3. *Floor Polishers* (cat. 20). Hugo Häring, Berlin and Biberach; Stedelijk Museum.
4. *Man with Sack* (Andersen 1970, no. 11). Hugo Häring, Berlin and Biberach; Stedelijk Museum.
5. *Head of Peasant* (Andersen 1970, no. 11). Hugo Häring, Berlin and Biberach; private collection.
6. *Head of Peasant. Study for Peasant Funeral* (Andersen 1970, no. 19). Hugo Häring, Berlin and Biberach; present location unknown.
7. Lost.
8. *Peasant Women* (Andersen 1970, no. 23). Lost.
9. *Reaping Woman* (Andersen 1970, no. 26). Lost.
10. *Peasant Funeral* (Andersen 1970, no. 21). Lost.
11. Lost.
12. Lost.
13. Lost.
14. *Village* (Andersen 1970, no. 6). Formerly Museum of Modern Art, through Alexander Dorner, Hannover (lost 1939 or earlier); present location unknown.
15. *On the Boulevard* (cat. 16). Hugo Häring, Berlin and Biberach; Stedelijk Museum.
16. *Work at the Mill* (Andersen 1970, no. 16?). Lost.
17. *Head of Peasant* (Andersen 1970, no. 30). Lost.
18. *Peasant Woman with Buckets and Child* (cat. 21). Hugo Häring, Berlin and Biberach; Stedelijk Museum.
19. *Peasant Women at Church* (Andersen 1970, no. 24). Lost.

Figures 28–31

*Malevich One-Person
Exhibition. Grosse Berliner
Kunstausstellung*
7 May–30 September 1927
(nos. 1–55)

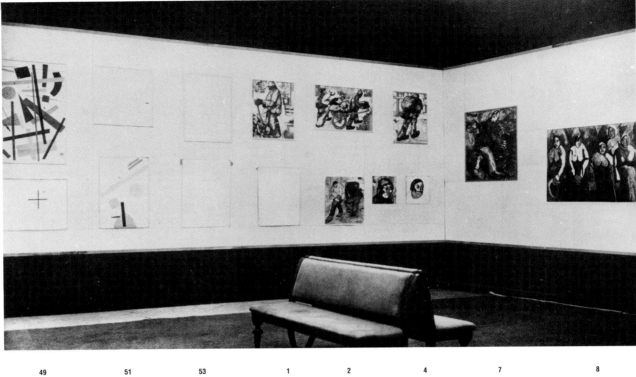

| 49 | | 51 | | 53 | | 1 | | 2 | | 4 | | 7 | | 8 |
| 50 | | 52 | | 54 | | 55 | | 3 | | 5 | 6 | | |

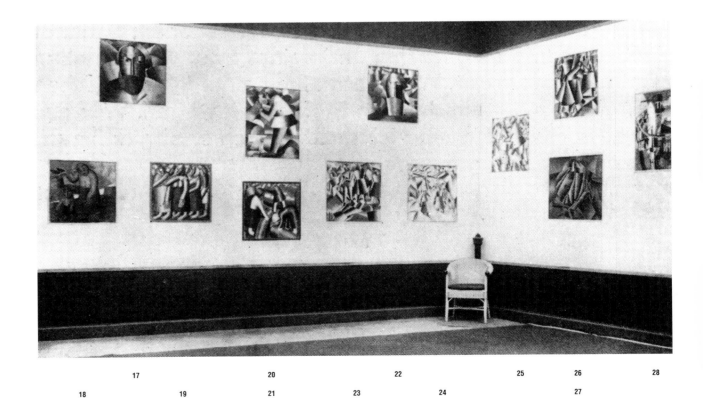

| | 17 | | 20 | | 22 | | 25 | 26 | | 28 |
| 18 | | 19 | 21 | | 23 | | 24 | | 27 | |

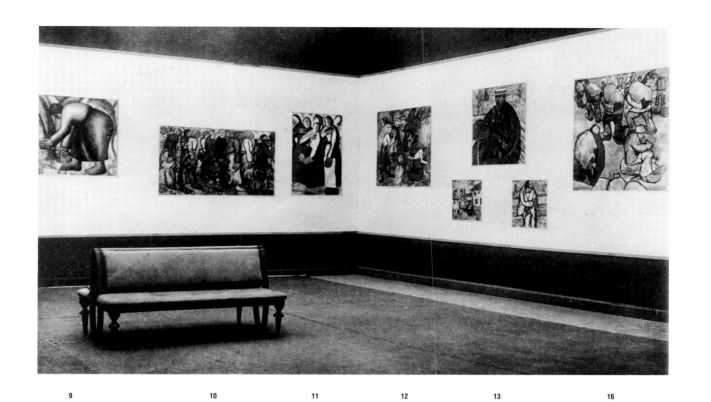

9 10 11 12 13 16

14 15

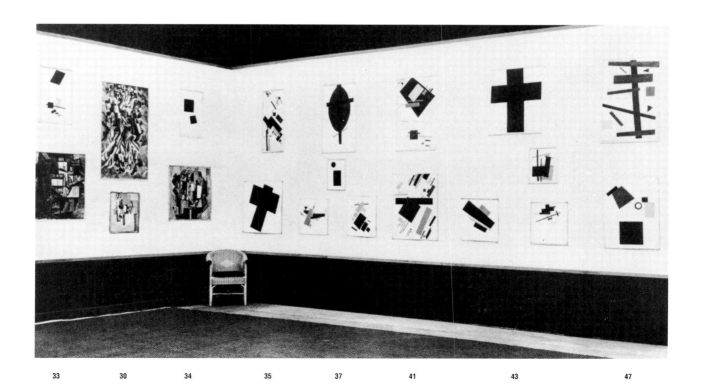

33 30 34 35 37 41 43 47

38 44

29 31 32 36 39 40 42 45 46 48

20. *The Woodcutter* (cat. 23). Hugo Häring, Berlin and Biberach; Stedelijk Museum.
21. *Taking in the Rye* (cat. 22). Hugo Häring, Berlin and Biberach; Stedelijk Museum.
22. *The Orthodox* (Andersen 1970, no. 31). Lost.
23. *Peasant Scene* (Andersen 1970, no. 35). Lost.
24. *Morning in the Country after Snowstorm* (cat. 24). Dr. Udo Rukser (brother-in-law of Hans Richter). Through Rose Fried Gallery, New York, to Solomon R. Guggenheim Museum.
25. *Carpenter's Scene* (Andersen 1970, no. 36). Lost.
26. *Peasant Woman with Buckets* (cat. 25). Through Alexander Dorner, Hannover, to the Museum of Modern Art.
27. *Face of a Peasant Girl* (cat. 26). Hugo Häring, Berlin and Biberach; Stedelijk Museum.
28. *An Englishman in Moscow* (cat. 38). Hugo Häring, Berlin and Biberach; Stedelijk Museum.
29. *Lady in a Tram* (cat. 35). Hugo Häring, Berlin and Biberach; Stedelijk Museum.
30. *Futurist Composition* (Andersen 1970, no. 38).
31. *Warrior of the First Division, Moscow* (cat. 39). Through Alexander Dorner, Hannover, to the Museum of Modern Art.
32. *Desk and Room* (Andersen 1970, no. 41).
33. *Suprematism: Painterly Realism of a Football Player. Color Masses in the Fourth Dimension* (cat. 47). Hugo Häring, Berlin and Biberach; Stedelijk Museum.
34. *Painterly Realism. Boy with Knapsack—Color Masses in the Fourth Dimension* (cat. 42). Through Alexander Dorner, Hannover, to the Museum of Modern Art.
35. *House under Construction* (Andersen 1970, no. 59). Sold to Ida Bienert, Dresden, ca. 1928; Mr. and Mrs. Armand Bartos; National Gallery of Australia, Canberra.
36. *Suprematist Painting* (Andersen 1970, no. 68). Through Alexander Dorner, Hannover, to the Museum of Modern Art.
37. *Suprematist Painting* (Andersen 1970, no. 73). Hugo Häring, Berlin and Biberach; Stedelijk Museum.
38. *Suprematist Painting. Rectangle and Circle* (cat. 44). Bequest of Alexander Dorner, Busch-Reisinger Museum, Harvard University.
39. *Suprematist Painting* (Andersen 1970, no. 58). Through Alexander Dorner, Hannover, to the Museum of Modern Art; Peggy Guggenheim Collection, Venice.
40. *Airplane Flying* (cat. 45). Through Alexander Dorner, Hannover, to the Museum of Modern Art.
41. *Suprematist Painting* (Andersen 1970, no. 51), Hugo Häring, Berlin and Biberach; Stedelijk Museum.
42. *Suprematist Painting* (Andersen 1970, no. 60). Hugo Häring, Berlin and Biberach; Stedelijk Museum.
43. *Suprematist Painting* (Andersen 1970, no. 69). Hugo Häring, Berlin and Biberach; Stedelijk Museum.
44. *Suprematist Painting* (Andersen 1970, no. 55). Hugo Häring, Berlin and Biberach; Stedelijk Museum.
45. *Suprematism, 18th Construction* (Andersen 1970, no. 52). Hugo Häring, Berlin and Biberach; Stedelijk Museum.
46. *Suprematist Painting* (Andersen 1970, no. 57). Hans von Riesen, Bremen; Wilhelm Hack, Cologne.
47. *Suprematism (Supremus No. 50)* (cat. 49). Hugo Häring, Berlin and Biberach; Stedelijk Museum.
48. *Suprematist Painting* (cat. 49). Hugo Häring, Berlin and Biberach; Stedelijk Museum.
49. *Suprematist Painting* (Andersen 1970, no. 62?). Lost.
50. *Suprematist Painting* (Andersen 1970, no. 71). Hugo Häring, Berlin and Biberach; Stedelijk Museum.
51. *White Square on White* (cat. 61). Through Alexander Dorner, Hannover, to the Museum of Modern Art.
52. *Suprematist Painting* (cat. 57). Hugo Häring, Berlin and Biberach; Stedelijk Museum.
53. *Suprematist Painting* (cat. 59). Hugo Häring, Berlin and Biberach; Stedelijk Museum.
54. *Suprematist Painting* (cat. 60). Hugo Häring, Berlin and Biberach; Stedelijk Museum.
55. *Suprematist Painting* (cat. 66). Hugo Häring, Berlin and Biberach; Stedelijk Museum.

The following fifteen works (figs. 32, 33) are not visible in the existing Berlin installation photographs, but they were among the works left there by Malevich. Twelve of these came to the Stedelijk Museum from Hugo Häring (56, 57, 59, 60, 63–70). Three came through the collection of Hans von Riesen; of these, two are in private collections (58, 61) and one is in the Kunstmuseum, Basel (62).

56. *Portrait of a Woman* (cat. 5). Hugo Häring, Berlin and Biberach; Stedelijk Museum.
57. *Province* (cat. 15). Hugo Häring, Berlin and Biberach; Stedelijk Museum.
58. *Washing Woman* (Andersen 1970, no. 17). Hans von Riesen, Bremen; private collection, Zurich.
59. *Chiropodist (at the Bathhouse)* (cat. 19). Hugo Häring, Berlin and Biberach; Stedelijk Museum.
60. *Bather* (cat. 18). Hugo Häring, Berlin and Biberach; Stedelijk Museum.
61. *Argentine Polka* (Andersen 1970, no. 10). Hans von Riesen, Bremen; Joachim Jean Aberbach, Sands Point, New York.
62. *Village* (Andersen 1970, no. 5). Hans von Riesen, Bremen; Kunstmuseum, Basel.
63. *Musical Instrument/Lamp* (cat. 34). Hugo Häring, Berlin and Biberach; Stedelijk Museum.
64. *Guardsman* (cat. 36). Hugo Häring, Berlin and Biberach; Stedelijk Museum.
65. *Lady at the Advertising Column* (cat. 40). Hugo Häring, Berlin and Biberach; Stedelijk Museum.
66. *Suprematist Painting* (cat. 50). Hugo Häring, Berlin and Biberach; Stedelijk Museum.
67. *Suprematist Painting* (cat. 67). Hugo Häring, Berlin and Biberach; Stedelijk Museum.
68. *Suprematist Painting. Eight Red Rectangles* (cat. 46). Hugo Häring, Berlin and Biberach; Stedelijk Museum.
69. *Suprematist Painting. Black Rectangle, Blue Triangle* (cat. 43). Hugo Häring, Berlin and Biberach; Stedelijk Museum.
70. *Suprematist Painting* (cat. 58). Hugo Häring, Berlin and Biberach; Stedelijk Museum.

Figure 32

From the Malevich One-Person Exhibition. Grosse Berliner Kunstausstellung (nos. 56–63)

56

57

58

59

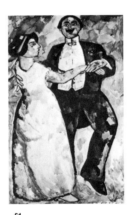

60

61

62

63

Figure 33

From the Malevich One-Person Exhibition. Grosse Berliner Kunstausstellung (nos. 64–70)

64

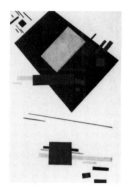

66

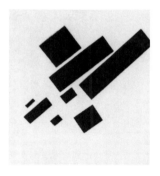

68

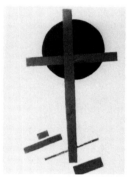

65

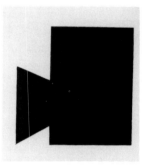

67

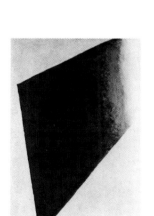

69

70

CATALOGUE ILLUSTRATIONS

Paintings

1

On the Boulevard, 1903
Oil on canvas
21⁵/₈ x 26 (55 x 66)
State Russian Museum

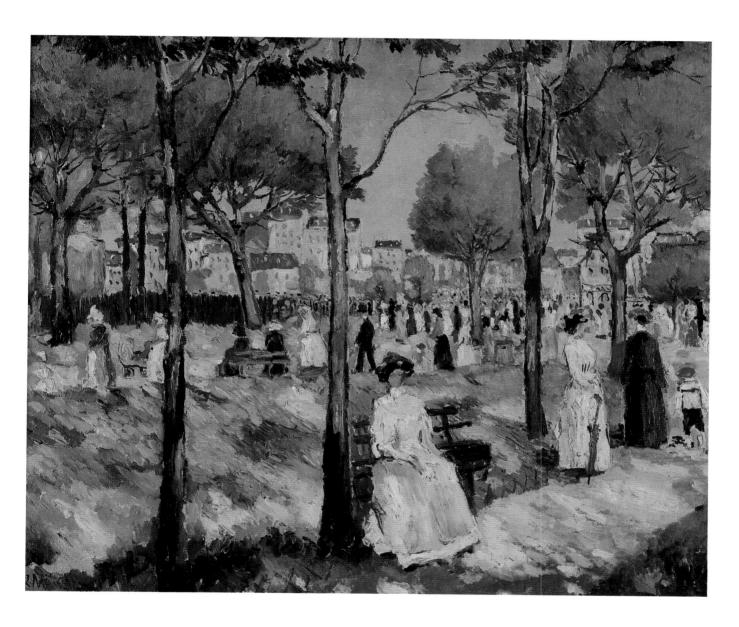

2

Apple Trees in Blossom,
1904
Oil on canvas
21⁵/₈ x 27 ¹/₂ (55 x 70)
State Russian Museum

3

Landscape, early 1900s
Oil on cardboard
7 ⁹/₁₆ x 12 ³/₁₆ (19.2 x 31)
State Russian Museum

4
Landscape with Yellow
House, early 1900s
Oil on cardboard
7 $^9/_{16}$ x 11 $^5/_8$ (19.2 x 29.5)
State Russian Museum

5

Portrait of a Woman,
ca. 1906
Oil on board
26 3/4 x 39 (68 x 99)
Stedelijk Museum

6

**Study for Fresco Painting
(The Triumph of Heaven),**
1907
Tempera on cardboard
28 ¹/₂ x 27 ¹/₂ (72.5 X 70)
(edges lost)
State Russian Museum

7

**Study for Fresco Painting
(Portrait),** 1907
Tempera on cardboard,
27 ¹/₄ x 27 ⁵/₈ (69.3 x 70)
State Russian Museum

8

Study for Fresco Painting,
1907
Tempera on cardboard
27 1/4 x 28 1/8 (69.3 x 71.5)
State Russian Museum

9

**Study for Fresco Painting
(Prayer?),** 1907
Tempera on cardboard
27 5/8 x 29 7/16 (70 x 74.8)
State Russian Museum

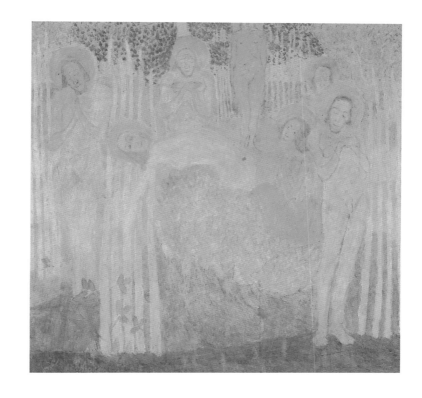

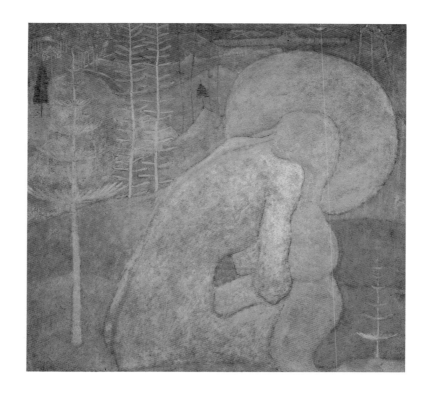

10
River in the Forest,
ca. 1908 or 1928(?)
Oil on canvas
20 7/8 x 16 1/2 (53 x 42)
State Russian Museum

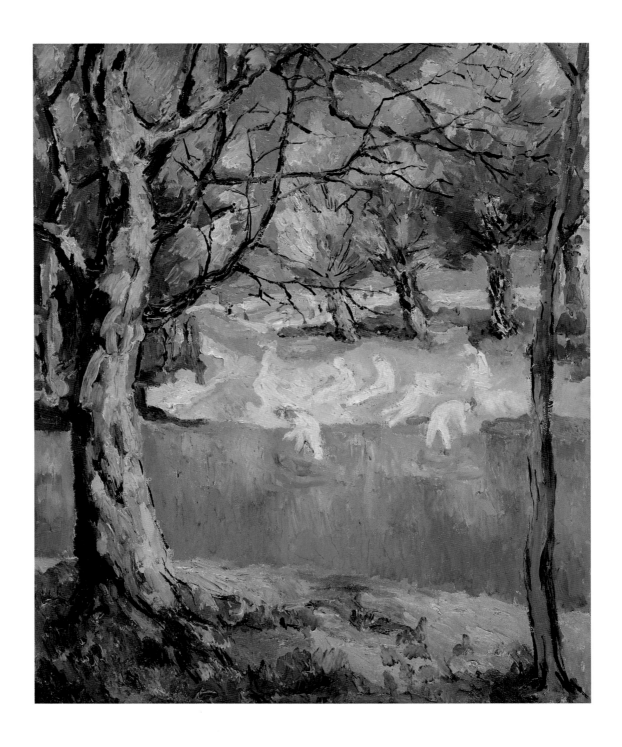

11
Female Bathers,
ca. 1908 or 1928(?)
Oil on canvas
23 1/4 x 18 7/8 (59 x 48)
State Russian Museum

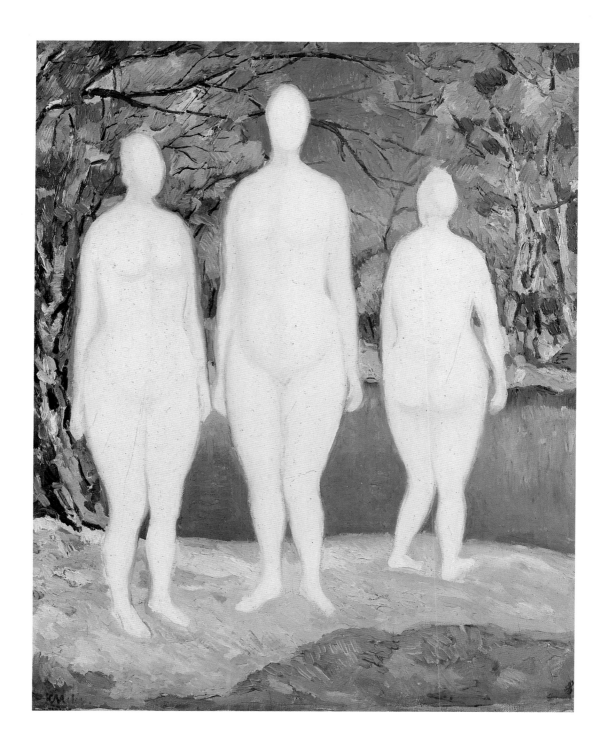

12
Self-Portrait,
ca. 1908 – 1909
Gouache and varnish
on paper
10 $\frac{5}{8}$ x 10 $\frac{9}{16}$ (27 x 26.8)
State Tretiakov Gallery

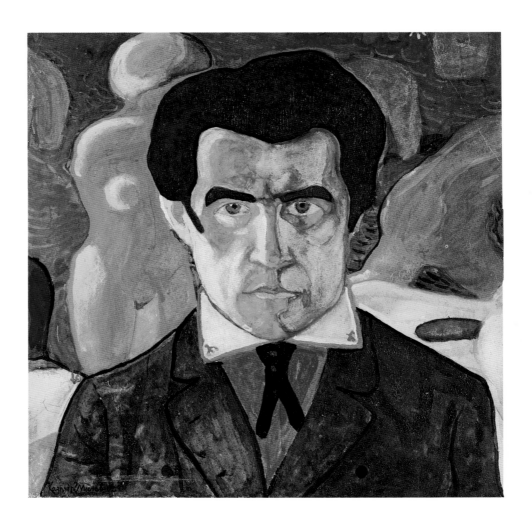

13

Self-Portrait,
ca. 1908–1909
Gouache, watercolor,
India ink, and varnish
on paper
18 3/16 x 16 1/4 (46.2 x 41.3)
State Russian Museum

14
Still Life, 1910
Watercolor and gouache
on paper
20 $^5/_8$ x 20 $^3/_8$ (52.5 x 51.8)
State Russian Museum

15
Province, 1911
Gouache on paper
27 ³/₄ x 27 ³/₄ (70.5 x 70.5)
Stedelijk Museum

On the Boulevard, 1911
Charcoal and gouache
on paper
28 ³/₈ x 28 (72 x 71)
Stedelijk Museum

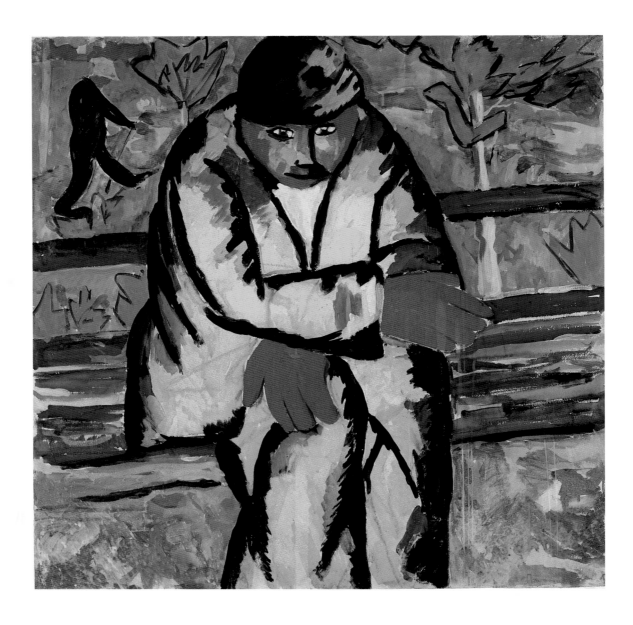

17

The Gardener, 1911
Charcoal and gouache
on board
35 7/8 x 27 1/2 (91 x 70)
Stedelijk Museum

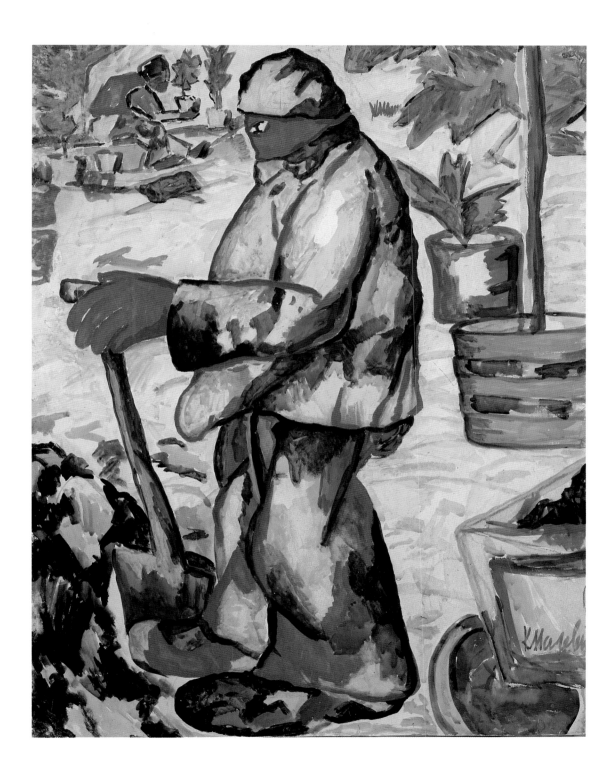

18
Bather, 1911
Charcoal and gouache
on paper (mounted
on paper),
41 $^3/_8$ x 27 $^1/_4$ (105 x 69)
Stedelijk Museum

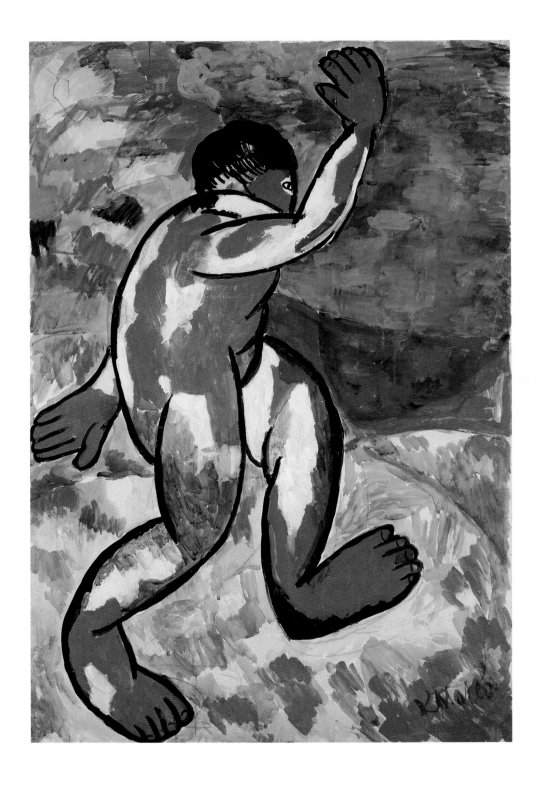

19

**Chiropodist (at the
Bathhouse),** 1911–1912
Charcoal and gouache
on paper
30 $^5/_8$ x 40 $^9/_{16}$ (77.7 x 103)
Stedelijk Museum

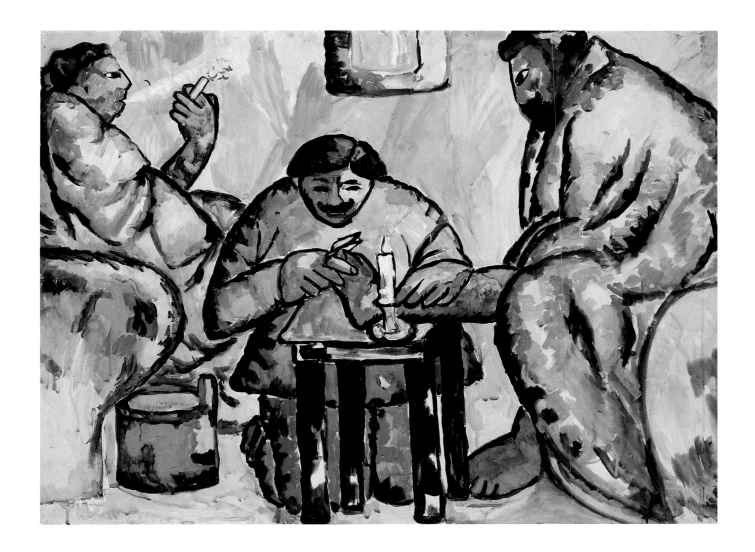

Floor Polishers,
1911–1912
Charcoal and gouache
on paper
30 ⁵/₈ x 27 ⁷/₈ (77.7 x 71)
Stedelijk Museum

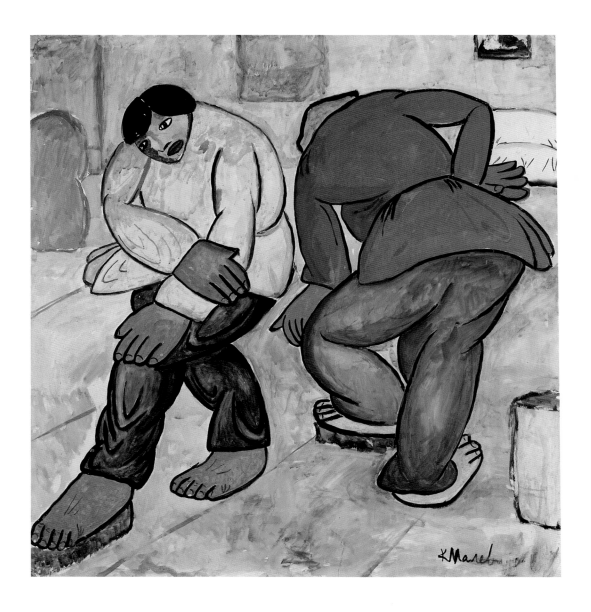

21
Peasant Woman with
Buckets and Child, 1912
Oil on canvas
28 ³/₄ x 28 ³/₄ (73 x 73)
Stedelijk Museum

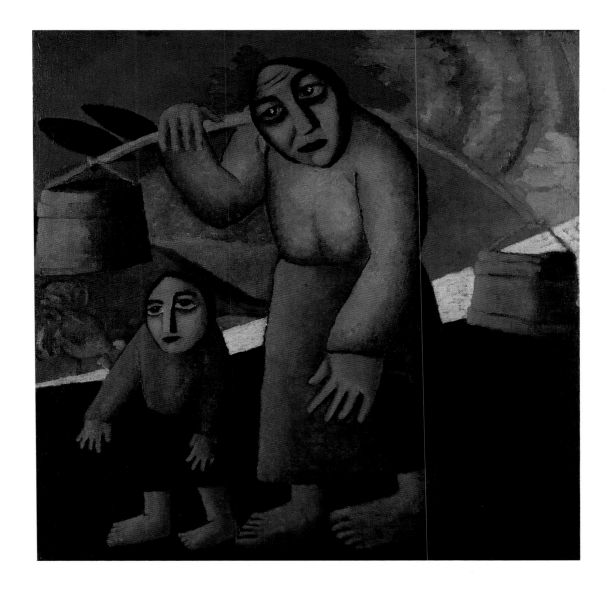

22
Taking in the Rye, 1912
Oil on canvas
28 3/8 x 29 3/8 (72 x 74.5)
Stedelijk Museum

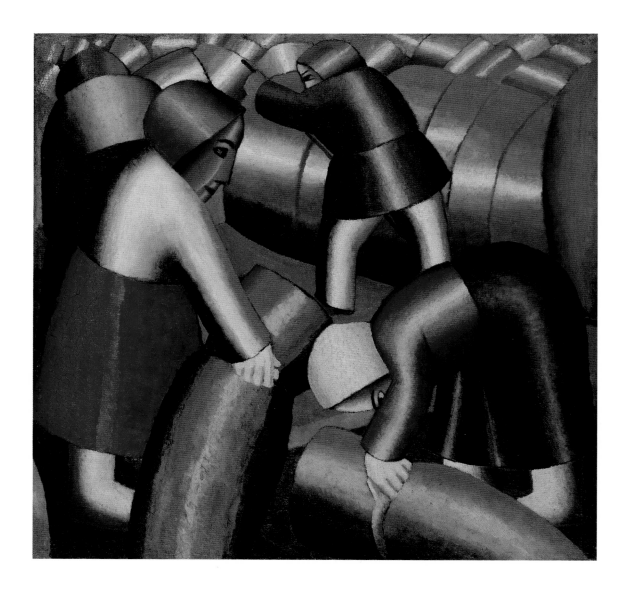

23

The Woodcutter, 1912
Oil on canvas
37 x 28 ⅛ (94 x 71.5)
Stedelijk Museum

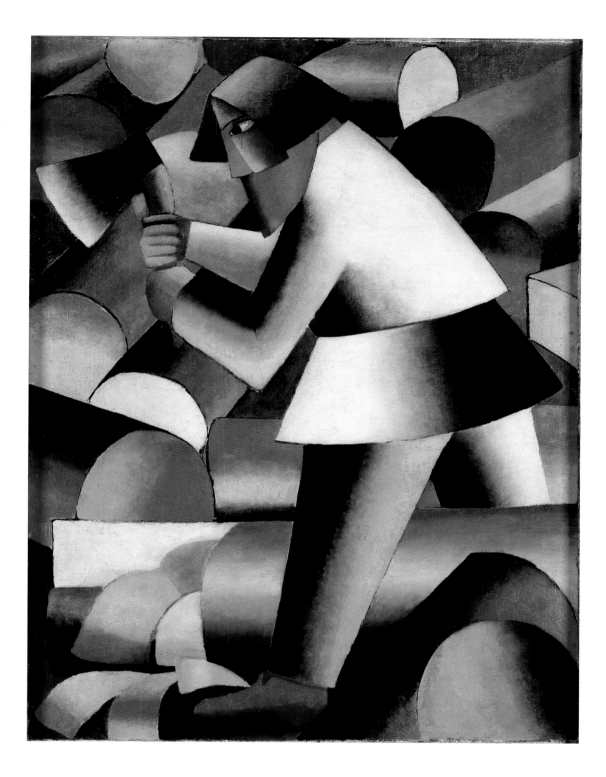

Figure 34

Peasant Women at Church,
1911 (verso of cat. 23)
Oil on canvas
29 1/2 x 38 3/8 (75 x 97.5)

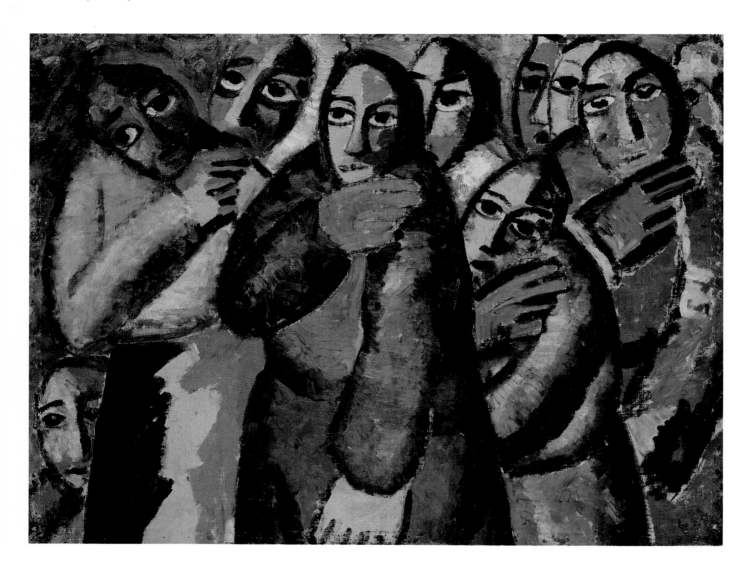

24

**Morning in the Country
after Snowstorm**, 1912
Oil on canvas
31 3/4 x 31 7/8 (80.7 x 80.8)
Solomon R.
Guggenheim Museum

Washington only

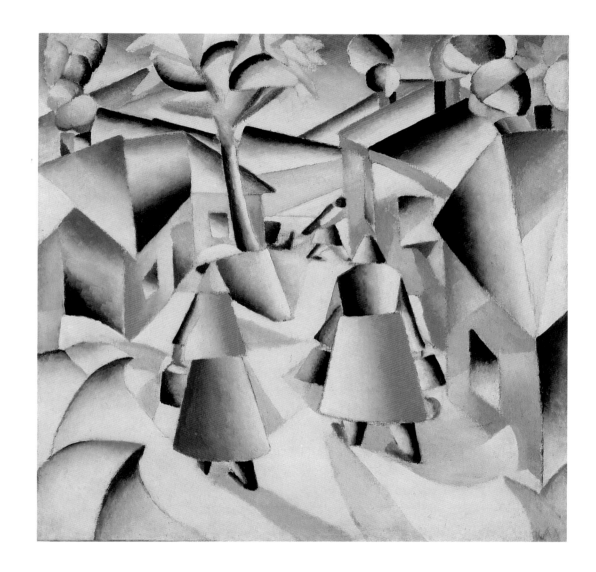

**Peasant Woman with
Buckets,** 1912
Oil on canvas
31 ⁵/₈ x 31 ⁵/₈ (80.3 x 80.3)
The Museum of
Modern Art

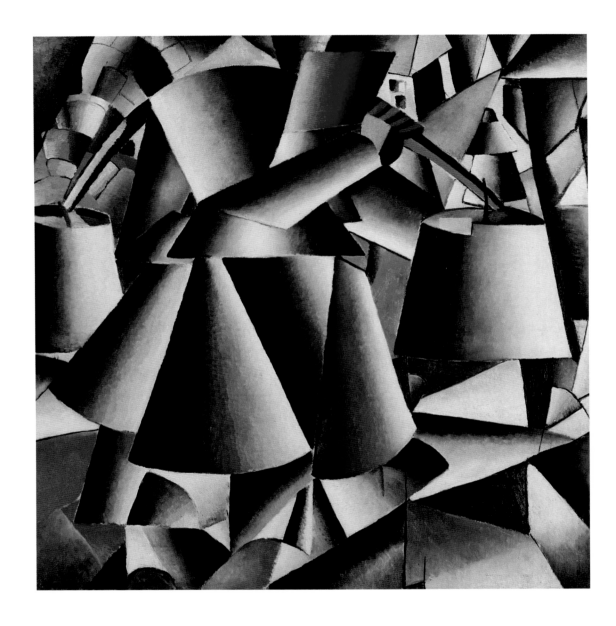

26

Face of a Peasant Girl,
1913
Oil on canvas
31 1/2 x 37 3/8 (80 x 95)
Stedelijk Museum

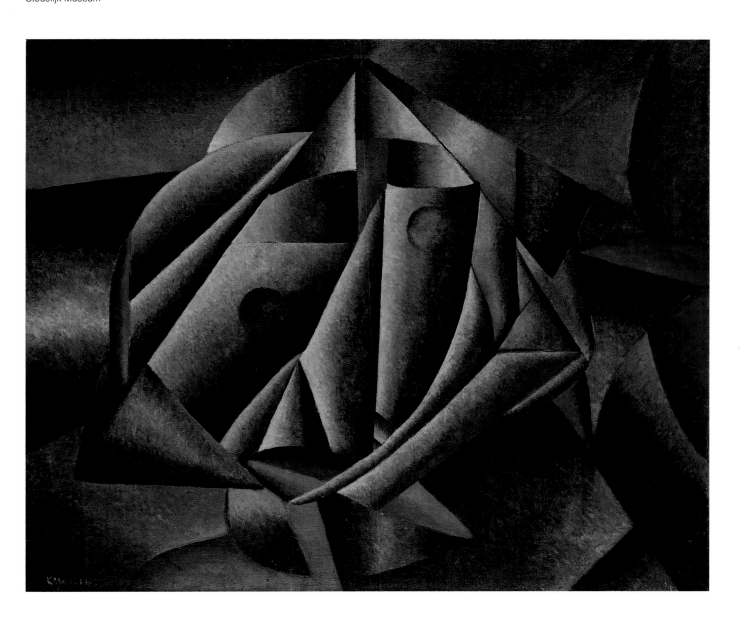

27

Knife Grinder/Principle of
Flickering, ca. 1913
Oil on canvas
31¹/₄ x 31¹/₄ (79.5 x 79.5)
Yale University Art Gallery

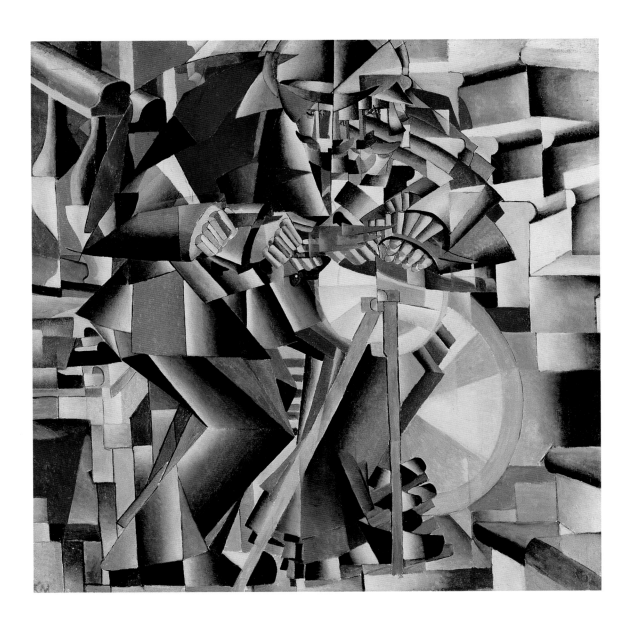

28

In the Grand Hotel,
ca. 1913
Oil on canvas
42 1/2 x 28 (108 x 71)
Kuibyshev Art Museum

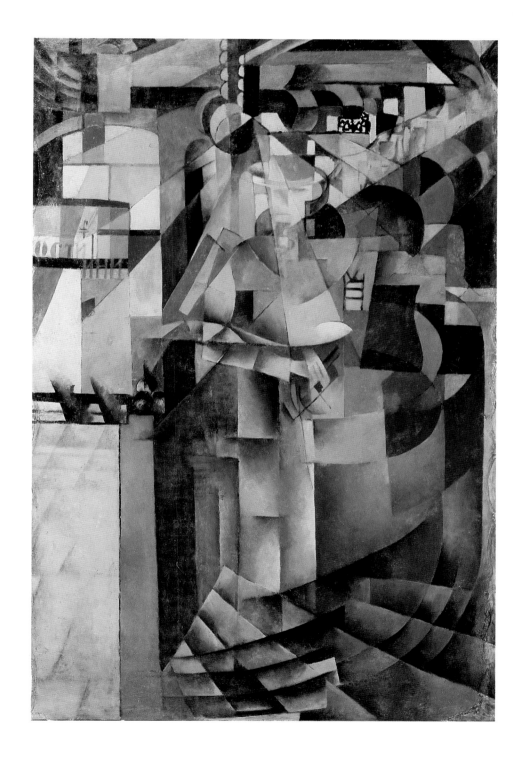

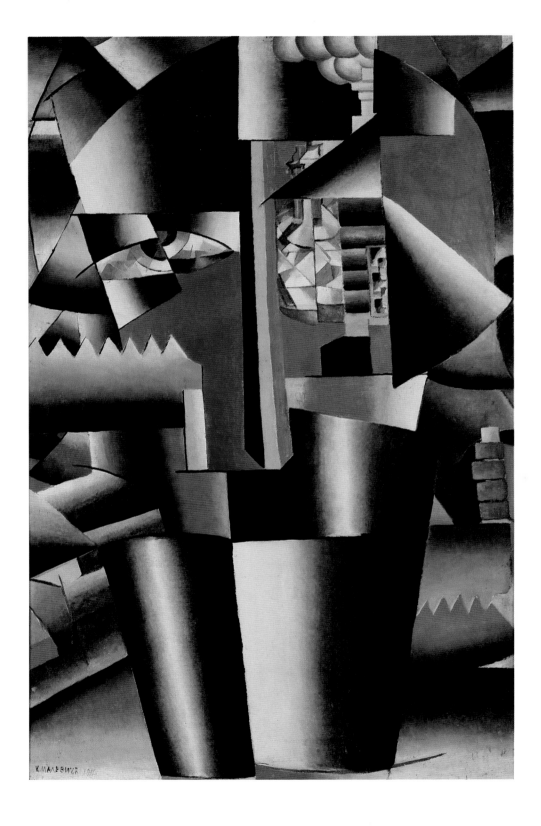

30
Through Station.
Kuntsevo, 1913
Oil on wood
19 ⁵⁄₁₆ x 10 (49 x 25.5)
State Tretiakov Gallery

31
Vanity Case, 1913
Oil on wood
19 ⁵⁄₁₆ x 10 (49 x 25.5)
State Tretiakov Gallery

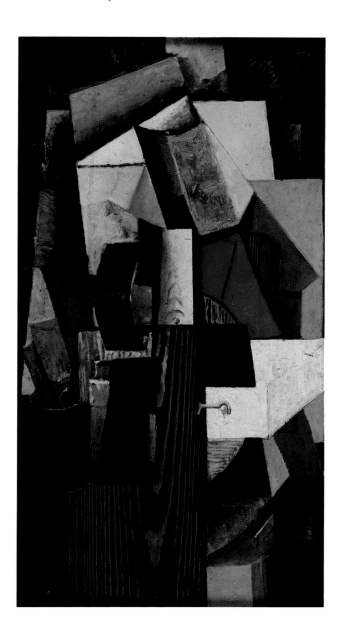

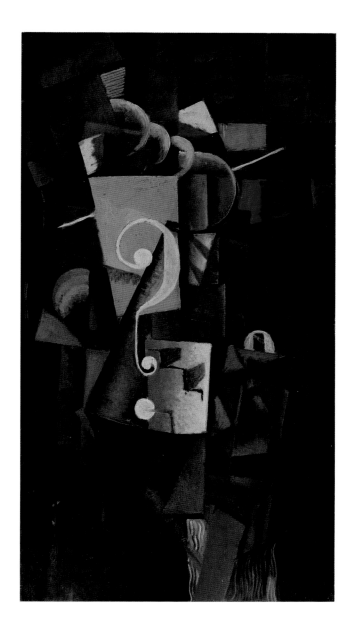

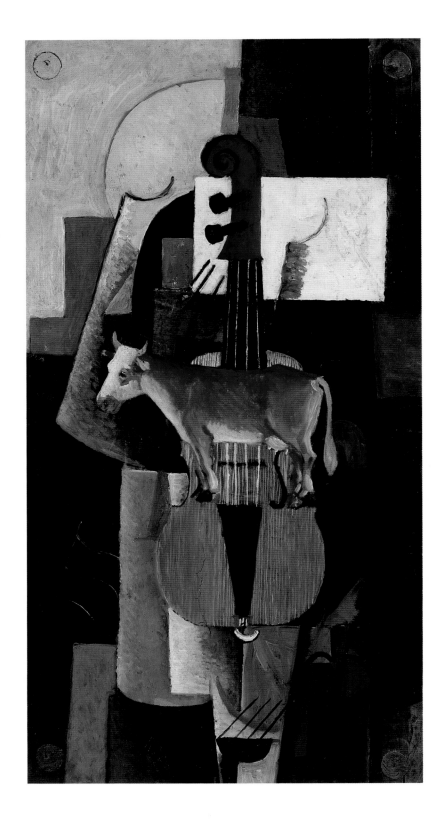

Portrait of the Composer
M. V. Matiushin, 1913
Oil on canvas
41⁷/₈ x 41⁷/₈
(106.3 x 106.3)
State Tretiakov Gallery

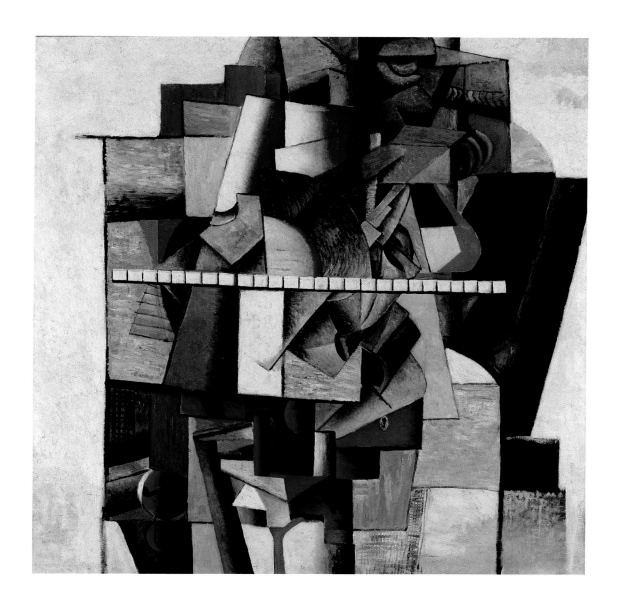

34

Musical Instrument / Lamp,
1913
Oil on canvas
32 7/8 x 27 3/8 (83.5 x 69.5)
Stedelijk Museum

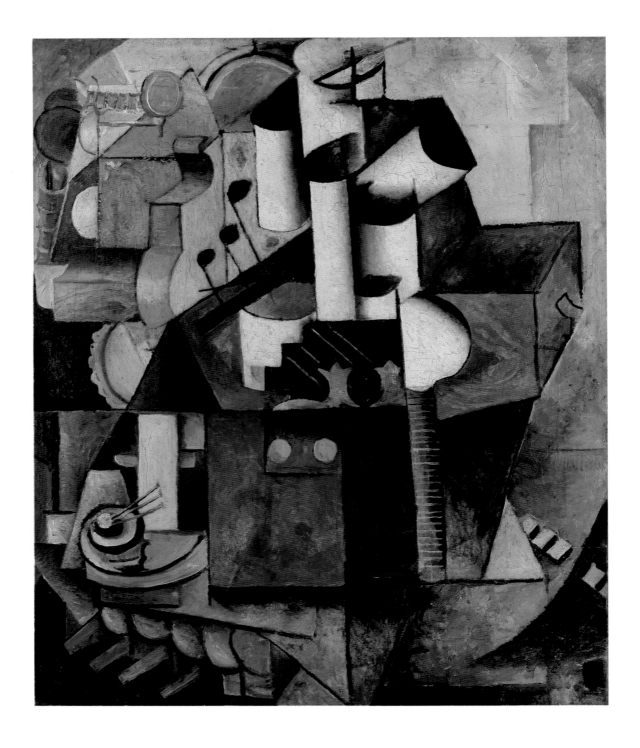

35

Lady in a Tram, 1913
Oil on canvas
34 ⁵/₈ x 34 ⁵/₈ (88 x 88)
Stedelijk Museum

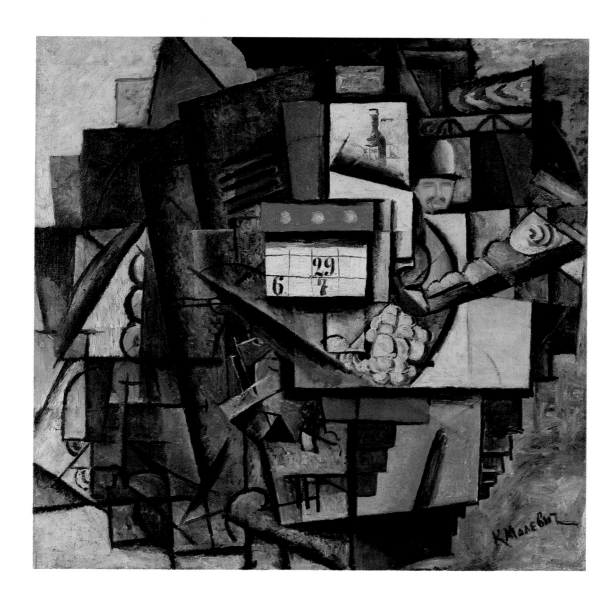

Guardsman, 1913–1914
Oil on canvas
22 $^{7}/_{16}$ x 26 $^{1}/_{8}$ (57 x 66.5)
Stedelijk Museum

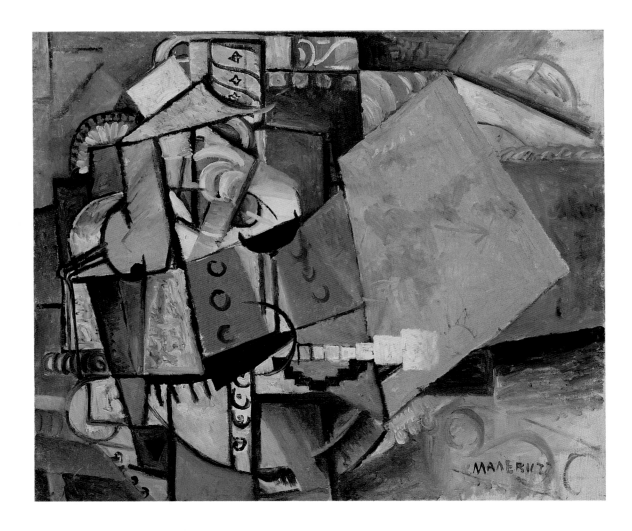

37

Aviator, 1914
Oil on canvas
49 ¼ x 25 ⅝ (125 x 65)
State Russian Museum

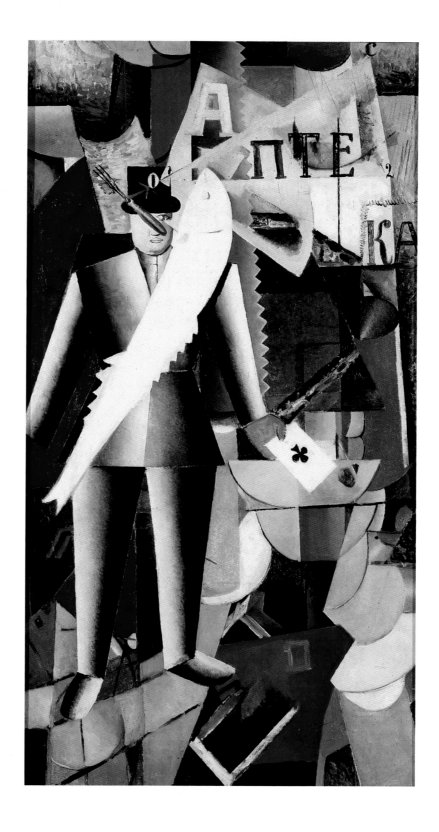

An Englishman in Moscow,
1914
Oil on canvas
34 ⁵/₈ x 22 ⁷/₁₆ (88 x 57)
Stedelijk Museum

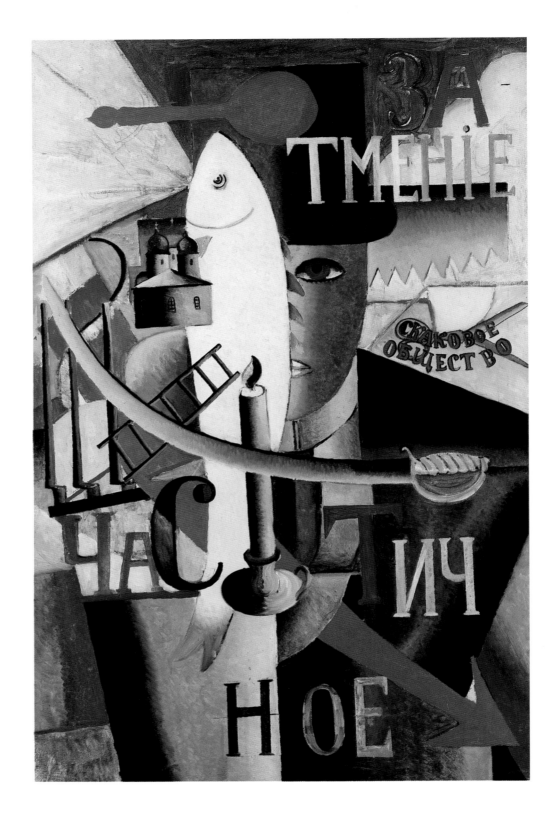

**Warrior of the First
Division, Moscow,** 1914
Oil and collage on canvas
21 1/8 x 17 5/8 (53.6 x 44.8)
The Museum of
Modern Art

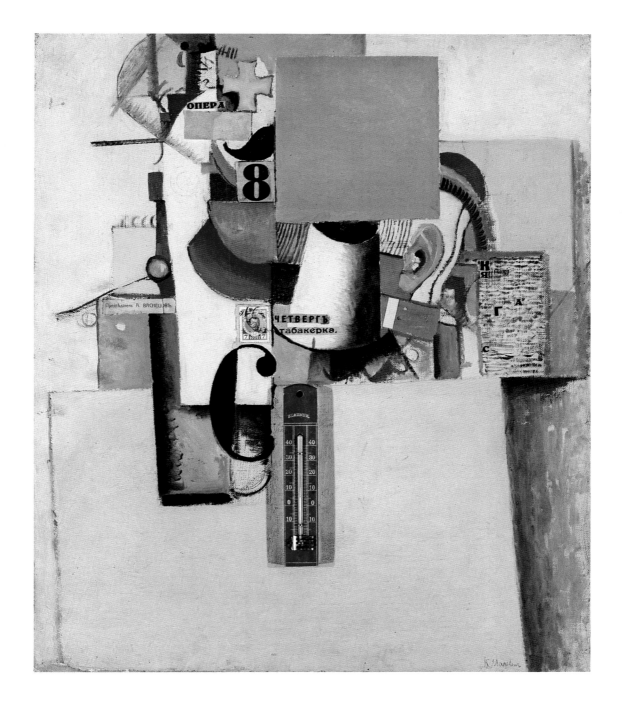

40
**Lady at the Advertising
Column**, 1914
Oil and collage on canvas
28 x 25 ¼ (71 x 64)
Stedelijk Museum

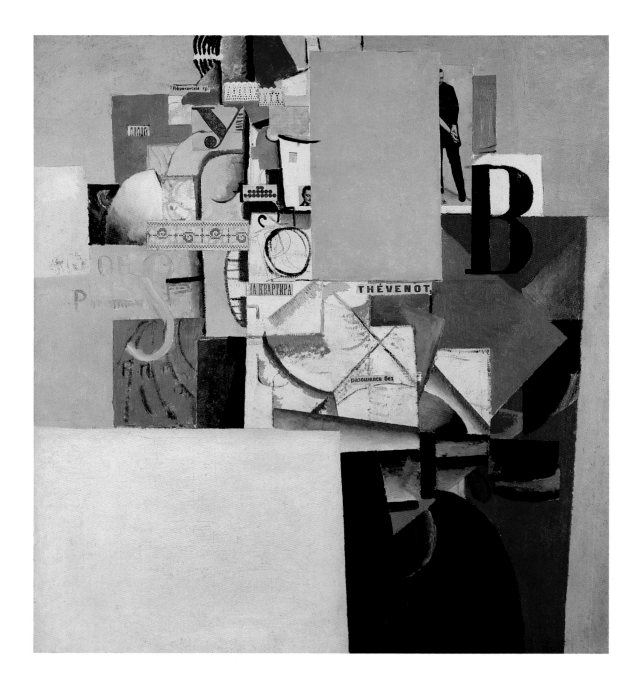

**Composition with
Mona Lisa,** 1914
Graphite, oil, and collage
on canvas
24 ³/₈ x 19 ¹/₂ (62 x 49.5)
Private collection

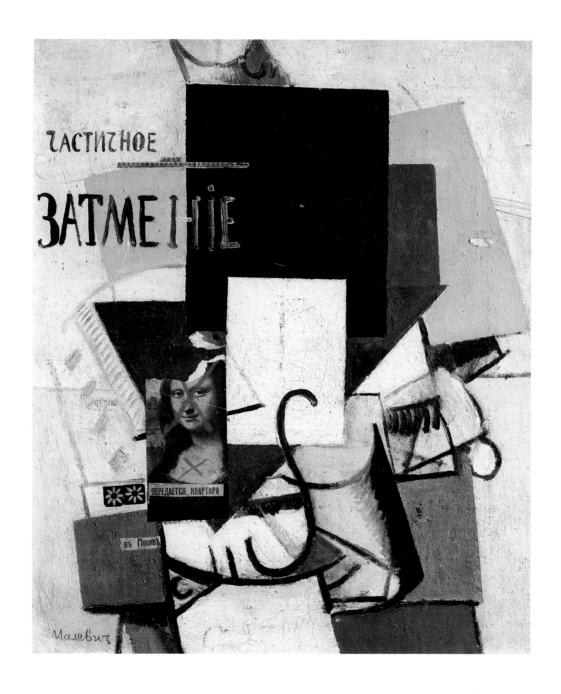

**Painterly Realism. Boy
with Knapsack — Color
Masses in the Fourth
Dimension,** 1915
Oil on canvas
28 x 17 ½ (71.1 x 44.4)
The Museum of
Modern Art

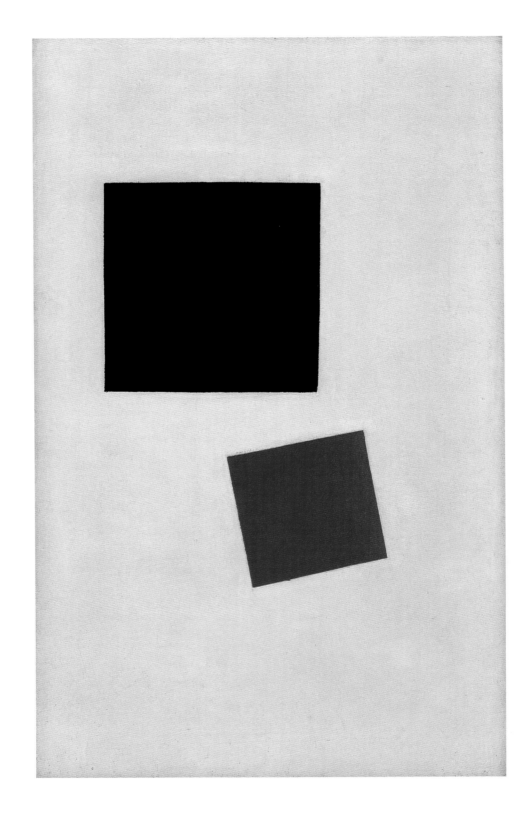

43
Suprematist Painting.
Black Rectangle, Blue
Triangle, 1915
Oil on canvas
26 $^{1}/_{8}$ x 22 $^{7}/_{16}$ (66.5 x 57)
Stedelijk Museum

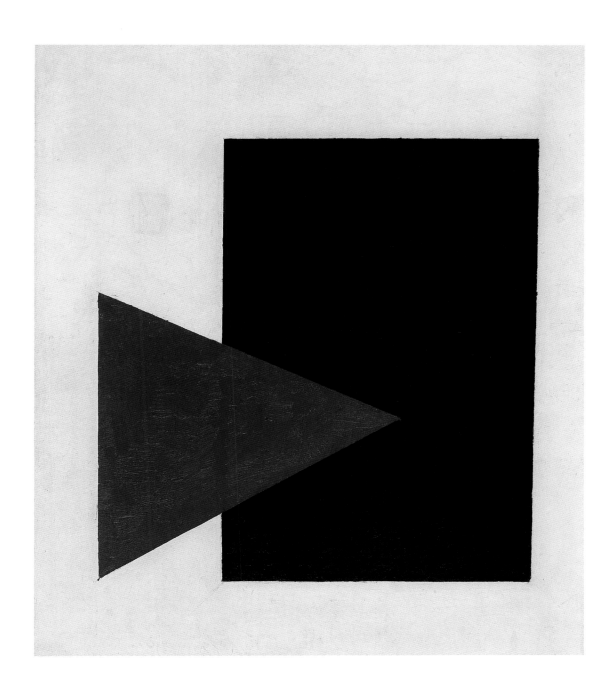

44

Suprematist Painting.
Rectangle and Circle, 1915
Oil on canvas
17 x 12 ¹/₁₆ (43.2 x 30.7)
Busch-Reisinger Museum

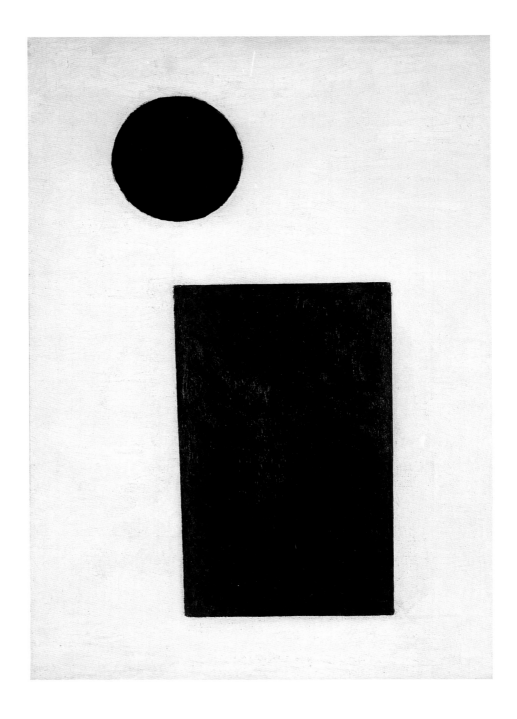

45
Airplane Flying, 1915
Oil on canvas
22 ¹/₂ x 19 (57.3 x 48.3)
The Museum of
Modern Art

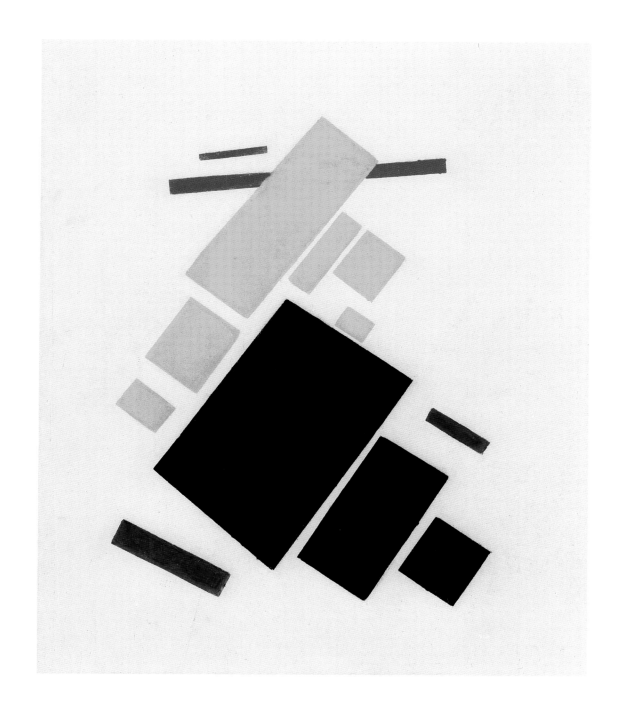

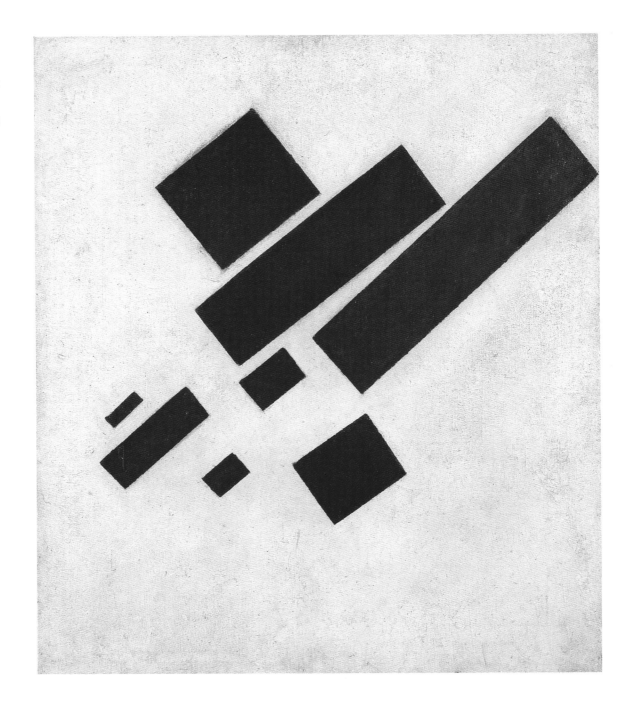

47

**Suprematism: Painterly
Realism of a Football
Player. Color Masses in
the Fourth Dimension,** 1915
Oil on canvas
27 ¹/₂ x 17 ³/₈ (69.9 x 44)
Stedelijk Museum

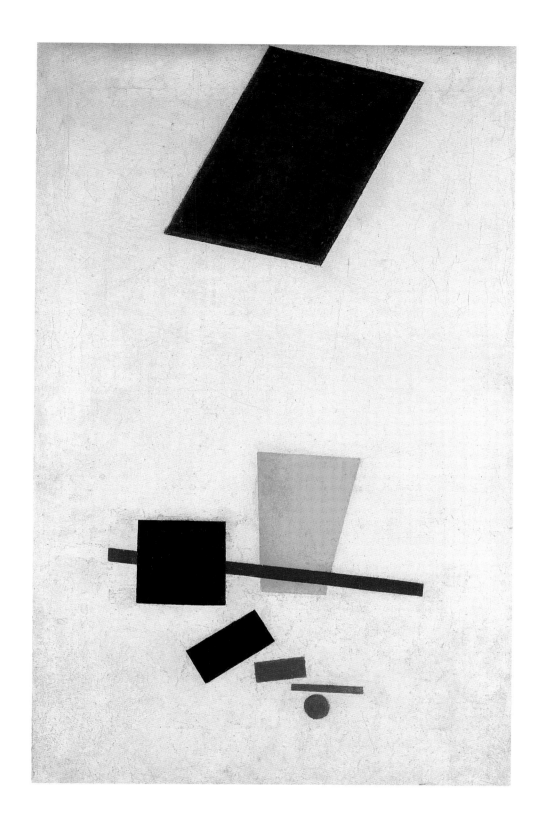

Suprematist Painting, 1915
Oil on canvas
31 1/2 x 24 3/8 (80 x 62)
Stedelijk Museum

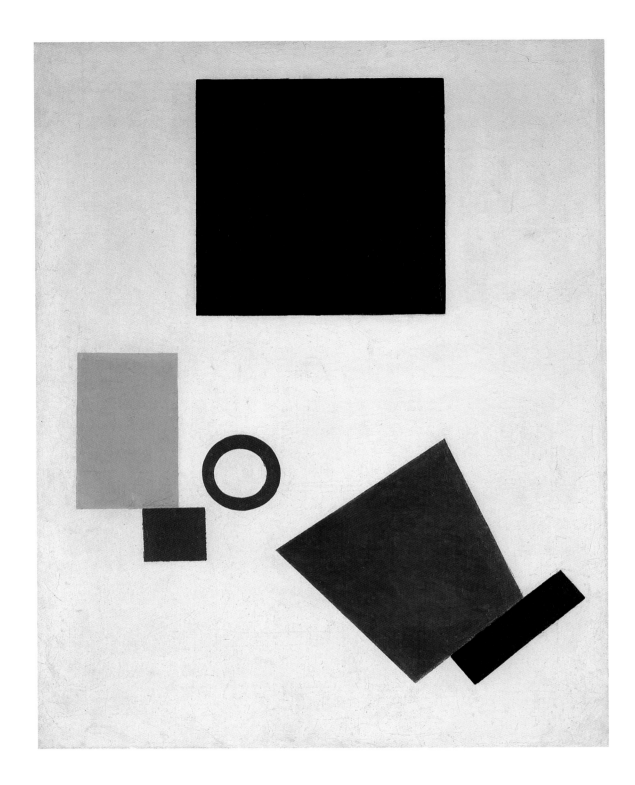

49

Suprematism (Supremus No. 50), 1915
Oil on canvas
38 ³/₁₆ x 26 (97 x 66)
Stedelijk Museum

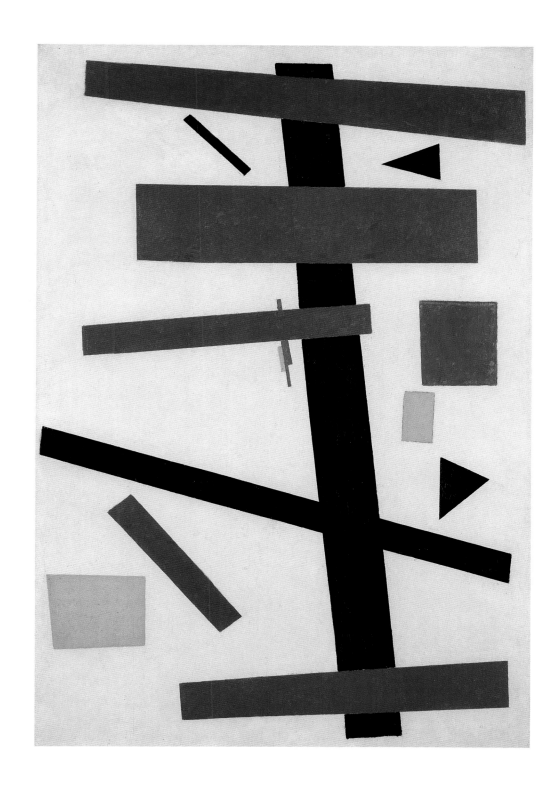

50

Suprematist Painting, 1915
Oil on canvas
39 7/8 x 24 3/8 (101.5 x 62)
Stedelijk Museum

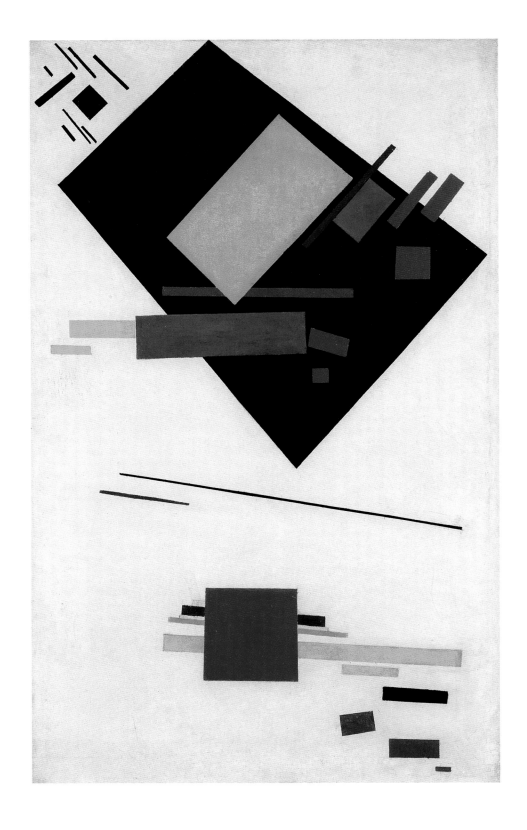

51

Red Square (Peasant Woman. Suprematism),
1915
Oil on canvas
20 $^{7}/_{8}$ x 20 $^{7}/_{8}$ (53 x 53)
State Russian Museum

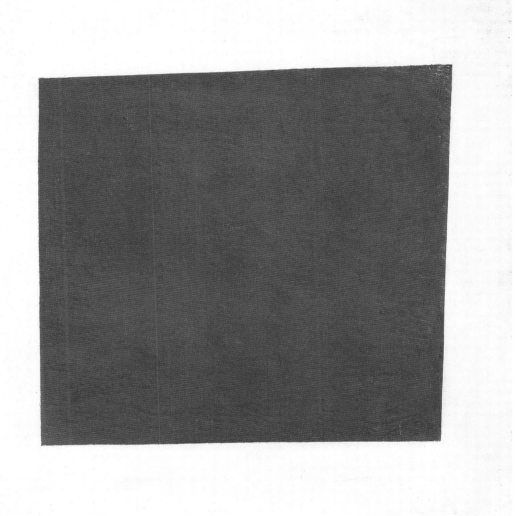

Four Squares, 1915
Oil on canvas
19 1/4 x 19 1/4 (49 x 49)
A. N. Radishchev State
Art Museum, Saratov

53
Suprematism:
Nonobjective Composition,
1915(?)
Oil on canvas
31$^1/_2$ x 31$^1/_2$ (80 x 80)
Sverdlovsk Art Gallery

Not in exhibition

54

Suprematism, 1915
Oil on canvas
34 $^{7}/_{16}$ x 28 $^{5}/_{16}$ (87.5 x 72)
State Russian Museum

55

Suprematism, 1915
Oil on canvas
31 5/8 x 31 7/8 (80.5 x 81)
State Russian Museum

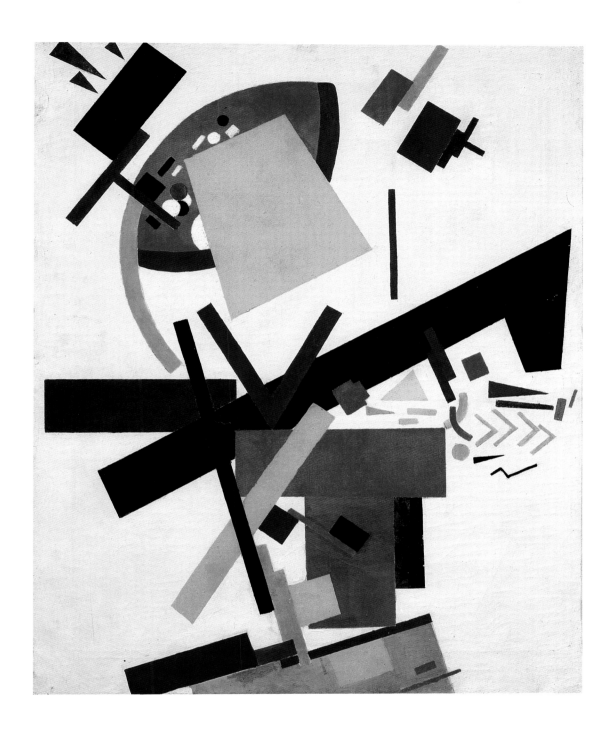

56
**Yellow and Black
(Supremus No. 58),** 1916
Oil on canvas
31$\frac{1}{2}$ x 27 $\frac{3}{4}$ (80 x 70.5)
State Russian Museum

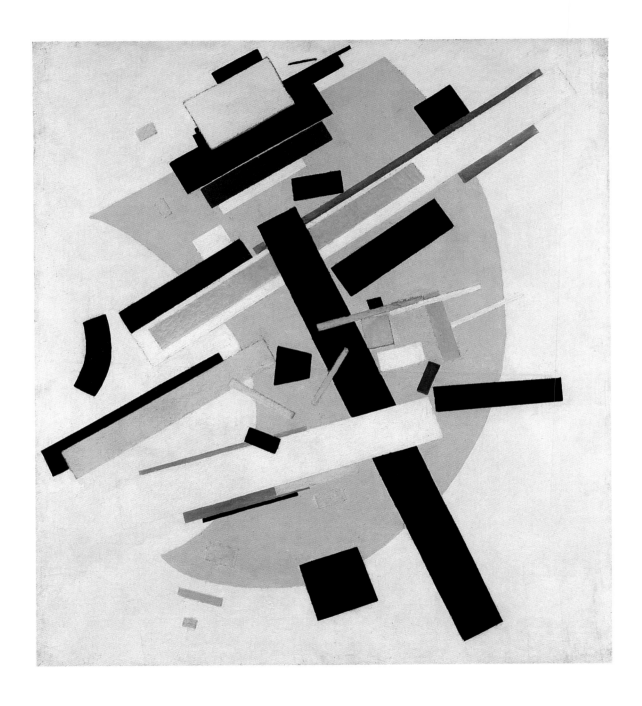

57

Suprematist Painting,
1917
Oil on canvas
38 x 25 $^{11}/_{16}$ (96.5 x 65.4)
The Museum of
Modern Art

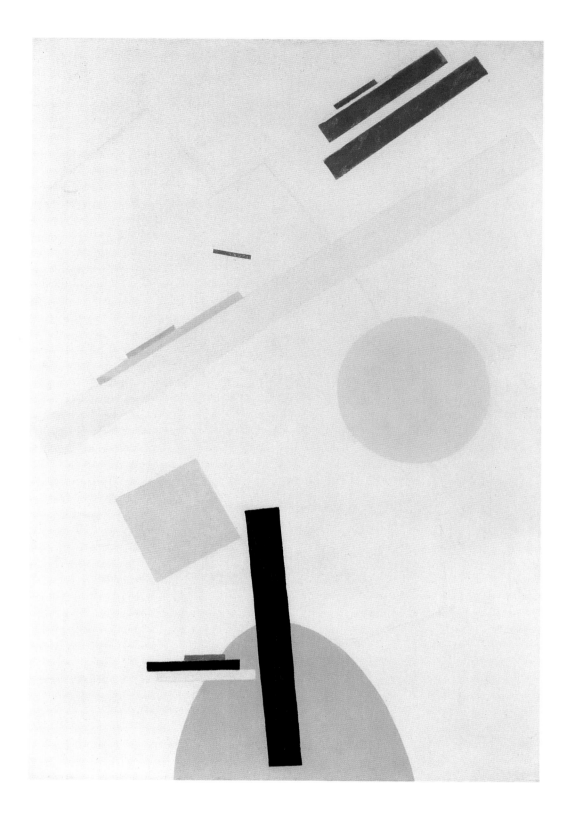

Suprematist Painting,
1917–1918
Oil on canvas
41 ³/₄ x 27 ³/₄ (106 x 70.5)
Stedelijk Museum

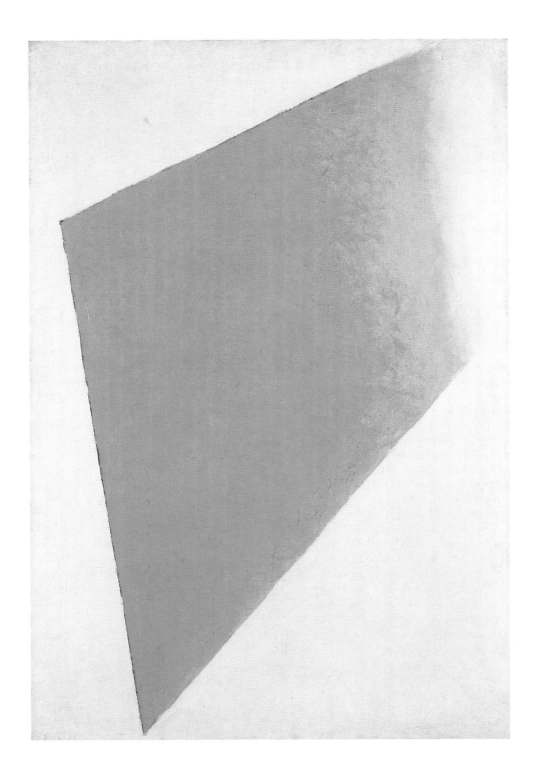

59
Suprematist Painting,
1917–1918
Oil on canvas
38 ³/₁₆ x 27 ⁹/₁₆ (97 x 70)
Stedelijk Museum

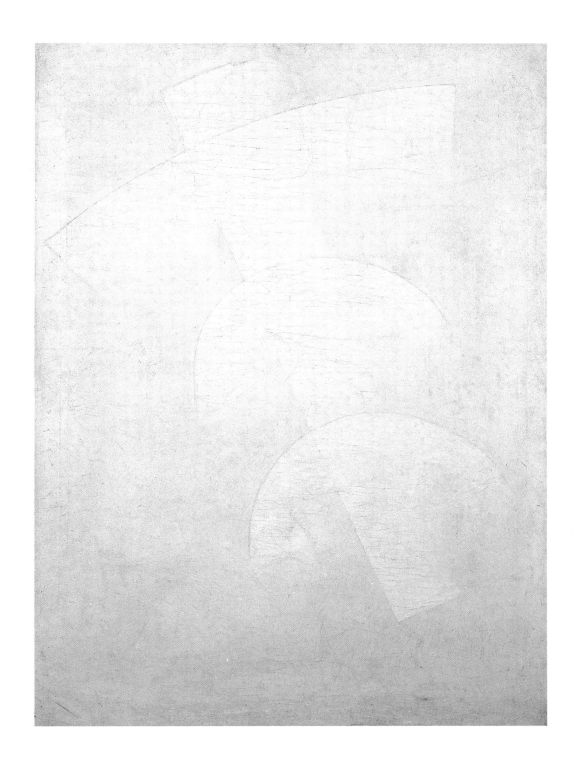

60

Suprematist Painting,
1917–1918
Oil on canvas
38 ³/₁₆ x 27 ⁹/₁₆ (97 x 70)
Stedelijk Museum

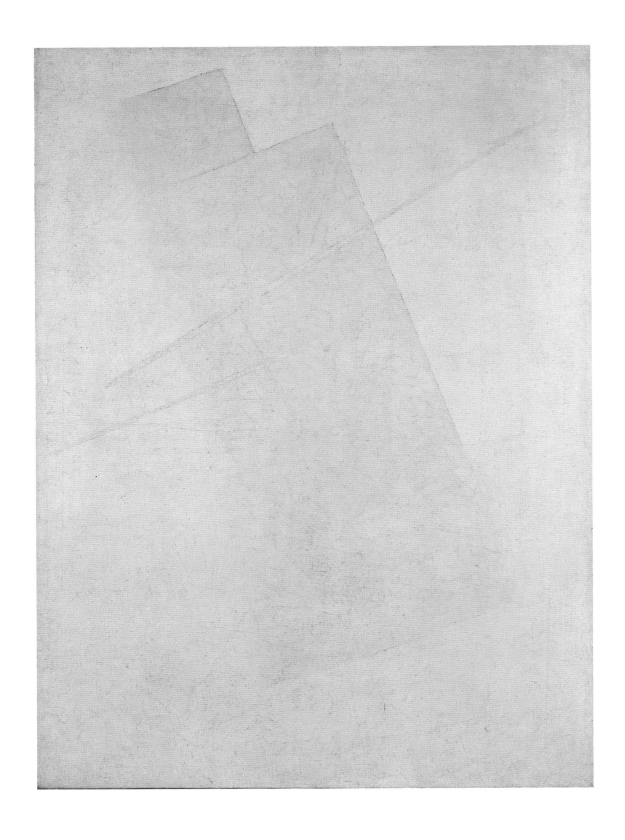

61

White Square on White,
1918
Oil on canvas
31 x 31 (78.7 x 78.7)
The Museum of
Modern Art

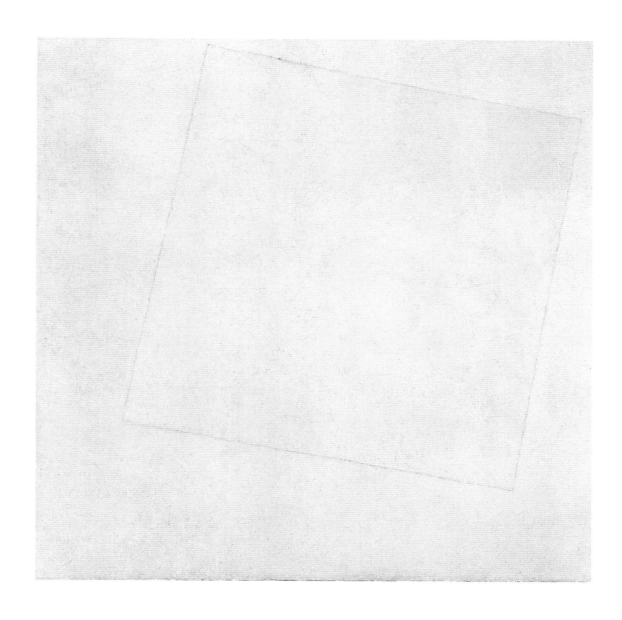

62

Black Square, ca. 1923
Oil on canvas
41$^{11}/_{16}$ x 41$^{11}/_{16}$ (106 x 106)
State Russian Museum

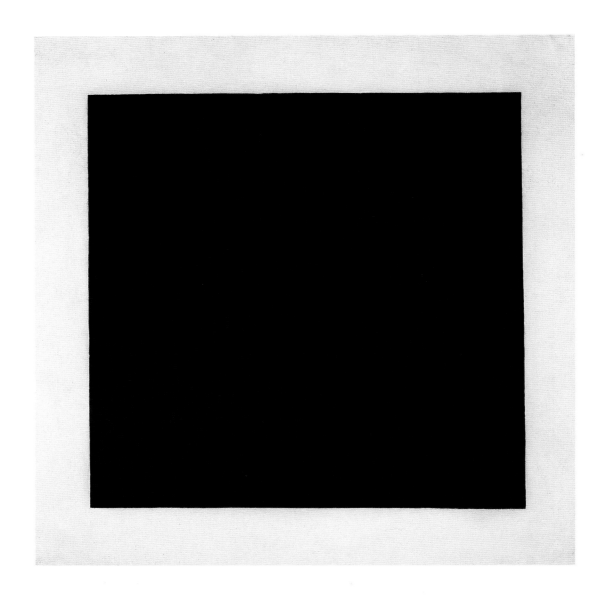

63

Black Cross, ca. 1923
Oil on canvas
41^{11}/$_{16}$ x 41^{11}/$_{16}$ (106 x 106)
State Russian Museum

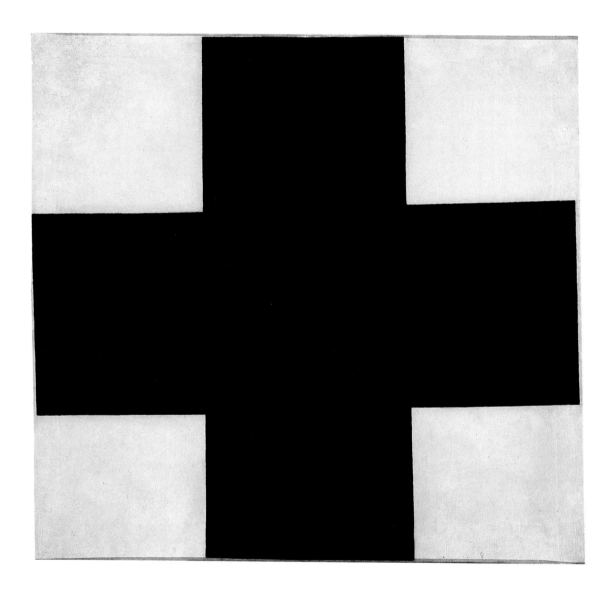

64
Black Circle, ca. 1923
Oil on canvas
41 3/8 x 41 3/8 (105 x 105)
State Russian Museum

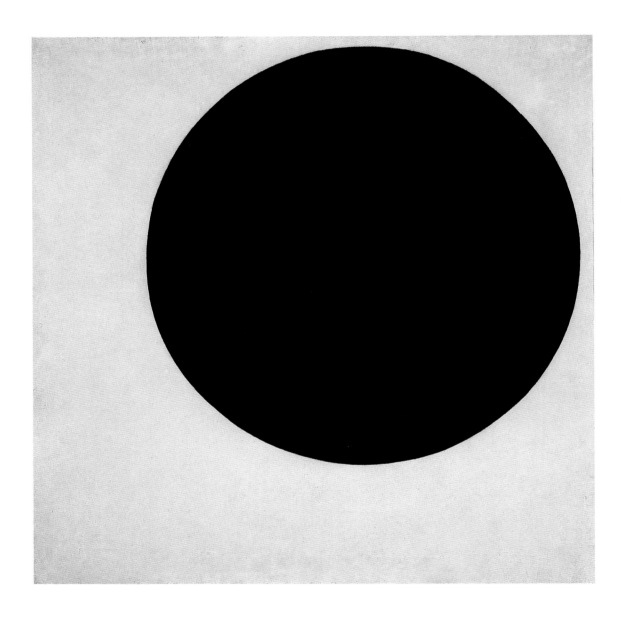

65

Suprematist Painting,
before 1927
Oil on canvas
33 ¹/₈ x 27 ³/₈ (84 x 69.5)
Stedelijk Museum

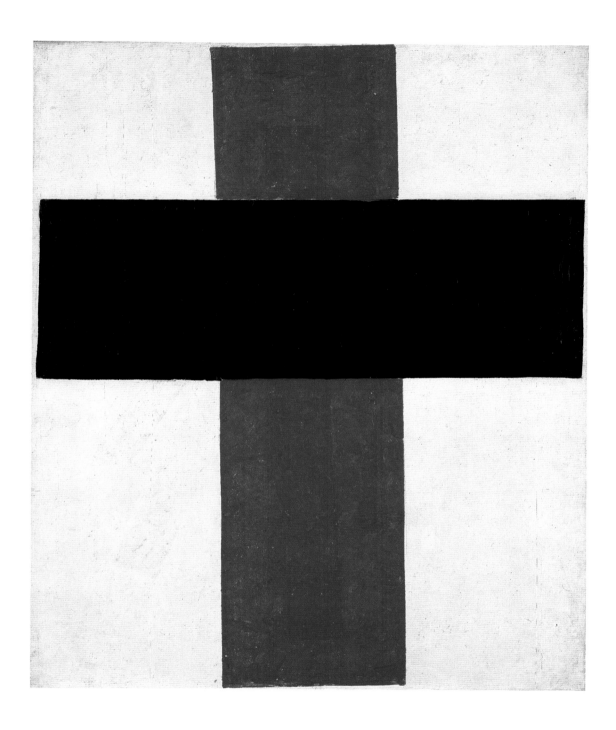

66
Suprematist Painting,
before 1927
Oil on canvas
34 $^5/_8$ x 27 (88 x 68.5)
Stedelijk Museum

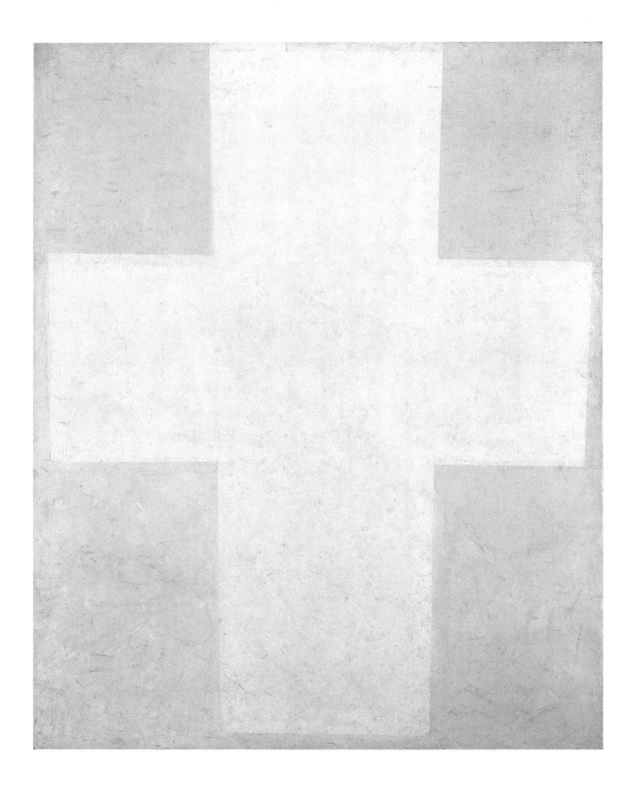

67

Suprematist Painting,
ca. 1927
Oil on canvas
28 ¹/₂ x 20 ¹/₈ (72.5 x 51)
Stedelijk Museum

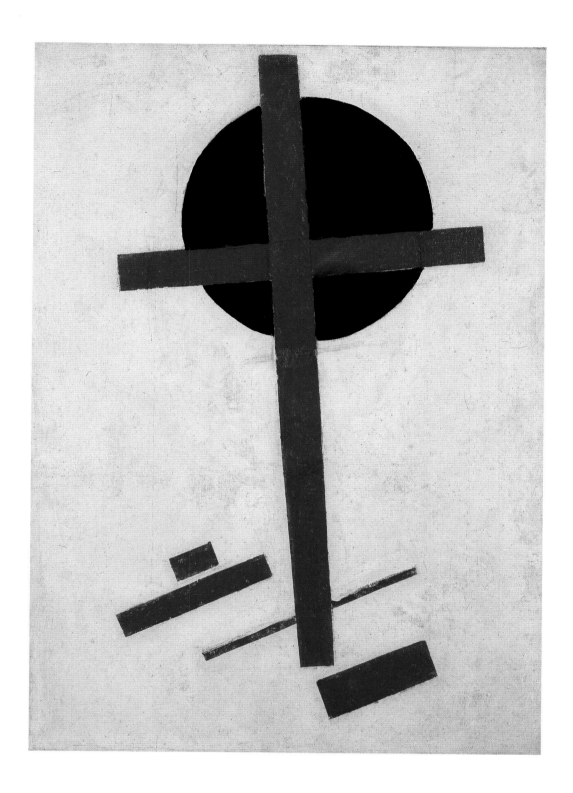

68
Black Square, 1929
Oil on canvas
31¹/₄ x 31¹/₄ (79.5 x 79.5)
(irregular)
State Tretiakov Gallery

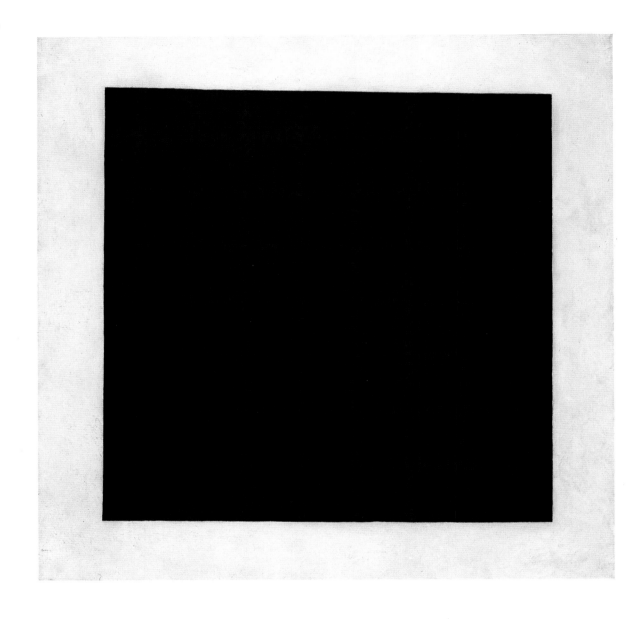

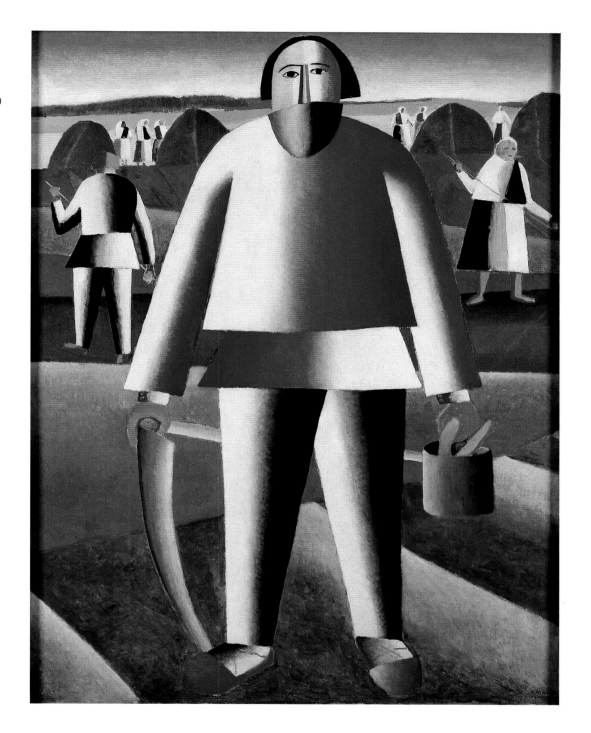

69

Haymaking, ca. 1928
Oil on canvas
33 ³/₄ x 25 ⁵/₁₆ (85.8 x 65.6)
State Tretiakov Gallery

Going to the Harvest.
Marfa and Vanka,
ca. 1928
Oil on canvas
32 ¼ x 24 (82 x 61)
State Russian Museum

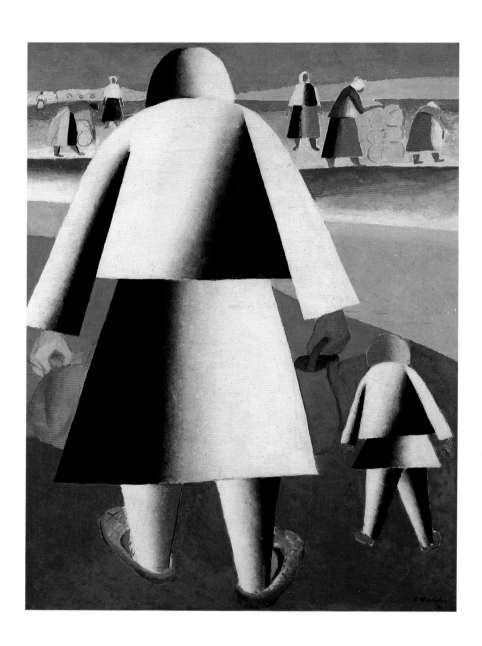

71

Girls in the Field,
ca. 1928
Oil on canvas
41 ³/₄ x 49 ¹/₄ (106 x 125)
State Russian Museum

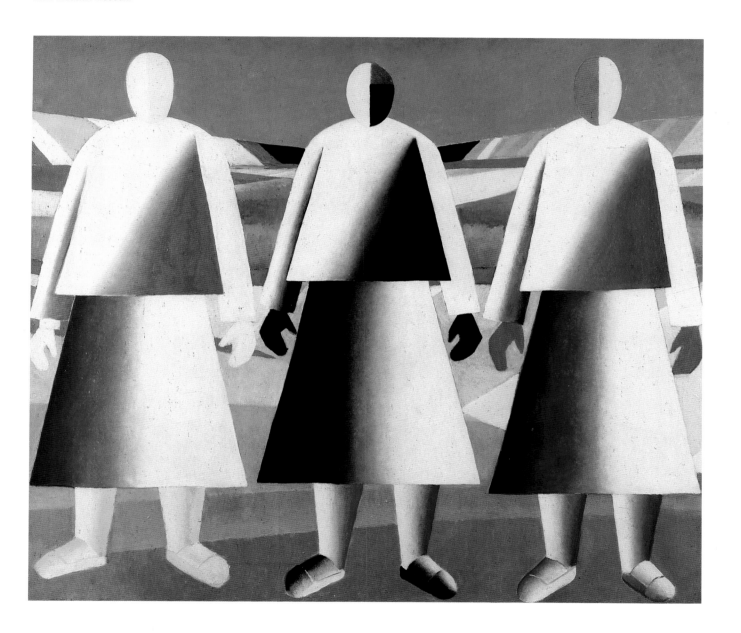

72

Head of a Peasant,
ca. 1928
Oil on plywood
28¹/₄ x 21¹/₈ (71.7 x 53.8)
State Russian Museum

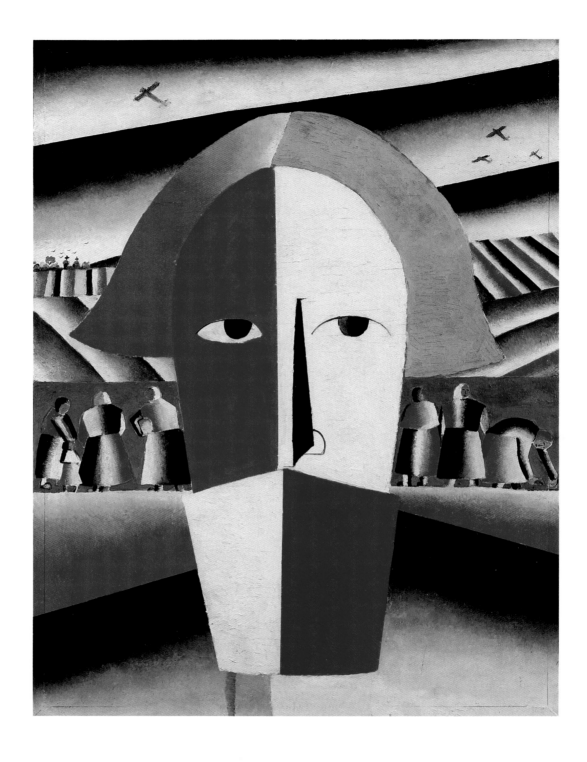

73

Peasant Woman, ca. 1928
Oil on canvas
38 ³/₄ x 31¹/₂ (98.5 x 80)
State Russian Museum

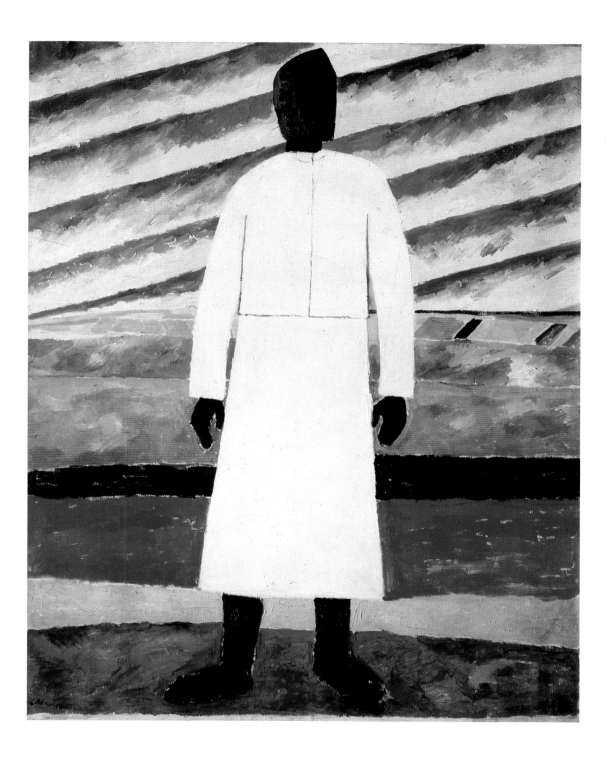

74
Female Portrait, ca. 1928
Oil on plywood
22 ⁷/₈ x 19 ¹/₄ (58 x 49)
State Russian Museum

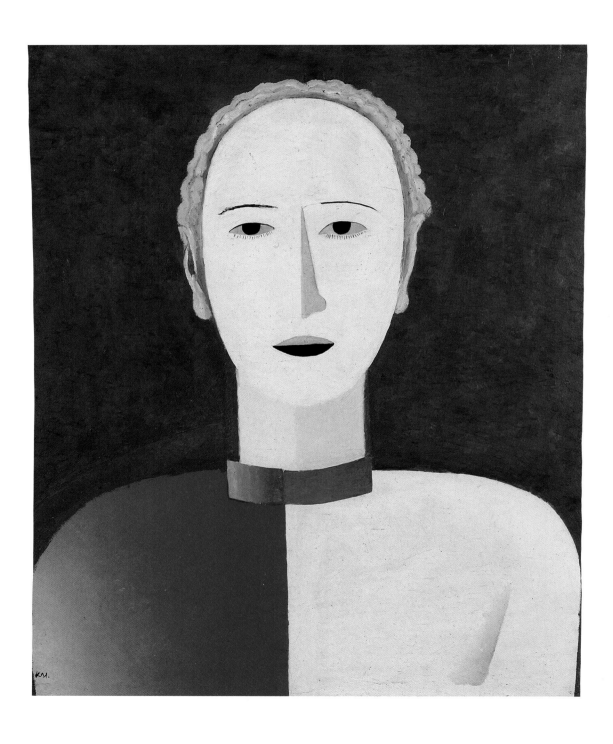

75

Sportsmen,
ca. 1928–1932
Oil on canvas
55 ³/₄ x 64 ⁵/₈ (142 x 164)
State Russian Museum

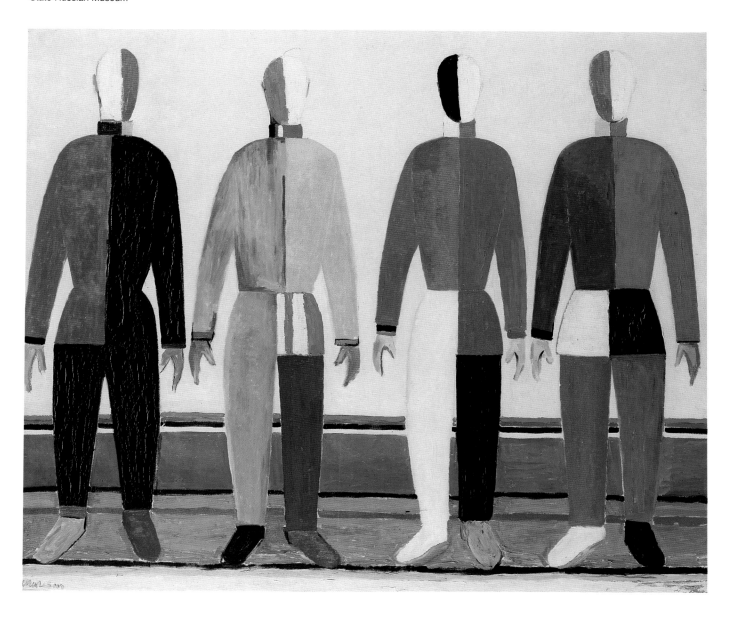

76

Woman with a Rake,
ca. 1928–1932
Oil on canvas
39 ³/₈ x 29 ¹/₂ (100 x 75)
State Tretiakov Gallery

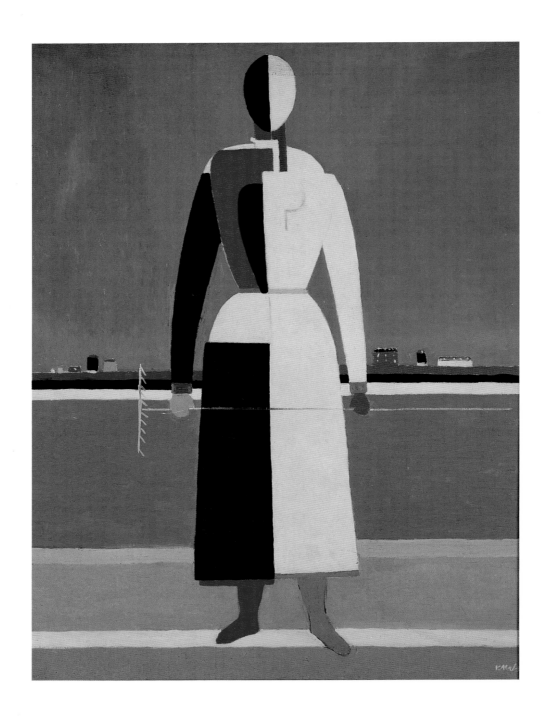

Red Cavalry,
ca. 1928–1932
Oil on canvas
35 7/8 x 55 1/8 (91 x 140)
State Russian Museum

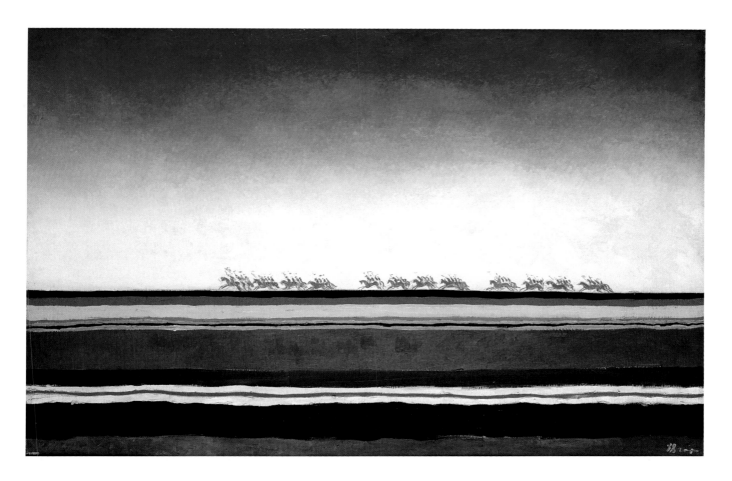

78
**Half-length Figure
("Prototype" of a New
Image),** ca. 1928–1932
Oil on canvas
18 1/8 x 14 1/2 (46 x 37)
State Russian Museum

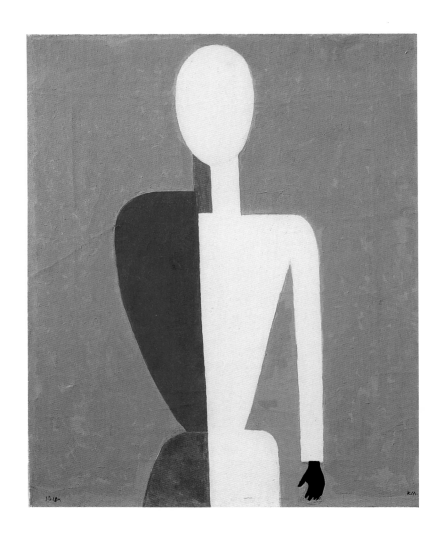

79

Three Female Figures,
ca. 1928–1932
Oil on canvas
18 ¹/₂ x 25 (47 x 63.5)
State Russian Museum

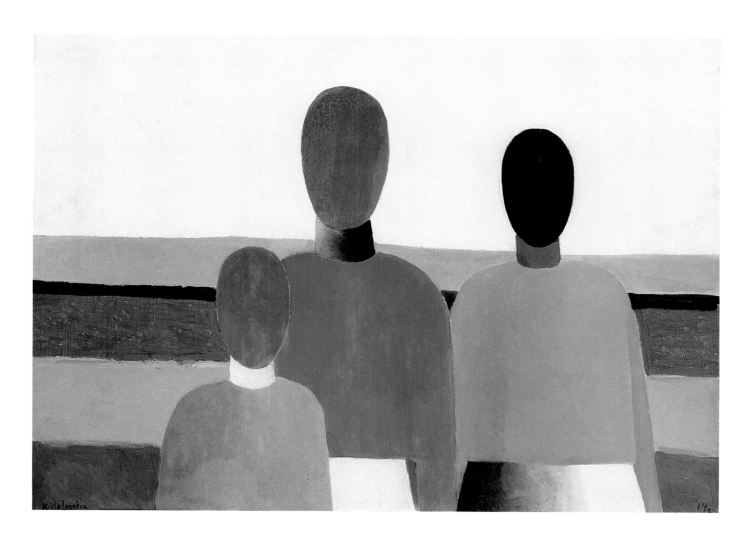

80

**Complex Premonition
(Half-Figure in a Yellow
Shirt),** 1928–1932
Oil on canvas
39 x 31¹/₈ (99 x 79)
State Russian Museum

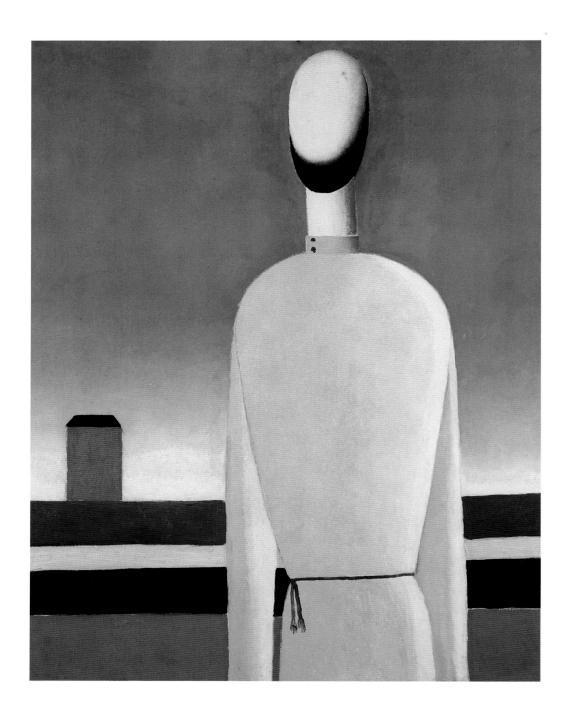

**Suprematism. Female
Figure,** ca. 1928–1932
Oil on canvas
49 ⁵/₈ x 41 ³/₄ (126 x 106)
State Russian Museum

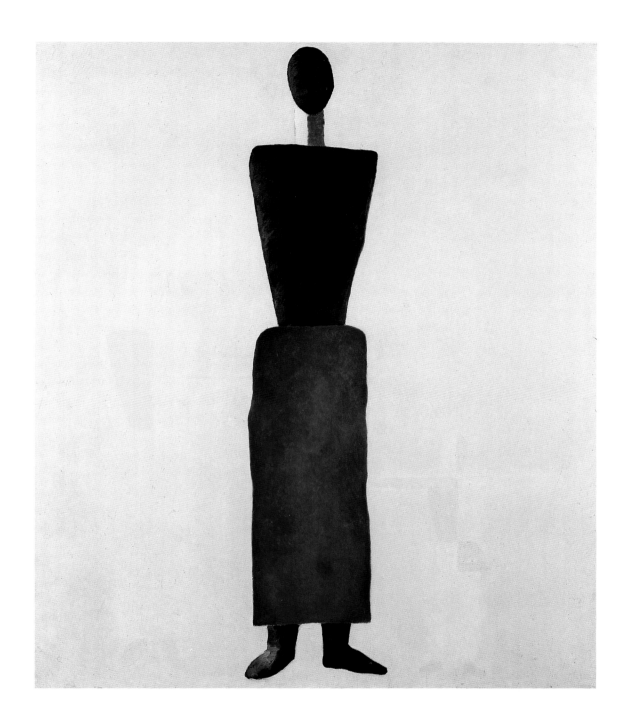

82

Peasants, ca. 1928
Oil on canvas
30 ¹/₂ x 34 ⁵/₈ (77.5 x 88)
State Russian Museum

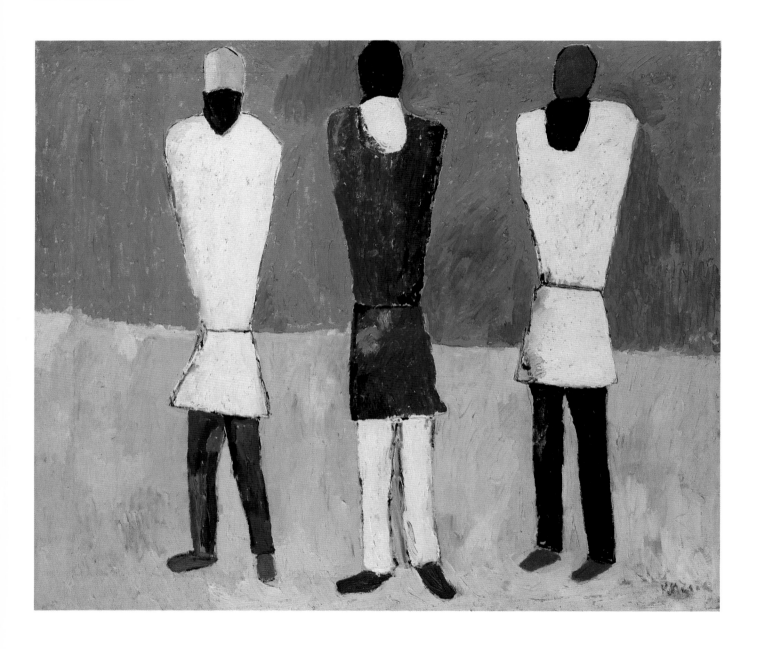

83

Half-length Figure,
ca. 1928–1932
Oil on canvas
28 ³/₈ x 25 ⁵/₈ (72 x 65)
State Russian Museum

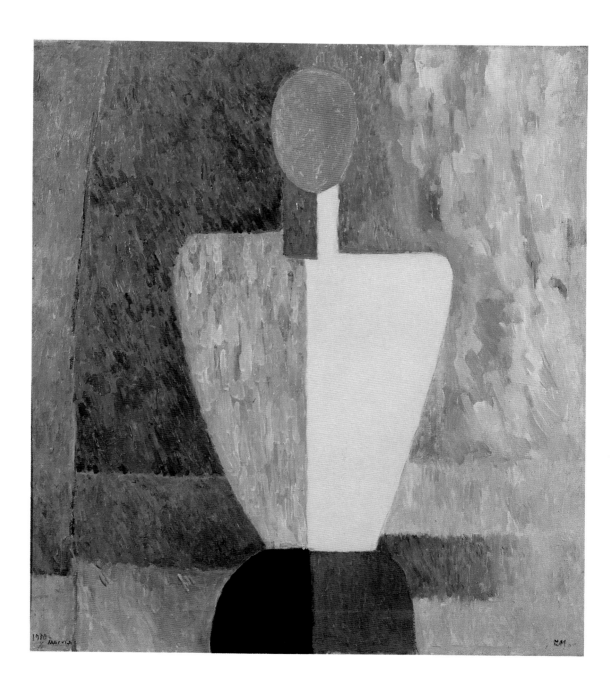

84

Red House, ca. 1932
Oil on canvas
24 3/4 x 25 5/8 (63 x 65)
State Russian Museum

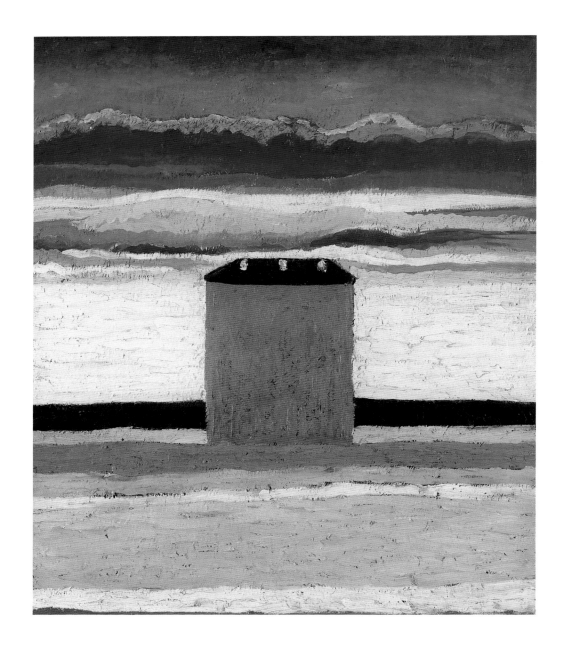

85

Flower Girl,
ca. 1929–1930(?)
Oil on canvas
31 1/2 x 39 3/8 (80 x 100)
State Russian Museum

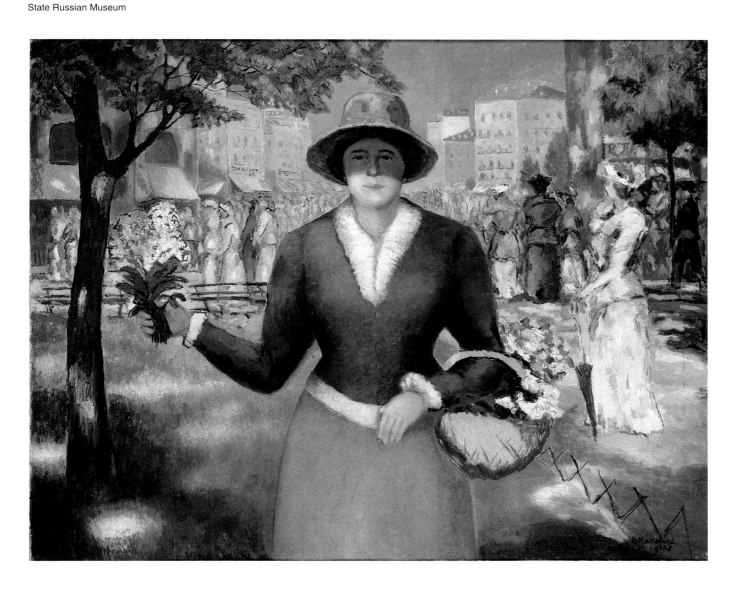

86
Reapers,
ca. 1929–1932(?)
Oil on wood
28 x 40 ⅝ (71 x 103.2)
State Russian Museum

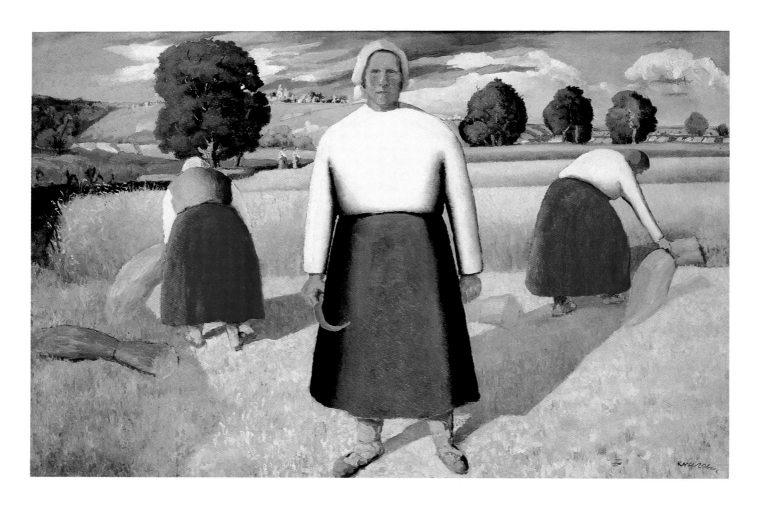

**Girl with a Comb in Her
Hair,** 1932–1933
Oil on canvas
13 ⁷/₈ x 12 ³/₁₆ (35.5 x 31)
State Tretiakov Gallery

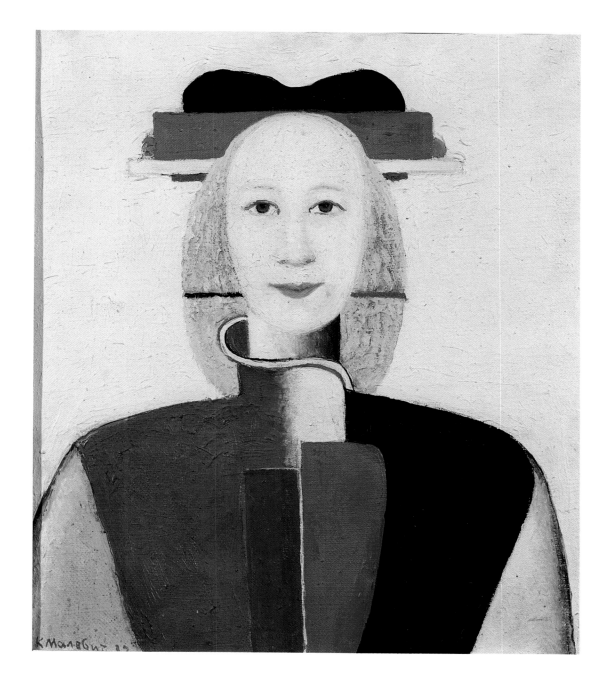

88

Girl with a Red Staff,
1932 – 1933
Oil on canvas
27 $^{15}/_{16}$ x 24 (71 x 61)
State Tretiakov Gallery

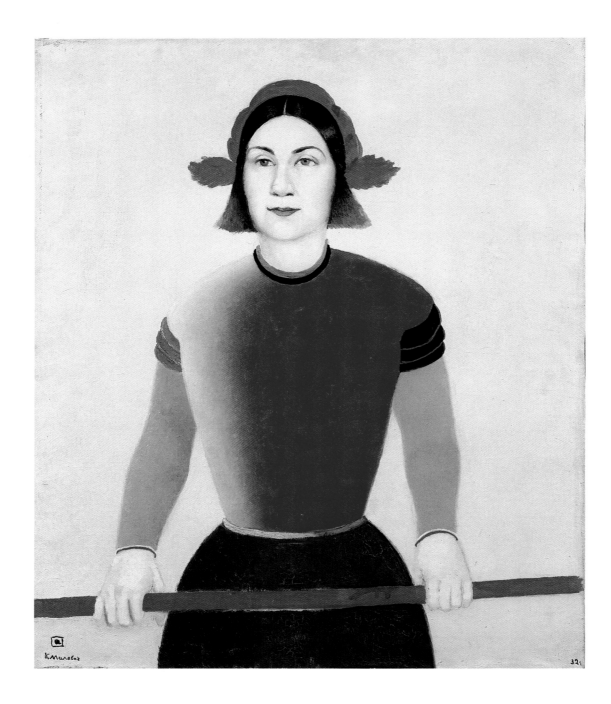

**Portrait of the Artist's
Wife**, 1933
Oil on canvas
26 ⅝ x 22 (67.5 x 56)
State Russian Museum

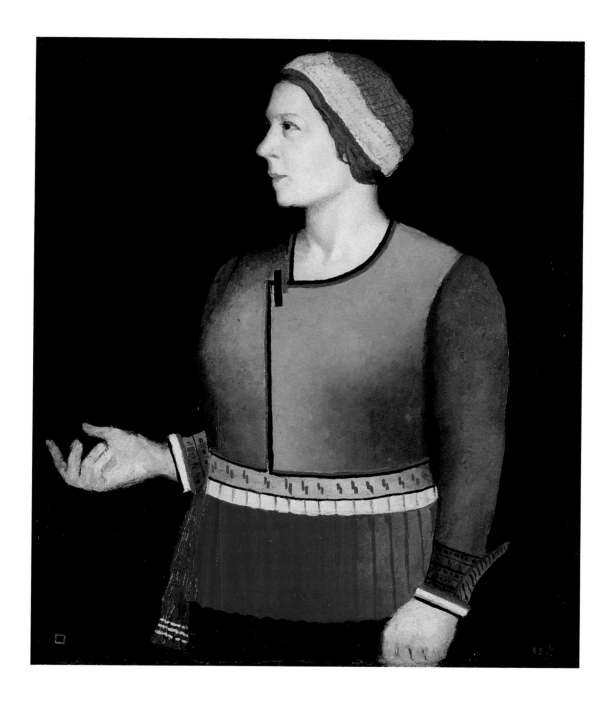

Male Portrait
(N. N. Punin), 1933
Oil on canvas
27 ¹/₂ x 22 ³/₈ (70 x 57)
State Russian Museum

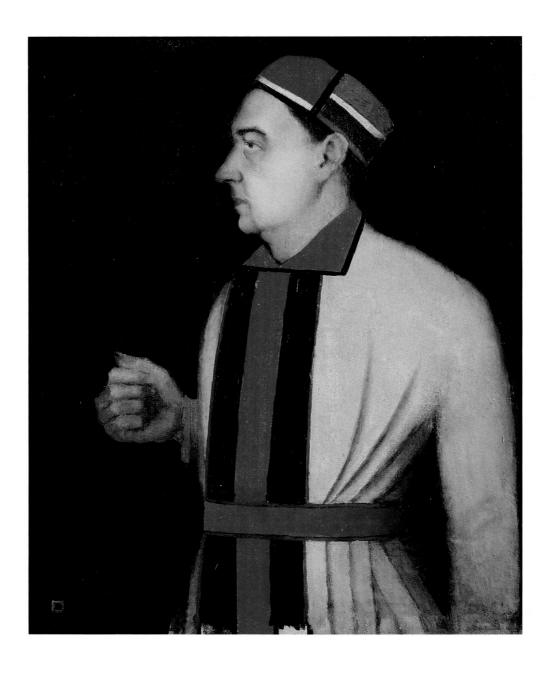

91

Self-Portrait, 1933
Oil on canvas
28 ³/₄ x 26 (73 x 66)
State Russian Museum

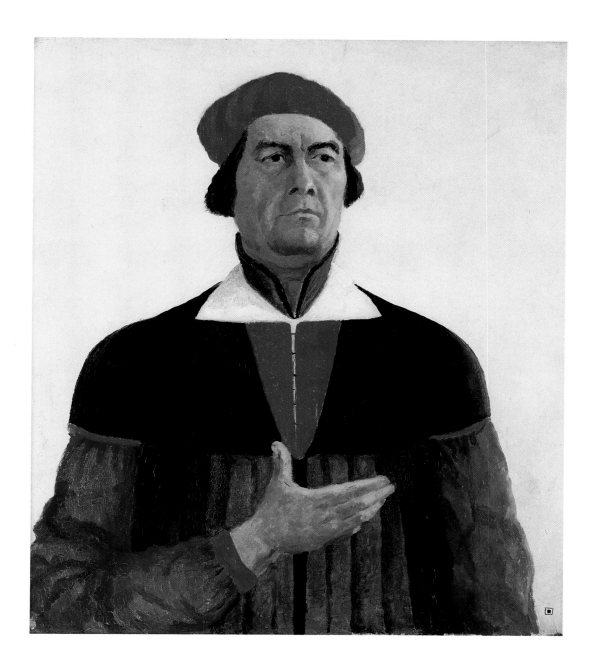

92

Shroud of Christ, 1908
Gouache on cardboard
9 $^3/_{16}$ x 13 $^1/_2$ (23.4 x 34.3)
State Tretiakov Gallery

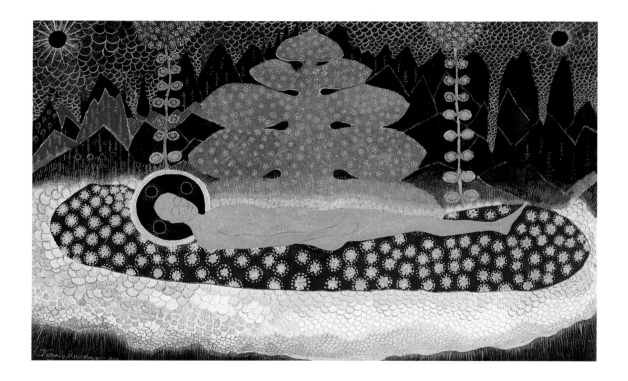

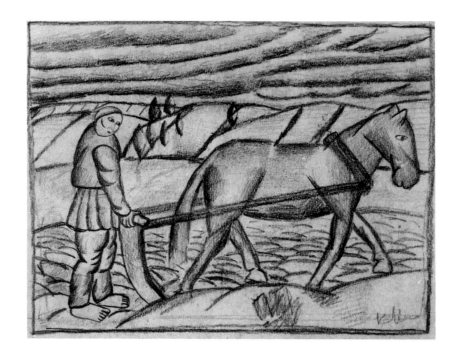

93

Plowman, 1910–1911
Graphite pencil on paper
7 9/16 x 8 9/16 (19.2 x 21.9)
State Russian Museum

94

**Two Men Pulling a
Handcart,** 1910–1911
Graphite pencil on paper
5 9/16 x 5 (14.1 x 12.8)
State Russian Museum

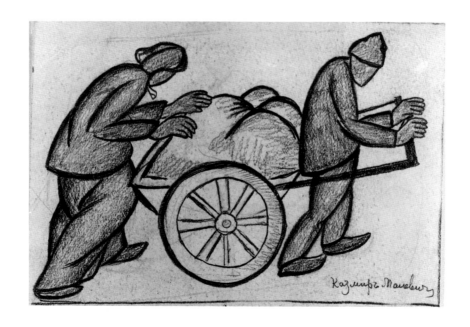

95

Houses, 1910–1911
Graphite pencil on paper
6 3/8 x 6 1/4 (16.2 x 15.9)
State Russian Museum

96

House with a Fence,
1910–1911
Graphite pencil on paper
6 15/16 x 6 3/4 (17.7 x 17.2)
State Russian Museum

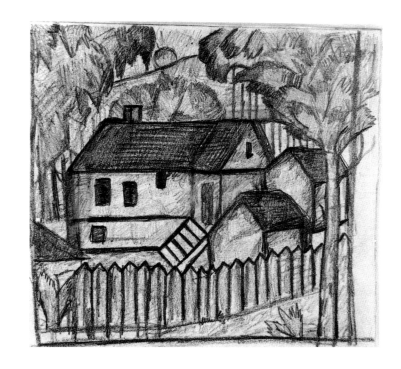

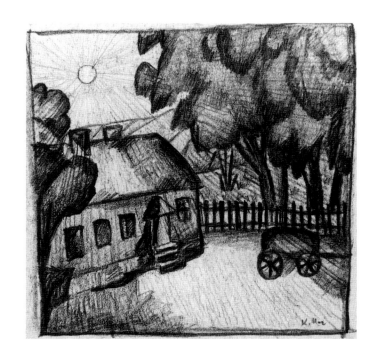

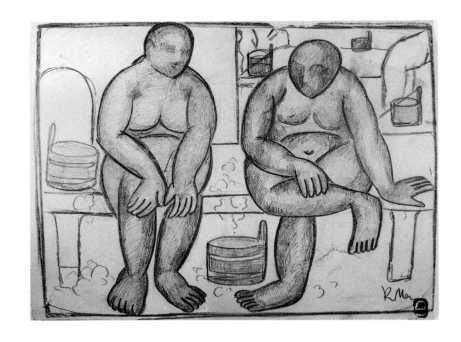

97

At the Bathhouse,
1910–1911
Graphite pencil on paper
5 1/4 x 6 3/8 (13.3 x 16.2)
State Russian Museum

98

At the Cemetery,
1910–1911
Graphite pencil on paper
6 x 7 (15.2 x 17.7)
State Russian Museum

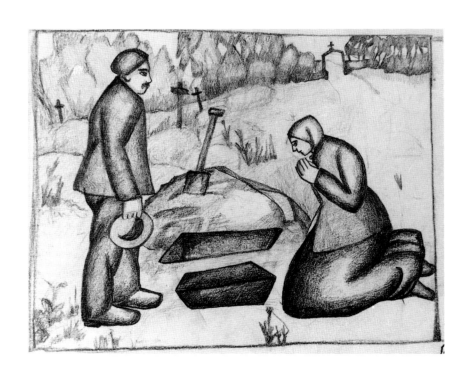

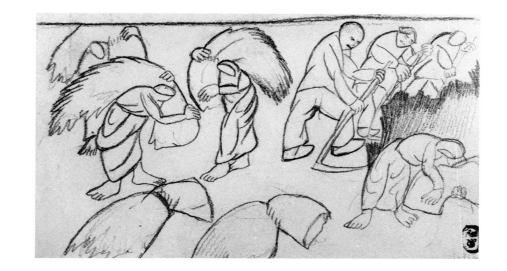

99

Harvest, 1910–1911
Graphite pencil on paper
3 5/8 x 5 1/2 (9.2 x 14)
State Russian Museum

100

Bathers, 1910–1911
Graphite pencil on paper
8 1/16 x 6 3/16 (20.4 x 15.8)
State Russian Museum

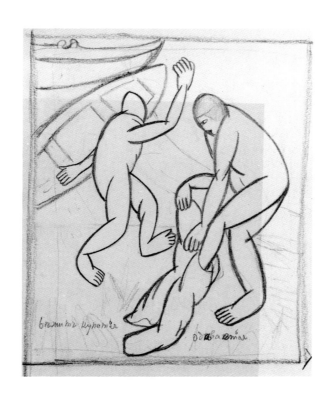

101

Woman in Prayer,
1910–1911
Graphite pencil on paper
7 5/16 x 5 9/16 (18.6 x 14.2)
State Russian Museum

102

Woman's Head in Profile,
1910–1911
Graphite pencil on paper
7 5/16 x 5 9/16 (18.6 x 14.2)
State Russian Museum

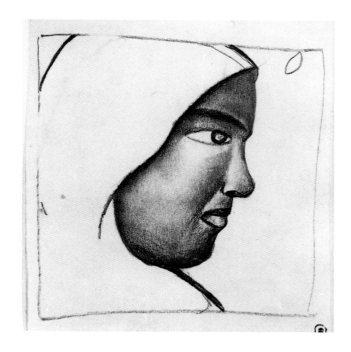

103

Peasant Women at Church,
1911
Graphite pencil on paper
8 9/16 x 7 1/4 (21.9 x 18.4)
State Russian Museum

105

Man with a Scythe, 1912
Watercolor and graphite
pencil on paper
6 13/16 x 4 9/16 (17.4 x 11.6)
State Russian Museum

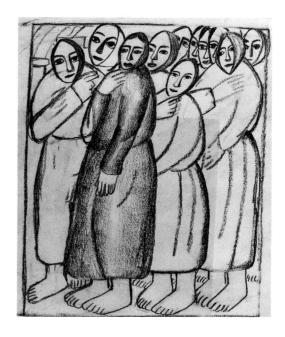

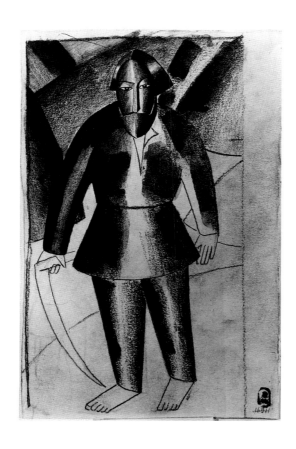

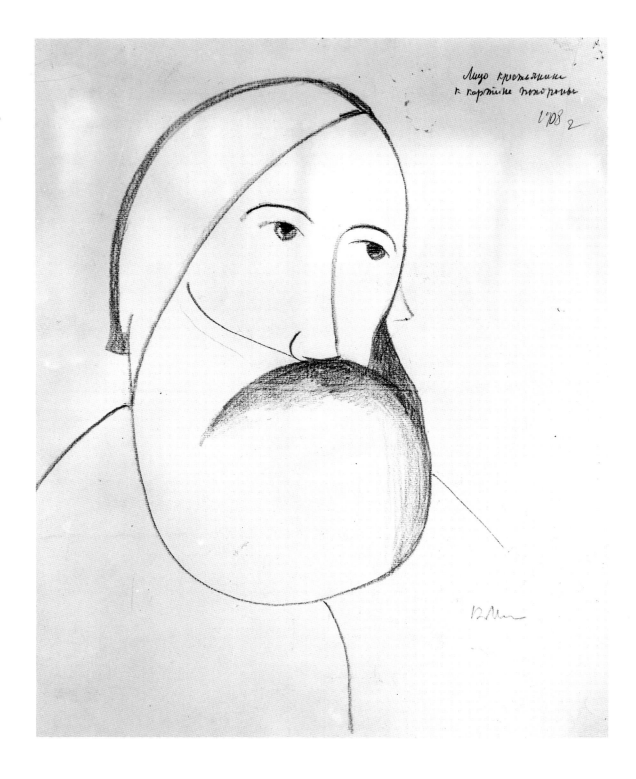

104
Face of a Peasant,
ca. 1911(?) or 1929(?)
Graphite pencil on paper
13 7/8 x 11 1/4 (35.3 x 28.5)
State Tretiakov Gallery

106

In the Field, 1911–1912
Graphite pencil on paper
6 ¹⁄₂ x 7 (16.6 x 17.7)
State Russian Museum

107

The Woodcutter,
1911–1912
Graphite pencil on paper
6 ¹¹⁄₁₆ x 6 ¹⁵⁄₁₆ (17.1 x 17.7)
State Russian Museum

108

**Peasant Woman with
Buckets,** ca. 1912
Graphite pencil on paper
4 ¹⁄₈ x 4 ³⁄₁₆ (10.5 x 10.7)
State Russian Museum

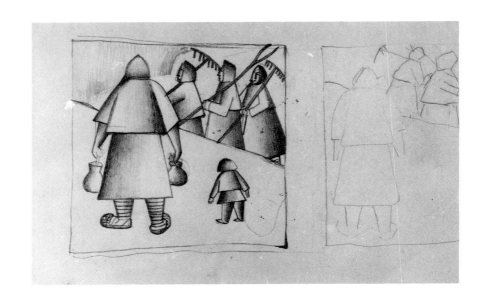

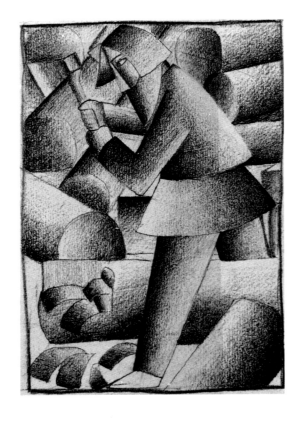

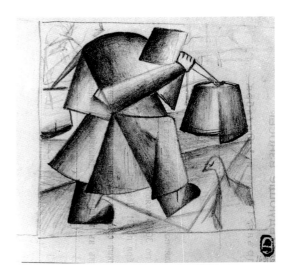

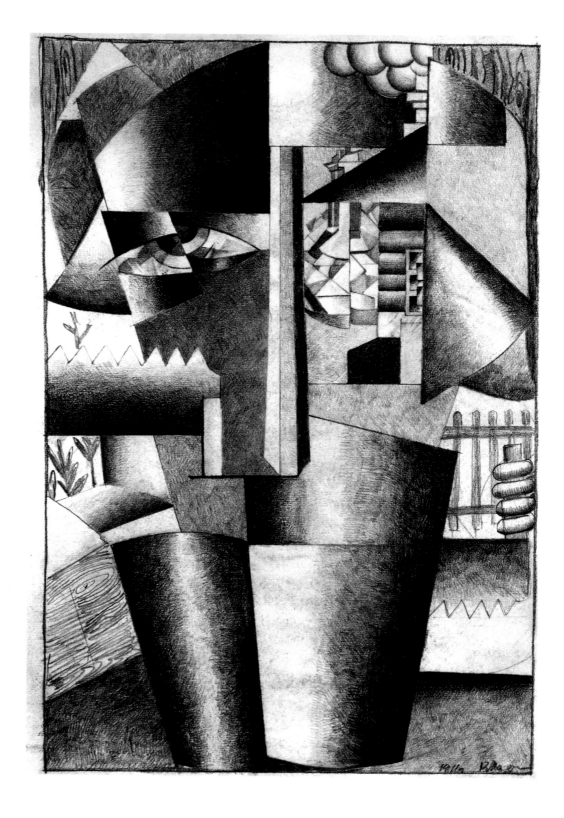

109

Cubism. Portrait of a Builder, 1913
Graphite pencil on paper
19 ³/₈ x 13 ¹/₈ (49.6 x 33.4)
State Tretiakov Gallery

110

**Cubo-Futurism. Dynamic
Sensory Experience of a
Model,** ca. 1913 (?)
Graphite pencil on paper
24 ⁵/₈ x 11 ⁵/₁₆ (62.4 x 28.7)
State Tretiakov Gallery

111

**Death of the Cavalry
General,** 1914
Pen and ink and graphite
pencil on ruled paper
6 ⁵/₈ x 4 ¹/₂ (16.8 x 11.5)
State Tretiakov Gallery

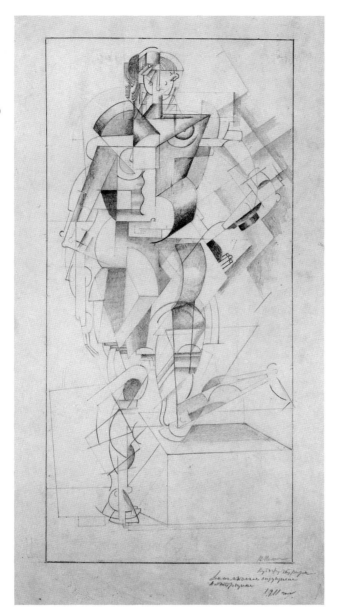

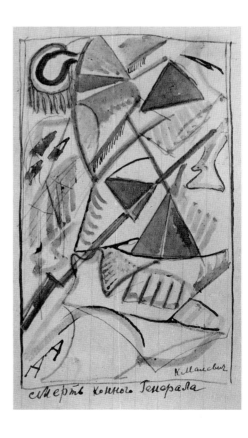

112

Stage Design, Act 1, Scene 1
Graphite pencil on paper
10 ³/₁₆ x 7 ¹⁵/₁₆ (25.9 x 20.2)
Leningrad State
Museum of Theatrical
and Musical Arts

133

Chatterbox
Graphite pencil and India
ink on paper
10 ⁵/₈ x 8 ¹/₄ (27 x 21)
Leningrad State
Museum of Theatrical
and Musical Arts

113

Stage Design, Act 1, Scene 2
Graphite pencil on paper
6 ⁷/₈ x 8 ⁵/₈ (17.5 x 22)
Leningrad State
Museum of Theatrical
and Musical Arts

114

Stage Design, Act 1, Scene 3
Graphite pencil on paper
6 ⁷/₈ x 8 ⁵/₈ (17.7 x 22.2)
Leningrad State
Museum of Theatrical
and Musical Arts

115

Stage Design, Act 2, Scene 5
Graphite pencil on paper,
8 ¹/₄ x 10 ⁵/₈ (21 x 27)
Leningrad State
Museum of Theatrical
and Musical Arts

116

Stage Design, Act 2, Scene 6
Graphite pencil on paper
8 ³/₈ x 10 ⁵/₈ (21.3 x 27)
Leningrad State
Museum of Theatrical
and Musical Arts

зеленая
до
похоронъ

2е Картина Зеленая и Черная № 162г.
1е Дъймо

до
Разговоры

13

Похоронщики 3 карт.
1е Дъймо

№ 163 г.
ГЛУПО

Бкарт. 6 карт.
1е картина Квадратъ 2 Дъйст.
2е дъй

2 Дъй. 5 кар. 6 кар.
Дом
№ 164 г.

117

Singer in the Chorus
Graphite pencil and
watercolor on paper
10 3/4 x 8 3/8 (27.3 x 21.3)
Leningrad State
Museum of Theatrical
and Musical Arts

118

Traveler
Graphite pencil on paper
10 11/16 x 8 3/8 (27.2 x 21.3)
Leningrad State
Museum of Theatrical
and Musical Arts

119

Many and One
Graphite pencil,
watercolor, and gouache
on paper
10 5/8 x 8 3/8 (27.1 x 21.2)
Leningrad State
Museum of Theatrical
and Musical Arts

120

Futurist Strongman
Graphite pencil on paper
10 5/8 x 8 1/4 (27 x 21)
Leningrad State
Museum of Theatrical
and Musical Arts

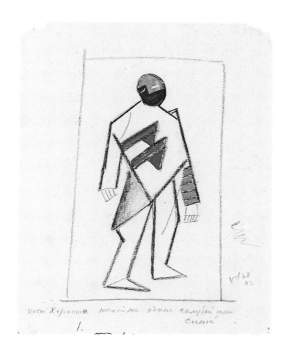

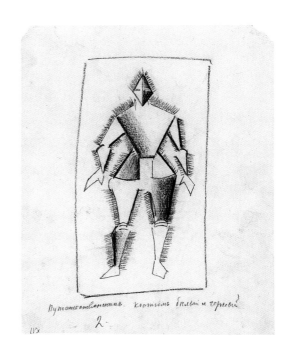

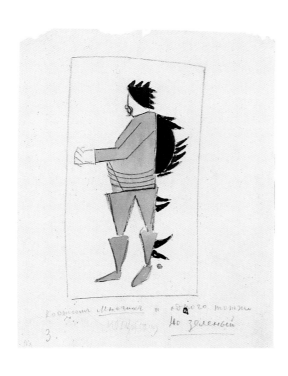

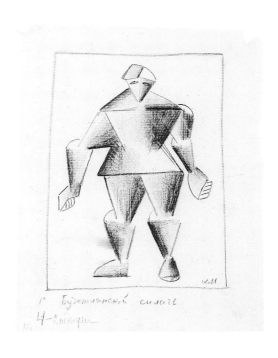

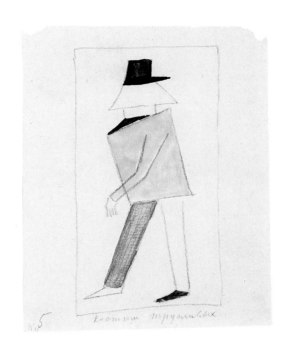

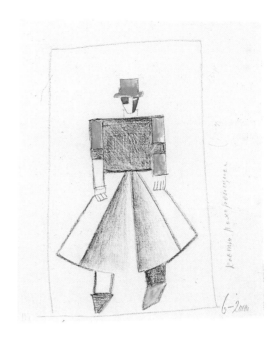

121

Coward
Graphite pencil,
watercolor, and gouache
on paper
10 9/16 x 8 1/4 (26.9 x 21)
Leningrad State
Museum of Theatrical
and Musical Arts

122

Pallbearer
Graphite pencil and
watercolor on paper
10 5/8 x 8 5/16 (27 x 21.1)
Leningrad State
Museum of Theatrical
and Musical Arts

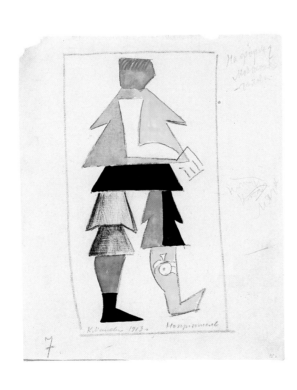

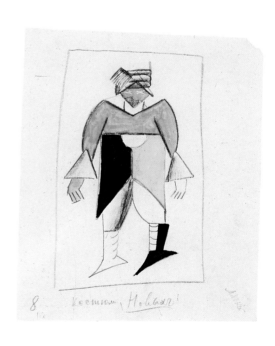

123

Enemy
Graphite pencil,
watercolor, and India ink
on paper
10 5/8 x 8 3/8 (27.1 x 21.3)
Leningrad State
Museum of Theatrical
and Musical Arts

124

The New One
Graphite pencil,
watercolor, and India ink
on paper
10 1/4 x 8 1/4 (26 x 21)
Leningrad State
Museum of Theatrical
and Musical Arts

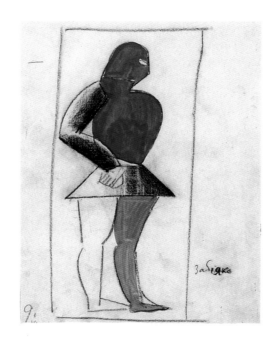

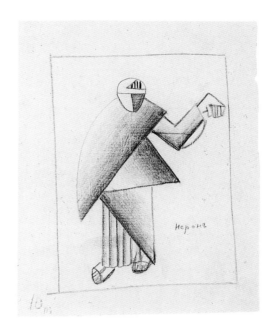

125

Bully
Graphite pencil and
watercolor on paper
10 1/2 x 8 1/4 (26.7 x 21)
Leningrad State
Museum of Theatrical
and Musical Arts

126

Nero
Graphite pencil on paper
10 5/8 x 8 7/16 (27 x 21.5)
Leningrad State
Museum of Theatrical
and Musical Arts

127

Reciter
Watercolor, India ink, and
charcoal on paper
10 11/16 x 8 7/16 (27.2 x 21.4)
State Russian Museum

128

**A Certain Character of
Ill-Intent**
Graphite pencil,
watercolor, and India ink
on paper
10 3/4 x 8 3/8 (27.3 x 21.3)
Leningrad State
Museum of Theatrical
and Musical Arts

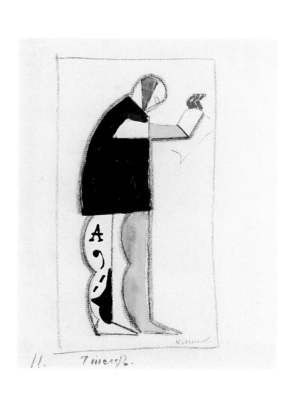

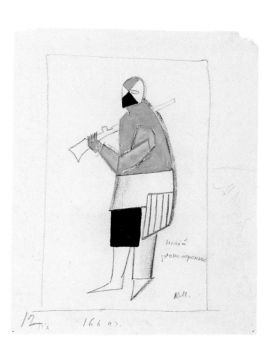

129

Old-Timer
Graphite pencil,
watercolor, and India ink
on paper
10 ⅝ x 8 ¼ (27 x 21)
Leningrad State
Museum of Theatrical
and Musical Arts

130

Sportsman
Watercolor, India ink,
and charcoal on paper
10 ¹¹/₁₆ x 8 ⁵/₁₆ (27.2 x 21.2)
State Russian Museum

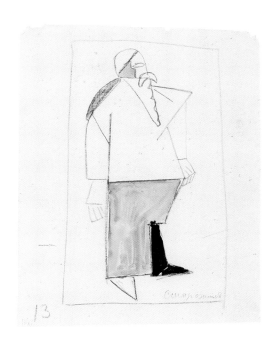

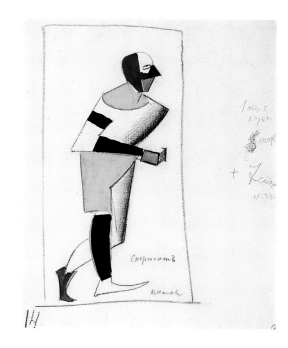

131

Attentive Worker
Graphite pencil, India ink,
and gouache on paper
10 ¹¹/₁₆ x 8 ⁵/₁₆ (27.2 x 21.2)
Leningrad State
Museum of Theatrical
and Musical Arts

132

Fat Man
Graphite pencil,
watercolor, and India ink
on paper,
10 ¹¹/₁₆ x 8 ⁵/₁₆ (27.2 x 21.2)
Leningrad State
Museum of Theatrical
and Musical Arts

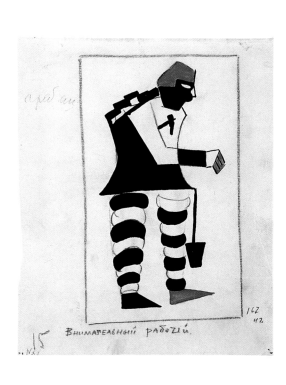

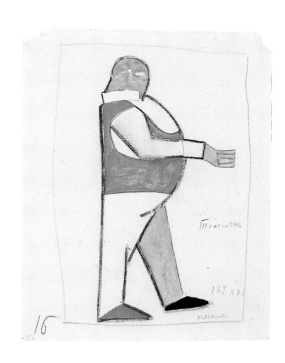

134

**Study for the Front Program
Cover for the First Congress
of the Committees on Rural
Poverty,** 1918
Watercolor, gouache,
India ink, and graphite
pencil on paper
15 3/8 x 14 7/8 (39.2 x 37.9)
Institute of Russian Liter-
ature, Pushkin House

135

**Study for the Back Program
Cover,** 1918
Watercolor, gouache,
India ink, and graphite
pencil on paper
12 7/8 x 16 1/4 (32.7 x 41.3)
Institute of Russian Liter-
ature, Pushkin House

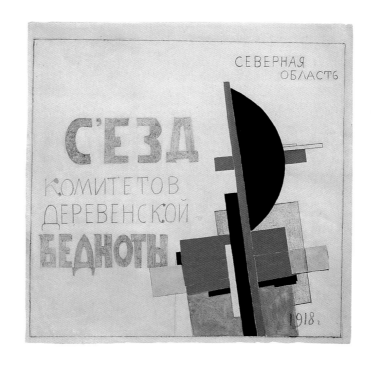

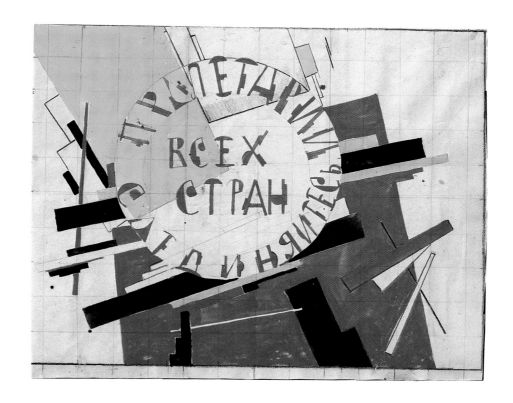

138

136

**Front and Back Program
Covers for the First Congress
of the Committees on Rural
Poverty,** 1918
Color lithograph
19 1/16 x 25 1/2 (48.5 x 64.8)
State Russian Museum

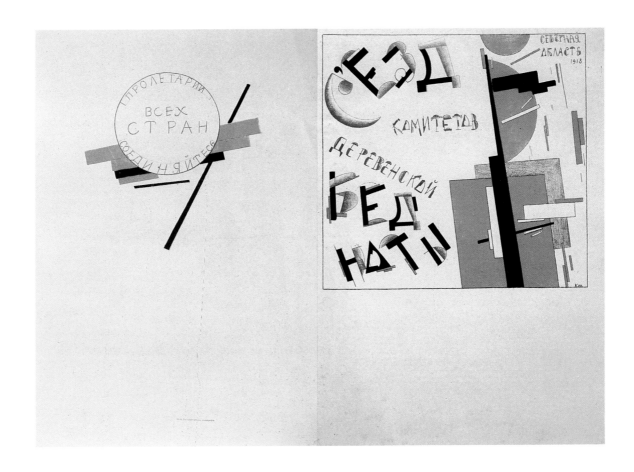

137

**Suprematism. Study for a
Curtain,** 1919
Gouache, watercolor,
India ink, and graphite
pencil on paper
17 $^3/_4$ x 24 $^5/_8$ (45 x 62.5)
State Tretiakov Gallery

Not in exhibition

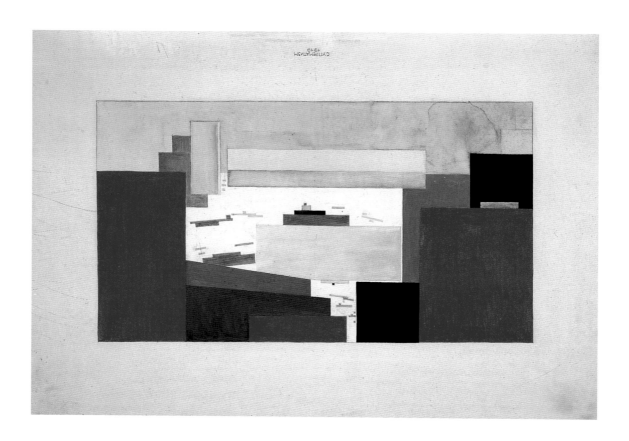

138 (recto)

**Suprematist Variations
and Proportions of Colored
Forms,** 1919
Graphite pencil,
watercolor, and India ink
on paper
9 3/4 x 13 1/4 (24.8 x 33.8)
State Russian Museum

138 (verso)

**Suprematist Variant of
Painting,** 1919
Graphite pencil,
watercolor, and India ink
on paper
9 3/4 x 13 1/4 (24.8 x 33.8)
State Russian Museum

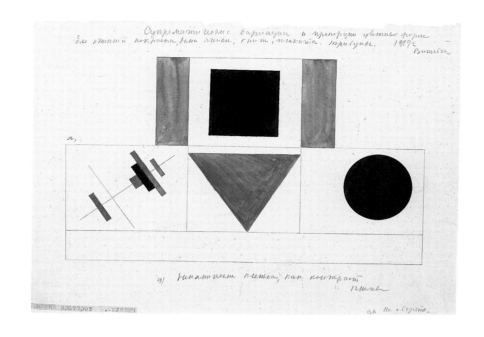

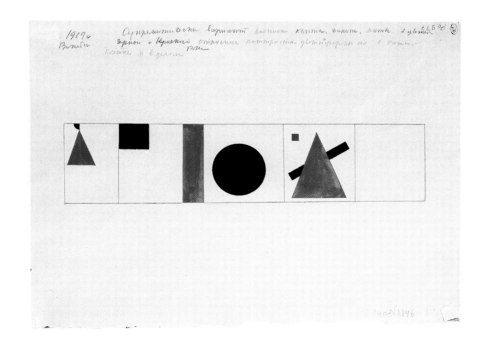

139

Design for Suprematist Fabric, 1919
India ink and gouache
(stenciled) on canvas
7 7/8 x 3 3/4 (20 x 9.6)
State Russian Museum

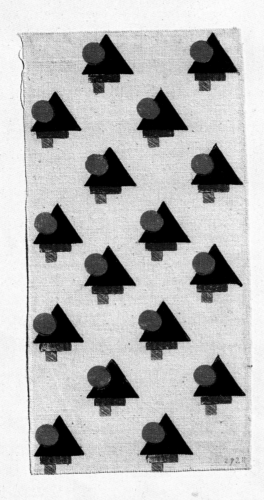

140

Design for Suprematist Fabric, 1919
Watercolor and graphite pencil on paper
14 1/16 x 10 5/8 (35.8 x 26.9)
State Russian Museum

141

Design for Suprematist Fabric, 1919
Watercolor, India ink, and graphite pencil on paper
14 1/4 x 10 5/8 (36.2 x 26.9)
State Russian Museum

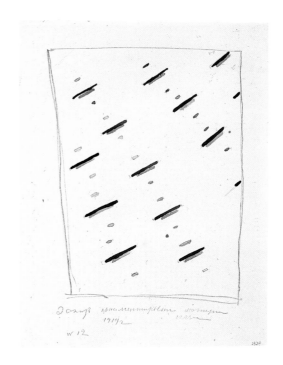

142

Design for Suprematist Fabric, 1919
Watercolor and graphite pencil on paper
14 x 10 5/8 (35.6 x 26.9)
State Russian Museum

143

Futurist Strongman,
ca. 1915(?) or 1920s
Watercolor and graphite pencil on paper
21 x 14 1/4 (53.3 x 36.1)
State Russian Museum

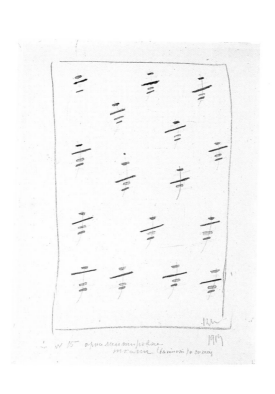

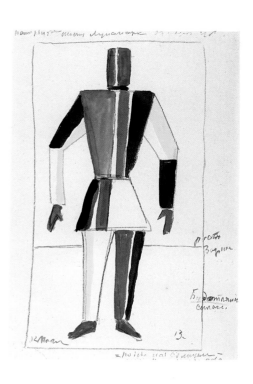

144

Suprematist Drawing,
ca. 1917–1918
Black crayon on paper
20 ⅝ x 13 ⅝ (52.5 x 34.5)
Stedelijk Museum

145

Suprematist Drawing,
1917–1918
Graphite pencil on paper
21 x 13 ¾ (53.5 x 35)
Stedelijk Museum

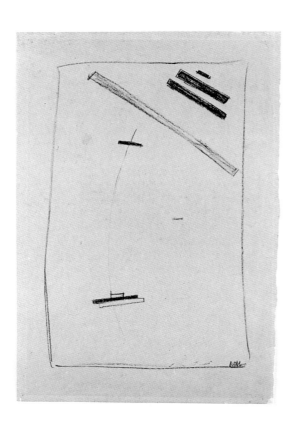

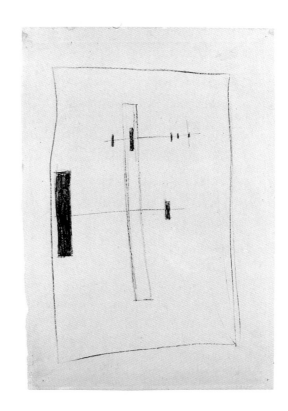

146

Suprematis,
ca. 1917–1918
Graphite pencil on paper
27 3/8 x 21 1/4 (69.5 x 54)
Stedelijk Museum

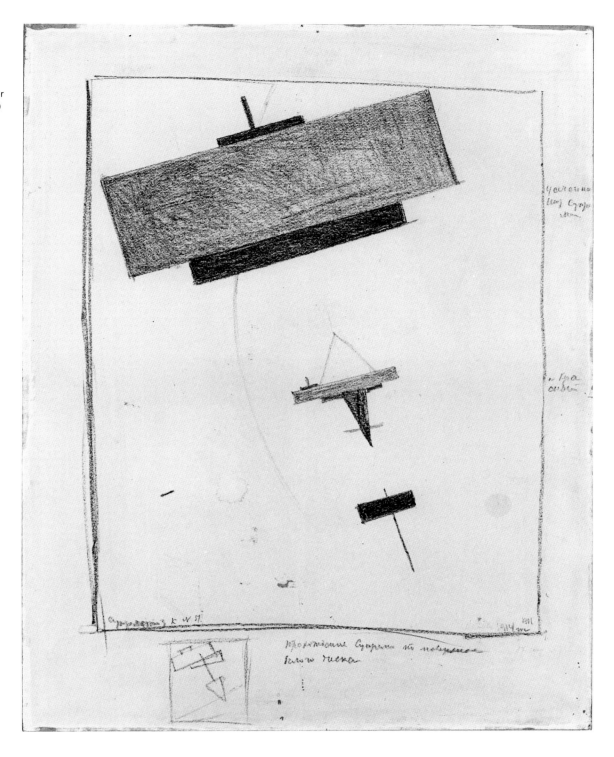

147

**Study Suprematis 52
System A4,**
ca. 1917–1918
Black crayon and
watercolor on paper
27 1/8 x 19 1/4 (69 x 49)
Stedelijk Museum

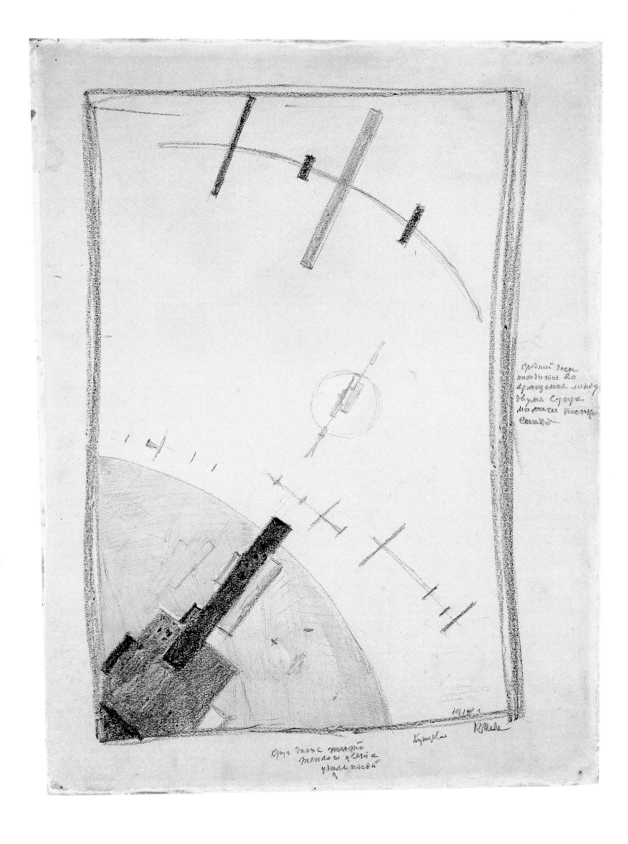

**Suprematism. Splitting of
Construction Form 78,**
ca. 1917–1919
Graphite pencil on paper
12 ³/₁₆ x 9 ⁵/₈ (32.5 x 24.5)
Stedelijk Museum

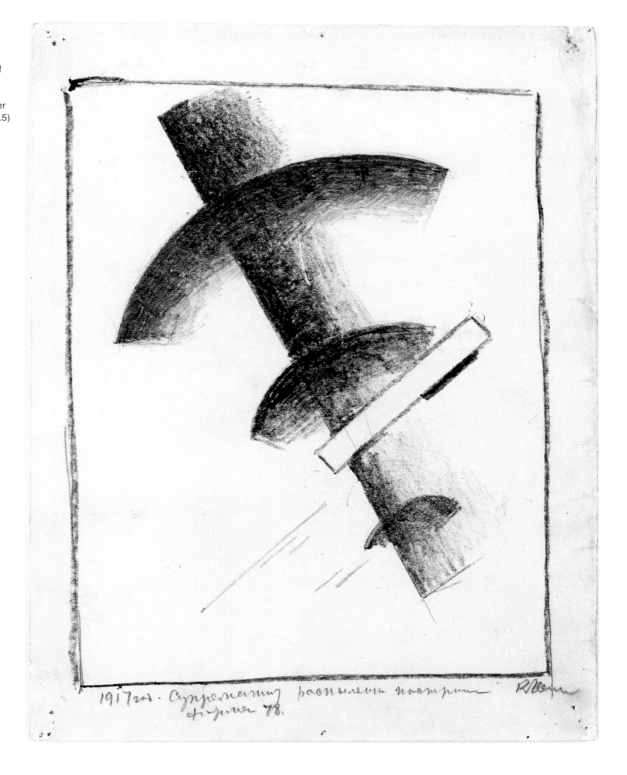

149
Suprematist Drawing,
ca. 1917–1919(?)
Black crayon and
graphite pencil on paper
12 5/8 x 9 5/8 (32.5 x 24.5)
Stedelijk Museum

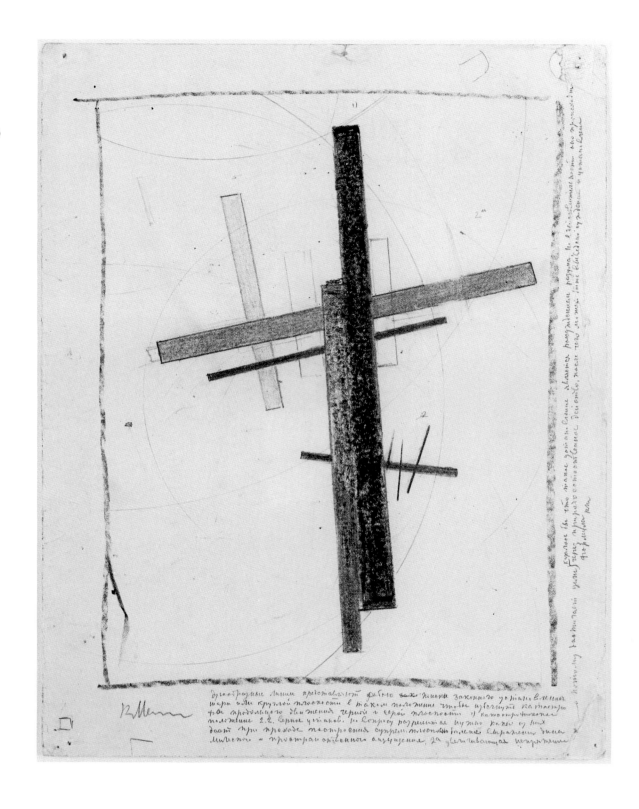

150

**Vertical Suprematist
Construction,** ca. 1920
Graphite pencil on paper
18 1/8 x 11 5/8 (46 x 29.5)
Stedelijk Museum

151

**Vertical Construction/
Suprematist,** ca. 1920
Graphite pencil and
black crayon on paper
16 1/8 x 11 5/8 (41 x 29.5)
Stedelijk Museum

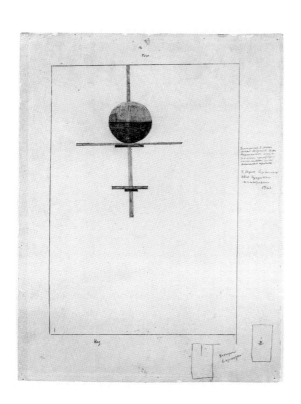

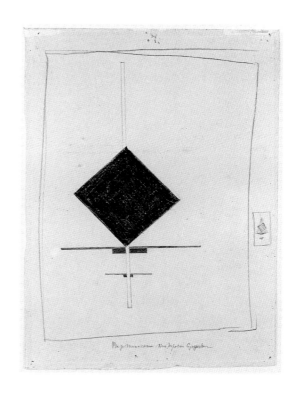

152

Poster for a Lecture, 1922
Collograph on paper
10 ⁷/₈ x 7 ¹/₈ (27.7 x 18.1)
State Russian Museum

153

Poster for a Lecture, 1922
Collograph on paper
10 ⁷/₈ x 7 ¹/₈ (27.7 x 18.1)
State Russian Museum

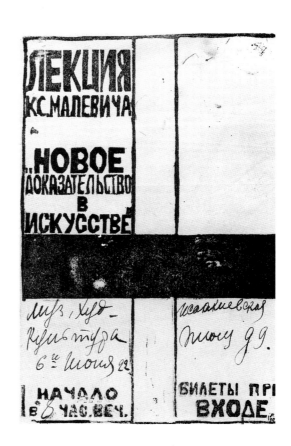

154

Table No. 1 Formula of Suprematism, 1920s(?)
Watercolor, gouache, and graphite pencil on paper
14 1/8 x 21 1/4 (36 x 54)
State Russian Museum

155

Table No. 3 Spatial Suprematism, 1920s(?)
Watercolor, white gouache, and graphite pencil on paper
14 13/16 x 21 5/16 (36 x 54.1)
State Russian Museum

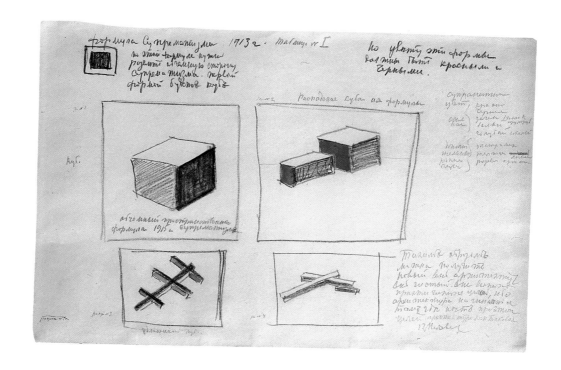

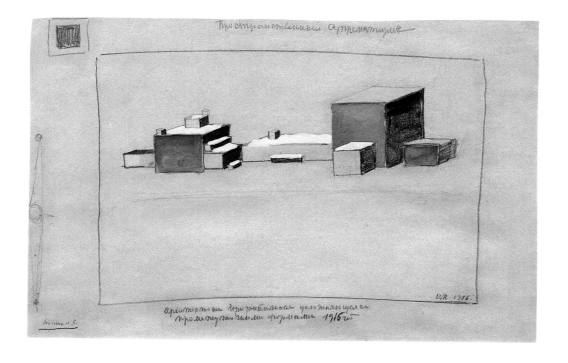

156

**Future Planits/Houses/for
Earth Dwellers/People,**
1923–1924
Graphite pencil on paper
17 5/16 x 12 1/8 (44 x 30.8)
State Russian Museum

157

**Future Planits for Earth
Dwellers,** 1923–1924
Graphite pencil on paper
15 5/16 x 11 5/8 (39 x 29.5)
Stedelijk Museum

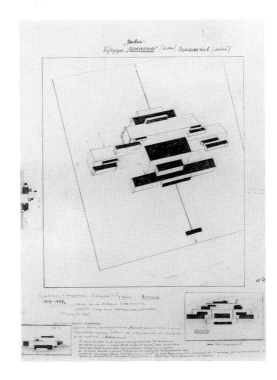

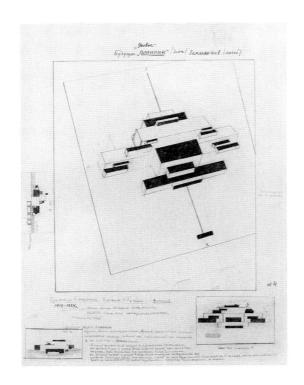

158

Modern Buildings,
1923–1924
Graphite pencil on paper
14 1/8 x 21 1/16 (36 x 53.5)
Stedelijk Museum

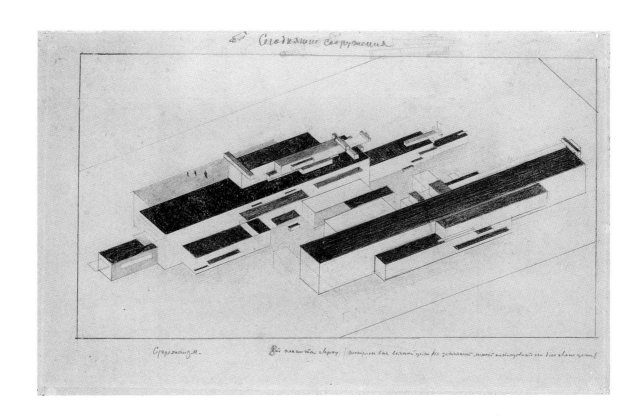

159
**Future Planits for
Leningrad. The Pilot's
Planit**, 1924
Graphite pencil on paper
12 x 17 11/16 (30.5 x 45)
Stedelijk Museum

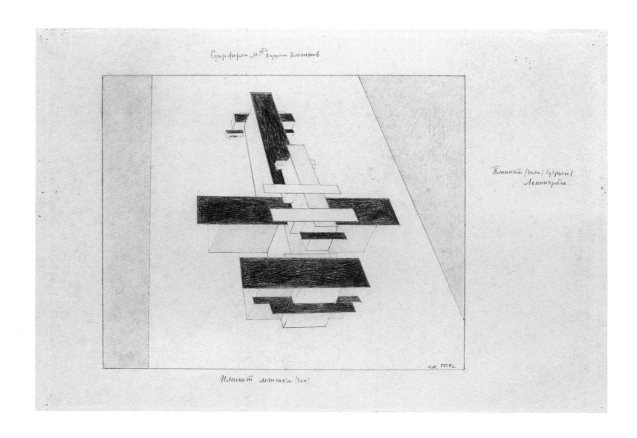

160
**Future Planits for
Leningrad. The Pilot's
Planit,** 1924
Graphite pencil on paper
12 ¼ x 17 ³/₈ (31 x 44.1)
The Museum of
Modern Art

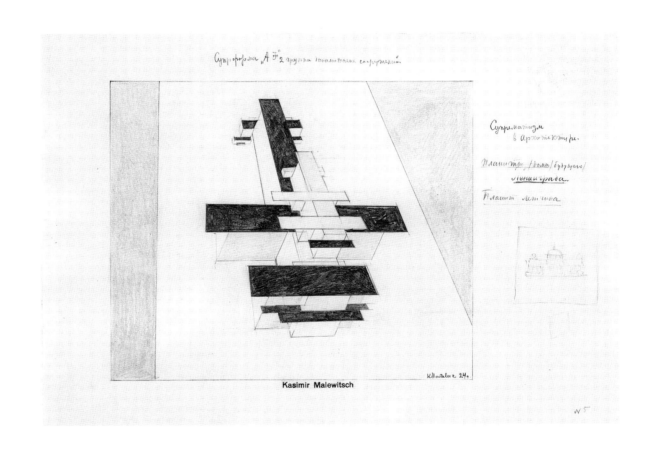

161

Two Squares, 1920s(?)
Graphite pencil on paper
19 ³/₄ x 14 ¹/₂ (50.2 x 36.8)
The Museum of
Modern Art

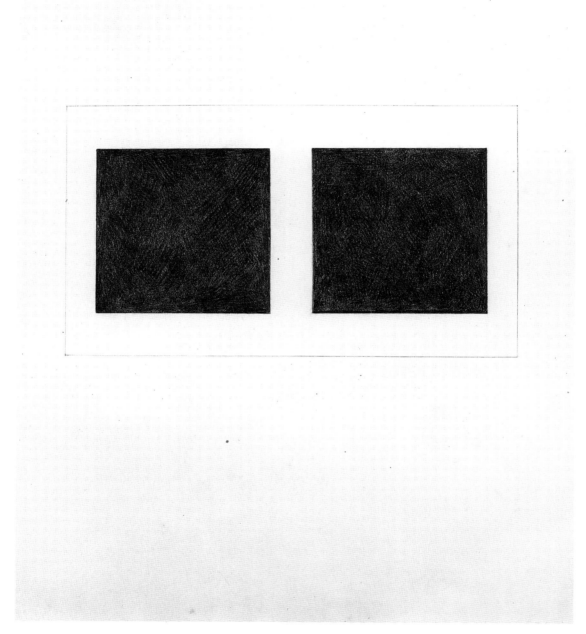

162

Circle, 1920s(?)
Graphite pencil on paper
18 $\frac{1}{2}$ x 14 $\frac{3}{8}$ (47 x 36.5)
The Museum of
Modern Art

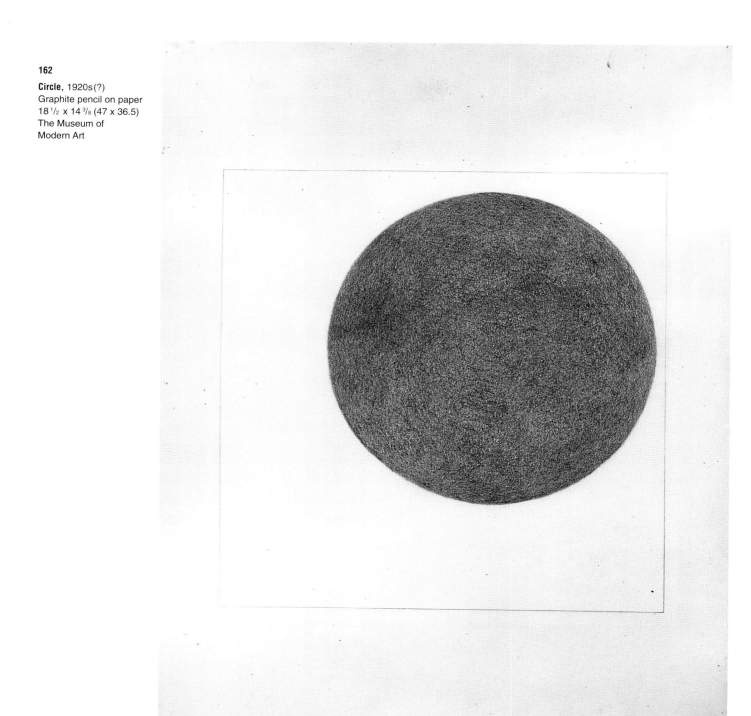

163

Suprematist Drawing,
before 1927
Black crayon on paper
13 ⁷/₈ x 8 ⁵/₈ (35 x 22)
Stedelijk Museum

164

Suprematist Drawing,
before 1927
Black crayon on paper
13 ⁷/₈ x 8 ⁵/₈ (35 x 22)
Stedelijk Museum

165

Standing Figure,
before 1927
Black crayon on paper
13^{15}/$_{16}$ x 8^{5}/$_{8}$ (35.5 x 22)
Stedelijk Museum

166

Standing Figure,
before 1927
Colored pencil on paper
13^{15}/$_{16}$ x 8^{11}/$_{16}$
(35.5 x 22.5)
Stedelijk Museum

Arkhitektons

167

Alpha, 1920
Plaster
13 x 14 $^{7}/_{16}$ x 33 $^{1}/_{4}$
(33 x 37 x 84.5)
State Russian Museum

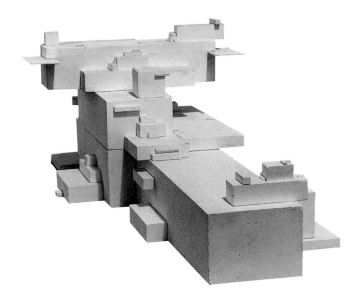

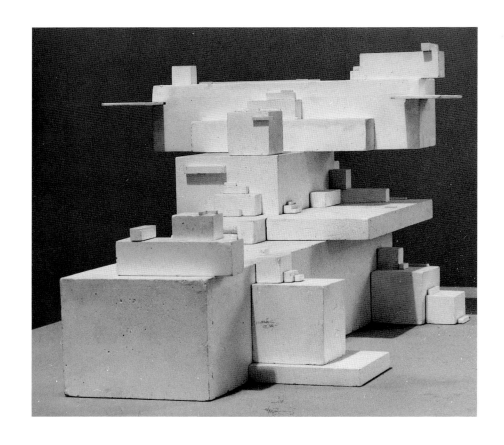

168

Beta, original before
1926
Plaster cast, 1989
10 $^{3}/_{4}$ x 23 $^{3}/_{8}$ x 39 $^{1}/_{16}$
(27.3 x 59.5 x 99.3)
Musée national d'art
moderne, Centre
Georges Pompidou

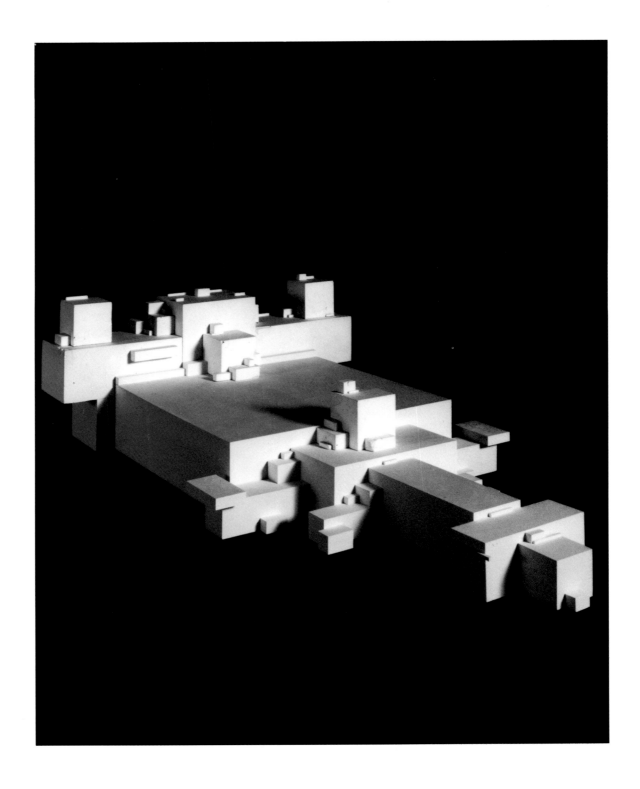

169

Gota, original plaster
1923(?)
Plaster cast, 1989
33 $^{9}/_{16}$ x 18 $^{7}/_{8}$ x 22 $^{13}/_{16}$
(85.2 x 48 x 58)
Musée national d'art
moderne, Centre
Georges Pompidou

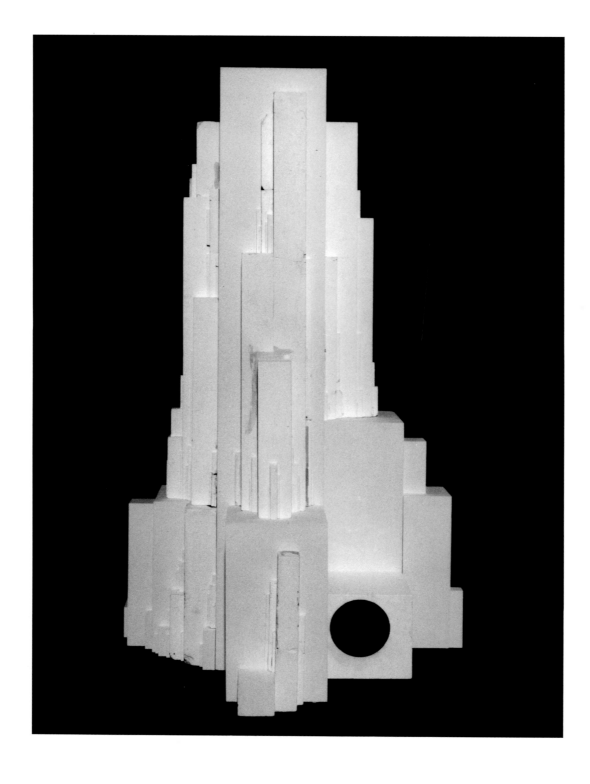

170

Gota 2-A, original plaster
1923–1927 (?)
Plaster cast, 1989
22 $^{7}/_{16}$ x 10 $^{1}/_{4}$ x 14 $^{3}/_{16}$
(57 x 26 x 36)
Musée national d'art
moderne, Centre
Georges Pompidou

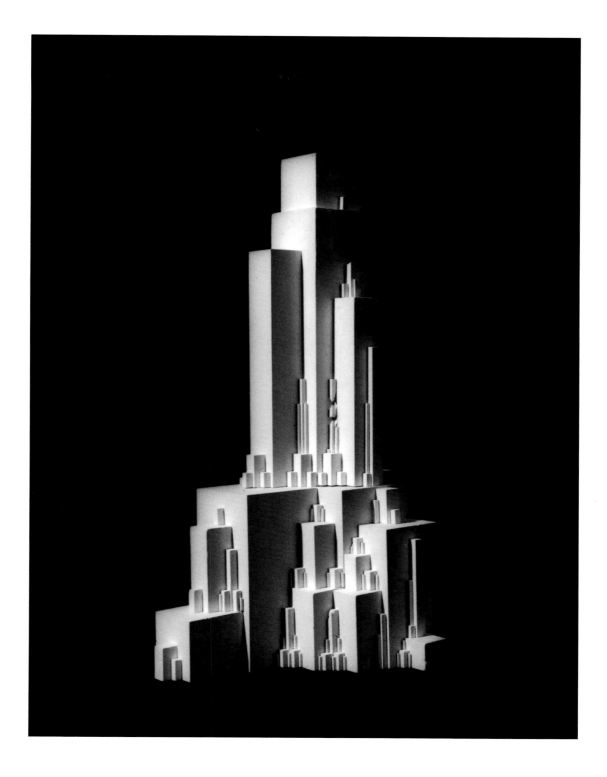

■ **Dmitrii Sarabianov**

Kazimir Severinovich Malevich is an integral part of the Russian avant-garde. Malevich's achievements are as inseparable from his personal qualities and creative foresight as they are from the natural evolution of his country's art. This evolution offered Malevich such extraordinary momentum that he quickly overtook avant-garde artists in Western Europe to reach a new level of achievement. His theory and practice of Suprematism mark a truly critical phase in the history of both Russian and Western painting. In developing Suprematism, Malevich formulated a completely original conception of artistic expression, which took him more than fifteen years to implement fully. During this time, he assimilated literally every phase of artistic development from nineteenth-century Realism to Cubism and Futurism.

Malevich was born and grew up in the Ukraine. Like many members of the Russian avant-garde, he did not receive a systematic education. In his autobiography, Malevich describes the explorations he made during the early stages of his artistic development. Writing about his very first pictures of peasants, he refers to a "naturalism" close to the spirit of Ivan Shishkin and Ilia Repin, two of Russia's foremost nineteenth-century Realists. Very few examples of this early, genuinely primitive Malevich have survived. We can judge this phase of his work, however, from a portrait of his mother painted in the Realist tradition of the Wanderers (peredvizhniki). Some of the characteristics of this style are also found in the painting of 1904 called *Portrait of a Woman* (cat. 5). Malevich's Impressionist phase followed, a relatively long and stable phase that contributed substantially to his creative achievements. This period was as necessary for Malevich's artistic development as it was for that of his contemporary Mikhail Larionov. Indeed, during their early years, most Russian avant-garde painters worked for a time in an Impressionist manner rather than in a Russian variant of Art Nouveau, unlike their Western European colleagues, who often began with Art Nouveau.

For Malevich, Art Nouveau was a passing interest and most of the works in this manner are not an organic part of his oeuvre. Examples are his studies for fresco paintings of 1907 (cat. nos. 6–9) and the gouache *Shroud of Christ* (cat. 92) of 1908. Nonetheless, these works fall within a definite chronological pattern. Most of Malevich's experiments in Art Nouveau were done later than his Impressionist paintings (except for *Wedding* of 1903), making his artistic evolution coherent and consistent.

Malevich's approach to Impressionism was both interesting and distinctive. He gave particular attention to landscape studies in which the dynamics are restrained and the composition strives toward stability, despite its fragmentary nature. His colored brushstrokes often achieve a singular energy and the outlined contours of his subjects are seemingly "fastened" to the surface. Many of these studies have a rather static awkwardness, which later became typical of Malevich's art and an expression of his most fundamental ideas. Indeed, his work of these years cannot be termed purely Impressionist. Both Malevich and Larionov reinterpreted the broken brushwork of Impressionism, concentrating on the surface plane of the picture. Within this system they found the potential to develop other systems of painting. Although Russian artists lagged behind their Western contemporaries in adopting Impressionism, the Russians were able to modify well-established styles with elements borrowed from newer trends in painting.

As his Impressionist phase ended, Malevich began to absorb and interpret a number of more recent currents in contemporary art, as he formulated his own personal style and methodology. In the *Female Bathers* of 1908 (cat. 11) he adds an almost blue-and-pink Symbolism to an approach that combines Impressionism with the graphic style of Art Nouveau. The self-portraits of the late years of the decade demonstrate his assimilation of both Fauvism and Expressionism. The several lines of development in twentieth-century art seem to be based on the same denominator peculiar to Malevich—an intense and persistent quest for an ultimate truth.

Neo-Primitivism—the movement developed by Mikhail Larionov and Natalia Goncharova—corresponded best to Malevich's internal stimuli and personal qualities, and the three artists became close colleagues. Malevich participated with Larionov and Goncharova in the first *Jack of*

ТЕАТРЪ ФУТУРИСТОВЪ.

Нѣсколько дней тому назадъ въ Петербургѣ состоялся спектакль футури
стовъ. Представлена была опера въ 2 дѣйствіяхъ А. Крученыхъ, муз. М. В
Матюшина „Побѣда надъ солнцемъ". На нашемъ рисункѣ изображена сцена 1-г
дѣйствія, названная авторами: „Все хорошо, что хорошо начинается".

Diamonds (1910) and the *Donkey's Tail* (1912) exhibitions, but he soon appropriated and modified the tenets of Neo-Primitivism. From 1910 to 1912 Malevich's identification with the peasant emerged —a concept vital to our understanding of his work. Like the other Neo-Primitivists, Malevich had his favorite subjects: portraits of peasants and peasants working in the fields, at church, or attending funerals. His work of these years resembles Goncharova's, especially his early pictures in the peasant cycle. Even the subjects of the two artists are similar—sullen peasant men and women, frozen forever in the awkwardness of their movements. The tense inner strength of these heroic figures, held almost at breaking point, is more noticeable in Malevich, however. He heightens the static quality and density of the figures and discovers a special structural principle, composing the painting with volumes, almost with ideal forms, as if he were erecting a building out of stones. Often Malevich chose a square canvas, which augments the static quality. Fossilized, crude, and powerful, the Russian countryside with its crystallized way of life, stationary in its tragic numbness, was the Russian countryside that took shape on Malevich's canvases. These peasant heads evoke the inner melody of medieval icons and frescoes from Novgorod. Malevich was carried forward irrevocably along this creative path toward Suprematism. Before moving decisively in that direction, however, he participated in several other developments in contemporary art.

Malevich's Cubist paintings *Perfected Portrait of I. V. Kliun, Through Station. Kuntsevo,* and *Vanity Case* (cat. nos. 29, 30, and 31) all date from 1913. Many works from the peasant cycle also can be considered Cubist, but those of 1913 exhibit a more "orthodox" Cubism, one that is closer to the Cubism of Braque, Picasso, and other Paris artists. Although Malevich created his best peasant paintings in 1911 and 1912—pictures in which he really seems to have come into his own— he clearly aspired to something new. He was tormented by a thirst for discovery and action.

In 1911, at the Moscow Salon, Malevich exhibited three series of paintings—yellow, white, and red—apparently in an attempt to integrate his color experiments into a new system. In 1912, endeavoring to combine his personal system with the methods of Italian Futurism, Malevich painted the *Knife Grinder/Principle of Flickering* (cat. 27). At the *Union of Youth* exhibition in 1913–1914 he showed six paintings from 1912 in a style he called "Transrational Realism" and six from 1913 in a style he termed "Cubo-Futurist Realism." At the 1916 exhibition *The Store,* he showed works from the preceding three years and titled them "Alogism of Forms." Malevich's use and manipulation of these and similar terms is most revealing. For him, as for many members of the avant-garde, the evolution of painting paralleled the development of theoretical thought and the formulation of personal creative principles.

Malevich's sally into "alogism," a movement close to Dada in the West, is important both as "manifesto" and as practical experience. Freedom of creative expression and the right to be absurd were now pitted against expediency and common sense, and Malevich's program included much of what was later proclaimed by the Dadaists. Without the experience of alogism, however brief, the transition to Suprematism would have been inconceivable. For Malevich, Suprematism proved to be the form that expressed maximum artistic freedom.

To appreciate Malevich's pre-Suprematist period, we need to consider the ultimate goal of his artistic development. If he seems to have lingered in the Impressionist phase, he quickly absorbed the trends that followed—a process characteristic of the Russian avant-garde—as if he had always been aware that his goal was Suprematism. Artistic development often requires a long period of maturation, but in Malevich's case it was distilled within

Figure 37

Poster for *0.10*
Petrograd, December 1915

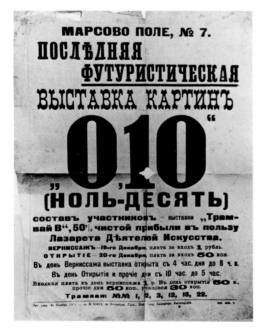

gave to his work on *Victory over the Sun* in his
correspondence with Matiushin, recently published
by Russian art historian Evgenii Kovtun.[1]

Exactly when the first Suprematist paintings were
painted, including the *Black Square* (fig. 1), is not
known, although they were shown at the *0.10*
exhibition in 1915 (figs. 37, 38). Since we cannot
assume that all of these works were painted on
the eve of the exhibition, the date for *Black Square*
is not necessarily 1915, just as Malevich's own
designation of the year 1913 cannot be considered
definitive. Thus the exact date of this artistic turn-
ing point, important not only for the artist but for the
whole of painting, remains unclear. But the date
is much less important than the revolution brought
about by the *Black Square.*

It was a leap into the abstract, and for Malevich it
marked a transition to a new means of comprehend-
ing the world. A few years later, in 1920, he wrote:

> Suprematism is divisible into three stages,
> according to the number of squares—black,
> red, and white, the black period, the colored
> period, and the white period. The last denotes
> white forms painted white. All three of these
> stages took place between the years 1913 and
> 1918. These periods were constructed accord-
> ing to a purely planar development, and the
> main principle of economy lay at the basis of
> their construction—of how to convey the power
> of statics or of apparent dynamic rest by means
> of a single plane.

Reduced to primary shapes (the pure plane, square,
circle, and cross), the economical, Suprematist
"figures" formed the basis of a new language that
could express an "entire system of world-building."[2]
Malevich rejected the outer skin of tangible objects.
Like no other artist who entered the world of
abstract art, he aborted all reminiscences of the
material world. The immense task of "recoding"
the world became his own. For Malevich the con-
ventional meanings that occur in the process of
such a recoding now assumed an absolute and
unconventional sense, higher than the meaning
of the real, objective world. Malevich, moreover,
mastered the conventions of earthly existence[3] in
order to speak in a cosmic language, to affirm the
global order and the general laws of the universe—
a language in which each separate element of the
system would contain the essential core, multiply-
ing and interrelating with similar elements. This

the evolution of a single artist. Of all the Russian
avant-garde, he was the most consistent in his
movement toward an ultimate goal.

The famous production of the Cubo-Futurist
opera *Victory over the Sun* (1913) was the real
launching pad for Malevich's abstract system called
Suprematism (fig. 35). This experimental presen-
tation, with libretto by Alexei Kruchenykh and
prologue by Velimir Khlebnikov, music by Mikhail
Matiushin, and sets and costumes by Malevich,
was a major event in the history of the avant-garde
(fig. 36). Rejecting traditional theater, Malevich and
his friends investigated a new musical and pictorial
language that in many ways anticipates perform-
ance art of our own time (cat. nos.112–133). In their
geometric simplicity Malevich's designs pointed
to his Suprematist discoveries of two years later.
Malevich expressed the special significance he

Figure 38
*0.10. The Last Futurist
Exhibition*
Petrograd, December
1915

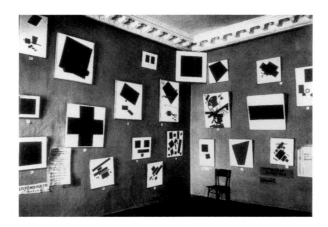

system was to be built in all its complexity.

Malevich wrote: "The keys of Suprematism are leading me to discover things still outside of cognition. My new painting does not belong solely to the earth. The earth has been abandoned like a house, it has been decimated. Indeed, man feels a great yearning for space, an impulse to 'break free from the globe of the earth.'"[4]

Malevich did not limit his activity to the world of art. His tendency toward synthesis corresponded to a long-standing tradition in Russian culture: the merging of art, literature, philosophy, politics, religion, and other forms of human intellectual endeavor. *Black Square* not only challenged a public that had lost interest in artistic innovation but also testified to a distinctive form of "god-seeking," the symbol of a new religion. It was a bold and dangerous step toward the position that places man before Nothing and Everything. The *Black Square* concentrates within itself eternal, universal space, transforms itself into other total formulas, and expresses *everything* within the universe. Malevich achieved this by condensing this *everything* into an absolutely impersonal, geometric form and an impenetrable black surface. In this lies the magic of the *Black Square*.

The Suprematist works that followed *Black Square* successfully developed the idea of overcoming the terrestrial pull. Despite their expression of forms in movement, Malevich's paintings abandoned their previous logic dictated by the laws of gravity. Forms were positioned without regard to the concepts of "above" and "below," which allowed them to soar in a universal space of independent structures. This soaring quality was not conveyed by illusionist means: it was not depicted, it was germane to the forms themselves. In turn, these

forms did not represent anything, their meaning is in their value as primary forms.

To a certain extent, Malevich's Suprematist canvases have much in common with icons. They "strove to be" a contemplation of life, a contemplation "in forms and colors." Malevich, however, stressed an important distinction between his work and icon painting. Suprematist paintings do not depict anything or anyone, but the icon always represents the deity. Yet the meaning that Malevich attached to his Suprematist paintings conferred on him the mantle of discoverer, prophet, and Messiah—"Kazimir the Great." The messianic spirit, categorical approach, and extremism that infused Malevich's work were inherent in many early twentieth-century cultural movements in Russia. This extremism, reflecting the pathos and dynamic of the changes preceding the 1917 Revolution, was a thirst to renew the world, and Malevich's entire artistic development was dictated by this vigorous, powerful movement for a decisive renewal. Surpassing the work of his predecessors, he absorbed some of their lessons and rejected others with a brusqueness typical of Russian avant-garde artists. Although the work of the Russian avant-garde was cruder and more cryptic than that of their French or German counterparts, it was also more decisive, more principled.

The orientation toward nonobjective art in the 1910s was rather widespread. It affected painting in many countries and artists such as Vasilii Kandinsky, Mikhail Larionov, Vladimir Tatlin, Nadezhda Udaltsova, and Liubov Popova in Russia; Piet Mondrian and the followers of De Stijl in Holland; Robert Delaunay in France; Franz Kupka in Czechoslovakia; and Morgan Russell and Stanton Macdonald-Wright in the United States. The traditions fed by their creativity traverse the twentieth century, sometimes diminishing in force and almost disappearing, at other times returning with increased vigor. Malevich's development within this movement toward nonobjective art was clearly one of the most prescient and fertile, a judgment now acknowledged by both Russian and Western artists and scholars.

In the 1920s Malevich's path grew more complex, as a result of several contradictory circumstances. The period of Suprematism was over. Malevich now shifted his emphasis from studio production to theoretical research, although this turning point was not a sign of creative crisis.

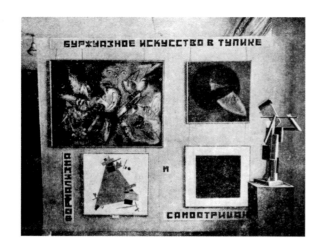

Figure 39

Exhibition of Bourgeois Art
State Tretiakov Gallery,
Moscow 1931
Installation by Alexei
Fedorov-Davydov

Figure 40

Malevich in His Laboratory
State Russian Museum,
Leningrad, 1932

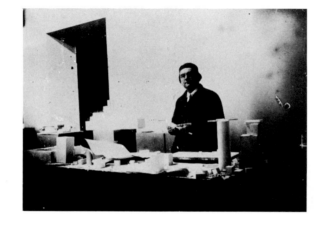

Figure 41

*Malevich at Work on
the Girl with a Red Staff*
(cat. 88)
Leningrad, 3 April 1933
Photograph by Nikolai
Suetin

Within the avant-garde, a manifesto was sometimes as important as the work of art.

In the late 1920s and early 1930s Malevich returned to figurative painting, passing through several stages of development and a number of formal variants. It is difficult to determine what prompted his return to this kind of painting, although there are many likely reasons. Among these are a general crisis of the avant-garde, a crisis that momentarily inspired a flood of classical references; the powerful and influential realist trends toward the end of the 1920s (represented by AKhRR—Association of Artists of Revolutionary Russia); Malevich's own wish to rethink his creative platform; his purely pedagogical desire to "process" all the phases he had experienced in arriving at Suprematism; the fortuitous circumstances related to leaving many of his works in Germany when he visited and lectured there in 1927; and his planned exhibition in Moscow in 1929, which required him to repeat a number of early works. Whatever the reasons for the changes in Malevich's artistic process, it is clear that he did not merely repeat himself. In some instances, his new paintings deviated only slightly from the originals; in others, he created an entirely new system of images. The second peasant series, from the late 1920s and early 1930s, provided Malevich with a highly idiosyncratic way out of nonobjective painting into a new kind of figuration (fig. 41). But this series was not only a response to the tragic situation that had developed in Russia by that time. Works such as *Peasant Woman, Sportsmen,* and *Complex Premonition* (cat. nos. 73, 75, and 80) are remarkable in their expressivity, for they still contain those ideas that Malevich discovered during the "cosmic period" of his creativity.

The art of Malevich has already left a deep imprint on contemporary artistic thought. Our recent reassessments of his theory and practice continue to open new avenues of inquiry, and the greater visibility of his art now heightens our awareness of his genius.

Translated from the Russian by John E. Bowlt

■ **Kazimir Malevich**

Before I begin to examine visual art as a whole, I must first analyze myself as a painter who used to depict nature as it appeared to the eye; and then I must examine the feelings or impetus that led me to depict it this way. I remember very well, from the time I was a child, those forms and states of nature that excited me and caused specific reactions.

I clearly remember that above all I was struck by shades and colors. I was impressed by storms, thunder, and lightning, and then the perfect calm after a thunderstorm. I was excited by the alternation of day and night. I remember, too, how difficult it was to go to bed or to tear myself away from my enthusiasm for observing, or rather simply looking at the burning stars, at the open sky as dark as a rook.

But each day I had to give in, and so from my bed near the window I would draw the curtain wide and once again look into space. I loved the moonlight in my room, too, shining through the windows onto the floor and bed and walls. Though many years have passed, even now I remember these phenomena vividly. I was not the only one in my family who liked listening to the thunderstorm and observing minute changes of color in nature. My father loved doing these things as well, but he could not express them on paper, nor could he draw. He could only draw an inimitable bucking goat (and he drew it superlatively) and a head that figured on medals, and then only facing left.

These may have been the only conditions that influenced me, the circumstances under which I lived in the southern Ukraine. . . . Yet this may not be enough; perhaps I should describe my father's way of life and the conditions under which he lived.

Our day-to-day life at home was like that of everyone working at sugar refineries in the 1800s. No one talked about art, and it took me quite a long time to find out that the word "art" existed and that there were artists who did nothing but draw whatever they liked.

My mother's life was occupied with housework; my father spent the whole day at the sugar refinery. The house was furnished simply. There were icons, which were hanging on the walls more for the sake of tradition and social convention than from religious feeling. Neither my father nor my mother was particularly religious, and they always had some pretext for avoiding church. Sometimes my father liked to amuse himself by inviting both the Catholic and the Russian Orthodox priests to our house at the same time.

As I briefly describe my life at home, I would like to mention what might have influenced me and thus offered some guidelines. There were painted icons, for example, which first and foremost must have influenced me, for they portray people in color. But it seems that this was so overshadowed by extraneous attitudes toward icons that it did not even occur to anyone to see the faces of ordinary people in these images, or that color was the means of depicting them. As a result, icons did not evoke any association with the life around us. I also used to go with my father to the refinery, where I saw the machines of those years, rapidly rotating centrifuges for bleaching the sugar. I used to stand beside the amazing, enormous apparatus my father supervised for boiling treacle and crystallizing sugar. But even this did not impel me to depict what I saw. There was another impression though, a more musical one: the noise, the hissing, the groaning of machinery, with its special, gentle rhythm. All this delighted me.

But nature intrigued me most, as it did my father, and we both loved its changes. Yet we were both silent, since we couldn't express to each other how "great" it was. But what was great and why it was great we did not discuss. Now, forty years later, I am still trying to understand this word, and I don't know whether I will be able to clarify its meaning even now.

I remember once after a heavy downpour just before sunset that there were enormous puddles in the street. A herd of cows was passing through them, and I stood transfixed, watching shreds of storm clouds pass across the disk of the sun, which was forcing its rays through the gaps between the tattered clouds reflected in an undisturbed puddle. Sometimes the water was stirred by the passing cows, and it rippled as they were reflected in it.

I remember that one day in March my father and I went to the station. There was still snow in the fields and an enormous cloud hung on the horizon,

its lower part a leaden blue shade. I remember a lake on a bright day, the sun reflected in its ripples like the ceaseless movement of the stars. All these things had a strong effect on me, but, I repeat, it was only an effect. I could only carry these amazing phenomena in my visual memory. All of these pictures were stored by my nervous system in some suitcase or other, like negatives that were to be developed, although there was no suggestion of this happening either. There was no advice from within me yet, nor did any come from outside, for no one was aware of what was happening to me, what I was thinking about or experiencing—if indeed I was experiencing anything at all. And who would have thought of making an artist out of me, when it was quite clear to my father that I must either make sugar or choose some easier profession? He felt that being on permanent night duty for twelve hours at a stretch was very arduous.

I loved to walk and to run off into the woods and the high hills where I could see the horizon around me. I still like to do this. One can infer that the whole of human culture had no influence on me, only the creations of nature. Yet my father used to say that man's culture would enable him to build machines that would liberate him completely from labor. Then my father always recalled the first sugar refineries, where the beets were cleaned by hand. Now the machines sliced them up. Then he would add that change would not happen soon. These ideas meant nothing to me, nor did they make me pay any more attention to that machine or arouse in me the desire to invent or devise new machines. But my father was not averse to fantasizing. I remember that at one time he had to do a lot of counting and that he had thoughts about inventing something like an adding machine.

Time passed, and I began to feel the urge to develop my negatives. I must say that even when I was very young—a child of four to six—I did not draw at all, the way most children of that age do. Somehow it never occurred to me that a pencil, charcoal, and paper were technical means for developing those negatives of one's impressions. And no one in my family told me about this.

I was evidently too stupid to think of it myself. I was more interested in watching storks and hawks soaring into the sky. I was greatly attracted by hawks, and this attraction cost the lives of many chickens. I used to tie them up or let them walk along the thatched roof of the cowshed. Then I

would wait for a hawk to swoop down in a ball from the sky and land on the roof. But I had a bow and arrow, ready with a needle in the arrow, and I often managed to save the chicken. This was a secret, of course, that I couldn't boast about to anyone. But this was enough for me. I was only seven at the time.

So nothing changed. The urge to develop the negatives grew stronger. But I had no means of doing this, and none of my friends in the area knew about this. One day, my father had to go to Kiev. He liked to have me with him because I listened to his stories, which played a large role in my life. He took me to Kiev. The first thing I did was go to look at the high places above the Dniepr. Then I had a good look at the shops, and in a shop window I saw a canvas with a delicious picture of a young girl sitting on a bench, peeling potatoes. The potatoes, and the peelings, were strikingly lifelike. This left the same kind of indelible impression on me as nature itself. Essentially, it also was a representation of a human figure, like those on the icons. But for some reason the painting in the shop window forcibly held my attention and made me very excited, while the icons had absolutely no effect on me. Only later did I realize that the energy of nature, to which I was organically related, did not affect me this way. Icons of the medieval masters would have affected me this way, too, but I still did not understand icon painting or where to find its essence. Clearly, the girl with potatoes, pots, and pans was so vividly portrayed that to me she seemed to be a part of nature. I had now seen her double, and I sensed that she was depicted by a human hand. But it did not occur to me to try to find that man, to learn from him how to do this kind of portrayal, and there was no one to guide me. I didn't even think of getting some paints in Kiev. Nor did I say anything to my father. I simply left Kiev and went on growing and taking delight in live nature until I was eleven years old. I did not suspect that there was paint that could represent nature. It was as if I lived in a backwater, where no one ever painted. And the means of painting simply evaded me.

But a day came that was just as staggering as the one on which I had seen the girl peeling potatoes. For some reason I noticed a painter who was painting a roof green, like the trees or the sky. This gave me the idea that one could depict a tree or the sky with paint. During a lunch hour, I climbed

Figure 42

Malevich in Kursk,
November 1900
Back row, second from
right; middle row, at left,
the sisters Maria Ivanovna
and Kazimira Zgleits
(Malevich's first wife)
and his brother Mechislav.

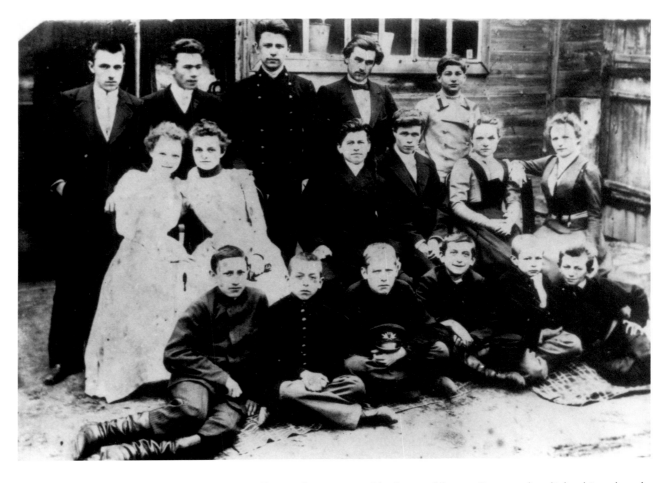

up on the roof and started to paint a tree. But nothing came of this. Yet this didn't bother me, because the act of painting was satisfying in itself. I experienced a very pleasant sensation from the paint on the brush.

But again, I asked the painter no questions, skilled as he was in his trade. I just went away full of the enjoyment of brush and paint. For me this was a great boost, but it was a misfortune for the painter, who went searching for his uninvited "apprentice" in order to box his ears. A little later I began to draw a mountain in ink on paper. But all the shapes ran together and the result was a blot that represented nothing. What an incredible blockhead! But meanwhile the negatives were lit in my brain; the cows were moving about in my negative—they were not frozen as in a kaleidoscope. Yet whenever I tried to represent them, to see them on paper, I only managed to reproduce the most unbelievable smudges.

At this point I stopped running around, and I spent more and more time each day doing pencil drawings. But the pencil really began to annoy me,

and in the end I gave it up and switched to a brush. Admittedly, these brushes came from a chemist's shop, where they were used to paint the throats of children suffering from diphtheria. Yet I found it easier than the pencil. The brush covered a larger area. For some reason I sat at home, never realizing that I ought to go outdoors to observe and paint. The idea didn't occur to me, just as it doesn't occur to small children. They paint from memory and depict only what they remember. But I was no longer a little boy, and yet I still acted like one. What did I want? To me this was very obvious. I wanted to paint what I saw; cows going through puddles after a shower and being reflected in the water. How great that was and how badly it all came out on paper! They were cows—but no one could make out what they were!

My twelfth, thirteenth, fifteenth birthdays passed, and I still understood nothing, although I was filled with a great happiness. Then my mother bought me a complete set of paints. I will never forget that great day in Kiev. I entered a shop for the first time

in which there were many pictures that really excited me. My mother and I did not know what to buy. Seeing our dilemma the salesman hurriedly came to our assistance. He suggested a box of paints that even artists would not have dreamed of owning with a full set of fifty-four colors, including all the flesh-colored paints recommended by some professor. All the way home I admired these paints. They pleasantly excited my nervous system, just as nature did. Emerald green, cobalt, cinnabar, ocher —they all evoked the same hues I saw in nature.

In order to remain in Kiev, where, as I found out later, there were "fantastic" artists such as Timonenko and Murashko, I moved to the little town of Konotop, in Chernigov province. There, with great diligence and zeal, I began to paint landscapes with storks and cows in the distance.

Only then did I realize that every family had its black sheep. From morning to night I worked with paints, never using a pencil. Days, months, a year, another year passed. Then my family moved to Kursk. While I was still in Konotop, I had learned about a school in Moscow where they taught you to paint nature as it really is. But my father hid the enrollment applications that I sent to the school, and exactly a month later he would announce to me that there were no vacancies.

Kursk was the town where I began my activities as a painter. From morning till evening I sat in the fields and forests and painted nature under different conditions of light. Then I found out that people whose work is the depiction of nature were called artists and that the work was called art. But nobody knew what art really was. Not only I but other artists, who painted in order to relax from office work. For them this kind of art was indeed recreation and consequently art was something you made to relax after work. But I didn't see it this way. I was a kind of sensitive instrument—like a barometer—that reacted to all the changes produced by sunlight in nature.

I reacted very simply, assimilating everything I saw and transferring it onto my canvas. The question of whether this was art—fine art—did not arise. The question was whether this resembled reality or not. There were others like me in Kursk. There were also some office workers who had studied at the Academy of Arts but had not graduated. Some had found jobs in customs and excise, in the treasury, or on the railways. Everyone had the same aim: to paint nature without rationalizing

it or changing it. This was during the years 1898 to 1901. By that time I had already had some practical experience, and I was by no means inferior to my colleagues. By 1898 I had already begun to exhibit publicly. I had been painting old men in the melon fields, women weeding fields; markets, stalls; the human figure. I already knew that there were some wonderful artists—Repin, Shishkin. We talked about Vasiliev. I knew that the famous Tretiakov Gallery was in Moscow, with paintings that were models of how to depict nature. But getting to Moscow was in the realm of fairy tales. For this I would have needed Konek-Gorbunok [the little hunchbacked horse]. The thought of Moscow really began to excite me, but I had no money. Moscow was an enigma for me. Nature was everywhere, but the means of portraying it were in Moscow, where famous artists lived. I, too, had to become a civil servant, not to earn money just for a trip to Moscow but to go there to live and study. I had a hellish time. I couldn't get the hang of my work, just as a wild bird does not know why it is caged.

At times during office hours I set up my drawing board and painted the view from the window. I was very serious about this. Everyone smiled, and my well-meaning colleagues said that this was not allowed. My superiors were embarrassed, too, but sometimes they were impressed by a finished study. A certain reverence for art led them to act leniently, but they did suggest that I not paint all day long, advising me to do it only after four o'clock. Months and years passed in this way, until I had saved up a little money and decided to move to Moscow.

The translation of "Iz 1/42: Avtobiograficheskie zametki, 1923–1925" by Xenia Glowacki-Prus and Arnold McMillin (Troels Andersen, *K. S. Malevich: Essays on Art,* vol. 2 [Copenhagen: Borgen, 1968], 147–155), has been revised.

■ **Kazimir Malevich**

My friends were troubled by my bold move, but their wives were very pleased. I have to say that my friends' wives hated me, because I was always taking their husbands away during any free time to go out sketching and thus they were never home. My friends would talk about all of the problems and horrors of the city, but that didn't scare me. I took account of my finances, figured that I had enough for a full academic year, and in spring I went to Kursk to work. Then I went to Moscow—that was in 1904. I went as an Impressionist who had already taken part in exhibitions.

In the spring, I went back to Kursk . . . and continued to work at Impressionism. I loved nature in the spring very much, in April and the beginning of May. I no longer went out on sketching expeditions but worked in the apple orchard of a little house, which I rented for twelve rubles a month. This orchard was my real studio.

My best friend, Kvachevsky, would come by to scold me. He couldn't bear my light blue tones, but in the end I brought him around. His color scale shifted in the direction of Impressionism, and he began to paint fine sketches. His works are collected in the Kursk Museum. *The Clear Glade (Yasnaya polyana)* is his best work; it could have been shown at any major exhibition (he died a long time ago).

I continued to work as an Impressionist in my studio garden. I understood that the essence of Impressionism was not to draw phenomena or objects to a "T" but that the whole point was in the pure texture of painting, purely in relating all my energy to phenomena and only to the quality they carried as painted forms. My entire work was like that of a weaver, who weaves an amazing texture of pure fabric, with the sole difference that I gave a form to this pure fabric of painting, a form that sprang only from the emotional requirements and properties of painting itself. I realized that the main stimulus for a painter always comes from these qualities alone. That's what it's all about. Everything else is extraneous—themes, for example, that express through painting the psychology of a man sitting for a picture, or illustrations of scenes from life, a world outlook, or the heroism of the masses.

I separated these two aspects of art and determined that the art of painting generally consists of two parts. One part is pure—the pure unit of painting as such; the other part consists of the objective theme, known as content. Together they comprised an eclectic art, a hybrid of painting and nonpainting. Reality became for me not a phenomenon that should be conveyed with full precision but a purely pictorial phenomenon. Therefore, none of the other qualities of an object played a central role, and they were present only insofar as the art of painting could not completely reshape their contours into an aspect of painting. By working at Impressionism, I learned that an objective image was never one of its concerns. If there was still a likeness, it was only because the painter had not yet found a form that would portray painting "as such," without evoking associations with nature and objects, without being an illustration or story, but a form that was a completely new creative fact, a new reality, a new truth.

Impressionism led me to look at nature again with new eyes, and nature in turn evoked new reactions in me, igniting my spiritual energy toward creativity, toward working on a completely different aspect of the phenomenon.

In analyzing my own activity I observed that, strictly speaking, I was working toward liberating the painted elements from the contours of natural phenomena and liberating my painting psychology from the power of an object. But another idea came to me, another feeling that seemed to fear this form of painting, that asked what form painting would take if it were liberated from the contours of an object and whether such a form could be found.

The preceding schools and the Wanderers, whom I loved, . . . worked in the following way: they used to select an appropriate subject *(Christ and the Adulteress* by Vasilii Polenov, *The Resurrection of Jairus' Daughter* by Ilia Repin) and put painting into the form this subject required. That's also what Rembrandt did *(The Prodigal Son).* But these masters made subject matter the main content expressed through painting. My approach was different. I did not want to make painting in any way a means but only its own self-content. In his *Crucifixion,* Ge conveyed the feeling of his painting by clothing it in his subject. Thus in *The*

Last Supper he conveyed the effect of light, using the figure of Judas as a means of achieving that effect. I saw another connection in this picture; I saw that it was also possible to make the subject a means. Strictly speaking, Ge and several other artists sensed pure painting, but they could not imagine the existence of nonobjective painting. They sensed the nonobjective but made representational things.

I also found myself in this situation. It still seemed to me that painting in its pure aspect was lacking something, that it had to be given a content. But the emotional energy of painting would not let me see images in their representational nature, especially if the theme had no origin in painting. The naturalism of objects didn't stand up to my criticism. I began to look for other possibilities, not outside but within the very core of the emotion of painting. I expected that the painting eventually would provide the form deriving from the properties of painting, and would avoid any vital connection with the object, with associations outside of painting. This position led me farther and farther from the academic study of nature, from naturalism, from illusionism. My acquaintance with icon painting convinced me that the point is not in the study of anatomy and perspective, not in depicting the truth of nature, but in sensing art and artistic reality through the emotions. In other words, I saw that reality or subject matter is something to be transformed into an ideal form arising from the depths of aesthetics. Therefore, in art, anything can become beautiful. Anything not in itself beautiful but realized on an artistic plane becomes beautiful.

In the fall I went again to Moscow, where I fell in with an artists' "commune." The commune was in Lefortovo, in a house belonging to the artist V. Kurdyumov. Or rather, not relying on his talent, Kurdyumov took two houses for his dowry when he married. The house where the communards gathered was a spacious, two-story, wooden house with twenty, nice, bright rooms. About thirty men were in the commune, and each had agreed to pay seven rubles a month for his room.

I took up residence in this commune, and by habit I started to work immediately. I painted Impressionist pictures and sketches. The company was merry but hungry. Feeling like a provincial among the communards from the Institute of Painting, Sculpture, and Architecture, I promptly paid my money and shared in all the expenses. But the communards didn't fulfill any of their obligations to the owner of the house, and no one even thought about paying him according to their agreement. Worst of all, no one even considered working. This demoralizing environment had the opposite effect on me. More and more, I strained every nerve toward work.

Within two or three months, my whole financial base crumbled, and I fell like a chicken into soup, completely unequipped for life in the big city. But I didn't give in to depression; I worked, studied art, and went to the studio. In spite of my naturalistic leaning, my feelings about nature, I became strongly moved by icons. I felt a certain kinship and something splendid in them. I saw in them the entire Russian people with all their emotional creativity. Then I'd recall my childhood: the little horses, flowers and roosters of the primitive murals and wood carvings. I sensed a bond between peasant art and icons: the icon is a high-culture form of peasant art. I discovered in icons the whole spiritual aspect of "peasant time." I came to understand the peasants through icons and saw their faces not as saints but as ordinary people. And I also came to understand the color and the attitude of the painter. I understood Botticelli and Cimabue. Cimabue was closer to me: he possessed the spirit I had sensed in peasants.

This was the third stage of my artistic transition. The first occurred when I switched from primitive representations of peasant art to the naturalist school, to Shishkin and Repin. This path was unexpectedly halted by a great moment, when, through painting, I stumbled on an extraordinary phenomenon in looking at nature. Before me among the trees stood a newly whitewashed house. It was a sunny day. The sky was cobalt blue. One side of the house was in shade and the other was lit by the sun. For the first time I saw the bright reflections of the blue sky, the pure, transparent tones. From then on I began working in bright, joyful, sunny colors. One of these sketches *(The Garden; possibly fig. 55)* is in the Tretiakov Gallery. I painted a great number of these sketches over the next few years. From that time on, I became an Impressionist.

Moscow, with its ancient icons, overturned all my theories and led me to the third stage of development. Through icon painting, I came to understand the emotional art of the peasants, which I had loved earlier but whose meaning I had not fully

Figure 43

Manuscripts from the Malevich Archive Stedelijk Museum, Amsterdam

understood. How did this art overturn my efforts at lifelikeness, accurate anatomy, perspective, the study of nature through drawing sketches? All of the Wanderers' convictions regarding nature and naturalism were overturned by the fact that the icon painters, who had achieved a great mastery of technique, conveyed meaning beyond fidelity to anatomy or spatial and linear perspective. They employed color and form on the basis of a purely emotional interpretation of the theme. They painted without regard to any of the rules established by the classics, especially the academic routine of Vladimir Makovsky and Repin. I pictured to myself distinctly the entire progression from the great icon art to the horses and roosters of the murals, spinning wheels, and costumes of peasant art. In exactly the same way, I also could see the other tradition, the art of the people of the upper classes, of the aristocrats and palaces. This was the art of antiquity and the Renaissance. I attributed the art of the Wanderers to the middle layer of society, to the intelligentsia and the revolutionary-minded classes. I also considered this tradition high, but it seemed to me that the art of the Renaissance and of antiquity was an art for the sake of beauty, while in the art of the Wanderers I saw an art of propaganda and a denunciation of the authorities and social reality.

Later, I proceeded neither in the tradition of antiquity and the Renaissance nor in that of the Wanderers. I remained on the side of peasant art and began to paint in the primitive spirit. In the first period, I imitated icon painting (cat. 6). The second period was exclusively themes of labor: I drew peasants at work, harvesting, threshing (cat. 22). In the third period, I came closer to a suburban genre: carpenters, gardeners, vacation spots, swimmers (cat. 18). The fourth period was inspired by city shop signs: floor polishers, maids, lackeys, servants (cat. 20).

The translation of "Otryvki iz 'Glav iz avtobiografii khudozhnika,' 1933" by Allan Upchurch (*October,* no. 34 [Fall 1985]: 25–34), has been revised.

Figure 44

*K. S. Malevich: His Way
from Impressionism
to Suprematism,*
Moscow, 1919–1920

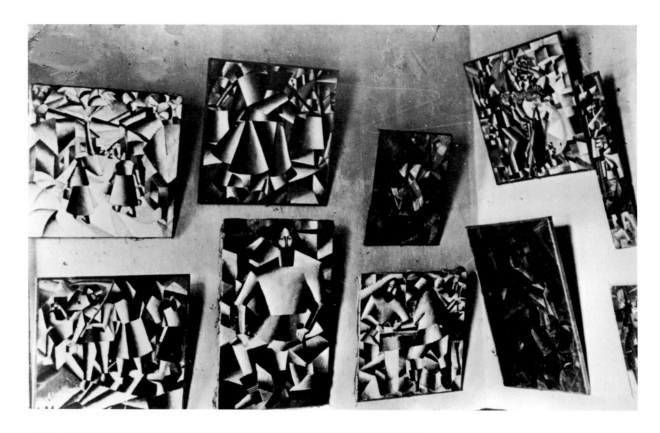

Figure 45

*K. S. Malevich: His Way
from Impressionism
to Suprematism,*
Moscow, 1919–1920

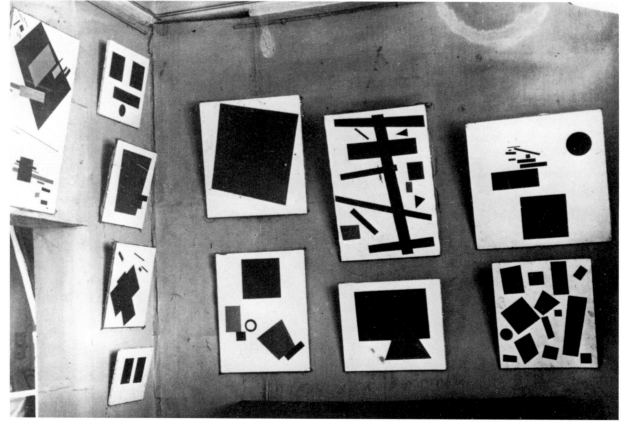

■ **Kazimir Malevich**

*A Note on the English Translation of
Kazimir Malevich's* Futurism-Suprematism

Kazimir Malevich was an extremely copious writer,
and it seems that for him the act of writing was no
less artistic and inventive than the act of painting.
Many of his texts have already been translated into
English in the four-volume series edited by Troels
Andersen between 1968 and 1978 (see Bibliogra-
phy), but a number of key essays still exist only in
manuscript form. The text translated below is from
a long work, titled "Futurism-Suprematism," that
Malevich wrote on various occasions in 1921. It
exists in at least two versions: part of one version
is in the archive of the Stedelijk Museum, Amster-
dam; part of another, formerly in the collection of a
student of Malevich, Efim Raiak, in Moscow, is now
in a private collection in that city. The translation
below is from the second version. "Futurism-
Suprematism" is one of many examinations that
Malevich made of the evolution of Cubism and
Futurism into Suprematism.

Malevich was not a master of elegant prose, and
his style abounds with oblique phrases, eccentric
punctuation, and grammatical errors. In the interest
of accessiblility, however, an attempt has been
made to clarify the more obscure passages of this
extremely tense and complex treatise.

In the future not a single
grounded structure will remain on Earth. Nothing
will be fastened or tied down. This is the true
nature of the universe. But while each unit of
matter is a singular part of nature, it will soon
merge with the whole.

This is what Suprematism means to me—the
dawn of an era in which the nucleus will move as
a single force of atomized energy and will expand
within new, orbiting, spatial systems. Synthesis,
therefore, is the one-dimensional condition of the
two- and three-dimensional world. Since primeval
times our awareness of the natural world has
become increasingly dynamic. Today we have
advanced into a new fourth dimension of motion.
We have pulled up our consciousness by its
roots from the Earth. It is free now to revolve in
the infinity of space. Go forward, art workers—in
your movement you will find the new Realism of
the world.

Suprematism as a great dynamism, a violent
change, an era of dynamism triumphant over
material.

Surface and volumetric Suprematism—colored,
black, and white.

In my notes on art, I almost always connect
Cubism, Futurism, and Suprematism. While
Cubism and Futurism are directly linked, it might
seem at first glance that there is no such link
between Futurism and Suprematism. Indeed,
there is none either in terms of composition or the
handling of paint. But if we try to penetrate this
creative act philosophically, the link manifests itself
in the notion of atomization—the freedom of units
regardless of their makeup. In other words, with
the atomization of the old organism and its liber-
ated units, a violent change is imminent. I think
that freedom can be attained only after our ideas
about the organization of solids have been com-
pletely smashed. This liberates each unit from the
single, complex mass made up of units of energy.
In reality, everything exists within the world; nothing
can exist independently. Nature's perfection lies in

177

the absolute, blind freedom of units within it—units that are at the same time absolutely interdependent.

Consequently, every solid is a unity of absolutely free units, and what we see in nature is simply the mass integration of free units and the various amalgams of steel and stone. This apparent amalgam, in fact, contains units of many kinds, including space. In other words, the fusion is not total, and thus solid matter does not exist in nature. There is only energy. Therefore, everything is linked and at the same time separate in its own motion. Much has been written about this in scholarly treatises by eminent people, and I need not elaborate on this idea. I want only to point out that this notion was the impetus for breaking up the visual complexity of a solid and dividing its mass into the separate energies of the colors of Suprematism.

My research has shown that color in its basic state is autonomous; that is, each ray has its own energy and characteristics. When colors are mixed, they produce different hues and release new color energies. This results from different color intensities and temperatures. The radiating colors generate the strengths of the different hues.

This raw energy of color has been the painter's strongest stimulus. Aroused by color in nature, the painter began to express this stimulus in canvases that we call pictorial acts. From this, various forms of pictorial activity emerged, which we categorize as landscape, genre, and so forth. Painting has always expressed materiality, impressions, density, transparency, weight, and so on, but never absolute color.

Thus painting used to represent the objective world of nature and to a degree the nonobjective world. In this way, stimulated by different colored materials or textures, the artist—the painter— began to reproduce them. But he did not realize that this stimulus also introduced pure nonobjective, pictorial composition—something that Cubism discovered later and expressed as its highest pictorial achievement. This is true of all the fundamental natural laws that I have discussed in my articles on Cubism, and according to my research, painting has attained its highest expression in this development.

Moreover, in Suprematism the mass of energy breaks down into individual color constructs on the two-dimensional plane—with the result that each plane or volume becomes an independent unit powered by its own motion. Thus, in expressing

pure colored form, the colored period of Suprematism discovered the very essence of color. This became the departure point from which the new movement continued to evolve, forced to integrate and produce a new pictorial form or concentration of forces. These powerful articulations of form constituted the painted picture. But did it really make sense to extrapolate color in order to destroy these forms? or to relate the pictorial energy to a new level of color? What was understood here was the conscious rejection of material, or the atomization of the picture as it approached a new articulation of energy.

As a result, Suprematist atomization of the picture and the reduction to a single color has released the action of atomization—like a multichambered cartridge—onto the individual elements of color energy, which were not interconnected before. This process of isolation has created the form of the black or colorless square, a form that in its atomization offered all kinds of other forms, and these in turn were painted many different colors. The result is that, as planes, all the Suprematist forms are units of the Suprematist square. Most of them fall into line along diagonal and vertical axes and interact within a dynamic field of expression. They also attain their maximum intensity when the Suprematist forms are positioned horizontally. Such forms, of course, do not express anything related to the objective world, and in the viewer's mind they are nonobjective. Consciousness now begins to operate with *supremes* [translator's italics], with individual units—the signs of dynamic mathematical connections. Expressing this dynamic functioning is the primary purpose of consciousness. The forms are built exclusively on white, which is intended to signify infinite space. The tactility of this dynamism, however, begins to assume importance in this kind of composition.

A picture does not require painted forms. But this nonnecessity for color and paint now acquires another meaning—color becomes redundant not because it is superfluous aesthetically but because something even more fundamental has been hidden. Like color, this dynamism is achieved through materials, and it emerges only when the composition attains perfection. Such perfection generates a new atomization.

Translated by John E. Bowlt

■ John E. Bowlt

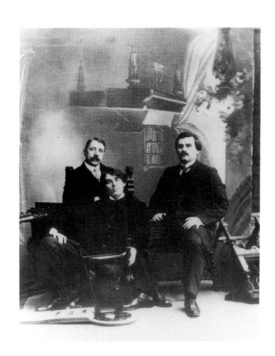

Figure 46

Alogical Portrait of the Futurists Mikhail Matiushin, Alexei Kruchenykh, and Kazimir Malevich, Saint Petersburg, December 1913

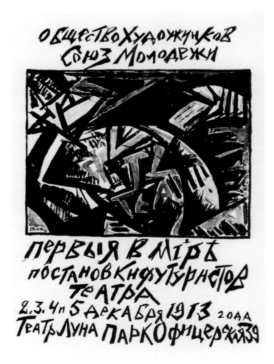

Figure 47

Olga Rozanova, *The First World Productions by the Futurists of the Theater,* 1913
Poster for two performances each of *Vladimir Maiakovsky* and *Victory over the Sun,* Saint Petersburg 1913
Collection of Mr. and Mrs. Nikita D. Lobanov-Rostovsky, London

One of the most startling photographs of the stellar members of Russia's Cubo-Futurist movement shows Mikhail Matiushin, Alexei Kruchenykh, and Kazimir Malevich posing beneath a grand piano suspended upside down (fig. 46).[1] This picture of 1913—the year of Vladimir Maiakovsky's *Vladimir Maiakovsky* and the Kruchenykh/ Matiushin/ Malevich *Victory over the Sun,* each performed twice at the Luna Park Theater in Saint Petersburg (fig. 47)—is a historic record of the avant-garde and an amusing photographic trick. It is also a document of deep symbolic significance. With an essential logic, Malevich, the prime mover of alogism and Suprematism, chose to be photographed in a musical or, rather, antimusical setting that refers clearly to his collaboration with Matiushin and Kruchenykh on the opera *Victory over the Sun.* Matiushin composed the music at his piano, and the raucous chorus was accompanied by an out-of-tune piano. The same ivory piano keys slash across Malevich's *Portrait of the Composer M. V. Matiushin,* painted the same year (cat. 33). But the photograph also refers to the relationships between noise (sound), image, and verbal language, which fascinated Malevich. In his paintings and writings he returned to them again and again.

The complexity of these relationships was a central concern of many Russian Modernists, from the Symbolists to the Constructivists. But in Malevich's case we are not dealing with a spontaneous interpretation of the Symbolists' legacy of synesthesia—with the color-sound experiments of the "amazing, but effeminate" Alexander Skriabin, as Malevich called him, or the "inner sound" that Vasilii Kandinsky required of the successful work of art.[2] Malevich was not especially interested in their efforts to equate sounds with colors, to build color organs, and to create a liturgy of the senses. His attitude toward sound was dictated rather by a more primitive, more brutal energy. He argued that sound and rhythm contained great potential to liberate art, to build "cylindrical sounds" and "musical cubes" on the ruins of the old forms, as his composer friends

Figure 48

Kazimir Malevich, *Troe*
(The Three), 1913
Booklet illustration,
page 83
Saint Petersburg:
Zhuravl

were doing, especially Nikolai Kulbin and Nikolai Roslavets.[3] The new music could "atomize" the object, Malevich claimed, and create an art of pure sound parallel to Suprematist painting—one reason why he invited Matiushin and Roslavets to contribute articles on experimental contemporary music to his unpublished journal *Supremus* in 1917–1918 and why he made portraits of both men.[4]

Roslavets, who at one time was Malevich's "only friend," was exploring the possibilities of microtonal music just as Malevich was formulating Suprematism.[5] Influenced by Arnold Schoenberg, Roslavets and Artur Lourié represented the avant-garde in Russian music. They were convinced that music must also codify and apply new conceptions of melody and harmony based on "the principles of 'free' music, which used quarter-tones, eighths, and tones of even smaller denominations in addition to normal tones and semi-tones."[6] Like Malevich, Roslavets and Lourié felt that in its originality Russian art had surpassed French Cubism and Italian Futurism by 1913, and they offered their tonal systems—"the music of interference, higher chromatics, and chromo-acoustics"—as the rightful heirs to the Italian "art of noise."[7] No doubt, in avoiding programme music, they would have agreed with Malevich's rejection of movie music as too illustrative and of radio as a "mechanical child born of science, the grandson of the gramophone, limiting its range to the field of sound; it too screams out through the loudspeaker."[8] Malevich elaborated his interpretation of "piped" music in his essay "And Images Triumph on the Screen," of 1925, just as Roslavets was making his final bid for musical freedom on the pages of the journal *Sovremennaia muzyka* (Contemporary Music).[9] Malevich sympathized with this aspiration toward "free music," because it coincided with Kruchenykh's emancipation of language and with Malevich's own application of *zaum* to painting. *Zaum,* meaning literally "beyond the mind" or "beyond reason," was primarily a language of invented words and "illogical" combinations of sounds used by many of the Russian Cubo-Futurist poets during the 1910s. But for Malevich the bridge to Suprematism in all its aesthetic forms was *zaum,* and he argued for a *zaum* of musical instruments as well as a *zaum* of poetry and a *zaum* of painting.[10] Music, poetry, and painting were linked inextricably in *Victory over the Sun,* and Malevich emphasized this union in a number of works from the period, such as the

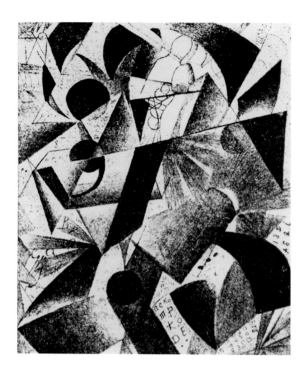

illustration for *Troe* (The Three) of 1913 (fig. 48), in which random notes, letters, and forms float in total disaccord.

Seen in this context, the grand piano about to crash and spill its cacophony upon the painter, poet, and musician is a clear symbol of their effort to dismantle the old artistic conventions and discover the primal sound that the Russian Cubo-Futurists were seeking. But there is another element that prompted Malevich to regard sound, music, and spoken language with particular interest, and this in turn should be looked at in the context of the Symbolist movement out of which he grew. This was the element of rhythm in melody and syntax. Poets such as Andrei Bely, Alexander Blok, and Viacheslav Ivanov saw rhythm as the vehicle that interconnected phenomena and processes that might seem disparate but essentially are not. Malevich wrote in his essay "Futurism-Suprematism" of 1921: "In reality everything exists in the world; there is nothing that can exist independently. Nature's perfection lies in the blind, absolute freedom of units that exists within her."[11] Rhythm could convey the innate harmony and integration of this "absolute freedom of units"—weather patterns, the cycle of seasons, the oscillations of the ocean, and the spirals and circles of crystals, shells, and fossils. These were the constants of natural beauty that Malevich remembered from childhood and evoked

СУПРЕМАТИЗМ

in his early and late paintings: "Night and day, that interchange really excited me; storms . . . and the complete stillness afterwards."[12]

Clearly, Malevich was aware of the intellectual meanings of rhythm through the many discussions and demonstrations in Moscow and Saint Petersburg of rhythm, rhythmics, and eurhythmics and because of the great enthusiasm for Wagner and Nietzsche. This interest in a continuum of movement coincided with Malevich's own search for an artistic lightness, free of concrete imagery—kinetic and, perhaps, ultimately invisible. He praised Velimir Khlebnikov and Kruchenykh for pursuing the same freedom in their experimental poetry: "They have set themselves the task, analogous to painting, to bring the poetry of the word out of practical realism, make it an end in itself . . . to build a poem not out of the utilitarian words of practical objective realism, but create verse out of poetic rhythm."[13] Malevich's awareness of this rhythmic element and his treatment of the theme were crucial to his artistic worldview, and they relate directly to his concern with language in general and *zaum* in particular. In his essay "On Poetry" he wrote: "There is poetry in which pure rhythm and tempo remain as movement and time; here rhythm and tempo rely on letters like signs containing this or that sound."[14]

That Malevich was drawn to sound and rhythm

as media of artistic expression is evident not only from his concrete activities, such as his contribution to *Victory over the Sun* and to the Suprematist ballet directed by Nina Kogan in Vitebsk in 1920, but also from his many theoretical investigations. In this respect, a statement that he included in his tract "There Exists in Nature," of 1916–1917, is especially important: "A painting should not be looked at just from the viewpoint of color, but it should be seen and heard, inasmuch as in the structures of objects and nature we introduce sound, color, and volume."[15] This statement contains several ideas that help us to understand Malevich's peculiar attitude toward language, pictographs, ideograms, and *zaum,* and, in turn, his use of non sequiturs and verbal games in his own pictures. Two examples are the scattered letters (in Cyrillic) "K YA SG A" in *Warrior of the First Division, Moscow* (see cat. 39) and "ASKoTRKODE" and other combinations of letters in the illustration for *Troe.* Encouraged in his pictorial use of letters of the alphabet by the work of the French Cubists, Malevich also investigated a further dimension of sound with particular significance for him— stimulating the spectator to hear as well as to see the painting.

Malevich used and analyzed verbal language as a system or conglomeration of "sensible" or "nonsensical" sounds; as a written, pictographic medium; and as a vehicle of propaganda for communicating both concrete and abstract ideas. Judging by the thousands of pages that Malevich wrote in the form of books, articles, autobiographies, diary entries, and manifestos, the third category— language as sermon and oration—was particularly important to him. Yet a curious aspect of all his linguistic convolutions is that they rarely describe or comment on the artist's pictorial work.

In spite of Malevich's occasional references to the *Black Square* of 1915 and his explanations of the *arkhitektony*—his experimental architectural models—the pictures he painted are conspicuously absent in his written texts. Nor does a reading of the essays clarify the meaning of the paintings. It is as if the essays were written in spite of, or counter to, the visual works. A case in point is Malevich's introduction to the album *Suprematizm. 34 risunka* (Suprematism. 34 Drawings) (Vitebsk 1920 [1921]) (fig. 49). His text seems to have very little in common with the black-and-white geometric compositions of squares and circles that follow. On this level,

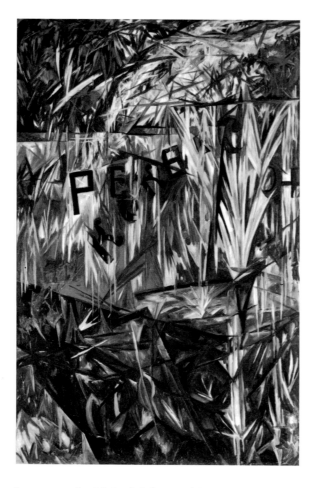

Figure 50

Natalia Goncharova,
Rayonist Fountain, ca. 1912
Oil on canvas,
55 1/8 x 34 3/8 (140.6 x 87.3)
Collection of Sam and
Ayala Zachs, Jerusalem

language for Malevich is a vehicle of persistent persuasion, but not of direct explanation, and perhaps for this reason many of his statements resound as utterances from the Old Testament:

> And his creative [force] arose to its full stature, with an entire lava of colors

or

> And through the desert he will come unto the people and the people unto him[16]

Like a priest or politician, Malevich provides vivid metaphors for abstract entities—from his recurrent motif of the "world of meat and bone," meaning "the material life"; "grub," as a noun and adjective meaning "everyday"; to "skull," meaning "human capacity for thinking." Such words and phrases were part of Malevich's own mix of Ukrainian, Russian, and Polish, rough and ready, rural rather than urban. Often this mix was too stenographic to express complex philosophical ideas clearly. The result is an "adolescent" language of mixed

metaphor, deliberately misused adjectives, and incomplete figures of speech that often turn the text into a juggling act and verbal game.

Whether Malevich's language succeeds or fails as sermon is almost immaterial, because its phonic and pictographic aspects are much more important. His introduction to *Suprematizm. 34 risunka,* for example, may be oblique and "irrelevant" to the images that follow, but visually it is a remarkable picture of black-and-white contrast, of written sentences interspersed with hieroglyphic and geometric forms. These four pages of "aestheticized crossings-out" illustrate Malevich's conviction that "all words are only distinguishing signs and that's all"; and that "man began to cognize the world . . . by composing signs."[17]

In other words, for Malevich the sign was useful not necessarily because of some approximate and perhaps fortuitous "meaning," such as "table" denoting a particular piece of furniture, but rather because of its "look"—the tension between black script and white page, ideogram and pictograph, vision and sound. The black oblongs and squares that interrupt the syntactic and grammatical structures of *Suprematizm. 34 risunka* and *O novykh sistemakh v iskusstve* (On New Systems in Art), seemingly applied as erasures of errors, take on the role of pictographic accompaniment to the "melody" of the text. This same kind of counterpoint is seen in some of the Cubo-Futurist paintings and drawings such as *An Englishman in Moscow* (cat. 38) and *Aviator* (cat. 37). Both of these were shown at *The Store* exhibition in Moscow, in 1916, under the heading "Alogism of forms." In these pictures, fragments of a comprehensible text (for example, "PARTIAL ECLIPSE") resound against an irrational plane of images (spoon, top hat, scissors). Often the sound element of the letters is also irrational, such as the scattered and "meaningless" "K YA SG A" in *Warrior of the First Division, Moscow,* or the floating "O," "S," and "2" that undermine the logic of "APTEKA" (pharmacy) in *Aviator.*

Malevich was not alone in this linguistic-pictorial game. Many examples can be found in concurrent works by Natalia Goncharova, such as *Rebus; Rayonist Fountain* of about 1912, (Sam and Ayala Zachs, Jerusalem; fig. 50), Mikhail Larionov's *Spring* of 1912 (Tretiakov Gallery, Moscow), and Olga Rozanova's *Nonobjective Composition* of 1914 (Russian Museum, Leningrad; fig. 51). At this stage, Malevich's orchestration is close to Kruchenykh's

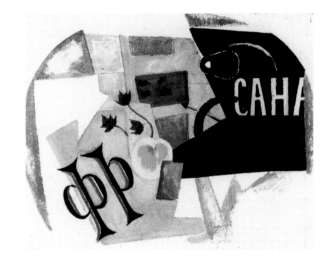

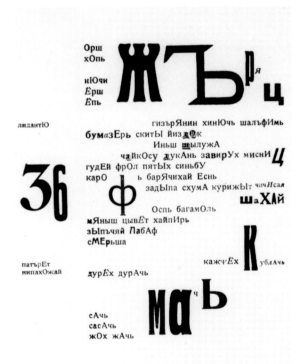

and Ilia Zdanevich's emancipation of words on the pages of their booklets, such as *Vzorval* (Explodity) and *Li Dantiu faram* (Le-Dantiu as a Beacon) (fig. 52). All are engaged in creating *zvukopis,* or "sound painting," a vibrating texture that critic Waldemars Matvejs (Vladimir Markov) termed the "noise" emitted by the surface of the work of art.[18]

Not surprisingly, Malevich was drawn to the *zaum* proposed by Khlebnikov and Kruchenykh in 1913 and elaborated throughout the decade. The third category of *zaum* that Kruchenykh described in 1921 especially attracted Malevich:

> III. Random *(naobumnoe)* (alogical, the casual, the creative outburst, the mechanical unification of words: slips of the tongue: misprints, lapsus: in part, this accommodates phonic and semantic shifts, national accent, stuttering, lisping, etc.)[19]

The spontaneity and "misprints" of this random language enabled Malevich to bewilder and mislead the viewer of his alogical paintings and drawings. His favorite device was to impose a word, or fragment of a word, or a letter on the picture, to short-circuit and contradict the apparent visual meaning. On a drawing of 1914–1915, he wrote, "How brazen"; on the famous square within a square for *Victory over the Sun,* he wrote, "Stupid" (cat. 115); and on what seems to be a store signboard for a fishmonger, he wrote, "Tailor."[20] Malevich's exposition of what he called the "logic of *zaum*"[21] and his conscious application of this kind of visual-verbal bluff extended the sentiments that he, together with Kruchenykh and Matiushin, expressed in their declaration of July 1913: "We proclaim the right of poets and artists to nullify the clear, limpid, noble, sonorous Russian language."[22]

At exactly the same time Larionov and his colleagues (Goncharova, Mikhail Le-Dantiu, I. Zdanevich) were propounding their Rayonist language based on similar explosions. Their miscellany *Oslinyi khvost i mishen* (Donkey's Tail and Target), also published in July 1913, contained several experimental poems that operated with the same principles of *zaum* as those of Kruchenykh. Anton Lotov's "Melody of an Oriental City" and A. Semenov's "ADN AK" are examples.[23] To these we might add the parallel publication of Lotov's collection *Rekord* (Record), with its poems composed of "verses, musical notes, and drawings."

Figure 53
Kazimir Malevich,
Arithmetic, 1913
Lithograph inserted
between cover and first
page of booklet
Let's Grumble
Saint Petersburg: EUY

The first line of one of these, "Street Melody,"
contains only eight silent letters (the Russian hard
sign). The poem continues:

Oz zzz zzz o
Kha dur tan
Esi Esi
Sandal guessed
Si Si
Pa
Ni ts [24]

Another is L. Frank's "Recollections":

Es ver veri
Kalma veri
Pakili. . . . !?!
Furmanton,
Argantili.
Pshekoshi
Ai, ai, ai, ai, ai, ai, ai . . . !
O, o, o, o, o, o, o,
P
Polikali, polimeli, they led, they sang
Tryn, bryn, bryn, tryn
Shpok!!! . . .
Why were you sitting in the armchair the
wrong way round? [25]

Whatever the hostilities between the first champions
of *zaum* in Saint Petersburg—Kruchenykh, Malevich,
Rozanova—and Larionov, Le-Dantiu, I. Zdanevich

in Moscow, and whatever their mystifications, the
divisions fell in the early 1920s, when Goncharova,
Kruchenykh, Larionov, and Igor Terentiev all used
the term "transmental" to describe their activities.

While Malevich the painter tried to create a pic-
torial equivalent to the new poetry, subtitling key
works of 1913–1914 "alogical," or calling them
zaumnyi realizm (*zaum* Realism) as he did at the
Union of Youth exhibition in Saint Petersburg, he
also wrote *zaum* poetry himself, as did Pavel
Filonov, Rozanova, and Varvara Stepanova.[26]
Some of the inscriptions in Malevich's paintings
and drawings can be read almost as *zaum* poems,
such as "A 7 I," in the lithograph called *Arithmetic*
(fig. 53). Still, Malevich used *zaum* in an eclectic
manner, combining the methods of Khlebnikov
(reducing roots and applying prefixes and suffixes
to create "legitimate" neologisms), Kruchenykh
(zvukopis), and Konstantin Bolshakov, Vasilii
Kamensky, Lotov, and I. Zdanevich (using both
real words and meaningless sounds). Malevich
describes these three methods in "On Poetry":
"There is poetry in which the poet describes a piece
of nature, adjusting it to the rhythm blazing within;
there is poetry in which the rhythm gratifies the
form of things. There is poetry in which the poet
destroys objects for the sake of the rhythm, leaving
behind fragmented pieces of unexpected juxtaposi-
tions of forms."[27] For example, Malevich seems
to have used pure *zaum* in his illustration to *Troe,*
quoted above. But more often than not he used
combinations of words and nonwords, such as
"African gr. U 25 V R OB [illegible] NA APART-
MENT THEVENOT came apart without" (cat. 40).
All these linguistic experiments were made in late
1913 and 1914, just before and after Malevich
collaborated with Khlebnikov and Kruchenykh on
Victory over the Sun.

It was clearly a short step from these word
combinations to Malevich's own interpretations
of *zaum* poetry:

I go
U el el ul el te ka

or

Kor re rezh zh me kon
Ikanon si re duel
Milo

or

Ule Ele lel li [28]

Figure 54

Boris Ender, *On Zaum,*
1924
Cover for Alexander
Tufanov, *On Zaum*
Petrograd

In his eulogy of *zaum,* published in 1918, Kru-
chenykh even included Malevich and Rozanova
among the eight primary practitioners of the new
medium.[29] This indicates that Malevich was writ-
ing such poetry before the first publication of his
verse in "On Poetry" and *On New Systems in Art* in
1919. He was creating his "Universal Landscape,"
just as Kruchenykh was establishing his "Universal
Poetic Language."[30]

Once again we return to the image of the grand
piano suspended above Malevich's head. Acci-
dentally or not, the image of a piano rather than a
phonograph or a music box also has a direct rele-
vance to Malevich's ideas on surface sound. The
piano, as a manual musical instrument that depends
on human interaction, produces a "natural" sound
guided by the gesture, breathing, mood, and gen-
eral physical attributes of the player. Just as
Malevich painted paintings and did not photograph
or make movies, so he listened to natural sound,
"to the storm . . . there was another impression—
more of a musical one".[31] This was the "free music"
that Kulbin advocated: "Light, thunder, the whistling
of wind, the rippling of water, the singing of birds."
Malevich, however, also recognized the usefulness
of processed, recorded sound. Along with Ivan
Kliun, Kulbin, and Matiushin, he understood that

the phonographic system was an invaluable tool
for the storage and retrieval of archival sound. He
implied this in his lecture on nonobjectivity at the
State Institute of Artistic Culture (GINKhUK) in
Leningrad in 1926 when he praised Thomas Edison,
adding that it was now impossible to return to the
pre-Edison epoch.[32]

Malevich's interest in sound recording as docu-
mentary registration (but not as true "culture") was
encouraged further by his contacts with the poet
and dramatist Terentiev and the poet and linguist
Alexander Tufanov at the Museum of Artistic
Culture/GINKhUK in 1923–1926. Matiushin and
his pupils, not least, Boris Ender (see fig. 54),
"researched the potentials of the human organism—
touch, hearing, sight, the back of the neck, atten-
tiveness, thought."[33] There, too, Malevich "decreed
the opening of a Department of Phonology," collab-
orating with Mikhail Druskin, Terentiev, and others.[34]
Although GINKhUK was closed before the depart-
ment or laboratory was established formally, a
number of important experiments were undertaken.
Tufanov's study of *zaum* and phonemes—the par-
ticular sounds that distinguish a given language—
was a direct consequence of his work there.
Although in his published volume, *K zaumi* (On
the Question of *Zaum*), Tufanov did not refer to
Malevich directly, he seems to have had Suprema-
tism in mind. After all, Tufanov's "palette of
morphemes" (the linguistic elements that indicate
grammatical relations) and attempts to create a
"special birdsong" were reminiscent of Malevich's
floating letters and verbal fragments: "From pho-
nemes, colors, lines, tones, noises and move-
ments we will create a music, incomprehensible in
the sense of spatial perceptions, but rich in its
world of sensations."[35]

Malevich's collaboration with Terentiev and
Tufanov in his analyses of sound in the mid-1920s
is important to us, because it helps explain the ulti-
mate phase in Malevich's artistic development—
his obvious interest in the language of the absurd.
Not by chance did the last representatives of the
avant-garde, the Oberiuty (the acronym of the
Leningrad group of absurdist writers led by Daniil
Kharms), hold Malevich in such high regard, dedi-
cating poetry to him and mentioning him in their
manifesto of 1928. Kharms, in particular, seems
to have been drawn to Malevich's worldview,
especially in his formulation of the "fifth meaning"
of the object:

Every object . . . has four working meanings and a FIFTH, quintessential meaning.

The first four are: 1) the graphic meaning (the geometric meaning), 2) the meaning of the purpose (the utilitarian meaning), 3) the meaning of the emotional influence upon man, and 4) the meaning of the esthetic influence upon man.

The fifth meaning is determined by the very fact of the existence of the object. This meaning lies beyond the connection between man and the object and serves the object itself. The fifth meaning is the free will of the object.

The fifth meaning of the cupboard is the cupboard. The fifth meaning of running is running.[36]

The parallel with Malevich's so-called fifth dimension (economy), with its rejection of the aesthetic condition and controlled time, is very striking here.[37] Perhaps Malevich's late Suprematism, with its "pure un-knowledge" (the dismissal of all mechanical knowledge) and "white idea," is the pictorial counterpart to Kharms' "immanent idea of the objective world."[38] Furthermore, Malevich not only painted "NONSENSE from the human point of view" but also wrote "nonsense": "I too am but a stair"; "clouds do not look like buckets of water"; "paintings the contents of which are not known to the artist"; "you left your purse in the tram"; "flights for the pen."[39] Such absurdist turns of phrase must have appealed to the Oberiuty, even though they felt that *zaum* had already fulfilled its purpose and was passé as an artistic method.

Just as the Oberiuty held that "no school is more hostile to us than *zaum*," so, in his late paintings, Malevich introduced a sensibility very different from that of the earlier alogical works.[40] His portraits and landscapes of about 1930 reflect the incongruous imagery of the Oberiuty. Like the people in Kharms' stories, Malevich's people often lack faces and limbs; they move outside of time and inhabit an eerie silence. Like the grand piano of 1913, they defy gravity and the sound of their language has been suspended, but their brooding violence and supernatural force are about to release the terrifying energy of their frenzied words.

A STUDY OF TECHNIQUE
TEN PAINTINGS BY MALEVICH
IN THE TRETIAKOV GALLERY

■ Milda Vikturina and Alla Lukanova

During preparations for the Malevich exhibition held in Leningrad, Moscow, and Amsterdam in 1988–1989, the first comprehensive technical examination was made of Malevich's paintings in the Tretiakov Gallery. This study of the paint layers of the artist's work was designed to yield a preliminary description of his painting method. The examination utilized a binocular stereoscopic microscope (MBS-2), filtered ultraviolet rays, x-rays, and special photography. Classification of this data should prove useful in determining several dates about which there is no consensus of opinion in either Western or Soviet literature. For a broader understanding of the artist's creative method, the investigators turned to two major writings by Malevich: *From Cubism and Futurism to Suprematism* (1916) and *From Cézanne to Suprematism* (1920).

After passing through the developmental stages of modern painting from Impressionism to Suprematism, Malevich returned to figurative painting toward the end of his life. The Malevich Collection in the Tretiakov Gallery includes works from each of these periods. The pictures examined in this study were divided into four groups, based on their stylistic characteristics and not on their dates:

Works of an Impressionist character:
Spring: Garden in Bloom, 1904, oil on canvas, no. 10611;
Sisters, 1910 (1930?), oil on canvas, no. 22005;
Landscape near Kiev, 1930, oil on canvas, no. p.46860.

Paintings in the Cubo-Futurist style:
Through Station. Kuntsevo, 1913, oil on wood, no. 11926;
Vanity Case, 1913, oil on wood, no. 11927;
Portrait of the Composer M. V. Matiushin, 1913, oil on canvas, no. p.46725.

Suprematist works:
Black Square, 1914–1915, oil on canvas, no. 11925;
Woman with a Rake, 1928–1932 (1915?), oil on canvas, no. 22571.

Later figurative canvases:
Girl with a Comb in Her Hair, 1932–1933, oil on canvas, no. 20843;
Girl with a Red Staff, 1932–1933, oil on canvas, no. 22570.

In the course of his career Malevich worked in many different styles, although he was concurrently developing his own pictorial language. Many questions arise in this connection. Which painterly means did Malevich use during various artistic periods to create both his representational and his nonfigurative compositions? Did he use academic painting methods to build up the paint layers? If so, how did the old and new principles relate to each other, under which circumstances, and to what degree? Where did the search for new technical devices lead? How were Malevich's creative experiments carried out, and what was their artistic effect?

The analysis of the first group of paintings revealed a conventional Impressionist painting technique in the direct *(alla prima)* application of the paint on the white ground and in the building of form and volume through color. A single paint layer is for the most part extremely opaque, and a predominance of light blue and white add to the effect of shimmering luminescence. While there is no underpainting in any of the three pictures, fragments of preliminary sketches were revealed.

Spring: Garden in Bloom differs significantly from the later *Landscape near Kiev* in the way in which the artist used painting materials (figs. 55, 56). The painted surface of *Spring* has a complex, opaque structure. Malevich used large quantities of oil paint on his brush and allowed the pigment to dribble downward and form a sharply peaked ridge or "spine" along the edges of the brushstroke. The alternation of thickly and thinly painted areas with no evident surface relief intensifies the luminescence of the surface as does the grain of the canvas, which shows through the thin paint.

Special surface photography isolated and defined the characteristics of the artist's brushwork (figs. 57, 58). An x-ray of the paint layer illustrates more clearly the arrangement of the brushstrokes, which are characteristically vertical and end in a quick

Figure 55

*Spring: Garden in
Bloom,* 1904
Oil on canvas,
State Tretiakov Gallery

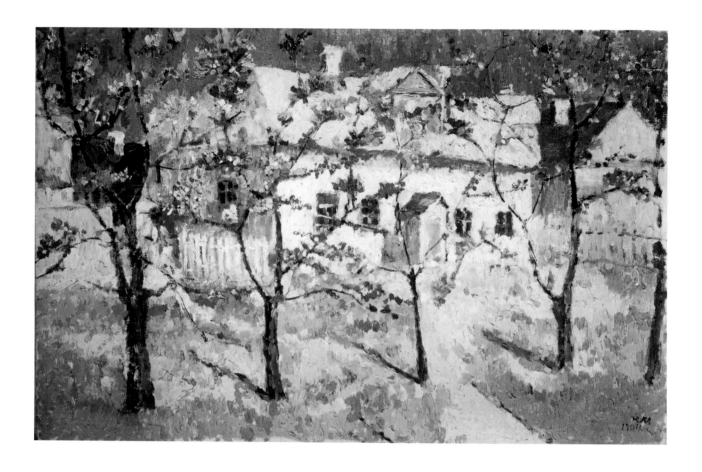

Figure 57

Spring: Garden in Bloom
(detail)
Special surface
photography

Figure 58

Spring: Garden in Bloom
(detail)
Special surface
photography

Figure 59

Spring: Garden in Bloom
(detail)
X-ray photograph

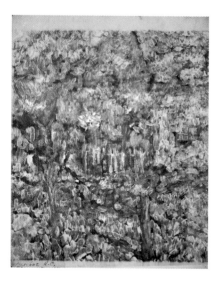

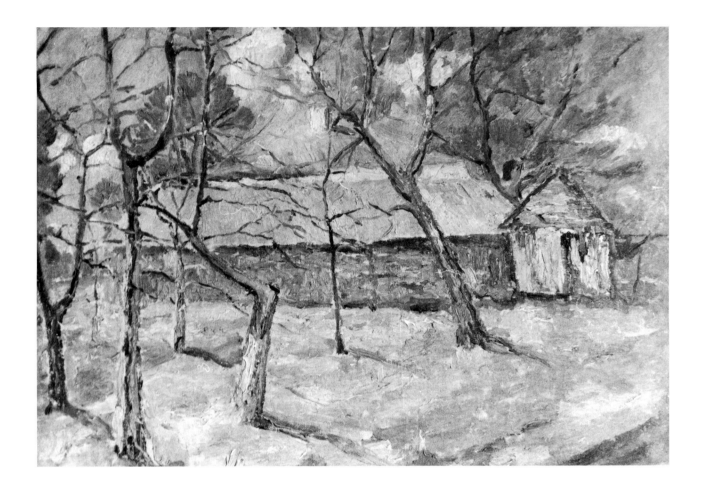

Figure 60

Landscape near Kiev
(detail)
Surface photography

Figure 61

Landscape near Kiev
(detail)
X-ray photograph

Figure 62

Sisters, 1910
Oil on canvas, State
Tretiakov Gallery

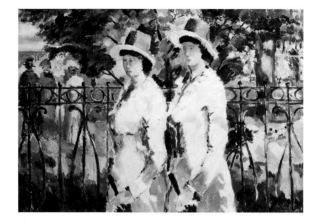

Figure 63

Sisters (detail)

Figure 64

Sisters (detail)
X-ray photograph

lift-off of the brush (fig. 59). Most of the brushstrokes follow the same direction, establishing the forms of the sloping roofs and the whimsically angled tree trunks.

In the early 1930s Malevich returned to a similar technique in *Landscape near Kiev.* Its dynamic surface structure is achieved by brushstrokes of different sizes, directions, and degrees of opacity (fig. 60). There is a greater lack of inhibition, more variety, and a painterly boldness in the movements of the artist's brush. The hand of the mature master who had refined Impressionist techniques can be seen here. A departure from Impressionistic coloration is seen, too, in the stronger resonance of colors. The paint contains a greater amount of lead white, which subdues the picture's overall key and produces high contrast in the x-ray (fig. 61). The expressive final brushstrokes and the preliminary painting and coloration do not lend the flickering Impressionist quality that characterizes *Spring.* During the time between these two works Malevich had mastered new painting devices, and thus *Landscape near Kiev* can be considered a painterly *reflection* of Impressionism.

An interesting example of a transitional stage in Malevich's creative work is the *Sisters,* which the investigators have dated 1910 (fig. 60). On the reverse of the canvas the artist inscribed: *"Two Sisters* was painted during Cubism and Cézannism [crossed out: "Two sensations"] under the strong feeling of Impressionist painting (during work on Cubism), and so as to free myself from Impressionism, I painted this canvas. K. Malevich. 1910. Paint[ed] the canvas in 4 hours."

On the art of the first decade of the twentieth century Malevich wrote: "Art that interprets the world according to a classical relationship is finished," and the "fundamentals of Cubism" are being established.[1] He considered Cézanne the moving force behind this innovation in painting. The range of color effects in the *Sisters* corresponds to that of Impressionist technique. Opaque layering of the paint creates a rich and varied surface texture (fig. 63). Malevich first organized areas of color by applying several strokes in one direction. Then adjacent to them he worked color areas with analogous but opposing brushstrokes. Blue sky, emerging through the treetops, further breaks up the brushstrokes, producing the effect of leaves fluttering in the shimmering air. In places, the primed canvas shows through, effacing the contours of

details and intensifying the picture's airiness. The multicolored reflections of light on the white dresses of the women and the shadows, composed of black mixed with white applied without smooth gradations, counter the volumes of the drapery folds. The modeling of the form is unconvincing compared to academic conventions of modeling: the x-ray confirms that the women's faces are painted in a thin layer of light ocher with highlights worked in an opaque ocher mixed with a large amount of white. The character of the opaque layers and the directions and shapes of the brushstrokes are clearly differentiated in the x-ray (fig. 64).

Malevich first painted the figures of the women and then the azure park fence; next, he painted the treetops; and, finally, by altering the color harmony, he rendered the background plane in an abbreviated perspective. Figures, treetops, and background are represented in diverse, parallel planes that contrast but do not interact. This coincides with Malevich's appraisal of Cézanne's system: "He [Cézanne] through form gave the sensation of the movement of forms toward contrast."[2]

Fascinated by Cézanne, Malevich strove to break away from the grip of representational art. In older painting "there was no attempt to resolve the tasks of painting as such, without any attributes of real life. There was no realism of the painted form and there was no creation."[3] Cubism showed the way for Malevich's abstract art.

The concern for tradition, the search for artistic sources, and the discovery of new paths through an understanding of earlier art were not rare in twentieth-century culture. In his stylistic innovations Malevich relied to a great extent on academic painting technique. Just as Leonardo da Vinci ascribed great significance to pigment and surface relief ("the soul of painting"), so Malevich in his theories and practice consistently emphasized that "the most important elements in painterly creation are color and texture: these are the essence of painting, but this essence has always been annihilated by the subject."[4]

Analysis of the three Cubo-Futurist pictures showed that in his approach to the new painting, Malevich made wide use of academic painting techniques. He understood the law of complementary colors and followed it in his organization of colors, taking into account the property of pigments to reflect or absorb light. The structure of each painted surface is directly dependent on the color

of the pigment; that is, Malevich was in part true to the old rules of oil painting. A study of the paint layers of *Vanity Case, Through Station. Kuntsevo,* and *Portrait of the Composer M. V. Matiushin* confirms this (see cat. nos. 31, 30, 33).

Concerned with space in painting, the Cubo-Futurists stressed the disintegration of forms almost to the point of making the object disappear. To achieve "pictorial contrasts," "nature was brought to abstraction, to the geometric simplicity of volumes."[5] Thus the combination of planes in space became the primary concern.

Malevich began his picture, on canvas or on wood panel, with a preliminary brush drawing to establish his original idea, determining the sizes and boundaries of the planes and geometrical units as well as their placement. As he developed these elements in color, he left the drawing incomplete in some areas. He then reestablished it directly onto the paint layer with a contrasting color, reaffirming in a sense the outline of the original drawing. These drawing variations can be seen in the portrait of Matiushin.

The development of Cubism in combination with Futurism meant interrelating the shapes that resulted from Cubist disintegration of the object, produced by the dynamics of movement, with proportionate areas of color, shaped according to their imagined movement around a central axis. For Malevich, this axis is the artist or viewer. The act of painting "blossoms" before the artist or viewer with colored surfaces composed of mixed tones and local color.[6] The artist physically senses color. "Painting is paint and color. It is within our organism My nervous system is colored by them. My brain burns with their color. . . . Colors have matured, but their form is not mature in the consciousness."[7]

To achieve the necessary color effect, Malevich constantly referred to the law of complementary color. Typical for him was the juxtaposition of red and green areas. Placed next to each other these complementary colors acquire the highest degree of brightness and lushness. "Differences are thus resolved, so as not to weaken the others but, on the contrary, to express their form and surface texture even more brilliantly. For this purpose not sameness but contrast is sought."[8]

During work on the *Portrait of the Composer M. V. Matiushin,* Malevich also explored new tonal effects of color in order to change color resonance.

Figure 65

Portrait of the Composer M.V. Matiushin (detail)

He resorted to a painterly device known to Leonardo, who wrote that when a transparent color "is placed on top of another, the individual colors are not altered, but a mixed color, different from each of its factors, is formed."[9] Following this principle, Malevich painted some of his shapes twice. Covering an area rather opaquely with red or violet, he then gave the same area a thin, transparent layer of black. While the black layer dulls the brightness of the red and violet, these hues, filtered through the black layer, acquire an extraordinary, mysterious resonance.

Other interesting devices in Malevich's painting technique were revealed by this study. After making the preliminary drawing, for example, Malevich covered large shapes with the same color. Then, to destroy the unity of the shapes, he usually changed the color. Dividing a large shape into smaller fragments, he painted the fragments with different colors. In the portrait of Matiushin, parts of the light ocher area are covered with yellow, green, and black pigments. Malevich treated other paintings in this group similarly.

In each of these three Cubo-Futurist paintings, there are "whitened" and "darkened," or "eclipsed," colors. "Whitened" tones are created by adding white pigment, which dulls color intensity as it increases reflectiveness. This device was known to the artists of the Realist school, but Malevich used it in his own way. In accordance with traditional oil painting, all elements in his pictures painted in "whitened" colors have a rich surface texture. Gradually washing out the local color along the edges of one of the shapes, he finished the section with pure white, which creates the effect of uneven lighting (see detail, fig. 65).

The lush "colored-shadow" range seems to build the form and model conventional volume. In this way, a so-called shadow is denoted by a primary color, with the gradual transition to a maximal light value conveyed by a highly whitened color and pure white. The brushstrokes in these instances are small and structural. In traditional painting technique, surface relief is raised in proportion to the lightness of the pigment. When Malevich added a dark tone to light colors, he significantly raised the relief made by the brushstrokes, and their vertical and horizontal directions can be seen clearly. In his Cubo-Futurist paintings Malevich used "darkened" colors abundantly, adding black pigment to the light primary colors. When a value range was

required, he conveyed deep "shadow" with black and maximal "light" with a pure primary color. In this way he achieved a gradual transition from "shadow" to "light." The paint surface generally is not very textured, but black paint applied in a thin layer does not always lack surface texture. In these paintings several small areas covered with a thin layer of black are interspersed with rather opaque, shiny ridges, giving the black areas a certain radiance.

Despite the wide range of color, Malevich's paintings retain a definite tonality. Areas rendered in diverse brushwork imbue the surface with an unusual play of "light," and the small areas of unpainted ground with buoyancy and animation.

In his manifestos Malevich strongly emphasized surface treatment: "Cubism, besides its constructive, architectonic and philosophic content, had various forms of surface treatment."[10] His Cubo-Futurist paintings exhibit many kinds of surface treatment: enameled, rough, lacquered, and mat surfaces; surfaces incised with lines made by the brush handle; and raised or relief surfaces. All were used, he wrote, "to achieve the rhythm of Cubist surface and form and the constructive unity between the elements of descriptive pictorial form," adding that "not everything painted in oils is pictorial."[11] For this reason, objects are indicated by means of areas of painted color. In *Vanity Case* (cat. 31) there is an "illusionistic panel with pronounced, layered details."[12] An almost geometrically correct rectangle is achieved with a thick layer

Figure 66

Vanity Case (detail)
Pictorial relief made by
applying pigment directly
from the tube

Figure 67

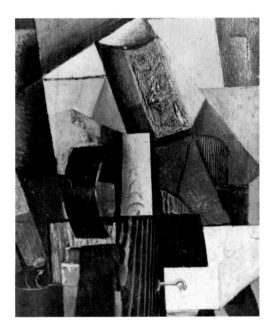

of ocher applied directly from the tube and then spread with a stiff brush on a layer of damp paint, producing a surface with sharp, protuberant brushstrokes (fig. 66). Next to this rectangle is a low, smoothly painted surface. "Any painted surface, transformed into a convex painted relief, is an artificial, colored sculpture, and any relief, transformed into surface, is painting." [13] In the portrait of Matiushin, the hair is painted first in light and dark ocher, and then undulating strands of hair are brushed over the damp paint layer, which gives them higher relief (fig. 67).

Surface texture is treated differently in *Through Station. Kuntsevo* (cat. 30). Here, Malevich put less emphasis on variations in relief, stressing instead new elements and forms characteristic of Futurist construction. To produce a "confrontation of contrasting forms in a picture," [14] he included fragments of a number and a complex, pale blue, curved line—an inverted base clef or a question mark—the lightest detail in the painting.

Examination of the paint layer in this group visually confirms his idea that "Cubist constructions... while overthrowing the repetition of forms and surface treatment, strive for economy" and lead to the recognition of new painting rules. [15]

In 1915 Malevich proclaimed Suprematism the highest and final stage in the development of the newest art. In the *0.10. Last Futurist Exhibition.* he exhibited the first Suprematist works, accompanied by a manifesto presenting the theoretical

foundation of his discoveries. "I have destroyed the ring of the horizontal and have emerged out of the circle of things." [16] Suprematism for Malevich was a stage in crossing the Rubicon of traditional artistic systems. Cubo-Futurism, which preceded it, pointed out the dynamics of the painted surface, forms, and color. Malevich went further in developing these principles, arriving at a painting style in which form and color dominated content and objects, becoming ends in themselves.

Black Square is Malevich's most significant Suprematist canvas (figs. 1, 68). In the minds of his contemporaries this painting acquired the force of a magical formula, and to this day it continues to envelop our consciousness with enigmas. "Within the square of the canvas is a square," Malevich told his student Kurlov, "depicted with the greatest expressiveness and according to the laws of the new art." In this canvas, Malevich "depicted only a square, perfect in expression and in relation to its sides; a square that does not have a single line parallel to the geometrically correct square canvas and that in itself does not repeat the parallelness of the lines of the sides. It is the formula for the law of contrast, which exists in art in general." [17]

An analysis of the paint layer of *Black Square* provided answers to many questions. Immediately apparent are the variations in the craquelure on the black field. The larger crevices are easily identified with the unaided eye, while others are barely visible. At the same time, along the perimeter of

the black square a band roughly 4.5 centimeters wide can be traced, which has no coarse craquelure. Substantial crevices in the black field of the square are confined to specific areas: there are more in the upper section of the square and fewer in the central and lower areas. Light blue, red, dark blue, yellow-green, pink, and violet pigments are visible through the coarser craquelure.

The white area bordering the black was painted after the black square was finished. In the white area the artist's brushstrokes can be seen clearly, as well as his fingerprints in several places. Brushstrokes ending in festoons are evidence of his rapid brushwork. In places, the white pigment has been lost. Between the brushstrokes, under a thin layer of white pigment, various colors are visible: green, dark blue, rose, red. This preliminary paint layer most likely covered the entire surface of the canvas.

Under a binocular stereoscopic microscope, pale traces of dark letters are visible under the layer of lead white in the upper right corner. These letters probably formed an inscription on the underlying composition.

Under normal light conditions as well as under reflected ultraviolet rays, small patches can be discerned along the lower edge and in the upper left corner of the black field. Under normal light these areas take on a brown tinge and a lacquer shine, and under fluorescent light they appear violet. In 1937 Alexei Rybakov, a specialist in painting technology, explained this as follows: "As a result of technical violations, the *Black Square* fell into such a state of disrepair during its first decade of life that the master was forced to repeat his 'authorial brush'".[18] It is entirely possible that these areas are nothing more than the artist's corrections in places where the upper layer of color had been destroyed. Corrections were made in black paint on a layer of pigment thinned with varnish. This altered the color, while the varnish imparted a shine to the restored areas.

It is apparent now that the condition of the paint layer of *Black Square* was caused less by "technical violations" than by poor binding between the thin, corrective layer of black paint and the rather thick lower layer of paint. In areas where the brushstrokes of the lower layer are thickest, the relief created by the brushstrokes emerges in some places through the top layer of black paint, creating a coarse craquelure. In areas of the lower layer where the paint is thinnest, it is difficult to discern crevices in the black paint.

The specific nature of the craquelure, paint layer textures, and complex relief results from the presence of two or more superimposed paint layers (figs. 1, 68). This strongly suggests that under the "square" lies a completely finished composition, coated with varnish or with pigment mixed with varnish as a medium. This is apparent because of the high surface texture of the dried-out lower paint layer that covers the entire canvas, the coloring of the entire surface of the canvas, and the shiny varnish in the areas of craquelure.

When the canvas is examined under an oblique ray of light, the mat surface areas in the black field

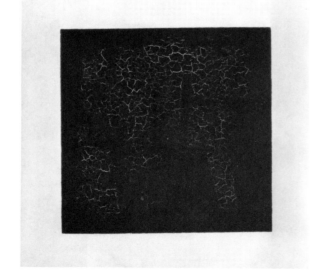

Figure 70

Girl with a Red Staff
(detail)
X-ray photograph

correspond exactly to geometric forms—to a triangle and quadrangle—and to intersecting lines at a distance. And, surprisingly, the edges of the coarse craquelure also conform to the contours of these figures. The relief height of the color in these surfaces differs from the relief height of all the other surfaces on the canvas. The existence of various colors in the craquelure—most of all red, yellow, dark blue, green, violet, as well as light blue and pink—indicates that these colors, as well as the whitened colors, were used as local color in the underlying composition.

Data obtained from visual analyses of the paint surface of *Black Square* support the x-ray image (fig. 69). The geometric planes are very clearly outlined as a result of a delicate black contour line. Individual compositional elements apparently were first blocked in with a brush in a dark color on the paint layer of the lower composition, and then painted over in various colors.

This evidence suggests that a Suprematist composition, or even, in the artist's terminology, a composition of "dynamic suprematism," existed on the layer underlying the *Black Square.* This conclusion coincides with the chronology of Malevich's creative work, as well as with his series of stylistic observations and theoretical statements.

Two figurative images from the 1930s, *Girl with a Comb in Her Hair* and *Girl with a Red Staff,* were analyzed next (cat. nos. 87, 88). True to his already complex technical system, Malevich began work on these canvases with a brush drawing, planning the basic shape of each compositional element. He then completely abandoned the rules of conventional painting. Painting directly on the ground, he omitted the underpainting used by the old masters to help resolve complex compositional problems. The basic color used for the female faces in these images is white, applied in short, structural brushstrokes to model the facial volumes. Freely situated, these brushstrokes are unrelated to the form. Only in one place—on the face of the *Girl with a Red Staff*—are the brushstrokes apparent. They emphasize the smooth sphere of the left cheek and mark the boundary between the face and the background plane. In *Girl with a Comb in Her Hair,* volumetric modeling is completely absent from the masklike, planar face.

In small areas of the face in *Girl with a Red Staff* the brushstroke relief is flattened, an example of the so-called enameled surface. The most highly

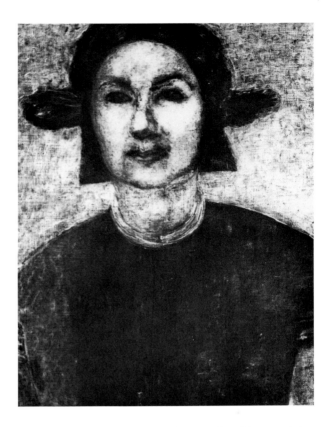

illuminated surfaces of the face—the ridge and tip of the nose, the cheek, and the forehead—are painted according to traditional painting rules for body color. Similarly, the light-colored brushstrokes, applied to a thinner layer of white paint, are not perceived as highlights. Modeling of volumes, seen more clearly in the x-ray, is weak and unconvincing, despite the thin layers laid into the areas of shadow (fig. 70). The varying thicknesses of the white paint layer are also visible in the x-ray. The final brushstrokes separate out the light areas of color and define the shapes and volumes.

When the paint layers were examined under filtered ultraviolet rays, the light areas took on a bluish white color and the lower layer of white pigment a light cream color. This effect seems to be caused by the chemical nature of the pigment. The lower layer is zinc white, which under fluorescent light appears as a cream color; and final brushwork is in lead white, which under ultraviolet rays looks light blue. It is also possible that Malevich covered the lower layer with Cremnitz white.

While the investigation of Malevich's work sequence in *Girl with a Red Staff* was carried out by visual analysis, his painting method in *Girl with a Comb in Her Hair* was reconstructed by

Figure 71

Girl with a Comb in Her Hair (detail)
X-ray photograph

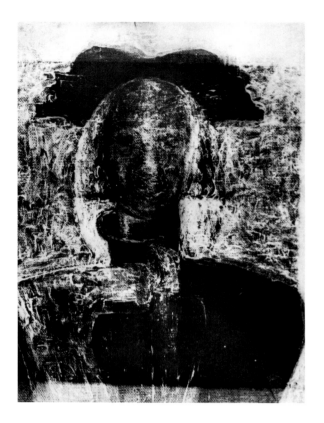

means of x-rays.

The clothing of the figure in *Girl with a Red Staff* reflects a familiar principle of painting: gradually adding white to a primary color here produces a range of tones from red through pink to white. The skirt was painted twice with different colors. Originally, the left half was light blue, corresponding to the color of the sleeve, while the right third of the skirt was black. The lower layers, which show through only in a few places, were then covered completely with a thin layer of green. The background color, painted after the figure was completed, partially covers the contour of the red scarf. A second background coat of paint altered this detail's outline. The background surface is finished with mastic varnish.

In the final stages of work on *Girl with a Comb in Her Hair,* Malevich changed many areas of the portrait, which can be clearly seen in the x-ray. In painting the background, he partially concealed the original contour of the comb and shoulders and altered the hairstyle. At first, the hair was short, but in reworking the background Malevich lengthened the hair to the shoulders. Revisions were also made in the clothing. In the first version, one edge of the left lapel was rounded. This edge was gradually

tapered, and in the final version the edges are straight.

The character of the artist's treatment of the color layer is clearly seen in the x-ray. The paint mixture was applied with a small brush and mastic.

A curious observation was made during a detailed study of the x-rayed layers of a head fragment in *Girl with a Comb in Her Hair* (fig. 71). On the right side of the hair, bent stripes are visible, applied in thin paint. These stripes form a shape similar to the Cyrillic letter "B." On the top of this "letter" are two vertical stripes with an uneven crossbar. As a unit these stripes resemble the Cyrillic letter "H."

This analysis of the painting technique used in the figurative portraits of the 1930s reveals that in these paintings the heritage of academic art has been enriched by Suprematist experience and discoveries.

A visual and x-ray analysis of one of Malevich's Suprematist paintings, which he called "Suprematism No. 6 within the contour of a peasant woman" and is now titled *Woman with a Rake* (ca. 1928–1932), has helped to establish not only his characteristic painting technique but also the precise sequence of his work on compositional elements.

A preliminary drawing, outlined on the thin ground layer, designated each element of the composition. Next, all the planes were covered with local color. The figure was painted first and then the background; in some parts of the background the paint layer is not perfectly contiguous to the figure. After completing the figure, Malevich worked out the architectural elements in wide, opaque, structural brushstrokes.

The figure is constructed of color planes within the contours of the image, with clearly defined edges where the planes meet. The white sections of the head (an oval, divided into black and white halves) and clothing are painted opaquely, with short, painterly brushstrokes that do not conform to the shapes. The woman's right breast is indicated by a descriptive black brushstroke, which was not painted over completely but tempered with white pigment. The black sections of the clothing were painted in thin layers and the red sections have an enamel-like surface with no clearly defined texture. The ground can be seen in the gaps created between the painted planes.

The background is divided into three zones: the top is painted blue; the middle is multicolored; and the ground line is indicated by four stripes of pink, ocher, white, and warm yellow. The buildings are

Figure 72
Woman with a Rake
(detail)
X-ray photograph

placed on a horizon indicated by bands of red, black, and white. The section below is painted green. The figure was executed with wide, textured, horizontal brushstrokes, before the lower and middle sections of the background were painted. The upper section was then painted with brushstrokes applied at random. Varnish, used as a thinner during the repainting of the central area of the light blue background over the woman's head and shoulders, has imparted a luster to this part of the picture, which makes the peripheral background areas appear mat. Where the light blue background meets the architectural landscape, there are additional, noncontiguous, vertical brushstrokes of an even lighter blue. Overpainted background areas function primarily to emphasize the distinct outline of the figure. In the final stage, the rake in the woman's hands was painted with white pigment into a paint layer that had not completely dried. Thus the white of the rake blends with the lower layer of paint in the black section of clothing, without detracting from the picture's color resolution.

X-ray photography reveals that the white paint mixture is worked with small, randomly placed brushstrokes (fig. 72), resembling heterogeneous white mountain ranges. Most of the black areas of the clothing were painted in thin layers, and little ridges of black paint lie on an untextured surface. White pigment is the most opaquely worked, and its color resonance is similar to that of the *Girl with a Comb in Her Hair.*

Malevich clearly strove to forge a new direction in the evolution of painting with his organic system. Not only was he familiar with the academic rules of oil painting and the technology of materials but on several occasions he followed these rules exactly in building up his paint layers. At the same time, he created his own system of modeling volumes and suggesting light. He altered and augmented several canons of oil painting but in no way violated the technique of painting in the works under investigation. Understanding the distinctive features of Malevich's palette and the special traits of his artistic style has significantly enriched our conception of the artist's originality.

Translated from the Russian by Karen Myers

ACQUISITION OF 34 MALEVICH
PAINTINGS BY SOVIET MUSEUMS
1919–1921

■ **Natalia Avtonomova**

Kazimir Malevich's name takes precedence on the list of 143 contemporary artists whose works were chosen for purchase in 1919–1920 by the Purchasing Committee acting for the State Art Foundation created by the Museum Bureau of IZO Narkompros (Visual Arts Section of the People's Commissariat for Enlightenment). In 1919–1920 the Museum Bureau acquired thirty-one paintings by Malevich for a total sum of 610 rubles and three additional works from January to May 1921 for 183,600 rubles (TsGALI [Central State Archives of Literature and Art, Moscow], f. 665, ed.khr.25, 1.14).

In 1919 the departments of Visual Arts and of Museum and Monument Preservation jointly supervised the reorganization of older museums and the construction of new ones, coordinating museum activities in Moscow, Petrograd, and the provincial areas. For this effort the most talented representatives of the intelligentsia were brought together—art historians, museum specialists, and prominent artists. Accepted at a museum conference in Petrograd, in February 1919, was a "Proposal for Museums of Painterly and Plastic Culture." The new museums were to be future centers for contemporary art. As open doors to artists' studios, they were planned for Moscow, Petrograd, and several other cities. Under the auspices of the museum department a special Purchasing Committee was created to select works for the State Art Foundation and distribute them to the newly organized art museums. The museums were given paintings, sculpture, and graphic works representing the varied manifestations of contemporary art. Vasilii Kandinsky chaired the committee, and its members included Natan Altman, Aristarkh Drevin, Robert Falk, Boris Korolev, Alexander Lentulov, and Alexander Rodchenko.

Malevich may well have been aware of the plans for creating the new museums and thus offered his best and most characteristic work to the committee for review. Inventory numbers were assigned to the works selected and values were established by a Tariff Committee. The data was entered in a register, and the works subsequently transferred by deed to various museums throughout the country.

Among the archival materials of the IZO Narkompros are minutes of Purchasing Committee meetings; the Museum Bureau's inventory ledger; photographs of pictures designated for the Moscow Museum of Painterly Culture and the Petrograd Museum of Artistic Culture (MZhK); and a list of the provincial museums organized in 1919 and 1920. Most of the documents cited are at TsGALI. Utilized in the present list were materials from the collection of the Fine Arts Department, Narkompros: f. 665, ed.khr. 5 (1–2), 6 (1–2), 7, 8 (1–3), 9, 13 (1–2), 14 (1–2), 15 (1–2), 17 (1), 19 (2), 21, 23, 25, 29.

These documents contain many inconsistencies in dating and titles. Pictures by Malevich often were titled simply *Cubism* or *Suprematism*. There are also inaccuracies in measurements, which are primarily in *"vershki"* (one *vershok* equals 4.45 cm or approximately 1¾ inches).

In the list that follows, paintings by Malevich are organized in order of registration in the inventory ledger. Reconstructed information and measurements in centimeters are in brackets. Dates are cited as they appear in the original documents.

1. Inv. no. 177. *[Cow and Violin]* (cat. 32)
 O[il] on board, 11 x 6 [48.9 x 26.7]

 Committee Minutes No. 15, 12 August 1919: listed among works allocated to provincial museums; brought to Vitebsk by com[rade] A. M. Brazer, 14 August 1919. In May 1920 twenty-six additional works by contemporary artists were transported to Vitebsk by Marc Chagall, to establish the collection of the Museum of Artistic Culture (TsGALI, f. 665, ed.khr. 25, 1.51. See article by A. Shatskikh, *Bulletin of the International Association of Art Critics* [AIKA] [Moscow: Contemporary Artist (Sovremennyi Khudozhnik)], p. 10).

 In a letter of August 1922, the dean of the Vitebsk Practical Art Institute wrote to the Artistic Department of GLAVNAUKA that "in early September the Museum of Artistic Culture would be opened" in the Vitebsk Institute and requested that the department "leave the pictures which had been transferred from the Museum Fund to the Institute in 1919" at the institute location. Although there were no paintings by Malevich on an attached list, the letter stated that "seven works have been transported by the former dean, Ermolaeva, to the Petrograd Museum of Artistic Culture, and two works have been transported to Moscow by the artist R. R. Falk" (TsGALI, f. 665, ed.khr. 29, 1.23).

 We suggest that *Cow and Violin,* transferred to the State Russian Museum in 1926 from the Petrograd Museum of Artistic Culture, was originally from Vitebsk, where Malevich was living and teaching in the art school at the time. When he left for Petrograd in spring 1922, either he or Vera Ermolaeva apparently transported the picture to the museum there (see fig. 14).

2. Inv. no. 178. *Guitar Player,* 1914 (cat. 28?)
 O[il on canvas], 10½ x 8½ [46.7 x 37.8]

 Committee Minutes No. 15, 12 August 1919: allocated to Provincial Museums Foundation; to Samara (Kuibyshev), transported by N. N. Popov, 15 August 1919.
 Life in the Grand Hotel (oil on canvas, 108 x 71) (cat. 28), collection of Kuibyshev Art Museum, accessioned in 1919 from State Art Foundation to Kuibyshev Regional Museum; accessioned in 1937 to Kuibyshev Art Museum. (Picture lined.)
 Malevich's *Musician 1914* (17) in catalogue of *Tram V. First Futurist Exhibition,* Petrograd, 1915.
 The references above most likely apply to the same painting.

3. Inv. no. 179. [Untitled]
 Oil [on canvas], 18 x 18 [80.1 x 80.1]

 Committee Minutes No. 15, 12 August 1919: allocated to Provincial Museums Foundation.
 We suggest that this could be the entry for Malevich's *Suprematism* (oil on canvas, 80 x 80), which in 1924 was sent from the State Foundation to the A.V. Lunacharsky Red Army Regional Art Museum, formerly the Kubansk Museum.

4. Inv. no. 180. *Portrait of Kliunkov,* 1916
 O[il on canvas], 25½ x 16 [113.4 x 71.2]

 Committee Minutes No. 15, 12 August 1919: allocated to Vitebsk; transferred by comrade A. M. Brazer (deeded 14 August 1919). Subsequent provenance similar to that suggested for *Cow and Violin,* inv. no. 177.
 Currently in State Russian Museum, accessioned in 1926 from the Petrograd Museum of Artistic Culture.

5. Inv. no. 181. *Reaping Woman*
 Oil [on canvas], 16¼ x 15½ [72.3 x 69]

 Committee Minutes No. 15, 12 August 1919: allocated to Provincial Museums Foundation; transferred to Astrakhan by comrade Eifert, 17 November 1919.
 Inscribed in black on the reverse of *Reaping Woman* (oil on canvas, 60 x 68)

in the Astrakhan Picture Gallery: *No. 181 15 ¹/₄ x 15 ¹/₂* [67.8 x 68.2].

6. Inv. no. 182. *Yellow and Black [Suprematism No. 58]* (cat. 56)
Oil [on canvas], 18 x 16 [80.1 x 71.2]

Not on the list of works intended for the Provincial Museums Foundation, it is on the list of seventy-six works received in June 1919 by Boris Ternovets, curator of the Second Museum of New Western Art, for the Moscow and Petrograd museums. Transferred to Petrograd Museum of Artistic Culture, July 1921, by Natan Altman. Currently in State Russian Museum.

7. Inv. no. 183. [Untitled]
Oil on board. Measurements unknown.

Allocated to the Provincial Museums Foundation (per deed 12 September 1921, signed by Alexander Drevin and David Shterenberg); the work was lost.

8. Inv. no. 184. *Cubism [Through Station]* (cat. 30)
O[il] on board, [43 x 25]

Committee Minutes, 14 May 1919: designated for Moscow Museum of Painterly Culture; transferred in 1920 (per deed no. 24). Currently in State Tretiakov Gallery.

9. Inv. no. 185. *Cubism [Vanity Case]* (cat. 31)
O[il] on board, [43 x 25]

Same provenance as *Through Station* (inv. no. 184). Currently in State Tretiakov Gallery.

10. Inv. no. 186. *Suprematism*
Oil [on canvas], 15 x 25 ¹/₂ [66.7 x 113.5]

Committee Minutes, 12 August 1919: to Provincial Museums Foundation designated for Rostov-Jaroslav; transferred to Rostov-Jaroslav Museum in August 1922 (per deed of that date). Present location unknown.

11. Inv. no. 187. *[Suprematism]* (cat. 52)
Oil [on canvas], 18 x 32 [80.1 x 142.4]

Committee Minutes No. 15, 12 August 1919: allocated to Provincial Museums Foundation. *Four Squares* (oil on canvas, 49 x 49), in A. N. Radishchev State Art Museum, Saratov, accessioned in 1929 from State Art Foundation through the State Tretiakov Gallery. On stretcher: many numbers and (in dark blue pencil): *Inven. N 187.* On an IZO Narkompros exhibition label: Malevich receipt book number 187 (barely legible) and the title *Four Squares.* Despite the discrepancy in measurements, we suggest that the same picture is being described.

12. Inv. no. 512. *Suprematism* (cat. 55)
Oil [on canvas], 18 x 18 [80.1 x 80.1]

To Moscow Museum of Painterly Culture (per deed no. 24, 1920).
In 1929 transferred with five other works by Malevich to State Tretiakov Gallery (per deed no. 175, 8 April 1929). Subsequently transferred to State Russian Museum, its present location.

13. Inv. no. 684. *Black Square* (cat. 68)
Oil [on canvas], [79 x 79]

Allocated to Moscow Museum of Painterly Culture; to State Tretiakov Gallery in 1929. On reverse: a reprise of *Black Square* of 1929; also seal of IZO Narkompros Museum Bureau; *685,* inscribed in black; 18 x 18. IZO Narkompros Museum Bureau label with number "684" preserved in State Tretiakov Gallery, although that bureau ceased to exist in September 1922. Label most probably attached to *Black Square* of 1915 and later affixed by mistake to the 1929 painting.

14. Inv. no. 685. *Red Square* (cat. 51)
Oil [on canvas], 12 x 12 [53.4 x 53.4]

Transferred to the Petrograd Museum of Artistic Culture by Natan Altman (per deed no. 53, 22 July 1921).
Although number 684 indicated in deed, Museum Bureau inventory ledger lists number 685 with following entry in black, on reverse of picture: "Deed No. 53–684. *684 12 x 12.*" Confusion most likely arose because both pictures were registered at the same time. Inventory ledger contains the following entries:
684 Malevich, K. Black Square. m. 79 x 79
MZHK/685 Malevich, K. Red Square. m. 12 x 12 (in Deed 53–684)
When the inventory numbers were placed on the reverse of the pictures, they were confused and so listed in the ledger.

15. Inv. no. 713. *Suprematism No. 57 [Dynamic Suprematism]*
O[il on canvas], [80 x 82]

Committee Minutes, 14 May 1919: allocated to Moscow Museum of Painterly Culture, transferred in 1920 (per deed no. 24). Accessioned by State Tretiakov Gallery in 1929. Currently in Tate Gallery, London.

16. Inv. no. 802. *Suprematism [Dynamic Suprematism]*
Oil [on canvas], [86 x 102]

Same provenance (allocated to State Tretiakov Gallery) as *Suprematism No. 57,* inv. no. 713. Currently in Ludwig Museum, Cologne.

17. Inv. no. 1194. *Mower*
Oil [on canvas], [114 x 67]

Per inventory ledger: allocated to Nizhnii

Novgorod (Gorky); transferred March 1920. Currently in Gorky State Art Museum.

18. Inv. no. 1215. *Suprematism* [No. 56]
Oil [on canvas], [80.5 x 71]

Included in a January 1920 list of works sent to the Russian Museum; transferred by Petr Neradovsky, 3 February 1920. Currently in State Russian Museum.

19. Inv. no. 1216. *The Aviator* (cat. 37)
Oil [on canvas], [125 x 65]

Same provenance (allocated to State Russian Museum) as *Suprematism No. 56,* inv. no. 1215.

20. Inv. no. 1277. *Suprematism* (cat. 53)
[Oil on canvas], [80 x 80]

Included among paintings sent to Ekaterinburg (Sverdlovsk), January 1920.
Malevich's *Suprematism. Nonobjective Composition* (oil on canvas, 80 x 80) is in the collection of the Sverdlovsk Art Gallery, acquired from the Sverdlovsk Regional Museum in 1936. This is most likely the painting indicated in the inventory ledger entry. (Picture lined.)

21. Inv. no. 1454. *Suprematism*
[Oil on canvas], measurements unknown

Acquired by the Purchasing Committee in June 1920; allocated to Lugansk and Bakhmut (Artemovsk) in the Donetsk Basin (deed no. 25, 2 July 1920); transferred by B. Volsky.
Present location unknown. There are no works by Malevich in the collections of either the Donetsk or the Lugansk museum.

22. Inventory no. 1611. *Suprematism*
Oil [on canvas], measurements unknown

Committee Minutes No. 2, 23 June 1920: allocated to Voronezh; transferred by Yurii Uspenskii (deed no. 28, 26 June 1920). In response to an October 1922 request by the GLAVNAUKA Art Department, however, the Voronezh Museum provided a list of works received in 1919–1920 on which pictures by Malevich appear. Present location unknown.

23. Inv. no. 1618. *Suprematism*
[Oil on canvas], measurements unknown

Committee Minutes No. 3, 28 June 1920: allocated to Ivanovo-Vosnesensk. Deed no. 36, 31 August 1920, however, indicates that the painting was transferred to Tsaritsin (Volgograd).
Currently there are no works by Malevich in the Volgograd Art Museum. There is, however, a *Suprematism* (oil on canvas, 50 x 50) in the Ivanovo Regional Art Museum. The Ivanovo Museum states

that it obtained the picture from the Central Museum Administration in the early 1920s. In the Manuscript Department, State Tretiakov Gallery, are deeds of paintings acquired from the State Art Foundation and transferred to the Ivanovo-Vosnesensk Museum, including a work by Malevich titled *Suprematism*. In 1929 those works not distributed earlier by the foundation's Museum Bureau were allocated through the Tretiakov Gallery. We suggest that the same painting, sold by the artist in 1920, is being described.

24. Inv. no. 1661. *Suprematism*
Oil [on canvas], [71 x 49]

Committee Minutes No. 5, 7 June 1920: allocated to Tula; transferred per deed no. 33, 4 August 1920. Currently in Tula Regional Art Museum.

25. Inv. no. 1738. *Woman and Piano [Cubism]*
Oil [on canvas], [44 x 66]

Committee Minutes, 22 July 1920: originally allocated to Ufa. The decision was reconsidered in December, and the picture sent to Krasnoyarsk. In response to its inquiry of October 1922, the GLAVNAUKA Art Department was informed that Malevich's *Woman and Piano* was in the Prieniseisk Regional Museum. Currently in the Krasnoyarsk State Museum named for V. I. Surikov. On reverse, a Museum Bureau label: *Painter: Malevich Kazimir Severinovich. Title: Woman and Piano. Measurements: 44 x 86. Inventory Ledger Number: 1738. Destination: Ufa.*

26. Inv. no. 1787. *Suprematism*
O[il on canvas], [75 x 83]

Committee Minutes No. 14, 3 September 1920: allocated to Barnaul; transferred by M. Trusov (per deed no. 37) 7 September 1920. The Altai Art Museum in Barnaul currently has no works by Malevich.

A copy of a registration form obtained from the Barnaul museum contains the following data: "Title: Train, Sta[tion] Mas[ter] and Gendarmes. Inventory No. 26. Materials: Oil, canvas. Measurements: Cubist. 75 x 83. Signature: None. State of Preservation: Satisfactory. Whence received and date when received: Unknown" (State Tretiakov Gallery, Manuscript Department, f. 4, ed.khr. 611, 1.16). The painting apparently has not survived.

27. Inv. no. 1815. *Samovar*
O[il on canvas], 19 x 14 [84.5 x 62.3]

Committee Minutes No. 14, 3 September 1920: originally allocated to the city of Perm. Deed no. 68, 11 August 1922, signed by Alexander Rodchenko, includes this painting in the list of works transferred from the State Art Foundation to the new

director of Museum Bureau, designated for the Rostov-Yaroslav Museum. Currently in Rostov-Yaroslav Architecture and Art Museum. (Picture lined.)

28. Inv. no. 1904. *Resting Carpenter*
O[il on canvas], 16 x 25 ¹/₂ [71.2 x 113.4]

Originally included in the group of paintings allocated to the Vitebsk Museum. In June 1920 Alexander Romm, director of the Museum Section of the Vitebsk Regional National Education Department [Gubnarobraz], wrote David Shterenberg, director of IZO Narkompros, about purchasing paintings by Malevich, requesting funds for this purpose. The purchase would include: 1) *Suprematism No. 55,* 2) *The Woodcutter (Futurist),* 3) *Resting Carpenter,* and 4) *Self-Portrait (17).* Shterenberg's response was positive: "Release funds equivalent to the established amount to A. Romm, Director of the Vitebsk Gubnarobraz, for the acquisition of four paintings by Malevich. Signed: Section Head Shterenberg" (TsGALI, f. 665, ed.khr. 5, 1.123). The actual purchase was hindered in some way, since these pictures remained in the State Art Foundation until 1921.

On 29 March 1921 (deed no. 48) *Resting Carpenter* was transferred to the Vladimir Museum. A document states that Malevich's *The Carpenter* (oil on canvas, 109 x 72 cm) was acquired in the 1920s from the Moscow Museum Bureau. This painting is also mentioned in the Vladimir Museum inventory ledger for 1931. There is no subsequent mention of the picture, which most likely has not survived. (It may have been transferred to Moscow for exhibition in 1919 – 1920; see figs. 44 – 45.)

29. Inv. no. 1905. *The Woodcutter (Knife Grinder)* (cat. 27)
O[il on canvas], 18 x 18 [80.1 x 80.1]

Allocated to the Vitebsk Museum (see provenance for *Resting Carpenter,* inv. no. 1904). In 1922 it was sent from the State Art Foundation to the First Russian Art Exhibition in Berlin, where it was bought by Katherine Dreier. Troels Andersen (1970) notes that an inscription on the reverse of the painting clearly documents the picture's allocation to Vitebsk. Currently in Yale University Art Gallery.

30. Inv. no. 1906. *Self-Portrait* (cat. 13)
Water[color on paper], 10 x 10³/₄ [44.5 x 47.8]

Allocated to the Vitebsk Museum (see provenance for *Resting Carpenter,* inv. no. 1904). In list of works transferred from State Art Foundation to new Museum Bureau director (per deed no. 68, 21 August 1922, signed by Alexander Rodchenko); however, *Self-Portrait* was designated for Petrograd Museum of Artistic Culture and transferred

per deed no. 70 in 1922. Currently in State Russian Museum.

31. Inv. no. 1907. *Suprematism No. 55*
O[il on canvas], 16 x 10³/₄ [71.2 x 47.8]

Allocated to the Vitebsk Museum (see provenance for *Resting Carpenter,* inv. no. 1904). Present location unknown.

32. Inv. no. 1995. *Peasant (The Mower)*
O[il on canvas], 12 x 18 [53.4 x 80.1]

Committee Minutes No. 2, 8 December 1920: transferred by comrade Y. A. Tepin to Smolensk (per deed no. 42) 25 January 1921. Present location unknown.

33. Inv. no. 1996. *Fruit (Still Life)* (cat. 14)
O[il on canvas], 11³/₄ x 11³/₄ [52.2 x 52.2]

Committee Minutes No. 2: acquired by State Art Foundation, transferred (per deed no. 70) to Petrograd Museum of Artistic Culture. Currently in collection of State Russian Museum.

34. Inv. no. 1997. *The Clock*
O[il on canvas], 10 x 24 [44.5 x 106.8]

Committee Minutes No. 2, 8 December 1920: obtained by comrade Tepin; transferred by him (per deed no. 42) 25 January 1921 to Smolensk Museum. Present location unknown.

In May 1920 ten additional paintings by Malevich were presented to the Purchasing Committee for review (minutes no. 29, 18 May 1921). GLAVNAUKA order no. 392/2962, 17 June 1922, signed by Alexander Rodchenko, documents the return of these paintings to the artist. The following paintings were included in this group:

a. Inv. no. 2934. *Suprematism*
O[il on canvas], 18 x 18 [80.1 x 80.1]

b. Inv. no. 2935. *Suprematism*
O[il on canvas], 14 x 23 [62.3 x 102.3]

Collection of Stedelijk Museum, Amsterdam. Label on reverse: *Museum Bureau, IZO Narkompros. Artist: Malevich. Title: Suprematism. Year: 1921. Measurements: 14 x 23. Inventory Ledger No. 2935.*

c. Inv. no. 2936. *Suprematism*
O[il on canvas], 9 x 22 [40 x 97.9]

d. Inv. no. 2937. *Suprematism*
O[il on canvas], 14 x 18 [62.3 x 80.1]

e. Inv. no. 2938. *Suprematism*
O[il on canvas], 13¹/₂ x 12 [60 x 53.4]

Included in list of works returned to the artist. Deed no. 8, however (11 August

1922, signed by Alexander Rodchenko), indicating paintings transferred from the State Art Foundation, lists a painting by Malevich titled *Suprematism* (inv. no. 2938; 13 1/2 x 12) for entry Number 80. Malevich most likely did not take back this picture. Present location unknown.

f. Inv. no. 2939. *Suprematism*
O[il on canvas], 10 x 11 or 12 x 11
[44.5 x 48.9 or 53.4 x 48.9]

g. Inv. no. 2940. *Cubism (Musical Instruments)* (cat. 34)
O[il on canvas], 19 x 16 [84.5 x 71.2]

Collection of Stedelijk Museum, Amsterdam. Label on reverse: *Museum Bureau, IZO Narkompros. Artist: Malevich. Title: Cubism—Musical Instruments. Year: 1921. Measurements: 16 x 19. Inventory Ledger No. 2940. Destination:—*

h. Inv. no. 2941. *Mowers (Cubism)*
O[il on canvas], 18 x 18 [80.1 x 80.1]

Andersen (1970) lists a *Peasant Scene* (no. 35, 80 x 80; location unknown). This may be inv. no. 2941. A painting of mowers appears in photographs of both the Moscow 1919–1920 and Berlin 1927 exhibitions (see figs. 44–45, 28–33).

i. Inv. no. 2942. *A Lady* (cat. 35)
O[il on canvas], 20 x 20 [89 x 89]

Collection of Stedelijk Museum, Amsterdam, titled *Lady in a Tram*. Label on reverse: *Museum Bureau, IZO Narkompros. Artist: Malevich. Title: Lady. Year: 1921. Measurements: 20 x 20. Inventory Ledger No.: 2942. Destination:—*

j. Inv. no. 2943. *Desk and Room*
O[il on canvas], 18 x 18 [80.1 x 80.1]

Collection of Stedelijk Museum, Amsterdam. On reverse: *Museum Bureau, Department of Fine Arts N.K.P. Artist: Malevich. Title: Desk and room. Year: 1921. Measurements: 18 x 18. Inventory Ledger No.: 2943. Destination:—*

One more painting by Malevich was registered on 28 March 1923 in the ledger book for entry 3001: *"Suprematism. o[il]."* It was included in the list of works that the artist did not take back after rejection by the Museum Bureau and publication of a notice about their return. Present location unknown.

Information on many of the documented paintings is incomplete. At this stage of investigation it is difficult to determine their place in Malevich's oeuvre. For example, deed no. 8, 30 January 1920, lists a work by Malevich titled *Suprematism* that had been allocated to Penza, but no inventory number is mentioned. In response to an inquiry from the GLAVNAUKA

Art Department in October 1922, the Penza Museum replied that it had received four works from the State Art Foundation, none of them by Malevich. In response to the same inquiry, however, the Elets Proletarian Museum indicated that of the twenty-two pictures it had received, item number 8 was listed as Malevich's *In Geometric Figures*. There are currently no works by Malevich in the Elets Museum.

There is no precise information on the provenance of *Suprematism* (oil on canvas, 87.5 x 72 cm) in the State Russian Museum (inv. no. Zh–1332), except that the painting was acquired in 1926 from the Petrograd Museum of Artistic Culture.

So far we have been able to compare only a portion of the archival materials with the information on the works themselves. The Museum Bureau inventory numbers and labels still preserved on many of the paintings are a kind of picture "passport." Other archival materials require further verification and study.

The author wishes to acknowledge the assistance of Angelica Z. Rudenstine.

Translated from the Russian by Karen Myers

With contributions by Troels Andersen, Nina A. Barabanovna, Elena V. Basner, Elena M. Fedosova, Tatiana E. Ganina, Elena Grushvitskaia, Joop M. Joosten, Evgenii F. Kovtun, Tatiana N. Mikhienko, Tatiana V. Sventorzhetskaia, Irina A. Vakar, and Julia M. Zabrodina

Note to the Reader

The dating of Malevich's work presents complex problems, which are currently the subject of intensive study by scholars in many countries. The chronology and dating offered here are intentionally and necessarily tentative in nature. They result from wide consultation and discussion among many specialists and emerge in particular from the new opportunities for study of the artist's career that have been possible since the exhibition held in Leningrad, Moscow, and Amsterdam in 1988–1989.

Considerable consensus now exists regarding the dating of many individual works; in other cases serious disagreement continues. The present exhibition offers an occasion for further study of these questions, which may result in a clearer definition of the chronology and a deeper understanding of the artist's development.

The transliteration system used in this book is a modified version of the Library of Congress system, although the soft and hard signs either have been rendered by *i* or have been omitted. When a Russian name has already received a conventional transliteration that varies from the above system (e.g., "Chagall," not "Shagal"), this has been preserved in the text.

Titles that can be traced to the artist are preceded by a ■. English translations are followed by transliterations of the original Cyrillic.

Titles from inscriptions, labels, and exhibition catalogues are transliterated; only when these differ from the current title are additional translations included.

All dimensions are in inches followed by centimeters. Dimensions transcribed from the backs of paintings are normally in old Russian measurements: "vershki" (4.45 cm = 1 vershok).

Inscriptions are given in the following order: from the recto of the work; from the verso and stretcher; from labels. Unless otherwise indicated, all inscriptions are in the artist's hand.

Frequently mentioned exhibitions are cited in abbreviated form.

Short Citations

Moscow 1908
Association of Moscow Artists *Moscovskoe tovarishchestvo khudozhnikov*
Sixteenth exhibition, 1908

Moscow 1910–1911
Jack of Diamonds *Bubnovyi valet*
First exhibition, December 1910 – January 1911

Moscow 1911
Moscow Salon *Moskovskii salon*
First exhibition, February 1911

Moscow 1912
Donkey's Tail *Oslinyi khvost*
11 March – 8 April 1912

St. Petersburg 1912
Union of Youth *Soiuz molodezhi*
April – May 1912

Moscow 1912–1913
Contemporary Art *Sovremennoe iskusstvo*
First exhibition, December 1912 – January 1913

St. Petersburg 1912–1913
Union of Youth *Soiuz molodezhi*
4 December 1912 – 10 January 1913

Moscow 1913
Target *Mishen*
24 March – 7 April 1913

St. Petersburg 1913–1914
Union of Youth *Soiuz molodezhi*
10 December 1913 – 10 January 1914

Moscow 1914
Jack of Diamonds *Bubnovyi valet*
February 1914

Paris 1914
Salon des indépendants
1 March – 30 April 1914

Petrograd 1915
Tram V. First Futurist Exhibition of Paintings
Tramvai V. Pervaia futuristicheskaia vystavka kartin
3 March 1915

Petrograd 1915/Russian Theater
Monuments of the Russian Theater from the Collection of L. I. Zheverzheev *Opis vystavlennykh v polzu lazareta shkoly naradnogo iskusstva e.i.v. gos. imp. Alexandry Fedorovny pamiatnikov russkogo teatra iz sobraniia L. I. Zheverzheeva.*
December 1915
Catalogue: Inventory of monuments of the Russian Theater exhibited at a benefit for the infirmary of the Empress Alexandra Fedorovna's School of People's Art from the collection of L. I. Zheverzheev. Introductory article by N. N. Evreinov.

Petrograd 1915–1916
0.10. The Last Futurist Exhibition
Posledniaia futuristicheskaia vystavka
Dobychina Gallery, 19 December 1915–17 January 1916

Moscow 1916
Futurist Exhibition. The Store *Futuristicheskaia vystavka. Magazin*
March 1916

Moscow 1917
Jack of Diamonds *Bubnovyi valet*
16 November–4 December 1917

Moscow 1919
Tenth State Exhibition. Nonobjective Creativity and Suprematism *Gosudarstvrennai vystavka. Bespredmetnoe tvorchestvo i Suprematizm*

Moscow 1919–1920
Sixteenth State Exhibition. K. S. Malevich, One-Person Exhibition. His Way from Impressionism to Suprematism, 1919–1920 *XVI Gosudarstvennaia vystavka. Personalnaia vystavka K. S. Malevich. Ego put ot impressionizma k suprematizmu.*

Berlin 1922
Erste russische Kunstausstellung,
Galerie van Diemen
Opened 12 October 1922

Venice 1924
XIV Exposizione internazionale d'arte della città di Venezia, 1924

Warsaw 1927
One-Person Exhibition
Hotel Polonia, 8–28 March 1927

Berlin 1927
One-Person Exhibition *Grosse Berliner Kunstausstellung*
7 May–30 September 1927

Leningrad 1927
New Tendencies in Art *Noveishie techeniia v iskusstve*
Russian Museum
Opened 1 November 1927

Moscow 1929
Exhibition of Works by K. S. Malevich *Vystavka proizvedenii K. S. Malevicha*
Tretiakov Gallery, 1929

In the Manuscript Section of the Tretiakov Gallery are two lists supplied by the artist of works in this exhibition. Although the works are not always clearly identifiable, those that can be identified are included in the catalogue of the present exhibition.

Leningrad 1932–1933
Artists in the RSFSR over the Last 15 Years
Khudozhniki RSFSR za XV let
State Russian Museum, 13 November 1932–May 1933
This exhibition traveled to Moscow in June 1933, although not all works were included. In Moscow paintings were shown in the Historical Museum, sculpture in the Pushkin Museum, and graphic art in the Tretiakov Gallery.

Paintings

■ 1 **On the Boulevard** *Na bulvare,* 1903
Oil on canvas
21⅝ x 26 (55 x 66)
Lower left: *KM*
Lower right: *1903*
Reverse: *K Malevich* [old orthography]
1903 g Etiud "Na bulvare" (K. Malevich 1903 Study "On the Boulevard")
On stretcher twice: *1145*
Metal label on stretcher: *Dom pisatelia Leningrad 530* (House of the Writer Leningrad 530)

State Russian Museum, inv. no. Zh–9303. Acquired from Leningrad Writers' Club, 1977.

2 **Apple Trees in Blossom** *Tsvetushchie yabloni,* 1904
Oil on canvas
21⅝ x 27½ (55 x 70)
Lower left: *K Malevich*
Lower right: *904 god* (1904)

State Russian Museum, inv. no. ZhB–1622. Acquired from artist, 1933.

3 **Landscape** *Peizazh,* early 1900s
Oil on cardboard
7⁹⁄₁₆ x 12³⁄₁₆ (19.2 x 31)
On mount: *Malevich*
Label on mount: *85*

State Russian Museum, inv. no. Zh–9452. Acquired on loan from artist's family, 1936. Transferred to permanent collection by order of the Ministry of Culture USSR, 1977.

4 **Landscape with Yellow House** *Peizazh s zheltym domom,* early 1900s
Oil on cardboard
7⁹⁄₁₆ x 11⅝ (19.2 x 29.5)
On mount: *Malevich*
Label on mount: *86*

State Russian Museum, inv. no. Zh–9411. Acquired on loan from artist's family, 1936. Transferred to permanent collection by order of Ministry of Culture USSR, 1977.

5 **Portrait of a Woman** *Zhenskii portret,* ca. 1906
Oil on board
26¾ x 39 (68 x 99)
Lower left: *K Malevich*
Andersen 1970, no. 1

Stedelijk Museum, A7648. Acquired from Hugo Häring, 1958.

Exhibition
Berlin 1927(?)

This painting and fourteen others that were taken by Malevich to Berlin for his 1927 exhibition do not appear in the existing installation photographs (figs. 27–33). Some or all of these works may have been shown. Surviving photographs of the room in which Malevich's work was shown include no door; it is clear, therefore, that some portion of the space is missing from the visual record. Until further evidence appears, it is impossible to establish which if any of these additional works were on public display.

The sitter for this portrait was thought to be Malevich's first wife, Kazimira Ivanovna Zgleits. In correspondence, her daughter denied this identification, suggesting that a relative of her mother was the subject.

■ 6 **Study for Fresco Painting (The Triumph of Heaven)** *Eskiz freskovoi zhivopisi (Torzhestvo neba),* 1907
Tempera on cardboard
28½ x 27½ (72.5 x 70) (edges lost)
Lower right: *K Malev*
Reverse: *Eskiz dlia freskovoi zhivopisi. K Malevich 426S* (Study for fresco painting. K. Malevich; 426S); signed on reverse, at later date: *K Malevich; 426S.*

State Russian Museum, inv. no. Zh–9408. Acquired on loan from artist's family, 1936. Transferred to permanent collection by order of Ministry of Culture USSR, 1977.

Exhibitions
Moscow 1908, no. 176, *The Triumph of Heaven;* Moscow 1911(?), possibly no. 332, 333, 334, or 336, *Yellow Series. Saints* (Seriia zheltykh. Sviatye)

■ **7 Study for Fresco Painting (Portrait)** *Eskiz freskovoi zhivopisi (portret)*, 1907
Tempera on cardboard
27 1/4 x 27 5/8 (69.3 x 70)
Lower center: *K. Malev*
Reverse: *eskiz freskovoi zhivopisi. K. Mal; 428b* ["b" crossed out] *V*

State Russian Museum, inv. no. Zh-9413. Acquired on loan from artist's family, 1936. Transferred to permanent collection by order of Ministry of Culture USSR, 1977.

Exhibition
Moscow 1911, no. 331, *Yellow Series. Portrait* (Seriia zheltykh. Portret)

■ **8 Study for Fresco Painting** *Eskiz freskovoi zhivopisi*, 1907
Tempera on cardboard
27 1/4 x 28 1/8 (69.3 x 71.5)
Lower left: *Kazmlr Malevich* [old orthography]
Reverse: *Eskiz dlia freski Eskiz dlia freskovoi zhivopisi Kazmir Malev* [old orthography] *4 eskiza; 429 A. K. Malevich* (Study for fresco study for fresco painting Kazmir Malev; 4 studies)

State Russian Museum, inv. no. Zh-9457. Acquired on loan from artist's family, 1936. Transferred to permanent collection by order of Ministry of Culture USSR, 1977.

Exhibition
Moscow 1911(?), possibly no. 332, 333, 334, or 336, *Yellow Series. Saints* (Seriia zheltykh. Sviatye)

■ **9 Study for Fresco Painting (Prayer?)** *Eskiz freskovoi zhivopisi (Molitva?)*, 1907
Tempera on cardboard
27 5/8 x 29 7/16 (70 x 74.8)
Lower left: *K. Malevicz 1907*
Reverse: *Eskiz dlia freskovoi zhivopisi* (Study for fresco painting) *K. Malevich* [old orthography] *427D; Malevich*

State Russian Museum, inv. no. Zh-9407. Acquired on loan from artist's family, 1936. Transferred to permanent collection by order of Ministry of Culture USSR, 1977.

Exhibitions
Moscow 1908(?), no. 177, *Prayer;* Moscow 1911(?), possibly no. 332, 333, 334, or 336, *Yellow Series. Saints* (Seriia zheltykh. Sviatye)

10 River in the Forest *Reka v lesu*, ca. 1908 or ca. 1928(?)
Oil on canvas
20 7/8 x 16 1/2 (53 x 42)
Lower left: *KM*
Lower right (barely legible): *08*
Reverse: *K. M. Etiud 1908 K Malevich Kursk* (K. M. Study 1908 K Malevich Kursk)

State Russian Museum, inv. no. ZhB-1573. Acquired from artist, 1933.

■ **11 Female Bathers** *Kupalshchitsy*, ca. 1908 or 1928(?)
Oil on canvas
23 1/4 x 18 7/8 (59 x 48)
Lower left: *K. Mal*
Dated(?) lower right: *8*
Reverse: *Moskva 1908 g. K Malewic* (Moscow 1908 K Malevich)

State Russian Museum, inv. no. Zh-9481. Acquired on loan from artist's family, 1936. Transferred to permanent collection by order of Ministry of Culture USSR, 1977.

Exhibition
Moscow 1929 (?) (possibly no. 8 on artist's list of exhibited works; Tretiakov Gallery, Manuscript Section, f. 8/II/286)

Dating this and the preceding work poses particular problems. The brushwork and palette of the two landscapes are closely related, arguing for extremely close dates of execution, but the figures in *Female Bathers* bear a far closer resemblance to works Malevich produced in the late 1920s. Although *River in the Forest* seems most likely to have been painted during the early Impressionist period, it may belong to a group of similar works painted by Malevich toward the end of his life. As with some other early and late works, the relationship between these paintings and their placement within the overall chronology of the artist's career remain a subject of considerable dispute. A similar painting was formerly in the collection of the literary historian Nikolai Khardzhiev, who dated it to the late period of Malevich's career. On 24 July 1932 Malevich wrote from Moscow to his artist-friend Lev Kramarenko in Kiev about a painting "Bathing Women in White," which had been left behind in Kiev (with two others) after his 1930 exhibition there. He urged Kramarenko to try to extract payment for all three works or to have them returned no later than September. It is possible that *Female Bathers* is the work to which Malevich refers.

■ **12 Self-Portrait** *Avtoportret*, ca. 1908-1909
Gouache and varnish on paper
10 5/8 x 10 9/16 (27 x 26.8)
Lower left: *Kazmlr Malevich* [old orthography]
Reverse: a pencil sketch of trees

State Tretiakov Gallery, inv. no. P46996. Gift of George Costakis, 1977.

The sketch on the verso is reminiscent of the tree forms in Malevich's tempera paintings of 1907 (see cat. nos. 6, 7). In its striking use of color and form, however, the *Self-Portrait* on the recto is clearly of

a later date. The work (as art historian Vasilii Rakitin suggested) may have been shown as part of the Red Series at the *First Moscow Salon* of 1910-1911 (see Angelica Z. Rudenstine, *Russian Avant-Garde Art: The George Costakis Collection* [New York, 1981], 254). The work might be identified with no. 349 in the 1910-1911 catalogue, *Portrait of M. K. S.*

■ **13 Self-Portrait** *Avtoportret*, ca. 1908-1909
Gouache, watercolor, India ink, and varnish on paper
18 3/16 x 16 1/4 (46.2 x 41.3)
Verso (stamped): *M.B. izo;* inscribed: *[M]alevich K.S. [A]vtoportret [ra]zmer 10 x 10 [po] inventarnoi knige No 1901* ([M]alevich K. S. [S]elf-Portrait [m]easurement 10 x 10 inventory book No. 1901); upper right: *No. 22 M. K. S. Malevich 181*
Label on verso: *M.Kh.K. 548*

State Russian Museum, inv. no. 56720. Acquired from Museum of Artistic Culture, 1931.

Exhibition
Moscow 1919-1920 (visible in inst. phot.)

14 Still Life, 1910
Watercolor and gouache on paper
20 5/8 x 20 3/8 (52.5 x 51.8)
Lower left: *Kazmir Malevich* [old orthography]
Verso: *540/MKhK/Malevich*

State Russian Museum, inv. no. R-8176. Acquired from Museum of Artistic Culture, Leningrad, 1931.

Exhibitions
Moscow 1910-1911(?), no. 146, *Fruits* (Frukty); Moscow 1919-1920 (visible in inst. phot.)

■ **15 Province** *Provintsiia*, 1911
Gouache on paper
27 3/4 x 27 3/4 (70.5 x 70.5)
Verso: *N 40/"Provintsiia"/16 x 16*
Andersen 1970, no. 2

Stedelijk Museum, A7649. Acquired from Hugo Häring, 1958.

Exhibitions
Moscow 1912(?), no. 161 or 162, listed as "Provincial Landscapes"; Moscow 1919-1920 (visible in inst. phot.); Berlin 1927(?) (see cat. 5)

■ **16 On the Boulevard** *Na bulvare*, 1911
Charcoal and gouache on paper
28 3/8 x 28 (72 x 71)
Lower right: *K. Malewitch*
Verso: *N 9* [deleted]/*N 37/K Malevich "Na bulvare"/21/16 x 16;* in red pencil: *20*
Andersen 1970, no. 9

Stedelijk Museum, A7650. Acquired from Hugo Häring, 1958.

Exhibitions
Moscow 1912, no. 166; St. Petersburg 1912, no. 125; Moscow 1919–1920 (visible in inst. phot.); Berlin 1927 (visible in inst. phot.)

■ **17 The Gardener** *Sadovnik*, 1911
Charcoal and gouache on board
35 ⁷/₈ x 27 ¹/₂ (91 x 70)
Lower right: *K Malevich*
Verso (not in artist's hand): *Malevich*
Label on verso: *635*
Andersen 1970, no. 12

Stedelijk Museum, A7652. Acquired from Hugo Häring, 1958.

Exhibitions
Moscow 1912, no. 154; Moscow 1919–1920 (visible in inst. phot.); Berlin 1927 (visible in inst. phot.)

18 **Bather** *Kupalshchik*, 1911
Charcoal and gouache on paper (mounted on paper)
41 ³/₈ x 27 ¹/₄ (105 x 69)
Lower right: *K Malev*
Formerly on verso: *K Malevich 34* [missing words]/*N 27 podr[amnik]* (stretcher)
Andersen 1970, no. 8

Stedelijk Museum, A7653. Acquired from Hugo Häring, 1958.

Exhibitions
Moscow 1911(?), no. 337, *Bathing* (Kupanie); Berlin 1927(?) (see cat. 5)

■ **19 Chiropodist (at the Bathhouse)** *Mozolny operator (v bane)*, 1911–1912
Charcoal and gouache on paper
30 ⁵/₈ x 40 ⁹/₁₆ (77.7 x 103)
Lower right: *Kazimir Mal*
Verso: *N 5 V* [both numbers deleted]/*N 45/K Malevich Mozolnyi operator (v bane)/ N 4* [deleted]/*N 26 podr[amnik]* (stretcher)
Andersen 1970, no. 3

Stedelijk Museum, A7654. Acquired from Hugo Häring, 1958.

Exhibitions
Moscow 1912, no. 157, *Chiropodist at the Bathhouse;* Moscow 1919–1920 (visible in inst. phot.); Berlin 1927(?) (see cat. 5)

■ **20 Floor Polishers** *Polotery*, 1911–1912
Charcoal and gouache on paper
30 ⁵/₈ x 27 ⁷/₈ (77.7 x 71)
Lower right: *KMalevi*
Verso: *N 11y* [deleted]/*41 K Malevich 'Polotery'/ 11 x 11*
Andersen 1970, no. 13

Stedelijk Museum, A7655. Acquired from Hugo Häring, 1958.

Exhibitions
Moscow 1912, no. 164; Moscow 1919–1920 (visible in inst. phot.); Berlin 1927 (visible in inst. phot.)

■ **21 Peasant Woman with Buckets and Child**
Krestianka s vedrami i rebenkom, 1912
Oil on canvas
28 ³/₄ x 28 ³/₄ (73 x 73)
Lower left: *K M*
Reverse: *183* [or *83*]/*N 60/Krestianka/s vedrami*
Andersen 1970, no. 27

Stedelijk Museum, A7676. Acquired from Hugo Häring, 1958.

Exhibitions
Moscow 1912–1913, no. 157, *Woman with Buckets and Child* (Zhenshchina s vedrami i rebenkom); Moscow 1919–1920 (visible in inst. phot.); Berlin 1927 (visible in inst. phot.)

■ **22 Taking in the Rye** *Uborka rzhi*, 1912
Oil on canvas
28 ³/₈ x 29 ³/₈ (72 x 74.5)
Reverse: *61 Uborka rzhi*
Andersen 1970, no. 28

Stedelijk Museum, A7678. Acquired from Hugo Häring, 1958.

Exhibitions
Moscow 1912–1913(?), no. 160, *Harvest* (Zhatva); St. Petersburg 1912–1913(?), no. 32, *Harvest;* Moscow 1919–1920 (visible in inst. phot.); Warsaw 1927 (visible in inst. phot.); Berlin 1927 (visible in inst. phot.)

23 **The Woodcutter** *Drovosek*, 1912
Oil on canvas
37 x 28 ¹/₈ (94 x 71.5)
Andersen 1970, no. 29

Verso: *Peasant Women at Church*, 1911 (fig. 34). Oil on canvas, 29 ¹/₂ x 38 ³/₈ (75 x 97.5), no. A7679.

Stedelijk Museum, A7678. Acquired from Hugo Häring, 1958.

Exhibitions
Moscow 1919–1920 (visible in inst. phot.); Warsaw 1927 (visible in inst. phot.); Berlin 1927 (visible in inst. phot.)

■ **24 Morning in the Country after Snowstorm** *Utro posle viugi v derevne*, 1912
Oil on canvas
31 ³/₄ x 31 ⁷/₈ (80.7 x 80.8)
Lower right: *KM*
Reverse (not in artist's hand): *K Malevitch: Le matin à la campagne d'après l'orage;* possibly in artist's hand (barely visible): *Peizazh zimoi* (Landscape in winter). According to Andersen (1970, 88, no. 32), a further inscription (now lost) in the

artist's hand was faintly visible when he examined the painting in 1969: *Utro posle viugi* (Morning after snowstorm).

A Salon label formerly on the stretcher (now preserved in Guggenheim files) inexplicably carries the number *2145*.
Andersen 1970, no. 32

Solomon R. Guggenheim Museum, inv. no. 52.1327.

Exhibitions
Moscow 1913, no. 90; St. Petersburg 1912–1913, no. 64; Paris 1914, no. 2156, *Le matin à la campagne d'après l'orage;* Moscow 1919–1920 (visible in inst. phot.); Warsaw 1927 (visible in inst. phot.); Berlin 1927 (visible in inst. phot.)

In December 1927, after the Berlin exhibition, the painting was probably purchased by Dr. Udo Rukser, brother-in-law of Hans Richter. Rukser emigrated to South America in about 1933. By 1952 the painting had been acquired from an unknown source by the Rose Fried Gallery in New York.

■ **25 Peasant Woman with Buckets** *Krestianka s vedrami*, 1912
Oil on canvas
31 ⁵/₈ x 31 ⁵/₈ (80.3 x 80.3)
Reverse: *Zhenshchina s vedrom/ dinamicheskogo razlozheniia N 1 Krest* [letters] *s vedrami/N 2* (Woman with buckets/dynamic de-composition); and *K Malewicz 1912 g/Kobieta z wiadrami/32* (Woman with buckets)
Andersen 1970, no. 34

Collection, The Museum of Modern Art, New York.

Exhibitions
Moscow 1913, no. 93, *Woman with Buckets* (Zhenshchina s vedrami); St. Petersburg 1913–1914(?), no. 61; Moscow 1919–1920 (visible in inst. phot.); Warsaw 1927 (visible in inst. phot.); Berlin 1927 (visible in inst. phot.)

■ **26 Face of a Peasant Girl** *Litso krestianskoi devushki*, 1913
Oil on canvas
31 ¹/₂ x 37 ³/₈ (80 x 95)
Lower right: *K M*
Lower left: *K Malevich*
On reverse, a harbor scene not by Malevich; it has been attributed to Alexander Vasilievich Kuprin (see Andersen 1970, 88, no. 33)

Stedelijk Museum, A7673. Acquired from Hugo Häring, 1958.

Exhibitions
St. Petersburg 1913–1914, no. 62; Moscow 1919–1920 (visible in inst. phot.); Berlin 1927 (visible in inst. phot.)

27 Knife Grinder/Principle of Flickering
Tochilshchik/Printsip melkaniia, ca. 1913
Oil on canvas
31¼ x 31¼ (79.5 x 79.5)
Lower left: *K. M.*
Reverse: *Tochilshchik/Printsip melkaniia*
Stenciled on reverse: *Mb IZO* [for
Museum Bureau (Muzeinoe biuro), Visual
Arts Department of Narkompros]
Stretcher, in red pencil: *MB Vitebsk;* in
pencil: *Tochil* [letters missing] *84/18 x 18;*
stenciled: *1100* (The museum in Vitebsk
was planned in 1919; paintings were still
in storage in 1921.)
Andersen 1970, no. 37

Yale University Art Gallery, Gift of
Collection Société Anonyme. Acquired
by Katherine S. Dreier from Galerie
van Diemen exhibition, Berlin, 1922.

Exhibitions
Moscow 1913, no. 95; St. Petersburg
1913–1914, no. 66, *Knife Grinder;* Berlin
1922, no. 127, *Messerschleifer;* New
York, Galleries of the Société Anonyme,
Modern Russian Artists, 13 February–
6 March 1924; Philadelphia, "Russian
Section" of *Sesqui-Centennial Interna-
tional Exposition,* 1 June–1 December
1926; New York, Macy's, *Exposition of Art
in Trade at Macy's,* 1927; Wilmington,
Delaware, Society of Fine Arts, *Exhibition
of Russian Painting and Sculpture:
Realism to Surrealism,* 11–31 January
1932, no. 36, *The Scissors Grinder*

▪ 28 In the Grand Hotel *Zhizn v Bolshoi
gostinitse,* ca. 1913
Oil on canvas
42½ x 28 (108 x 71)

Kuibyshev Art Museum, inv. no. Zh–431.
Acquired from Kuibyshev Ethnographic
Museum, 1937.

Records exist of documents signed in
Moscow in August 1919, transferring
approximately thirty pictures from the
State Museum Fund to the city of Samara
(now Kuibyshev). The only painting by
Malevich listed is titled *Guitar Player* (see
Avtonomova, no. 2). The pictures were
delivered to the Ethnographic Museum
in Kuibyshev by the artist Popov (who had
signed the act authorizing the transfer).
The acquisition documents recording the
arrival of the works have since been lost.
In 1937 the only work by Malevich then in
Kuibyshev was transferred from the Ethno-
graphic Museum to the Art Museum, and
in the transfer documents it is titled *In the
Grand Hotel.* This work remains the only
picture by Malevich in the city. Moreover,
references to a Malevich painting by this
title apparently occur in guides to the
Ethnographic Museum dating from the
1920s and 1930s (information supplied by

A. Ia. Bass of the Kuibyshev Museum,
in conversations with Irina Vakar and
Tatiana Mikhienko, April 1990). Whether
In the Grand Hotel is the painting sent to
Kuibyshev in 1919 as *Guitar Player* is
not clearly documented. According to
Bass, it seems more likely that *In the
Grand Hotel* was substituted for *Guitar
Player* after the 1919 documents were
signed in Moscow but before the thirty
designated paintings were actually sent.
Natalia Avtonomova suggests alterna-
tively that the same painting has been
recorded under two different titles. The
issue is further complicated by the style
of the work, which makes it difficult to
place securely within Malevich's career
as it is presently known. (The possibility
that the painting is by another hand should
perhaps not be entirely excluded from
consideration.) Further research in the
Narkompros Archives, as well as in those
of the Kuibyshev museums, may throw
added light on this issue.

▪ 29 Perfected Portrait of I. V. Kliun
Usovershenstvovannyi portret I. V. Kliuna,
1913
Oil on canvas
44⅛ x 27⅝ (112 x 70)
Lower left: *K Malevich* [old orthography]
1911
Reverse: *Portrait de M-eur Kliunkoff K.
Malevitch 16 x 25 ¼*
Three labels (now lost): *M.X.K.443/
Cimaise/2144*

State Russian Museum, inv. no. ZhB–1469.
Acquired from Museum of Artistic Culture,
Leningrad, 1926.

Exhibitions
St. Petersburg 1913–1914, no. 65,
*Perfected Portrait of Ivan Vasilievich
Kliunkov* (Usovershenstvoyannyi portret
Ivana Vasilievich Kliunkova); Paris 1914,
no. 2155, *Portrait de Ivan Klyunkov;*
Leningrad 1927 (visible in inst. phot.);
Moscow 1929, no. 27, *Portret I. V. Kliuna*

Kliun (Ivan Vasilievich Kliunkov, 1873–
1943) was an artist-friend and a disciple
of Malevich. The title *Portrait of Ivan
Vasilievich Kliunkov* appeared for the first
time in the 1912–1913 catalogue of the
St. Petersburg *Union of Youth* exhibition.
The work, however, was an earlier
version of the portrait (reproduced in
Ogonek, no. 1 [1913]: 20, with a review of
the exhibition). The appearance of the
earlier version (Andersen 1970, no. 31) in
that exhibition is corroborated by a careful
drawing of it in Alexander Benois' copy of
the catalogue (preserved in the State
Russian Museum), extensively annotated
with such drawings. The present work, an
example of Malevich's most developed

Cubo-Futurist style, is clearly the work
shown in the *Union of Youth* exhibition the
following year.
 Malevich later dated this work as well
as some of his drawings to 1911 (see
Cow and Violin, cat. 32, and cat. nos.
109, 110), apparently to establish an
earlier date for the conceptual origins of
his Cubo-Futurist phase.

▪ 30 Through Station. Kuntsevo *Stantsiia bez
ostanovki. Kuntsevo,* 1913
Oil on wood
19⁵⁄₁₆ x 10 (49 x 25.5)
Reverse, before wood backing and
cradle were added in 1929: *Stantsiia
bez ostanovki* (Through station); below:
K. Malevich

State Tretiakov Gallery, inv. no. 11926.
Acquired from Museum of Painterly
Culture, Moscow, 1929.

Kuntsevo was a community of summer
houses outside Moscow, now part of the
city; according to existing documents,
Malevich vacationed there during the
summers of 1913, 1914, and 1916 (see,
for example, his letter to Matiushin
[Tretiakov Gallery, Manuscript Section,
f. 25/9]; also in the Tretiakov archives
is a photograph of Malevich and his wife
inscribed in the artist's hand on the
reverse, *Kuntsevo 1916*).
 The three works *Through Station.
Kuntsevo, Vanity Case,* and *Cow and
Violin* (cat. nos. 30–32), are closely
linked stylistically. All three were painted
on sections of wooden shelving, originally
mounted with wooden poles inserted
through the four corners of each panel.
The sawed-off residual dowel fragments
are clearly visible in the corners of
each painting.

▪ 31 Vanity Case *Tualetnaia shkatulka,* 1913
Oil on wood
19⁵⁄₁₆ x 10 (49 x 25.5)
Reverse, before wood backing and cradle
were added in 1929: *K Malewitz*

State Tretiakov Gallery, inv. no. 11927.
Acquired from Museum of Painterly
Culture, Moscow, 1929.

▪ 32 Cow and Violin *Korova i skripka,* 1913
Oil on wood
19¼ x 10³⁄₁₆ (48.8 x 25.8)
Reverse (probably at a later date):
*Alogicheskoe sopostavlenie dvukh form
"skripka i korova" kak moment borby s
logizmom estestvennostiu, meshchanskim
smyslom i predrazsudkom. K Malevich
1911 god* (The alogical juxtaposition of
two forms "violin and cow" as an aspect
of the struggle against logic by means of
the natural order, against Philistine
meaning and prejudice. K Malevich 1911)

Reverse: *4085* (early inventory number of State Russian Museum)
Label on reverse (now lost): *M.kh.K. 444;* second label (also lost): *No. 6 Malevich 444/M.Kh.K/5 7/8 II*

State Russian Museum, inv. no. ZhB–1550. Acquired from Museum of Artistic Culture, Leningrad, 1926.

Exhibitions
Moscow 1916, no. 21, under the heading *Alogism of Form 1913. Cow and Violin* (Alogizm form 1913. Korova i skripka); Moscow 1929 (no. 28, *Alogism 1911,* in artist's list of exhibited works; Tretiakov Gallery, Manuscript Section, f. 8/II/286)

Cow and Violin first appeared in the 1916 exhibition *The Store,* among a group of works titled *Alogism of Form 1913.* In the 1929 Moscow exhibition it appeared as *Alogism 1911,* and the two Tretiakov paintings (cat. nos. 30, 31) are dated 1911 in that museum's 1984 collection catalogue. Andersen (1970, 23) more convincingly dated the present work 1913, placing *Through Station. Kuntsevo* and *Vanity Case* slightly earlier, in 1912–1913.

■ **33 Portrait of the Composer M. V. Matiushin**
Portret kompozitora M. V. Matiushin, 1913
Oil on canvas
41⁷/₈ x 41⁷/₈ (106.3 x 106.3)
Formerly inscribed in gray, lower left (barely visible through white paint): *Portret M. Matiushina/K. Malevich* [old orthography]
Reverse, upper left, in artist's hand (?): *M. V. MATIUSHINU/K. S. MALEVICH* (To M. V. Matiushin/K. S. Malevich)
Stretcher: Costakis collection stamp
Paper label on reverse: *Portret khudozhnika M. V. Matiushina. Rabota K. S. Malevicha. Prinadlezhit M. Matiushinu. Leningrad. ul. Literatorov. 19* (Portrait of the artist M. V. Matiushin. Work by K. S. Malevich. Belongs to M. Matiushin, Leningrad, Literaturov Street 19)

State Tretiakov Gallery, inv. no. P46725. Gift of George Costakis, 1977.

Exhibitions
Moscow 1914, no. 56, *Portrait of the Composer Matiushin;* Petrograd 1915, no. 20, *Portrait of M. V. Matiushin. Composer of the opera "Victory over the Sun" [Property of Matiushin] 1913* (Portret M. V. Matiushina. kompozitora opery "Pobeda nad solntsem"/sobst. Matiushina/1913); Petrograd, The Academy of Arts, *Exhibition of Works by Petrograd Artists of All Trends, 1918–1923,* 1923 (visible in inst. phot.); Moscow 1929 (no. 29 on artist's list of exhibited works, dated 1912; Tretiakov Gallery, Manuscript Section, f. 8/II/286)

Mikhail Vasilievich Matiushin (1861–1934) was a painter, composer, art theoretician, and teacher. He wrote the music for the futurist opera *Victory over the Sun* (1913) and was a lifelong friend of Malevich, whom he met in 1912. In the *Tram V* exhibition catalogue of 1915, the portrait was dated 1913, and a preliminary drawing for it bears that date (graphite pencil, 13 x 12.2 cm; private collection; reproduced in *Malévitch: Colloque international tenu au Centre Pompidou, Musée national d'art moderne, Paris, 1978* [Lausanne, 1979], pl. 62). At the 1929 *Exhibition of Works by K. S. Malevich,* the portrait bore the less plausible date of 1912.

The portrait remained in the collection of Matiushin and then in that of his widow; it was acquired directly from her by the literary historian Nikolai Khardzhiev, from whom George Costakis purchased it.

34 Musical Instrument/Lamp, 1913
Oil on canvas
32⁷/₈ x 27³/₈ (83.5 x 69.5)
Signed upper right: [illegible after restoration]
Labels formerly on reverse (printed): *V. Ts. Muzynoe* [sic] *Biuro/Otdela izobrazitelnykh iskusstv N.K.P./Avtor: Malevich/Nazvanie: Kubizm-muzyk. instrument* [letters missing]/*God:1921/ Razmer: 16 x 19/Po inventarnoi knige no. 28 (4) 0/Naznacheno:* (A[ll Union] C[entral] Museum Bureau of the Department of Visual Arts of Narkompros/Artist: Malevich/Title: Cubism-Music. Instrument/ [letters missing]/Year: 1921/Measurements: 16 x 19/According to inventory book no. 28 [4] 0/Destination:)
Another label (handwritten): *'La Lampe'/ prix 300 lire/K Malewitsch Moscou/ Wolchonka N.9.7*
Andersen 1970, no. 39

Stedelijk Museum, A7680. Acquired from Hugo Häring, 1958.

Exhibitions
St. Petersburg 1913–1914 (?), no. 70, *Lamp* (Lampa); Moscow 1919–1920 (visible in inst. phot.); Berlin 1927 (?) (see cat. 5)

■ **35 Lady in a Tram** *Dama v tramvae,* 1913
Oil on canvas
34⁵/₈ x 34⁵/₈ (88 x 88)
Lower right: *K Malevich*
Reverse: *U ostano* [vki] (By a stop). *tramv* [aia] (tram) *Dama/Moscou Malewitsch Wolchonka* (Lady/Moscow Malevich Volkhonka); (labels) *Nazvanie: Dama/God: 1921/Razmer: 20 x 20/Po inventarnoi knige No. 2942* (Title: Lady/ Year: 1921/Measurement: 20 x 20/ According to inventory No. 2942)
Label (handwritten): *"La dame au tramway"/prix 500 lires/K. Malewitsch*

Moscou Wolchonka m. 9 lag. 7
Andersen 1970, no. 42

Stedelijk Museum, A7659. Acquired from Hugo Häring, 1958.

Exhibitions
Moscow 1914, no. 57; Petrograd 1915, no. 16, *Lady in a Tram 1912;* Moscow 1919–1920 (visible in inst. phot.); Berlin 1927 (visible in inst. phot.)

■ **36 Guardsman** *Gvardeets,* 1913–1914
Oil on canvas
22⁷/₁₆ x 26¹/₈ (57 x 66.5)
Lower right: *K Malevich*
Reverse: *Gvardeets*
Andersen 1970, no. 40

Stedelijk Museum, A7658. Acquired from Hugo Häring, 1958.

Exhibitions
Moscow 1914, no. 60; Berlin 1927 (?) (see cat. 5)

■ **37 Aviator** *Aviator,* 1914
Oil on canvas
49¹/₄ x 25⁵/₈ (125 x 65)
Reverse: *K. Malevich* [old orthography] *1914 Awiator*
Stretcher, possibly in artist's hand: *Aviator No. 82*
Reverse: label from Artistic Department, State Russian Museum: *No. 45. 16/II– 1920* (16 February 1920)

State Russian Museum, inv. ZhB–1348. Acquired from IZO Narkompros, 1920.

Exhibitions
Petrograd 1915, no. 19; Moscow 1916, no. 24, *Aviator;* Leningrad 1927 (visible in inst. phot.)

■ **38 An Englishman in Moscow** *Anglichanin v Moskve,* 1914
Oil on canvas
34⁵/₈ x 22⁷/₁₆ (88 x 57)
Reverse: *K.S. Malevich 1914g/Mlody Anglik/34*
Andersen 1970, no. 43

Stedelijk Museum, A7656. Acquired from Hugo Häring, 1958.

Exhibitions
Petrograd 1915, no. 18; Moscow 1916, no. 23; Moscow 1919–1920 (visible in inst. phot.); Berlin 1927 (visible in inst. phot.)

As suggested by Andersen (1970, 92, no. 43), in place of the painted spoon at the upper left, there may originally have been a wooden spoon applied as a collage element. Yakov Tugenkhold, in his review of the 1916 exhibition *The Store* ("Futuristicheskaia vystavka 'Magazin,' " *Apollon,* no. 3 [1916]: 61–62), refers to "this

épatant wooden spoon glued onto the painting by Malevich."

■ 39 **Warrior of the First Division, Moscow** *Ratnik 1g razriada Moskva*, 1914
Oil and collage on canvas
21 1/8 x 17 5/8 (53.6 x 44.8)
Lower right: *K Malevich*
Reverse: *K Malevich 1914 g/Ratnik 1g razriada Moskva*; below this:
2 [letters missing]
Andersen 1970, no. 45

Collection, The Museum of Modern Art, New York.

Exhibitions
Moscow 1916 (?) *(hors catalogue)*; Moscow 1919–1920 (visible in inst. phot.); Berlin 1927 (visible in inst. phot.)

A review of the Moscow exhibition *The Store*, published in *Ranee utro (Early Morning)* on 26 March 1916, included a reference to "pictures hanging on the walls adorned with spoons, thermometers" (for the full text, see Angelica Z. Ruden-stine, *Russian Avant-Garde Art: The George Costakis Collection* [New York, 1981], 57). Although not clearly identifiable as any work listed in the exhibition catalogue, *Warrior of the First Division, Moscow* may well have been one of the paintings mentioned.

■ 40 **Lady at the Advertising Column** *Dama u afishnogo stolba*, 1914
Oil and collage on canvas
28 x 25 1/4 (71 x 64)
Reverse: *K Malewicz* and *Dama u afishn⁹⁰ stolba/1914g* (Lady at the Advertising Column/1914)
Andersen 1970, no. 44

Stedelijk Museum, A7657. Acquired from Hugo Häring, 1958.

Exhibitions
Petrograd 1915, no. 11; Moscow 1919–1920 (visible in inst. phot.); Berlin 1927 (?) (see cat. 5)

■ 41 **Composition with Mona Lisa** *Kompositsiia s Monoi Lizoi*, 1914
Graphite, oil, and collage on canvas
24 3/8 x 19 1/2 (62 x 49.5)
Lower left (not in artist's hand): *Malevich*
Upper left (barely visible, scratched into white paint): *zatme . . . chastichnoe* (a partial eclipse); in green paint: *chastichnoe zatmenie* [old orthography] (partial eclipse); below, in gray-black paint: *zatmenie* (eclipse)
Attached to reproduction of Mona Lisa and below it to left, two collage elements from a newspaper: *peredaetsia kvartira/v Moskve* (apartment available/in Moscow)

Left center, half-erased imprint of news-paper writing (in mirror image): *Petrograd*

Private collection, Leningrad.

St. Petersburg was renamed Petrograd on 1 August 1914; the painting, therefore, must postdate this event. The postcard of the Mona Lisa is torn and may reflect a loss of collage elements. Other collage fragments may have been lost: for example, Anna Leporskaia recalled, in conversation with an acquaintance, that a cigarette had originally been attached to the lips of the Mona Lisa. A thread across the black rectangle is sewn through the canvas and attached on the verso with a knot and tape. It almost certainly held a collage element, now lost.

■ 42 **Painterly Realism. Boy with Knapsack — Color Masses in the Fourth Dimension** *Zhivopisnyi realizm malchika s rantsem — Krasochnye massy v 4-m izmerenii*, 1915
Oil on canvas
28 x 17 1/2 (71.1 x 44.4)
Andersen 1970, no. 46

Collection, The Museum of Modern Art, New York.

Exhibitions
Petrograd 1915–1916, no. 41; Moscow 1919–1920 (visible in inst. phot.); Warsaw 1927 (visible in inst. phot.); Berlin 1927 (visible in inst. phot.)

A postcard dating from ca. 1920 in the collection formed by George Costakis reproduces this work; the title is inscribed on the reverse in pencil. The postcard was acquired from Malevich by Vasilii Bobrov the artist. The inscription, while not in Malevich's hand, is surely contemporary and provides the only known evidence for identifying this painting with the title in the *0.10* exhibition catalogue (see Angelica Z. Rudenstine, *Russian Avant-Garde Art: The George Costakis Collection* [New York, 1981], 57).

43 **Suprematist Painting. Black Rectangle, Blue Triangle**, 1915
Oil on canvas
26 1/8 x 22 7/16 (66.5 x 57)
Andersen 1970, no. 54

Stedelijk Museum, A7671. Acquired from Hugo Häring, 1958.

Exhibitions
Moscow 1919–1920 (visible in inst. phot.); Berlin 1927 (?) (see cat. 5)

The orientation of some Suprematist paintings remains a subject for debate. In the 1919 one-person exhibition, this work was hung with the present right

edge at the top. However, it is not entirely clear that Malevich (who was in Vitebsk at the time) was fully consulted about the installation.

44 **Suprematist Painting. Rectangle and Circle**, 1915
Oil on canvas
17 x 12 1/16 (43.2 x 30.7)
Andersen 1970, no. 50

Busch-Reisinger Museum, Harvard University, Cambridge, Massachusetts, Alexander Dorner Trust, inv. no. 1957.128. Bequest of Alexander Dorner, 1957.

Exhibitions
Moscow 1919–1920 (visible in inst. phot.); Berlin 1927 (visible in inst. phot.)

■ 45 **Airplane Flying**, 1915
Oil on canvas
22 1/2 x 19 (57.3 x 48.3)
Reverse (before lining and visible in an x-ray): *Suprema* [letter missing]/*Aero-plan* [letters missing] *t K Malevich* [According to the conservator, the inscription was "Aeroplan letit 1914 god K Malevich" ("Airplane flies 1914 K. Malevich"), which was copied onto the new canvas.]
Andersen 1970, no. 49

Collection, The Museum of Modern Art, New York.

Exhibitions
Petrograd 1915–1916 (visible in inst. phot.); Moscow 1919–1920 (visible in inst. phot.); Warsaw 1927 (visible in inst. phot.); Berlin 1927 (visible in inst. phot.)

The painting is oriented here as Malevich hung it in the 1915 *0.10* exhibition; it was hung this way again in the 1927 Warsaw and Berlin exhibitions. In the 1919 one-person show it was hung with the present lower edge at the top. It is not clear that Malevich was fully consulted about the 1919 and 1927 installations. Whether he changed his mind about the orientation of some of his Suprematist works is not documented.

46 **Suprematist Painting. Eight Red Rectangles**, 1915
Oil on canvas
22 5/8 x 19 1/8 (57.5 x 48.5)
Andersen 1970, no. 47

Stedelijk Museum, A7672. Acquired from Hugo Häring, 1958.

Exhibitions
Petrograd 1915–1916 (visible in inst. phot.); Moscow 1919–1920 (visible in inst. phot.); Berlin 1927 (?) (see cat. 5)

▪ **47 Suprematism: Painterly Realism of a Football Player. Color Masses in the Fourth Dimension** *Zhivopisnyi realizm futbolista — Krasochnye massy v 4-m izmerenii,* 1915
Oil on canvas
27 ¹/₂ x 17 ³/₈ (70 x 44)
Reverse: *Futbolist 1915 god* [old orthography] (Football player 1915)
Andersen 1970, no. 51

Stedelijk Museum, A7682. Acquired from Hugo Häring, 1958.

Exhibitions
Petrograd 1915–1916, no. 40, (also visible in inst. phot.) Moscow 1919–1920 (visible in inst. phot.); Warsaw 1927 (visible in inst. phot.); Berlin 1927 (visible in inst. phot.)

The painting is oriented here as Malevich hung it in the 1915 *0.10* exhibition. It was also hung this way in the 1927 Berlin exhibition; in the 1919 one-person show it was hung with the present lower edge at the top. It is not clear that Malevich was fully consulted about the installations of the 1919 and 1927 exhibitions. Whether he changed his mind about the orientation of some of his Suprematist works is not documented.

48 Suprematist Painting, 1915
Oil on canvas
31 ¹/₂ x 24 ³/₈ (80 x 62)
Andersen 1970, no. 53

Stedelijk Museum, A7683. Acquired from Hugo Häring, 1958.

Exhibitions
Petrograd 1915–1916 (visible in inst. phot.); Berlin 1927 (visible in inst. phot.)

The painting is oriented here as Malevich hung it in the 1915 *0.10* exhibition; it was also hung this way in his 1919 one-person show. In the 1927 exhibition in Berlin it was hung with the present lower edge at the top. It is not clear that Malevich was fully consulted about the installations of the 1919 and 1927 exhibitions. Whether he changed his mind about the orientation of some of his Suprematist works is not documented.

▪ **49 Suprematism (Supremus No. 50)**
Suprematizm (Supremus N 50), 1915
Oil on canvas
38 ³/₁₆ x 26 (97 x 66)
Reverse: *K. Malewicz/Supremus"/N 50/ Moskwa/38* (K. Malewicz/Supremus/No. 50/Moscow/38)
Andersen 1970, no. 56

Stedelijk Museum, A7663. Acquired from Hugo Häring, 1958.

Exhibitions
Moscow 1919–1920 (visible in inst. phot.); Warsaw 1927 (visible in inst. phot.); Berlin 1927 (visible in inst. phot.)

50 Suprematist Painting, 1915
Oil on canvas
39 ⁷/₈ x 24 ³/₈ (101.5 x 62)
Andersen 1970, no. 48

Stedelijk Museum, A7681. Acquired from Hugo Häring, 1958.

Exhibitions
Petrograd 1915–1916 (visible in inst. phot.); Moscow 1919–1920 (visible in inst. phot.); Berlin 1927 (visible in inst. phot.)

▪ **51 Red Square (Peasant Woman. Suprematism)**
Krasnyi kvadrat (Krestianka Suprematizm), 1915
Oil on canvas
20 ⁷/₈ x 20 ⁷/₈ (53 x 53)
Reverse: *Krestianka Suprematury; 684 12 x 12;* also: stamp of IZO Narkompros, *MB IZO*
Stretcher: *Dlia zhurnala klishe cherez setku* (For journal negative through screen)
Reverse: label from Museum of Artistic Culture: *M.Kh.K. 390;* label of 1932–1933 Leningrad exhibition: *No. 2341*

State Russian Museum, inv. no. ZhB–1643. Acquired from Museum of Artistic Culture, Leningrad, 1926.

Exhibitions
Petrograd 1915–1916, no. 43, *Painterly Realism of a Peasant Woman in Two Dimensions* (Zhivopisnyi realizm krestianki v 2-kh izmereniiakh); Moscow 1917(?), possibly one of nos. 140–199, all titled *Suprematism of Painting* (Suprematizm zhivopisi); Moscow 1919(?), possibly one of nos. 140–155, all titled *Suprematism;* Moscow 1919–1920 (visible in inst. phot.); Moscow 1929(?) (no. 19, *Red Square on a White Background* [Krasnyi kvadrat na belom], on artist's list of exhibited works; Tretiakov Gallery, Manuscript Section, f. 8/II/286); Leningrad 1932–1933, no. 1238, *Red Square. 1913.*

▪ **52 Four Squares** *Chetyre kvadrata,* 1915
Oil on canvas
19 ¹/₄ x 19 ¹/₄ (49 x 49)

A. N. Radishchev State Art Museum, Saratov, inv. no. Zh–1089. Acquired from State Museum Fund, 1929.

53 Suprematism: Nonobjective Composition, 1915(?)
Oil on canvas
31 ¹/₂ x 31 ¹/₂ (80 x 80)

Sverdlovsk Art Gallery, inv. no. Zh–397. Acquired from Sverdlovsk Ethnographic Museum, 1936.

Exhibition
Moscow, *Jack of Diamonds,* December 1916 (see Kanae Yamamoto, "Kiro no bijutsu jo hakken," *Bijutsu* 1, no. 5 [March 1917]: 1–7, for a discussion of the exhibition and a sketch of the Sverdlovsk painting)

The picture's orientation here corresponds to that of Yamamoto's sketch made at the 1916 *Jack of Diamonds* exhibition. Whether Malevich specified the orientation on that occasion is not known.

The painting was sent, as part of the Narkompros program, to Ekaterinburg (Sverdlovsk) in January 1920 (see Avtonomova, no. 20).

54 Suprematism, 1915
Oil on canvas
34 ⁷/₁₆ x 28 ⁵/₁₆ (87.5 x 72)
Reverse: *464 M.Kh.K.*
Stretcher: *N[izhnii] Novgorod* (Lower Novgorod)
Reverse: label from Museum of Artistic Culture: *M.Kh.K. 464;* formerly on reverse, label of 1932–1933 exhibition with *no. 2347*

State Russian Museum, inv. no. ZhB–1332. Acquired from Museum of Artistic Culture, Leningrad, 1926.

Exhibitions
Petrograd 1915–1916, one of nos. 48–59, all titled *Painterly Masses in Motion* (Zhivopisnye massy v dvizhenii) (also visible in inst. phot.); Moscow 1917(?), possibly one of nos. 140–199, all titled *Suprematism of Painting* (Suprematizm zhivopisi); Moscow 1919 (?), possibly one of nos. 140–155, all titled *Suprematism;* Moscow 1929 (?), possibly one of several works titled *Suprematism* on artist's list of exhibited works (Tretiakov Gallery, Manuscript Section, f. 8/II/286); Leningrad 1932–1933 *(hors catalogue)*

55 Suprematism, 1915
Oil on canvas
31 ⁵/₈ x 31 ⁷/₈ (80.5 x 81)
Reverse: *512 Malevich* [old orthography] *18 x 18* ["512" is Narkompros inventory number; see Avtonomova, no. 12]
Reverse: label for 1932–1933 Leningrad exhibition with *no. 2345*

State Russian Museum, inv. no. ZhB–1408. Acquired from State Tretiakov Gallery, 1929.

Exhibitions
Moscow 1917(?), possibly one of nos. 140–199, all titled *Suprematism of Painting* (Suprematizm zhivopisi); Moscow 1919(?), possibly one of nos. 140–155, all titled *Suprematism;* Moscow 1929(?) (possibly one of several works titled

Suprematism on artist's list of exhibited works; Tretiakov Gallery, Manuscript Section, f. 8/II/286); Leningrad 1932–1933 (visible in inst. phot.; exhibition label on reverse)

The picture was assigned to the Museum of Painterly Culture, Moscow, in 1920. In 1929 it was accessioned by the State Tretiakov Gallery and subsequently transferred to the State Russian Museum. It has been published as *Dynamic Color Composition* (see Andersen 1970, 31).

▪ **56 Yellow and Black (Supremus No. 58),** 1916
Oil on canvas
31¹/₂ x 27³/₄ (80 x 70.5)
Reverse: *Sup* [Latin letters] *No. 58* [crossed out] *K.M. 182 16 x 18* ("182" is Narkompros inventory number; see Avtonomova, no. 6)
Labels on stretcher: *M.Kh.K. 391* (Museum of Artistic Culture 391); *No. 42 Malevich; No. 4084* (from 1932–1933 Leningrad exhibition)

State Russian Museum, inv. no. ZhB–1687. Acquired from Museum of Artistic Culture, Leningrad, 1926.

Exhibitions
Moscow 1917(?), possibly one of nos. 140–199, all titled *Suprematism of Painting* (Suprematizm zhivopisi); Moscow 1919(?), possibly one of nos. 140–155, all titled *Suprematism;* Moscow 1929(?) (included, with its former inventory number, 4084, on the artist's list of exhibited works; Tretiakov Gallery, Manuscript Section, f. 8/II/286); Leningrad 1932–1933 (visible in inst. phot.; exhibition label formerly on reverse; *hors catalogue)*

In June 1919 the painting was received by Boris Ternovets, curator of the Second Museum of New Western Art, and in July 1921 it was transferred to the Petrograd Museum of Artistic Culture by Natan Altman. The work has been published as *Supremus No. 58, Dynamic Composition, Yellow and Black* (see Andersen 1970, 29).

57 Suprematist Painting, 1917
Oil on canvas
38 x 25 ¹¹/₁₆ (96.5 x 65.4)
Andersen 1970, no. 61

Collection, The Museum of Modern Art, New York.

Exhibitions
Moscow 1919–1920 (visible in inst. phot.); Warsaw 1927 (visible in inst. phot.); Berlin 1927 (visible in inst. phot.)

58 Suprematist Painting, 1917–1918
Oil on canvas
41³/₄ x 27³/₄ (106 x 70.5)
Reverse (presumably by artist): *K Malevich*
Andersen 1970, no. 65

Stedelijk Museum, A7670. Acquired from Hugo Häring, 1958.

Exhibition
Berlin 1927(?) (see cat. 5)

59 Suprematist Painting, 1917–1918
Oil on canvas
38³/₁₆ x 27⁹/₁₆ (97 x 70)
Andersen 1970, no. 63

Stedelijk Museum, A7665. Acquired from Hugo Häring, 1958.

Exhibitions
Warsaw 1927 (visible in inst. phot.); Berlin 1927 (visible in inst. phot.)

See Catalogue 148 for a drawing related to this painting.

60 Suprematist Painting, 1917–1918
Oil on canvas
38³/₁₆ x 27⁹/₁₆ (97 x 70)
Andersen 1970, no. 64

Stedelijk Museum, A7666. Acquired from Hugo Häring, 1958.

Exhibitions
Moscow 1919–1920 (visible in inst. phot.); Berlin 1927 (visible in inst. phot.)

61 White Square on White, 1918
Oil on canvas
31 x 31 (78.7 x 78.7)
Andersen 1970, no. 66

Collection, The Museum of Modern Art, New York.

Exhibitions
Moscow 1919–1920 (visible in inst. phot.); Berlin 1927 (visible in inst. phot.)

In the 1919 exhibition this work was hung with the present lower edge at the top. It is not clear that Malevich was fully consulted about this installation. Whether he changed his mind about the orientation of some of his Suprematist works is not documented.

The painting has been relined, but an x-ray reveals that the composition was painted over an earlier Suprematist work.

▪ **62 Black Square** *Chernyi kvadrat,* ca. 1923
Oil on canvas
41¹¹/₁₆ x 41¹¹/₁₆ (106 x 106)
Reverse: *K Malevich 1913*
Stretcher: *K Malevich Square No. 1; No. 30*
Formerly on reverse: label with *XIV^eme Exposition Internationale des Beaux Arts, Venice, 1924. K. S. Malevich The basic form/square type/ 1 ar 7 ¹/₂ x 1 ar 8V*

State Russian Museum, inv. no. Zh–9484. Acquired on loan from artist's family, 1936. Transferred to permanent collection by order of Ministry of Culture USSR, 1977.

Exhibition
Venice 1924, no. 111, *Suprematisme: forma quadrata*

▪ **63 Black Cross** *Chernyi krest,* ca. 1923
Oil on canvas
41¹¹/₁₆ x 41¹¹/₁₆ (106 x 106)
Reverse: *K Malevich 1913 god Suprematizm* (K Malevich 1913 Suprematism); *K Malevich*
Stretcher: *K Malevich No. 2; No. 29*

State Russian Museum, inv. no. Zh–9485. Acquired on loan from artist's family, 1936. Transferred to permanent collection by order of Ministry of Culture USSR, 1977.

Exhibition
Venice 1924, no. 112, *Suprematisme: forma croce*

▪ **64 Black Circle** *Chernyi krug,* ca. 1923
Oil on canvas
41³/₈ x 41³/₈ (105 x 105)
Reverse: *K Malevich 1913*
Stretcher: *verkh No. 3 krug* (top No. 3 circle); also *No. 31*
Formerly on reverse: from 1924 Venice exhibition label with *osnovnaia ploskost (vid kruga) 1913 r* (basic plane in the form of a circle)

State Russian Museum, inv. no. Zh–9472. Acquired on loan from artist's family, 1936. Transferred to permanent collection by order of Ministry of Culture USSR, 1977.

Exhibitions
Venice 1924, no. 113, *Suprematisme: forma rotonda;* Moscow 1929 (no. 46, "Basic plane viewed as a circle" [osnovnaia ploskost v vide kruga] on the artist's list of exhibited works; Tretiakov Gallery, Manuscript Section, f. 8/II/286)

According to the recollections of Konstantin Rozhdestvensky (in conversation with Elena Basner, 1988) and of Anna Leporskaia (in conversation with Troels Andersen, 1971), Catalogue Numbers 62–64 were executed in the State Institute of Artistic Culture ([G]INKhUK) by Malevich's students

Leporskaia, Rozhdestvensky, Nikolai
Suetin, and Lev Yudin.

65 Suprematist Painting, before 1927
Oil on canvas
33 1/8 x 27 3/8 (84 x 69.5)
Andersen 1970, no. 69

Stedelijk Museum, A7662. Acquired from
Hugo Häring, 1958.

Exhibition
Berlin 1927 (visible in inst. phot.)

As Andersen has noted (1970, 99, no. 69),
this composition was painted over a 1916
Suprematist work recorded in a drawing
(Andersen 1970, no. 92).

66 Suprematist Painting, before 1927
Oil on canvas
34 5/8 x 27 (88 x 68.5)
Andersen 1970, no. 70

Stedelijk Museum, A7667. Acquired from
Hugo Häring, 1958.

Exhibition
Berlin 1927 (visible in inst. phot.)

67 Suprematist Painting, ca. 1927
Oil on canvas
28 1/2 x 20 1/8 (72.5 x 51)
Andersen 1970, no. 72

Stedelijk Museum, A7669. Acquired from
Hugo Häring, 1958.

Exhibition
Berlin 1927(?) (see cat. 5)

▪ **68 Black Square** *Chernyi kvadrat,* 1929
Oil on canvas
31 5/16 x 31 5/16 (79.5 x 79.5) (irregular)
Reverse: *suprematizm 1913 g nachalnyi
element vpervye vyiavilsia v pobede nad
solnts* [old orthography] (Suprematism
1913 the initial element first appeared in
victory over the sun)
Stretcher: stamp from 1932–1933
Leningrad exhibition
Stretcher: paper label from Department
of Visual Arts People's Commissariat for
Enlightenment (IZO Narkompros).
Exhibition of works of art, with penciled
notation *F. No. 684* and half-preserved
signature *Malevich.* ("F. No. 684" refers
to 1919–1920 Narkompros inventory of
works distributed to central and provincial
museums. Label apparently removed at
some stage from stretcher of 1915 *Black
Square,* State Tretiakov Gallery, inv. no.
11925, and attached to 1929 version; see
Avtonomova, no. 13.)

State Tretiakov Gallery, inv. no. 21987.
Purchased from Moscow exhibition *Artists
in the RSFSR over the Last 15 Years,* 1934.

Exhibition
Leningrad 1932–1933, no. 1237, traveled
to Moscow in June 1933 *(hors catalogue)*

The present work is a repetition of the
original *Black Square* (Tretiakov Gallery,
oil on canvas, 79.2 x 79.5 cm), shown
in the December 1915 *0.10* exhibition,
Malevich's first public presentation of his
Suprematist work (see fig 38).
 The earlier version of *Black Square*
(though in very stable condition) has
extensive surface drying cracks, the result
of having been painted over another
work; these cracks would have developed
within ten years after *Black Square* was
completed (see study by Lukanova and
Vikturina). Thus, when art historian Alexei
Fedorov-Davydov was organizing a large
exhibition of Malevich's work in 1929,
he may well have asked the artist to paint
a new version of this important painting.
 In the 1929 exhibition *Black Square*
carried the date 1913, and Malevich fre-
quently recorded this as the date of origin
for his radical motif, relating it to the drop
curtain for *Victory over the Sun.* No docu-
mentary evidence supporting such an
early date for the first Suprematist paint-
ings has been located, however. Nikolai
Khardzhiev takes the convincing position
(shared by many other scholars) that the
"first truly Suprematist constructions
should be dated May 1915." Khardzhiev
cited as partial evidence a letter from
Malevich to Matiushin, dated 27 May
1915, in which the artist sent a number
of drawings for the second (unrealized)
edition of Kruchenykh's libretto. One
of these sketches was a curtain design
depicting a black square, of which
Malevich wrote: "This drawing will have
great significance for painting; what has
been done unconsciously is now bearing
extraordinary fruit" *(K istorii russkogo
avangarda* [Stockholm, 1976], 95).

▪ **69 Haymaking** *Na senokose,* ca. 1928
Oil on canvas
33 3/4 x 25 5/16 (85.8 x 65.6)
Lower right: *K. Malevich motiv* [old
orthography] *1909* (K Malevich motif 1909)

State Tretiakov Gallery, inv. no. 10612.
Acquired from artist, 1929.

Exhibitions
Moscow 1929 (no. 15 on artist's list of
exhibited works; Tretiakov Gallery, Manu-
script Section, f. 8/II/286). (According to
archival sources, the present painting was
borrowed from the Tretiakov on 10 Octo-
ber 1932 for display at the 1932–1933
Leningrad exhibition. On 21 October 1932,
however, for reasons not recorded, it
was returned to the Tretiakov before the
opening of the exhibition [Central State
Archives of Literature and Art, f. 643,
op. I e/x II].)

The painting is a free adaptation of the
1912 painting *Man with a Scythe* (Kosar),
which appeared in a number of exhibi-
tions in 1912–1913. This later version was
first shown in the 1929 Moscow exhibi-
tion, and reproduced in the accompanying
pamphlet by Alexei Fedorov-Davydov with
the date 1911. Troels Andersen (1970, 21)
originally suggested a date of 1911(?) but
now accepts a date of about 1927–1929.
Charlotte Douglas was the first to suggest
1928–1929, a date now widely accepted
("Malevich's Paintings—Some Problems
of Chronology," *Soviet Union* 5, pt. 2
[1978]: 306–307).

▪ **70 Going to the Harvest. Marfa and Vanka** *Na
zhatvu. Marfa i Vanka,* ca. 1928
Oil on canvas
32 1/4 x 24 (82 x 61)
Lower right: *K Malevich*
Reverse: *No. 14 1909–10/Na zhatvu*
Stretcher: *Malevich*

State Russian Museum, inv. no. Zh–9492.
Acquired on loan from artist's family, 1936.
Transferred to permanent collection by
order of Ministry of Culture USSR, 1977.

Exhibitions
Moscow 1929 (no. 33, *Going to the
Harvest .3600,* on artist's list of exhibited
works; Tretiakov Gallery, Manuscript
Section, f. 8/II/286); Leningrad 1932–
1933, no. 1247, *Harvest* (also visible in
inst. phot.)

Going to the Harvest is a late version of a
1912 painting (present location unknown;
Andersen 1970, 21) first shown in the
1912–1913 St. Petersburg *Union of Youth*
exhibition (no. 35, *In the Field*) (fig. 5).
As in the case of the early version of
Perfected Portrait of I. V. Kliun (cat. 29),
a careful drawing of this early version
appears in Alexander Benois' annotated
copy of the 1912 catalogue.

▪ **71 Girls in the Field** *Devushki v pole,* ca. 1928
Oil on canvas
41 3/4 x 49 1/4 (106 x 125)
Reverse: *1912 Devushki v pole*
Stretcher: *K Malevich Devushki v pole
1912 g No 26 "Supronaturalizm"*
(K Malevich Girls in the field 1912
No. 26 "Supronaturalism")

State Russian Museum, inv. no. 9433.
Acquired on loan from artist's family, 1936.
Transferred to permanent collection by
order of Ministry of Culture USSR, 1977.

Exhibitions
Moscow 1929(?) (possibly no. 22 or 41,
both titled *Three Female Figures* [Tri
zhenskie figury], on the artist's list of
exhibited works; Tretiakov Gallery, Manu-
script Section, f. 8/II/286); Leningrad
1932–1933 (visible in inst. phot.)

• 72 **Head of a Peasant** *Golova krestianina,*
ca. 1928
Oil on plywood
28 1/4 x 21 1/8 (71.7 x 53.8)
Reverse: *Malevich I No. 13 1910 g
Golova krestianina*

State Russian Museum, inv. no. 9488.
Acquired on loan from artist's family, 1936.
Transferred to permanent collection by
order of Ministry of Culture USSR, 1977.

Exhibition
Moscow 1929(?) (possibly no. 63 or 64,
both titled *Head of a Peasant,* on artist's
list of exhibited works; Tretiakov Gallery,
Manuscript Section, f. 8/II/286)

• 73 **Peasant Woman** *Krestianka,* ca. 1928
Oil on canvas
38 3/4 x 31 1/2 (98.5 x 80)
Lower left: *K. Malevich*
Lower right: *1913*
Stretcher: *K. Malevich*

State Russian Museum, inv. no. Zh–9388.
Acquired on loan from artist's family, 1936.
Transferred to permanent collection by
order of Ministry Culture USSR, 1977.

• 74 **Female Portrait** *Zhenskii portret,* ca. 1928
Oil on plywood
22 7/8 x 19 1/4 (58 x 49)
Lower left: *KM*
Reverse: *Malevich Malewicz Motiv 1909
god* (K Malevich Malewicz Motif of 1909)
[date corrected and "1919" entered in red
ink above] and *Pisano kraskami Dosekina
Pol Veronez, belilo kadmii rozovaia
Polikap "Elido duncel"* (Painted with
Dosekin's Paolo Veronese paints, egg-
white cadmium pink Polikap "Elido
duncel"); added above: *Zhenskii portret*

State Russian Museum, inv. no. Zh–9440.
Acquired on loan from artist's family, 1936.
Transferred to permanent collection by
order of Ministry of Culture USSR, 1977.

Exhibitions
Moscow 1929(?) (possibly no. 25, *Female
Portrait* [Zhenshchiny portret], or no. 29,
Motif of 1909. Head. 3596 [Motiv 1909-ogo
goda. Golova. 3596], on artist's list of
exhibited works; Tretiakov Gallery, Manu-
script Section, f. 8/II/286); Leningrad
1932–1933, no. 1250, *Portrait of a Woman*
(also visible in inst. phot.)

• 75 **Sportsmen** *Sportsmeny,* ca. 1928
Oil on canvas
55 3/4 x 64 5/8 (142 x 164)
Lower left: *K Malevich*
Lower right: *K Mal*
Reverse: *Sportsmen K Mal;* above this:
*Suprematizm v konture "sportsmenov"
1915 go K* [letters missing] (Suprematism
within the contours of the "sportsmen" of
the year 1915 K [letters missing])

Reverse: label from 1932–1933
Leningrad exhibition

State Russian Museum, inv. no. Zh–9439.
Acquired on loan from artist's family, 1936.
Transferred to permanent collection by
order of Ministry of Culture USSR, 1977.

Exhibition
Leningrad 1932–1933, no. 1255 (also
visible in inst. phot.)

• 76 **Woman with a Rake** *Zhenshchina s
grabliami,* ca. 1928–1932
Oil on canvas
39 3/8 x 29 1/2 (100 x 75)
Lower right: *KM* [illegible]
Reverse: *Moskva KM 1915 g.
Suprematizm No. 6 v konture krestianki*
(Moscow KM 1915. Suprematism No. 6
within the contours of a peasant woman)

State Tretiakov Gallery, inv. no. 22571.
Acquired from artist, 1933, from
Leningrad exhibition *Artists in the RSFSR
over the Last 15 Years.*

Exhibition
Leningrad 1932–1933, no. 1256, *Woman
with a Rake. Color Composition*
(Zhenshchina s grabliami. Tsvetnaia
compozitsiia) (also visible in inst. phot.)

This work was first dated about 1930 by
Charlotte Douglas ("Beyond Suprematism
—Malevich: 1927–1933," *Soviet Union* 7,
pts. 1–2 [1980] 214–227). The motif
used here as the basis for depicting the
woman's body is clearly related to Male-
vich's studies for Suprematist clothing dat-
ing from 1923 (see, for example, *Design
for a Suprematist Dress,* State Russian
Museum, Leningrad, inv. no. /Rs979/;
reproduced in *Kazimir Malevich,* exh. cat.
[1988–1989], 250, no. 171).
 Malevich must have been referring
to *Woman with a Rake* (the only picture
purchased by the Tretiakov at this time)
in a letter of 24 December 1932 to Alexei
Volter, director of the Tretiakov Gallery.
Bargaining for a higher price than had
been offered initially, he argued that with-
out at least 1,500 rubles he could not
continue his work: "Com[rade] Volter I'd
have to be paid more rubles well at least
1500r after all You are the only buyer
there is no one else to sell to, and I have
to work It has to be sold so that it's pos-
sible to paint another few works on that
money. therefore I am sending this bill
since I have no choice, but still you should
give this some thought, that now this is
too little. I shake your hand K Malevich"
[Lack of punctuation is characteristic of
Malevich's writing style].
 The original letter carries a handwritten
marginal note by Volter giving orders to
solve this problem (Central State Archives
of Literature and Art, f. 990, op. I e/x 145).

• 77 **Red Cavalry** *Krasnaia konnitsa,*
ca. 1928–1932
Oil on canvas
35 7/8 x 55 1/8 (91 x 140)
Lower left: *K Malevich*
Lower right: *18 god [19]18*
Reverse: *Skachet krasnaia konnitsa/iz
oktiabrskoi stolitsy./na zashchitu
sovetskoi granitsy* (The red cavalry
gallops/from the capital of [the] October
[Revolution]/to defend the Soviet border)

State Russian Museum, inv. no. Zh–9435.
Acquired on loan from artist's family, 1936.
Transferred to permanent collection by
order of Ministry of Culture USSR, 1977.

Exhibition
Leningrad 1932–1933, no. 1254 (also
visible in inst. phot.)

• 78 **Half-length Figure ("Prototype" of a New
Image)** *Tors/ Pervoobrazovanie novogo
obraza,* ca. 1928–1932
Oil on canvas
18 1/8 x 14 1/2 (46 x 37)
Lower right: *KM*
Lower left: *1910*
Reverse: *No. 3 "pervo-obrazovanie
novogo obraza/problema/tsvet i forma/i/
soderzhanie"* (No. 3 "prototype of a new
image"/problem/color and form/and/
content); also *Tors* (Torso)
Stretcher: *No 3 K Malevich*

State Russian Museum, inv. Zh–9400.
Acquired on loan from artist's family, 1936.
Transferred to permanent collection by
order of Ministry of Culture USSR, 1977.

Exhibitions
Moscow 1929(?) (possibly no. 36,
Female Torso [Zhenskii tors], 1910, on
artist's list of exhibited works; Tretiakov
Gallery, Manuscript Section, f. 8/II/286);
Leningrad 1932–1933, no. 1248, *Color
Composition. Female Torso on a Blue
Background* (Tsvetnaia kompozitsiia.
Zhenskii tors na golubom) (also visible in
inst. phot.)

• 79 **Three Female Figures** *Tri zhenskie figury,*
ca. 1928–1932
Oil on canvas
18 1/2 x 25 (47 x 63.5)
Lower left: *K. Malewicz*
Lower right: *14r [1914]*
Reverse: *K Malevich 1918; esk[iz]*
(ske[tch])
Stretcher: *K Malevi; K Malevich*

State Russian Museum, inv. no. Zh–9471.
Acquired on loan from artist's family, 1936.
Transferred to permanent collection by
order of Ministry of Culture USSR, 1977.

Exhibitions
Moscow 1929(?) (possibly no. 22 or 41,
both titled *Three Female Figures,* on

artist's list of exhibited works; Tretiakov Gallery, Manuscript Section, f. 8/II/286); Leningrad 1932–1933, no. 1253, *Color Composition. Three Figures* (Tsvetnaia kompositsiia. Tri figury) (also visible in inst. phot.)

▪ **80 Complex Premonition (Half-Figure in a Yellow Shirt)** *Slozhnoe predchuvstvie (tors v zheltoi rubashke),* ca. 1928–1932
Oil on canvas
39 x 31¹/₈ (99 x 79)
Reverse: *K Malewicz Slozhn/oe/ predchuvstvie 1928–1932 g Kompositsiia slozhilas iz elementov oshchushcheniia pustoty, odinochestva, besvykhodnosti zhizni 1913 g. Kuntsevo* (K Malevich Complex Premonition 1928–1932 The composition coalesced out of elements of the sensation of emptiness, of loneliness, of hopelessness [exitlessness] of life 1913 Kuntsevo)

State Russian Museum, inv. no. Zh–9477. Acquired on loan from artist's family, 1936. Transferred to permanent collection by order of Ministry of Culture USSR, 1977.

Malevich's inscription, giving two widely divergent dates for the work — 1928–1932 and 1913 — suggests an attempt to offer a logical explanation for the dual dating of the entire cycle of works painted in the late twenties and early thirties but recalling themes of the first decades of the century. For a discussion of some of the questions raised by this problem, see Charlotte Douglas, "Malevich's Painting — Some Problems of Chronology," *Soviet Union* 5, pt. 2 (1978): 301–326.

▪ **81 Suprematism. Female Figure** *Suprematizm. Zhenskaia figura,* ca. 1928–1932
Oil on canvas
49⁵/₈ x 41³/₄ (126 x 106)
Stretcher: *Suprematizm* [old orthography] *No. 35 1915 g figur* (Suprematism No. 35 1915 figure)

State Russian Museum, inv. no. Zh–9493. Acquired on loan from artist's family, 1936. Transferred to permanent collection by order of Ministry of Culture USSR, 1977.

Exhibition
Moscow 1929(?) (possibly no. 40, *Full Figure* [Polnaia figura] or *Full-Length Female Figure,* 1916, or no. 56, *Female Figure,* on artist's list of exhibited works; Tretiakov Gallery, Manuscript Section, f. 8/II/286)

Traces of an earlier composition (two Suprematist figures) can be seen beneath the white background.

▪ **82 Peasants** *Krestiane,* ca. 1928
Oil on canvas
30¹/₂ x 34⁵/₈ (77.5 x 88)
Lower right: *K Malev*
Stretcher: *1909 "Krestiane" No. 18* and *Malevich*

State Russian Museum, inv. no. Zh–9480. Acquired on loan from artist's family, 1936. Transferred to permanent collection by order of Ministry of Culture USSR, 1977.

Exhibition
Moscow 1929 (?) (possibly *Peasants* on artist's list of exhibited works; Tretiakov Gallery, Manuscript Section, f. 8/II/286)

▪ **83 Half-length Figure** *Tors,* ca. 1928–1932
Oil on canvas
28³/₈ x 25⁵/₈ (72 x 65)
Lower left: *1910 Moskva* (1910 Moscow)
Lower right: *K Mal*
Reverse: *1910 g Tors* (1910 Half-length Figure)
Stretcher: *Malevich*

State Russian Museum, inv. no. Zh–9470. Acquired on loan from artist's family, 1936. Transferred to permanent collection by order of Ministry of Culture USSR, 1977.

Exhibition
Moscow 1929 (?) (possibly no. 27, 1915, or no. 36, 1910, both titled *Female Torso* [Zhenskii tors], on artist's list of exhibited works; Tretiakov Gallery, Manuscript Section, f. 8/II/286)

▪ **84 Red House** *Krasnyi dom,* ca. 1932
Oil on canvas
24³/₄ x 25⁵/₈ (63 x 65)
Reverse: *"Krasnyi dom" 1932 K Malevich*

State Russian Museum, inv. no. Zh–9438. Acquired on loan from artist's family, 1936. Transferred to permanent collection by order of Ministry of Culture USSR, 1977.

Exhibition
Leningrad 1932–1933, no. 1251 (also visible in inst. phot.)

An x-ray made by the State Russian Museum reveals that the present composition was painted over a portrait of a man.

▪ **85 Flower Girl** *Tsvetochnitsa,* ca. 1929–1930(?)
Oil on canvas
31¹/₂ x 39³/₈ (80 x 100)
Lower right: *K Malevich* [old orthography] *1903*
Reverse: label from 1932–1933 Leningrad exhibition: *No. 2328;* a second label (torn): *No. 176 OT 14/12/1930* [acquisition number and date]

State Russian Museum, inv. no. ZhB–1502. Acquired from artist, 1930.

Exhibition
Leningrad 1932–1933 (hors catalogue)

▪ **86 Reapers** *Zhnitsy,* ca. 1929–1932 (?)
Oil on wood
28 x 40⁵/₈ (71 x 103.2)
Lower right: *K Malevich*
Reverse: *Malevich "Zhnitsy" 1905*

State Russian Museum, inv. no. Zh–9450. Acquired on loan from artist's family, 1936. Transferred to permanent collection by order of Ministry of Culture USSR, 1977.

▪ **87 Girl with a Comb in Her Hair** *Devushka s grebnem v volosakh,* 1932–1933
Oil on canvas
13⁷/₈ x 12³/₁₆ (35.5 x 31)
Lower left: *K Malevich 32*
Reverse: *No. 6* ["4" just visible under "6"] *Eskiz k portretu/abstraktnyi/1933 K Malevich* (Study for a portrait/abstract/ 1933 K Malevich)
Stretcher: stamp of 1932–1933 Leningrad exhibition

State Tretiakov Gallery, inv. no. 20843. Acquired from artist, 1934, from Moscow exhibition *Artists in the RSFSR over the Last 15 Years.*

Exhibition
Leningrad 1932–1933, *Study for a Portrait. Abstract* (Eskiz portreta. Abstrakt) on preliminary list of works submitted by artist to exhibition (Central State Archives of Literature and Art, f. 643, op. I. e/x II, 15); included *hors catalogue* in Moscow showing of exhibition (see Central State Archives of Literature and Art, f. 643, op. I. e/x 15, for evidence regarding works shown in Moscow exhibition)

▪ **88 Girl with a Red Staff** *Devushka s krasnym drevkom,* 1932–1933
Oil on canvas
27¹⁵/₁₆ x 24 (71 x 61)
Lower left: a monogram (black square) and *K Malevich*
Lower right: *32g* (1932)
Reverse: *No. 8 "Devushka s krasnym drevkom" 1933 K Malevich*
Stretcher: stamp of 1932–1933 Leningrad exhibition

State Tretiakov Gallery, inv. no. 22570. Acquired from artist, 1934, from Moscow exhibition *Artists in the RSFSR over the Last 15 Years.*

Exhibition
Leningrad 1932–1933(?), no. 275, *Female Portrait* (Zhenskii portret), on preliminary list of works submitted by artist to exhibition (Central State Archives of Literature and Art, f. 643, op. I. e/x II, 15); included *hors catalogue* in Moscow showing of exhibition (see Central State Archives of Literature and Art, f. 643,

op. I. e/x 15, for evidence regarding works shown in Moscow exhibition)

The subject of the painting resembles Angelika Andreevna Vorobeva (sister of Malevich's wife, Natalia Andreevna). The identity of the sitter has been corroborated by Vorobeva herself, by Malevich's daughter Una Uriman, and — in conversation with Troels Andersen — by Anna Leporskaia. In a photograph taken on 3 April 1933 (fig. 41) Malevich is still at work on the portrait though it is already framed. He substantially altered the work after this photograph was taken, possibly between the Leningrad exhibition of 1932–1933 and that held in Moscow later in 1933.

■ 89 **Portrait of the Artist's Wife** *Portret zheny khudozhnika,* 1933
Oil on canvas
26 ⁵/₈ x 22 (67.5 x 56)
Lower left: a monogram (black square)
Lower right: *33 g* ([19]33)

Reverse: *No. 9 Zhenskii portret N. M. K. Malevich. 1933* (No. 9 Female portrait N. M. K. Malevich. 1933)
Formerly on reverse (now lost): label from State Russian Museum with 60

State Russian Museum, inv. no. ZhB–1572. Acquired from artist, 1934.

Exhibition
Leningrad, State Russian Museum, *Woman in Socialist Development,* 1934 (?), no. 99, *Female Portrait* (Zhenskii portret)

The subject is Natalia Andreevna Malevich, née Manchenko (born 1902).

■ 90 **Male Portrait (N. N. Punin)** *Muzhskoi portret,* 1933
Oil on canvas
27 ¹/₂ x 22 ³/₈ (70 x 57)
Lower left: a monogram (black square); *K.33*
Stretcher: *K. Malevich*
Reverse: label from 1935 Leningrad exhibition
State Russian Museum, inv. no. ZhB–1517. Acquired from Leningrad City Council, 1940.

Exhibition
Leningrad, State Russian Museum, *First Exhibition of Leningrad Artists,* 1935, no. 275, *Portrait of a Man* (Muzhchiny portret)

Nikolai Nikolaevich Punin (1888–1953) was an influential art critic who lectured and published widely on modern art between 1918 and 1930. An editor of the leftist periodical *Iskusstvo kommuny,* he

published an important monograph on Tatlin in 1921.

Although this work was in the 1935 exhibition as *Portrait of a Man,* the sitter has long been identified (by Nikolai Khardzhiev and Anna Leporskaia) as Punin.

■ 91 **Self-Portrait** *Avtoportret,* 1933
Oil on canvas
28 ³/₄ x 26 (73 x 66)
Lower right: a monogram (black square)
Reverse: a monogram (black square); *Malewicz 1933 Leningrad "Khudozhnik"* ("The Artist")

State Russian Museum, inv. no. ZhB–1516. Acquired from artist's family, 1935.

Drawings and Watercolors

92 **Shroud of Christ** *Plashchanitsa,* 1908
Gouache on cardboard
9 ³/₁₆ x 13 ¹/₂ (23.4 x 34.3)
Lower left: *Kazmir Malevich 1908*
Verso: fragmentary watercolor and pencil sketch for a portrait of a man

State Tretiakov Gallery, inv. no. P46845. Gift of George Costakis, 1977.

93 **Plowman** *Pakhar,* 1910–1911
Graphite pencil on paper
7 ⁹/₁₆ x 8 ⁹/₁₆ (19.2 x 21.9)
Lower right: *K Mal*
Verso along lower edge (not in artist's hand): *K. S. Malevich* [old orthography] *1912./Vystavka "S. M."* [Soiuz Molodezhi] and *K. S. Malevich 1912* (K. S. Malevich 1912/Exhibition "U.Y." [Union of Youth])

State Russian Museum, inv. no. RB–7661. Acquired from Levkii Zheverzheev, 1928.

Exhibition
St. Petersburg, 1912–1913, one of nos. 38–43, listed as "Studies"

The handwriting on the verso is that of Levkii Ivanovich Zheverzheev (1881–1942), president of the Union of Youth and a supporter of *Victory over the Sun.* The large group of drawings of this period, which he gave to the Russian Museum in 1928 (all in present exhibition, cat. nos. 93–103, 105–108), may well have been acquired directly from the 1912–1913 *Union of Youth* exhibition; they may even have been given to Zheverzheev by Malevich for his generosity in absorbing the costs of the ventures. Several of these drawings are directly related to paintings shown in that exhibition or in the immediately preceding *Contemporary Art. First*

Exhibition. Whether they are preparatory drawings, or possibly records of paintings already completed, is not certain.

94 **Two Men Pulling a Handcart** *Dvoe s ruchnoi telezhkoi,* 1910–1911
Graphite pencil on paper
5 ⁹/₁₆ x 5 (14.1 x 12.8)
Lower right: *Kazmir Malevich* [old orthography]

State Russian Museum, inv. no. R–25050. Acquired from Levkii Zheverzheev, 1928.

Study for (?) the painting *Greenhouses/Earth Carriers* (Teplitsky/Perenoshchiki zemli), 1911 (present location unknown; reproduced Andersen 1970, no. 4).

95 **Houses** *Doma,* 1910–1911
Graphite pencil on paper
6 ³/₈ x 6 ¹/₄ (16.2 x 15.9)
Verso: a rough sketch of a woman bathing a child.

State Russian Museum, inv. no. R–25045. Acquired from Levkii Zheverzheev, 1928.

Study for (?) the large gouache *Village* (Derevnia), ca. 1911 (Kunstmuseum, Basel; reproduced Andersen 1970, 81, no. 5).

96 **House with a Fence** *Doma v ograde,* 1910–1911
Graphite pencil on paper
6 ¹⁵/₁₆ x 6 ³/₄ (17.7 x 17.2)
Lower right: *K. Ma*
Verso (not in artist's hand): *K. S. Malevich*

State Russian Museum, inv. no. R–56194. Acquired from Levkii Zheverzheev, 1928.

97 **At the Bathhouse** *V bane,* 1910–1911
Graphite pencil on paper
5 ¹/₄ x 6 ³/₈ (13.3 x 16.2)
Lower right: *K Mal*

State Russian Museum, inv. no. R–25049. Acquired from Levkii Zheverzheev, 1928.

98 **At the Cemetery** *Na kladbishche,* 1910–1911
Graphite pencil on paper
6 x 7 (15.2 x 17.7)
Lower right (not in artist's hand): *K. S. Malevich*

State Russian Museum, inv. no. R–56195. Acquired from Levkii Zheverzheev, 1928.

99 **Harvest** *Zhatva,* 1910–1911
Graphite pencil on paper
3 ⁵/₈ x 5 ¹/₂ (9.2 x 14)

State Russian Museum, inv. no. R–56192. Acquired from Levkii Zheverzheev, 1928.

■ 100 **Bathers** *Kupalshchiki,* 1910–1911
Graphite pencil on paper
8 $^{1}/_{16}$ x 6 $^{3}/_{16}$ (20.4 x 15.8)
Lower left: *bezhit kupatsia* (running off to bathe)
Lower right: *odevaetsia* (getting dressed)

State Russian Museum, inv. no. R–25043.
Acquired from Levkii Zheverzheev, 1928.

The running figure served as a study for (?) *Bather,* 1911 (cat. 18).

101 **Woman in Prayer** *Moliashchaiasia zhenshchina,* 1910–1911
Graphite pencil on paper
7 $^{5}/_{16}$ x 5 $^{9}/_{16}$ (18.6 x 14.2)

State Russian Museum, inv. no. R–25044.
Acquired from Levkii Zheverzheev, 1928.

102 **Woman's Head in Profile** *Zhenskaia golova v profil,* 1910–1911
Graphite pencil on paper
7 $^{5}/_{16}$ x 5 $^{9}/_{16}$ (18.6 x 14.2)
Verso (not in artist's hand): *1912 g. K. S. Malevich* (1912 K. S. Malevich); also a rough sketch of the same subject

State Russian Museum, inv. no. 25047.
Acquired from Levkii Zheverzheev, 1928.

Exhibition
St. Petersburg 1912–1913(?), possibly one of nos. 38–43, listed as "Studies"

103 **Peasant Women at Church** *Krestianki v tserkvi,* 1911
Graphite pencil on paper
8 $^{9}/_{16}$ x 7 $^{1}/_{4}$ (21.9 x 18.4)
Verso (not in artist's hand): *K. S. Malevich* [old orthography]*/1912*

State Russian Museum, inv. no. RB–7662.
Acquired from Levkii Zheverzheev, 1928.

Exhibition
St. Petersburg, 1912–1913(?), possibly one of nos. 38–43, listed as "Studies"

Study for (?) a painting of the same title in the Stedelijk Museum (see verso cat. 23). The inscription, identical to that on *Plowman* (cat. 93), is in Zheverzheev's hand; like *Plowman, Peasant Women at Church* may have been in the *Union of Youth* exhibition.

■ 104 **Face of a Peasant** *Golova krestianina,* ca. 1911(?) or ca. 1929(?)
Graphite pencil on paper
13 $^{7}/_{8}$ x 11 $^{1}/_{4}$ (35.3 x 28.5)
Lower right in pencil: *K Mal*
Upper right, in a different pencil: *Litso krestianina k kartine Pokhorony 1908g.* (Face of peasant for the painting The Funeral 1908)
Below, in a third pencil: *1908 g*

State Tretiakov Gallery, inv. no. 10469.
Acquired from artist, 1929, on the eve of his one-person show.

Exhibition
Moscow 1929(?)

In a 1929 brochure Alexei Fedorov-Davydov ("Tretiakov Gallery Exhibition of K. S. Malevich," p. 6) refers to the two-dimensional nature of Malevich's art, citing *The Head of a Peasant* as an example. He may have been referring to this drawing.
The painting *Peasant Funeral* (present location unknown; Andersen 1970, 85, no. 21) was reproduced in *Ogonek* in connection with a review of the 1912–1913 *Union of Youth* exhibition. Andersen convincingly dated the painting 1911. Although *Face of a Peasant* is clearly related in subject matter to *Peasant Funeral,* its economy of line and abstract formulation (a style very different from that of Malevich's typical drawings of the period, such as *Peasant Women at Church* [cat. 103]) lead to a tentative hypothesis that *Face of a Peasant* might have served as an evocative reminiscence of the early period but actually dates from the late 1920s, perhaps shortly before its acquisition by the Tretiakov Gallery.

■ 105 **Man with a Scythe** *Kosar,* 1912
Watercolor and graphite pencil on paper
6 $^{13}/_{16}$ x 4 $^{9}/_{16}$ (17.4 x 11.6)
Verso (not in artist's hand): *1912. K. S. Malevich*

State Russian Museum, inv. no. R–25046.
Acquired from Levkii Zheverzheev, 1928.

Exhibition
St. Petersburg 1912–1913 (?), possibly one of nos. 38–43, listed as "Studies"

Study for (?) a 1912 painting of same title, acquired in 1921 by the Gorky State Art Museum (inv. no. Zh343). The painting was shown in the 1912–1913 *Union of Youth* exhibition (no. 156) and in the 1913 *Target* exhibition (no. 96).

■ 106 **In the Field** *V pole,* 1911–1912
Graphite pencil on paper
6 $^{1}/_{2}$ x 7 (16.6 x 17.7)

State Russian Museum, inv. no. R–56193.
Acquired from Levkii Zheverzheev, 1928.

One sheet of two studies for (?) a 1912 painting of same title (present location unknown; reproduced in *Ogonek,* no. 1 [1913], n.p. [fig. 5]; and Andersen 1970, 21). This painting was shown in the 1912–1913 *Union of Youth* exhibition.

107 **The Woodcutter** *Drovosek,* 1911–1912
Graphite pencil on paper
6 $^{11}/_{16}$ x 6 $^{15}/_{16}$ (17.1 x 17.7)
Verso (not in artist's hand): *K.S.Malevich*

State Russian Museum, inv. no. R–25048.
Acquired from Levkii Zheverzheev, 1928.

Study for (?) a 1912 painting of same title (cat. 23), shown in the 1912–1913 *Union of Youth* exhibition.

■ 108 **Peasant Woman with Buckets** *Krestianka s vedrami,* ca. 1912
Graphite pencil on paper
4 $^{1}/_{8}$ x 4 $^{3}/_{16}$ (10.5 x 10.7)

State Russian Museum, inv. no. R–56191.
Acquired from Levkii Zheverzheev, 1928.

Study for (?) a 1912 painting of same title (cat. 25), shown in Moscow's *Contemporary Art. First Exhibition,* 1912–1913.

■ 109 **Cubism. Portrait of a Builder** *Kubizm. Portret stroitelia,* 1913
Graphite pencil on paper
19 $^{3}/_{8}$ x 13 $^{1}/_{8}$ (49.6 x 33.4)
Lower right: *1911 K Mal*
Lower edge, below outline: *Kubizm Eskiz k portretu stroitelia. So[versheneishii] [old orthography]* (Cubism Study for portrait of a builder. Most perfected)

State Tretiakov Gallery, inv. no. 10470.
Acquired from artist, 1929, on the eve of his one-person show.

Exhibition
Moscow 1929(?) (although the appearance of the drawing is not documented, its acquisition immediately preceding the exhibition suggests that it was included)

This drawing recapitulates (in virtually every detail) the 1913 *Perfected Portrait of I. V. Kliun* in the State Russian Museum (cat. 29). While it may be a preparatory study, its degree of finish suggests that it is more likely contemporaneous with or even later than the painting.
A lithograph entitled *Portrait of a Builder. Most Perfected* (published in Alexei Kruchenykh and Zina V., *Piglets [Porosiata],* August 1913), dated 1913, is sketchier in technique and lacks detail, suggesting that it preceded both the present drawing and the Leningrad painting. A 1913 date for this drawing is therefore plausible, though the possibility of a later date cannot be excluded.

■ 110 **Cubo-Futurism. Dynamic Sensory Experience of a Model** *Kubofuturizm. Dinamicheskoe oshchushchenie natiurshchika,* ca. 1913(?)
Graphite pencil on paper
24 $^{5}/_{8}$ x 1 $^{5}/_{16}$ (62.4 x 28.7)
Lower right: *K Mal*

215

Below ruled outline: *Kubofuturizm/ Dinamicheskoe oshchushchenie natiurshchika*
Verso: pencil sketches of rectangles, volutes, and a violin fingerboard

State Tretiakov Gallery, inv. no. 10471. Acquired from artist, 1929, on the eve of his one-person show.

Exhibition
Moscow 1929 (?) (although the appearance of the drawing is not documented, its acquisition immediately preceding the exhibition suggests that it was included)

Malevich produced several studies on the theme of the *Dynamic Sensory Experience of a Model,* all of which he dated 1911. Some of these didactic drawings were used in his book *On New Systems in Art,* published in Vitebsk in 1919. The sketches on the verso of the Tretiakov drawing include motifs developed in the 1913 paintings *Cow and Violin* (cat. 32) and *Lady in a Tram* (cat. 35), and *Dynamic Sensory Experience of a Model* clearly cannot have been executed earlier. It seems probable that the work dates from about 1913; however, it should perhaps not be ruled out that Malevich produced this very finished version in about 1919, at the time of the Vitebsk publication.

▪ **111 Death of the Cavalry General** *Smert konnogo generala,* 1914
Pen and ink and graphite pencil on ruled paper
6 5/8 x 4 1/2 (16.8 x 11.5)
Lower right: *K Malevich*
Below outline: *Smert konnogo generala*

State Tretiakov Gallery, inv. no. R–2737. Gift of Alexei Sidorov, 1969.

The drawing was first published in the catalogue of the 1975 Tretiakov Gallery exhibition, *Drawings of Russian and Soviet Artists from the Collection of A. A. Sidorov* (no. 120). The source for the 1914 date is Alexei Sidorov (1891–1978), the art historian and critic.

Stage and Costume Designs for the Opera *Victory over the Sun,* 1913

Music by Mikhail Matiushin, libretto by Alexei Kruchenykh, prologue by Velimir Khlebnikov. Two performances of the opera, 3 and 5 December 1913, in St. Petersburg at the Luna-Park Theater, Officer Street, 39.

▪ **112 Stage Design, Act 1, Scene 1** *Eskiz dekoratsii. 1 deimo, 1 kartina*
Graphite pencil on paper
10 3/16 x 7 15/16 (25.9 x 20.2)

Above image: *do poiav* [illegible] *val* (until the appear [illegible] roll)
Lower margin: *1ia stsena/belaia s chernoi/ 1e deimo/No. 161 pch* (1st scene/white with black/Act 1/No. 161pch)
Right margin: *Figuru cheloveka* (Figure of a man)

Leningrad State Museum of Theatrical and Musical Arts, inv. no. KP 5199/164. Acquired from State Research Institute of Music, 1937.

Exhibition
Petrograd 1915/Russian Theater, no. 1133

▪ **113 Stage Design, Act 1, Scene 2** *Eskiz dekoratsii. 1 deimo, 2 kartina*
Graphite pencil on paper
6 7/8 x 8 5/8 (17.5 x 22)
Beneath image: *2ia kartina zelenaia i* [word deleted] *chernaia/1e Deimo,* (2d scene green and [word deleted] black/Act I)
Upper right margin: *zelenaia/do/ pokhoronshch* (green/as far as/the pallbear[ers])
Lower right margin: *N. 162 nch* (No. 162 nch)

Leningrad State Museum of Theatrical and Musical Arts, inv. no. 5199/165. Acquired from State Research Institute of Music, 1937.

Exhibition
Petrograd 1915/Russian Theater, no. 1134

▪ **114 Stage Design, Act 1, Scene 3** *Eskiz dekoratsii. 1 deimo, 3 kartina*
Graphite pencil on paper
6 7/8 x 8 5/8 (17.7 x 22.2)
Beneath image: *Pokhoronshchiki 3 kart/ 1e deimo* (Pallbearers scene 3/act 1)
Right margin: *do/Razgovorshchik* (as far as/Chatterbox)

Leningrad State Museum of Theatrical and Musical Arts, inv. no. KP 3569/549. Acquired from Levkii Zheverzheev, 1925.

Exhibition
Petrograd 1915/Russian Theater, no. 1135

▪ **115 Stage Design, Act 2, Scene 5** *Eskiz dekoratsii. 2 deimo, 5 kartina*
Graphite pencil on paper
8 1/4 x 10 5/8 (21 x 27)
Beneath image: *5 kart* ["6" deleted] *kart/ kvadrat/2 deistvie/1 kart/2e dei* (scene 5 ["6" deleted] scene/square/act 2/scene 1/act 2).
Right margin: *N 163 nch/Glupo* (No. 163 nch/Stupid)

Leningrad State Museum of Theatrical and Musical Arts, inv. no. KP 5199/166. Acquired from State Research Institute of Music, 1937.

Exhibition
Petrograd 1915/Russian Theater, no. 1136

▪ **116 Stage Design, Act 2, Scene 6** *Eskiz dekoratsii, 2 deimo, 6 kartina*
Graphite pencil on paper
8 3/8 x 10 5/8 (21.3 x 27)
Beneath image: *2 deis* ["2 kar" deleted] *6 kar/dom/N 164 nch* (Act 2 ["scene 2" deleted] scene 6/house/No. 164 nch)
Verso: *Pish (?) Napisal* (Pish [?] painted)

Leningrad State Museum of Theatrical and Musical Arts, inv. no. KP 5199/167. Acquired from State Research Institute of Music, 1937.

Exhibition
Petrograd 1915/Russian Theater, no. 1137

▪ **117 Singer in the Chorus** *Khorist*
Graphite pencil and watercolor on paper
10 3/4 x 8 3/8 (27.3 x 21.3)
Beneath image: *kost. khorista takoi zhe odin goluboi ili/sinii* (the same cost[ume] for singer in the chorus one light blue or/dark blue)
Lower left: *1.*
Right margin: *khor* [deleted]*/N 168 nch* (chorus [deleted]/No. 168 nch)
Verso: pencil drawing of male figure

Leningrad State Museum of Theatrical and Musical Arts, inv. no. KP 5199/178. Acquired from State Research Institute of Music, 1937.

Exhibition
Petrograd 1915/Russian Theater, no. 1148

▪ **118 Traveler** *Puteshestvennik*
Graphite pencil on paper
10 11/16 x 8 3/8 (27.2 x 21.3)
Beneath image: *Puteshestvennik. Kostium belyi i chernyi* (Traveler. White and black costume)
Lower left: *2*

Leningrad State Museum of Theatrical and Musical Arts, inv. no. KP 5199/177.

Exhibition
Petrograd 1915/Russian Theater, no. 1141

▪ **119 Many and One** *Mnogie i odin*
Graphite pencil, watercolor, and gouache on paper
10 5/8 x 8 3/8 (27.1 x 21.2)
Beneath image, first line: *kostium mnogikh* [deleted] *i odnogo totzhe/* [illegible]*/No zelenyi* (Costume for many ["for many" deleted] and the same for one [illegible]/But green)
Lower left: *3*

Leningrad State Museum of Theatrical and Musical Arts, inv. no. KP 5199/176. Acquired from State Research Institute of Music, 1937.

Exhibition
Petrograd 1915/Russian Theater, no. 1149

■ 120 **Futurist Strongman** *Budetlianskii silach*
Graphite pencil on paper
10 5/8 x 8 1/4 (27 x 21)
Lower left: *4 – 2 shtuki* (4 – 2 pieces)
Beneath image: *1 Budetlianskii silach*
(1 Futurist strongman)
Lower right: *KM*

Leningrad State Museum of Theatrical
and Musical Arts, inv. no. KP 5199/175.
Acquired from State Research Institute
of Music, 1937.

Exhibition
Petrograd 1915/Russian Theater, no. 1140

■ 121 **Coward** *Truslivyi*
Graphite pencil, watercolor, and gouache
on paper
10 9/16 x 8 1/4 (26.9 x 21)
Lower center: *kostium truslivykh* (costume
for the cowards)
Lower left: *5*
Verso: pencil drawing of a hat

Leningrad State Museum of Theatrical
and Musical Arts, inv. no. KP 5199/174.
Acquired from State Research Institute
of Music, 1937.

Exhibition
Petrograd 1915/Russian Theater, no. 1147

■ 122 **Pallbearer** *Pokhoronshchik*
Graphite pencil and watercolor on paper
10 5/8 x 8 5/16 (27 x 21.1)
Right margin: *kostium pokhoronshchika 2*
[illegible] *spor.* (Costume for a pallbearer
2 [illegible] argument)
Lower right: *6 – 2 sht.* (6 – 2 pc.)

Leningrad State Museum of Theatrical
and Musical Arts, inv. no. 5199/173.
Acquired from State Research Institute
of Music, 1937.

■ 123 **Enemy** *Nepriiatel*
Graphite pencil, watercolor, and India ink
on paper
10 5/8 x 8 3/8 (27.1 x 21.3)
Lower center: *KMalevi 1913/Nepriiatel*
(KMalevi 1913/Enemy)
Lower left: *7*
Upper right margin: *na forme meshok-
golova* (sack head on the uniform)
Center right margin: *nogi* [illegible deleted
word] *miagkie* (soft [illegible] feet)

Leningrad State Museum of Theatrical
and Musical Arts, inv. no. KP 4588/I.
Acquired from F. A. Orlova, 1934.

Exhibition
Petrograd 1915/Russian Theater, no. 1143

■ 124 **The New One** *Novyi*
Graphite pencil, watercolor, and India ink
on paper
10 1/4 x 8 1/4 (26 x 21)
Lower center: *kostium Novykh* (costume
for The New Ones)
Lower left: *8*
Lower right: *miagkii* (soft)

Leningrad State Museum of Theatrical
and Musical Arts, inv. no. KP 5199/172.
Acquired from State Research Institute
of Music, 1937.

Exhibition
Petrograd 1915/Russian Theater, no. 1142

■ 125 **Bully** *Zabiiaka*
Graphite pencil and watercolor on paper
10 1/2 x 8 1/4 (26.7 x 21)
Lower left: *9*
Right margin: *Zabiiaka*

Leningrad State Museum of Theatrical
and Musical Arts, inv. no. KP 5199/170.
Acquired from State Research Institute
of Music, 1937.

■ 126 **Nero** *Neron*
Graphite pencil on paper
10 5/8 x 8 7/16 (27 x 21.5)
Lower left: *10*
Right of image: *Neron*

Leningrad State Museum of Theatrical
and Musical Arts, inv. no. KP 5199/171.
Acquired from State Research Institute
of Music, 1937.

Exhibition
Petrograd 1915/Russian Theater, no. 1139

■ 127 **Reciter** *Chtets*
Watercolor, India ink, and charcoal
on paper
10 11/16 x 8 7/16 (27.2 x 21.4)
Lower center: *Chtets*
Lower left: *11.*
Lower right: *K Malev*

State Russian Museum, inv. no. RB – 7659.
Acquired from Levkii Zheverzheev, 1928.

Exhibition
Petrograd 1915/Russian Theater, no. 1138

■ 128 **A Certain Character of Ill-Intent** *Nekii
zlonamerennyi*
Graphite pencil, watercolor, and India ink
on paper
10 3/4 x 8 3/8 (27.3 x 21.3)
Lower center: *166 nch*
Lower left: *12.*
Lower right: *KM*
Right of image: *Nekii/zlonamerennyi*

Leningrad State Museum of Theatrical
and Musical Arts, inv. no. KP 5199/179.
Acquired from State Research Institute
of Music, 1937.

Exhibition
Petrograd 1915/Russian Theater, no. 1144

■ 129 **Old-Timer** *Starozhil*
Graphite pencil, watercolor, and India ink
on paper
10 5/8 x 8 1/4 (27 x 21)
Lower left: *13*
Lower right of image: *Starozhil*
Right margin: *miagkii* (soft)

Leningrad State Museum of Theatrical
and Musical Arts, inv. no. KP 5199/169.
Acquired from State Research Institute
of Music, 1937.

Exhibition
Petrograd 1915/Russian Theater, no. 1145

■ 130 **Sportsman** *Sportsmen*
Watercolor, India ink, and charcoal
on paper
10 11/16 x 8 5/16 (27.2 x 21.2)
Lower left: *14*
Lower right of image: *Sportsmen/K. Malev*

State Russian Museum, inv. no. RB – 7660.
Acquired from Levkii Zheverzheev, 1928.

Exhibition
Petrograd 1915/Russian Theater, no. 1146

■ 131 **Attentive Worker** *Vnimatelnyi rabochii*
Graphite pencil, India ink, and gouache
on paper
10 11/16 x 8 5/16 (27.2 x 21.2)
Left of image: *griban* [illegible]
Beneath image: *Vnimatelnyi rabochii*
Lower left: *15*
Lower right: *167 nch*

Leningrad State Museum of Theatrical
and Musical Arts, inv. no. KP 5199/180.
Acquired from State Research Institute
of Music, 1937.

Exhibition
Petrograd 1915/Russian Theater,
no. 1150 or 1151

■ 132 **Fat Man** *Tolstiak*
Graphite pencil, watercolor, and India ink
on paper
10 11/16 x 8 5/16 (27.2 x 21.2)
Lower left: *16*
Right of image in center: *Tolstiak*
Lower right of image: *165 nch/K Malevi*

Leningrad State Museum of Theatrical
and Musical Arts, inv. no. KP 5199/181.
Acquired from State Research Institute
of Music, 1937.

133 Chatterbox *Razgovorshchik*
Graphite pencil and India ink on paper
10 ⁵/₈ x 8 ¹/₄ (27 x 21)
Upper right: *razgovorshchik/cherni kostium/frak i tsi* [lindr] (chatterbox/black costume/tails and top hat)
Lower right: *Chernye/kostiumy/turetskii/ starogo/stilia* (Black/costumes/Turkish/of old style)
Verso: pencil drawing of a male figure

Leningrad State Museum of Theatrical and Musical Arts, inv. no. KP 5199/168. Acquired from State Research Institute of Music, 1937.

■ ■

134 Study for the Front Program Cover for the First Congress of the Committees on Rural Poverty *Eskiz oblozhki papki materialov Sezda komitetov derevenskoi bednoty,* 1918
Watercolor, gouache, India ink, and graphite pencil on paper
15 ³/₈ x 14 ⁷/₈ (39.2 x 37.9)
Text at left: *Sezd komitetov derevenskoi bednoty* (Congress of Committees on Rural Poverty)
Upper right: *Severnaia oblast* (Northern district)
Lower right: *1918 g.* (1918)

Manuscript Section, Institute of Russian Literature (Pushkin House, Leningrad). The M. V. Matiushin Collection, inv. no. 656a.

The Congress of Committees on Rural Poverty took place at the Winter Palace in Petrograd, 3–4 November 1918.

135 Study for the Back Program Cover, 1918
Watercolor, gouache, India ink, and graphite pencil on paper
12 ⁷/₈ x 16 ¹/₄ (32.7 x 41.3)
In circle: *Proletarii vsekh stran soediniaites* (Proletariats of the World Unite)

Manuscript Section, Institute of Russian Literature (Pushkin House, Leningrad). The M. V. Matiushin Collection, inv. no. 656b.

136 Front and Back Program Covers for the First Congress of Committees on Rural Poverty *Oblozhka papki materialov Sezda komitetov derevenskoi bednoty,* 1918
Color lithograph
19 ¹/₁₆ x 25 ¹/₂ (48.5 x 64.8)
Text front cover left: *Sezd komitetov derevenskoi bednoty* (Congress of Committees on Rural Poverty)
Upper right: *Severnaia oblast 1918* (Northern district 1918)
Lower right: *KM*
Text back cover: *Proletarii vsekh stran soediniaites* (Proletarians of the World Unite)

State Russian Museum, inv. no. Sgr 15932. Acquired from K. A. Kardabovsky, 1986.

137 Suprematism. Study for a Curtain *Suprematizm. Eskiz zanavesa,* 1919
Gouache, watercolor, India ink, and graphite pencil on paper
17 ³/₄ x 24 ⁵/₈ (45 x 62.5)
Center: *Suprematizm/1919*
Beneath this in pencil: *Dekoratsiia yubileinogo zasedaniia/* [illegible] *komiteta po borbe s bezrabotitsei.Vitebsk* (Decoration for the Jubilee Session [illegible]/ of the Committee for the Struggle against Unemployment. Vitebsk U[novis])

State Tretiakov Gallery, inv. no. RS–1881. Acquired from Sophie Lissitzky, 1959.

This work has been attributed to El Lissitzky; it has also been suggested that Malevich and Lissitzky worked on it together.

138 (recto) Suprematist Variations and Proportions of Colored Forms *Suprematicheskie variatsii i proportsii tsvetnykh form,* 1919
Graphite pencil, watercolor, and India ink on paper
9 ³/₄ x 13 ¹/₄ (24.8 x 33.8)
Above image: *Suprematicheskie variatsii i proportsii tsvetnykh form/dlia stennoi pokraski doma, yacheiki, knigi, plakata, tribuny. 1919 g. Vitebsk* (Suprematist variations and proportions of colored forms for house wall painting, political club rooms, books, posters, rostrums. 1919 Vitebsk)
Above square on extreme left: *a,*
Below image: *a) dinamicheskaia kletka, kak kontrast/K. Malevich.* (a) dynamic square as a contrast/K Malevich) Below this, lower right corner: *sm. na oborote* (see other side); lower left corner, a semiobliterated typewritten label: *Tribuna oratorov K. Malevich* (Speaker's rostrum K. Malevich)

State Russian Museum, inv. no. RS–977 (recto). Acquired from artist, 1930.

138 (verso) Suprematist Variant of Painting *Suprematicheskii variant rospisi,* 1919
Graphite pencil, watercolor, and India ink on paper
9 ¹/₄ x 13 ¹/₄ (24.8 x 33.8)
Above image: *1919 g/Vitebsk/ Suprematicheskii variant rospisi kanta, paneli, lenty v tsvetakh/chernogo i krasnogo K Ma . . . /stroene kontrasta tsveta i formy ego v kazhdoi kletke i v tselom* (1919/Vitebsk/Suprematist version of the painting of an edging, a panel, a ribbon in the colors of black and red KMa . . . /the building of contrast of its color and form in each square and as a whole)

State Russian Museum, inv. no. RS–977 (verso). Acquired from artist, 1930.

Exhibition
Leningrad 1932–1933 (?), no. 1240, *Wall Decoration (Oformlenie sten)*

139 Design for Suprematist Fabric, 1919
India ink and gouache (stenciled) on canvas
7 ⁷/₈ x 3 ³/₄ (20 x 9.6)
Lower right: *29211*
Beneath image: *Pervaia tkan suprematicheskoi ornamentirovki vypolnena v 1919 g. v g. Vitebske. K Malevich* (First fabric with Suprematist design executed in 1919 in Vitebsk. K. Malevich)

State Russian Museum, inv. no. Rs–976. Acquired from artist, 1930.

140 Design for Suprematist Fabric, 1919
Watercolor and graphite pencil on paper
14 ¹/₁₆ x 10 ⁵/₈ (35.8 x 26.9)
Lower right: *KM/1919*
Above image: *Eskiz. Obraztsy dlia tekstilia* (Study. Textile examples)
Beneath image: *Ornamentirovka tkani. Sitets No. 10* (Fabric design. Cotton print No. 10)

State Russian Museum, inv. no. Rs–972. Acquired from artist, 1930.

141 Design for Suprematist Fabric, 1919
Watercolor, India ink, and graphite pencil on paper
14 ¹/₄ x 10 ⁵/₈ (36.2 x 26.9)
Beneath image: *Eskiz ornamentirovki materii K Mal 1919 g. No. 12* (Study for a fabric design K Mal 1919 No. 12)

State Russian Museum, inv. no. Rs–974. Acquired from artist, 1930.

142 Design for Suprematist Fabric, 1919
Watercolor and graphite pencil on paper
14 x 10 ⁵/₈ (35.6 x 26.9)
Lower right: *KM/1919*
Beneath image: *No. 15 ornamentirovka tkani (batist) i sitets* (No. 15 fabric design [cambric] and cotton print)

State Russian Museum, inv. no. Rs–973. Acquired from artist, 1930.

143 Futurist Strongman *Budetlianskii silach,* ca. 1915(?) or 1920s(?)
Watercolor and graphite pencil on paper
21 x 14 ¹/₄ (53.3 x 36.1)
Lower left: *K Malev*
Lower right: *13*
Across top: *Peterburg teatr Lunapark Ofitser ul.* (Petersburg theater Lunapark Officer st.)
Right margin: *rost 3 arshi* (height 3 arshi[ns]); in black beneath this: *Budetlianskii/silach*
Beneath image: *"Pobeda nad Solntsem"/*

opera Matiushina slova Kruchenykh
("Victory over the Sun" opera by Matiushin
lyrics by Kruchenykh)

State Russian Museum, inv. no. RB–23097.
Acquired from artist's family, 1936.

Although associated through its inscriptions with the 1913 production of *Victory over the Sun,* the style of this work is distinctly different. It may date from 1915, when Malevich was preparing the second production, or possibly from the 1920s, when he was engaged in designing Suprematist textiles and clothing. (See, for example, the 1923 design for a Suprematist dress in the State Russian Museum, Leningrad, inv. no. RS–979; reproduced in *Kazimir Malevich,* exh. cat. [1988–1989], 250, no. 171.)

144 **Suprematist Drawing,** ca. 1917–1918
Black crayon on paper
20 5/8 x 13 5/8 (52.5 x 34.5)
Lower right: *K M*
Verso: traces of a Suprematist drawing
Andersen 1970, no. 82

Stedelijk Museum, A7697. Acquired from
Hugo Häring, 1958.

Exhibition
Berlin 1927(?)

This drawing and others left by Malevich in Berlin after his 1927 exhibition there do not appear in the surviving, but incomplete, installation photographs (see cat. 5). Some of the drawings almost certainly were exhibited, but it has been impossible thus far to find documentary evidence establishing which if any were included.

145 **Suprematist Drawing,** 1917–1918
Graphite pencil on paper
21 x 13 3/4 (53.5 x 35)
Andersen 1970, no. 94

Stedelijk Museum, A7696. Acquired from
Hugo Häring, 1958.

Exhibition
Berlin 1927(?) (see cat. 144, above)

146 **Suprematis,** ca. 1917–1918
Graphite pencil on paper
27 3/8 x 21 1/4 (69.5 x 54)
Lower right, inside framing edge (?):
K Malevich 1914 god KM 17 god
(K Malevich 1914 KM [19]17)
Upper right: *Usechenie nad supr.* (A
truncation above supr.)
Middle right: *Krasnyi* (Red)
Lower left, inside framing edge:
Suprematiz K N 51 [or 57?]
Below framing edge: *prokhozhdenie
Suprema po poverkhnosti belogo diska*
(The passage of Suprem. over the
surface of a white disk)
Andersen 1970, no. 79

Stedelijk Museum, A7692. Acquired from
Hugo Häring, 1958.

Exhibitions
Warsaw 1927 (visible in inst. phot.);
Berlin 1927(?) (see cat. 144, above)

147 **Study Suprematis 52 System A4** *Etiud
suprematis 52 sistema A 4,*
ca. 1917–1918
Black crayon and watercolor on paper
27 1/8 x 19 1/4 (69 x 49)
Lower right, below framing edge:
Kuntsevo K Malev; above this, within
framing edge: *191[?] g.*
Above this in a different color (below right,
inside framing edge): *Etiud suprematis
52 sistema A 4* (Study Suprematis 52
system A 4)
Center right, outside framing edge:
*Srednii disk nakhoditsia vo kruzhenii
mezhdu dvumia supr. postroeniiami*
(The middle disk is whirling between two
supr. constructions)
Center, below framing edge: *krug disha
pisat/teplogo tsveta/uglo kosoi* (the circle
of the disk to be painted/warm color/
oblique angle)
Andersen 1970, no. 81

Stedelijk Museum, A7691. Acquired from
Hugo Häring, 1958.

Exhibitions
Warsaw 1927 (visible in inst. phot.); Berlin
1927(?) (see cat. 144, above)

148 **Suprematism, Splitting of Construction
Form 78** *Suprematizm, raspylenie
postroeniia/forma 78,* ca. 1917–1919
Graphite pencil on paper
12 3/16 x 9 5/8 (32.5 x 24.5)
Lower right: *K Malevich*
Beneath outline: *1917 god Suprematizm
raspylenie postroeniia/forma 78*
Andersen 1970, no. 76

Stedelijk Museum, A7690. Acquired from
Hugo Häring, 1958.

Exhibition
Berlin 1927(?) (see cat. 144, above)

149 **Suprematist Drawing,** ca. 1917–1919(?)
Black crayon and graphite pencil
on paper
12 5/8 x 9 5/8 (32 x 24.5)
Lower left: *K Mal*
Below and right, outside framing edge:
*Dugoobraznye linii predstavliaiut soboi
poiski zakonnogo ustanovleniia shara ili
krugloi ploskosti v takom polozhenii
chtoby izbegnut katastrofy prodolnogo
dvizheniia chernoi i seroi ploskosti.1/
Katastroficheskoe polozhenie.2.2 Vernoe
ustanovlenie po voprosu razreshitsia
nuzhno kakoi iz nikh dast pri prikhode
postroeniia suprem. ploskostei bolshe
vyrazhenie dinamicheskogo i prostrans-*

*tvennogo oshchushcheniia 2 a uvelich-
ivaiushchee napriazhenie dostigaet tseli
Kazalos by chto takoe ustanovlenie
yavliaetsia rassuzhdeniem razuma no v
deistvitelnosti ono proiskhodit cherez
prirodoestestvennoe deistvo, posle chego
mozhet byt vyvedeno suzhdenie i
ustanovlenie formuly. KM* (The arched
lines represent a search for the legitimate
establishment of a sphere or a curved
plane placed so as to avoid the catas-
trophe of a linear movement of the black
and gray plane. 1/A catastrophic position,
2.2 It is necessary to ascertain with
certitude which of them will give the
greatest expression of dynamic and
spatial sensation in passing through the
construction of supr. planes. 2 a the
increasing tension achieves the aim.
Such an ascertainment would appear to
be intellectual reason, but in reality it
originates from a natural action, after
which the reasoning and ascertainment
of the formula may be deduced.)
Andersen 1970, no. 83

Stedelijk Museum, A7689. Acquired from
Hugo Häring, 1958.

Exhibition
Berlin 1927(?) (see cat. 144, above)

150 **Vertical Suprematist Constructions**
Vertikalnykh supremat postroenii,
ca. 1920
Graphite pencil on paper
18 1/8 x 11 5/8 (46 x 29.5)
Right center: *Postroit v magnitnykh
osiazaniiakh belye vertikalnyoe
gorizontalnie* [illegible] *stliu lilovaia tale
magnitnyaia krugom K serii vertikalnykh
supremat postroenii 17 god* (To build
in magnetic sensations white vertical
horizontal [illegible] of steel [or "have
become"?] lilac as well as magnetic/
around [or "inner circle"?]. From the series
of vertical supremat[ist] constructions 1917)
Below right: *postroi v tsentre* (build in
the center)
Above: *verkh*
Below center: *niz*
Andersen 1970, no. 77

Stedelijk Museum, A7694. Acquired from
Hugo Häring, 1958.

Exhibition
Berlin 1927(?) (see cat. 144, above)

151 **Vertical Construction/Suprematis**
Vertikalnoe postroenie/Suprematiz, ca. 1920
Graphite pencil and black crayon
on paper
16 1/8 x 11 5/8 (41 x 29.5)
Beneath image: *Vertikalnoe postroenie
suprematiz* (Vertical construction
Suprematis)
Verso: a Suprematist composition in
red, yellow, black, and blue watercolor
Andersen 1970, no. 78

Stedelijk Museum, A7693. Acquired from Hugo Häring, 1958.

Exhibition
Berlin 1927(?) (see cat. 144, above)

▪ **152 Poster for a Lecture** *Afisha lektsii*, 1922
Collograph on paper
10 7/8 x 7 1/8 (27.7 x 18.1)
Printed across top: *Lektsiia/K.Malevicha*
(Lecture/by K.Malevich).
Printed center: *ob iskusstve, tserkvi./ fabrike, kak o/trekh putiakh utve-/ rzhdaiushchikh boga.* (about art, church,/ factory, as the/three ways af-/firming the existence of God)
Handwritten in ink: *6.⁹⁰ yunia 22 g/ Muz.Khud.Kultury/Isaakievskaia ploshch.9* (4th of June, 22/Mus[ical] Art[istic] Culture/St. Isaac's Sq. 9)
Printed across lower edges: *nachalo 8 bilety pri vkhode* (Beginning at 8 ["8" handwritten in ink] tickets at the door)

State Russian Museum, inv. no. Sgr 15934. Acquired from K. A. Kardabovsky, 1986.

▪ **153 Poster for a Lecture** *Afisha lektsii*, 1922
Collograph on paper
10 7/8 x 7 1/8 (27.7 x 18.1)
Printed upper left: *Lektsiia/K. S. Malevicha /"Novoe/dokazatelstvo/v/ iskusstve"* (New Testimony in Art)
Printed below: *nachalo/v. 8 chas. vech* (Beginning at 8 p.m. ["8" handwritten in ink])
Handwritten in ink lower left: *Muz.Khud./ Kultury/6.⁹⁰ yunia 22 g* (Mus[ical] Art[istic]/ Culture/6th of June 22)
Handwritten in ink lower right: *Isaakievskaia/Ploshch. d.9.* (St. Isaac's/ Sq. h[ouse]. 9.)
Printed bottom right: *bilety pri/vkhode* (tickets at/the door)

State Russian Museum, inv. no. Sgr 15933. Acquired from K. A. Kardabovsky, 1986.

▪ **154 Table No. 1 Formula of Suprematism**
Tablitsa No. 1 Formula Suprematizma, 1920s(?)
Watercolor, gouache, and graphite pencil on paper
14 1/8 x 21 1/4 (36 x 54)
The four drawings (left to right, top to bottom) are numbered by the artist: no. 1, no. 2, no. 3, no. 4.
Left of drawing no. 1, in light pencil: *r.No. 1* (d[rawing] No. 1)
Below this: *kub* (cube)
Within penciled "frame" of this drawing, below cube: *obemnyi prostranstvennyi suprematizm formula 1915 g.* (volumetrical spatial Suprematism 1915)
Across top of drawing no. 2, in light pencil: *r. No. 2* (d[rawing] No. 2); *Raspadenie kuba na formuly* (breakdown of the cube into formulas)

Margin, right of drawing no. 2, in light pencil:
suprematich tsvet (supremat[ist] color[s])
krasno (red)
chernoe (black)
osnovnye (basic) *zelen* (green) *polev* (grass) *izumrud* (emerald)
belyi (white)
goluboi kobalt (light blue cobalt)
dopolnitelnye redkie sluchai (supplemental rare cases)
ultramarin (ultramarine)
zheltaia [word crossed out] *limon* (yellow [word crossed out] lemon)
rozovaia kraplak (pink)

Left of drawing no. 3, in light pencil:
risunok No. 1 [deleted] *risun No. 3* (drawing No. 1 [deleted] draw[ing] No. 3)
Below drawing no. 3: *udlinennyi kub* (elongated cube)
Left of drawing no. 4, in light pencil: *r. No. 4* (d[rawing] No. 4)
Right margin, beside drawing no. 4, in light pencil: *Takim obrazom mozhno poluchit novyi vid arkhitektury Vid chistyi: vne vsiakikh prakticheskikh tselei, ibo arkhitektura nachinaetsia tam, gde net praktich tselei. Arkhitektura kak takovaia KMalevich* (In this way we can arrive at a new type of architecture A pure type: outside any practical aims, because architecture begins where there are no practic[al] aims. Architecture as such KMalevich)
Upper left, in darker pencil: *Formula Suprematizma 1913 g. Po etoi formule nuzhno razvit obemnuiu storonu suprematizma. Pervoi formoi budet kub* (Formula of Suprematism 1913 The volumetrical aspect of suprematism should be developed according to this formula. The first form will be the cube)
Upper right, in same dark pencil: *Po tsvetu eti formy dolzhny byt krasnymi i chernymi* (In color these forms should be red and black)

The two inscriptions in dark pencil were probably added by the artist some time after the drawings themselves were completed, possibly when the sheet was submitted to the 1932–1933 exhibition.

State Russian Museum, inv. no. RB–23163. Acquired from artist's family, 1936.

Exhibition
Leningrad 1932–1933, no. 1243, *Formula of Spatial Suprematism* (Formula prostranstvennogo suprematizma)

▪ **155 Table No. 3 Spatial Suprematism**
Prostranstvennyi suprematizm, 1920s(?)
Watercolor, white gouache, and graphite pencil on paper
14 13/16 x 21 5/16 (36 x 54.1)
Lower right corner: *KM 1916*
Above image, on left: a monogram (black square)

Across top: *Prostranstvennyi suprematizm*
Below image: *Arkhitektona Gorizontalnaia uslozhniaiushchaiasia promezhutochnymi formami 1916 god* (Horizontal architectona rendered more complex by intermediate forms 1916)
Below image, lower left corner: *Tablitsa No. 3* (Table no. 3)

State Russian Museum, inv. no. RB– 23098. Acquired from artist's family, 1936.

Exhibition
Leningrad 1932–1933, no. 1244, *Spatial Suprematism. Dynamic Coloring* (Prostranstvennyi suprematizm. Dina-micheskaia ottsvetka)

▪ **156 Future Planits/Houses/for Earth Dwellers/ People** *Budushchie planity/doma/dlia zemlianitov/liudei*, 1923–1924
Graphite pencil on paper
17 5/16 x 12 1/8 (44 x 30.8)
Above image in pencil: *Unovis. "Novoe iskusstvo dlia sooruzhenii" Budushchie planity/doma/zemlianitov/* (Unovis. "New art for structures" Future planits/houses/ for earth dwellers/people)
Below image in pencil: *Suprematizm planitnyi v sooruzheniiakh forma "aF₂" gruppa material beloe matovoe steklo, beton stal, zhelezo, elektricheskoe otoplenie, planit bez trub dymovykh. Okraska planita chernaia i belaia preimushchestvennaia krasnaia v iskliuchitelnykh sluchaiakh zavisit ot padeniia ili podniatiia dinamicheskoi sostoianiia goroda, gosudarstva* (Planit Suprematism in the structures of form "aF₂" group material is white frosted glass, concrete steel, iron, electric heating, of planits without smoke ducts. The color of planits predominantly black and white in exceptional cases red depends on the fall or rise in the dynamic condition of the city or state)
Below this in ink: *Planit dolzhen byt osiazaem dlia zemlianita vsestoronne on mozhet byt vsiudu na verkhu i vnutri doma, odinakovo zhit kak vnutri tak i na kryshe planita. Sistema planitov daet vozmozhnost soderzhat ego v chistote, on moetsia bez vsiakikh dlia etogo prisposoblenia, kazhdyi ego obem etazh nizkoroslyi, no tam mozhno khodit i skhodit kak po lestnitse. Steny ego otepliaiutsia kak i potolki i pol* (The planit must be tangible for the earth dwellers in every way he can be everywhere on top and inside the house, live equally well inside or on the roof of the planit. The planit system enables it to be kept clean, it can be washed without any of the appliances, each of its volumes is a low story, but you can go up and down it like a flight of stairs. The walls are heated as well as the ceilings and floor)
Upper verso, probably not in artist's hand: *Yubileinaia v-ka 1932 (No. 2369/Malevich/*

*"Prostranstvennyi graf suprematizma"
1920)* (Jubilee ex-n 1932 [No. 2369/
Malevich/"Spatial graph of suprematism"
1920]) *Gos. Russkii muzei/
Khudozh.otdel/1931 g Mal 24/Priniato
dlia vrem.expoz./rab. Malevicha* (St[ate]
Russian Museum/Art Section/1931
Mal 24/Accepted for temp. exhib./works
of Malevich)

State Russian Museum, inv. no. Rs –10482.
Acquired from State Hermitage Museum
(originally from F. F. Notgaft collection).

Exhibition
Leningrad 1932–1933, no. 1245, *Spatial
Suprematism. 1920* (Prostranstvennyi
suprematizm. 1920)

■ **157 Future Planits for Earth Dwellers**
Budushchie planity dlia zemlianitov,
1923–1924
Graphite pencil on paper
15 5/16 x 11 5/8 (39 x 29.5)
Above image: *Unovis Budushchie planity/
doma/zemlianitov/liudei.*
Right: *Novoe iskusstvo dlia sooruzhenia*
(A new art of constructions)
Below: *Suprematizm v sooruzheniiakh.
Suprforma "A F" F gruppa planitov 1913–
24 seichas mysliu material beloe matovoe
steklo, beton, tol elektricheskoe otoplenie
planit bez trub. Okraska zhilogo planita-
chernaia, belaia preimushchestvenno.
Krasnaia, chernaia i belaia v iskliuchi-
telnykh sluchaiakh, zavisit ot napria-
zhennosti sil gosudarstva i ego slabosti
v dinamichnosti. Planit dolzhen byt
osiazaem dlia zemlianita vse storonne
on mozhet byt v nem i na nem byt,
planit prost kak malenkaia veshchitsia
vezde dostupen dlia zhivushchego v
nem zemlianita, on mozhet sidet i zhit v
khoroshuiu pogodu na poverkhnosti ego.
Planit blagodaria svoei konstruktsii i
sistemy dast vozmozhnost soderzhat
ego v gigiene on mozhet mytsia kazhdiy
den, ne sostavliaet nikakoi trudnosti, a
blagodaria nizkoroslosti ne opasen N 4 N
16 Vid ABCD.* (Suprematism in construc-
tions. The supraform "AF" of the second
group of planits 1913–1924. I am now
thinking of material[:] white opaque glass,
concrete, tarred felt, heating by electricity,
a planit without pipes. The coloring of
the residential planit is predominantly
black and white. Red, black, and white
in exceptional circumstances, it depends
upon the tension of the state's powers
and its weakness in dynamicism. The
planit must be universally tangible for
man, inside as well as outside, the planit
is as simple as a tiny speck, everywhere
accessible to the man living in it, who,
in fine weather, may sit on its surface.
The planit thanks to its construction
and system will afford the opportunity to

keep it clean; it can be washed every day
without the least difficulty, and thanks to
its small stature is harmless No. 4, No.
16, Aspect ABCD.)
Right: *podval-razrez* (basement, cross
section)
Label on verso: *Komitet Russkogo otdela
mezhdunarodnoi vystavki v Venetsii K. S.
Malevich: Budushchie planity zemlianitov*
(Committee for the Russian section of the
international exhibition in Venice. K. S.
Malevich: Future planits of earth dwellers)
(Venice 1924)
Andersen 1970, no. 84

Stedelijk Museum, A7684. Acquired from
Hugo Häring, 1958.

Exhibitions
Venice 1924, no. 349, *Futuro-planit;*
Berlin 1927(?) (see cat. 144)

■ **158 Modern Buildings** *Segodniashnye
sooruzheniia,* 1923–1924
Graphite pencil on paper
14 1/8 x 21 1/16 (36 x 53.5)
Above image: *Segodniashnye sooruzheniia*
Below image: *Suprematizm vid planita
sverkhu. Postroen vne vsiakoi tseli no
zemlianit mozhet izpolzovat ego dlia
svoikh tselei* (Suprematism. View of the
planet from above. Built without any
purpose, but which may be used by man
for his own purposes)
Andersen 1970, no. 85

Stedelijk Museum, A7688. Acquired from
Hugo Häring, 1958.

Exhibition
Berlin 1927(?) (see cat. 144)

■ **159 Future Planits for Leningrad. The Pilot's
House** *Planity budushchego Leningrada.
Planit letchika dom,* 1924
Graphite pencil on paper
12 x 17 11/16 (30.5 x 45)
Lower right: *KM 1924g*
Above image: *Suprforma "A F" 2 gruppa
planitov* (The supraform "A F" of the 2d
group of planits)
Right: *Planity/doma/budushchego/
Leningrada* (Future planits/houses/
for Leningrad)
Below image: *Planit letchika/dom*
(The pilot's planit/house)
Andersen 1970, no. 86

Stedelijk Museum, A7698. Acquired from
Hugo Häring, 1958.

Exhibitions
Venice 1924 (?), no. 350, *Planit di aviatore;*
Berlin 1927(?) (see cat. 144)

■ **160 Future Planits for Leningrad. The Pilot's
Planit** *Planity budushchego Leningrada.
Planit letchika dom,* 1924
Graphite pencil on paper
12 1/4 x 17 3/8 (31.1 x 44.1)
Lower right: *K Malevich 24 g*
Above image: *Suprforma "A F" 2 gruppa
dinamicheskikh sooruzhenii.* (The
supraform "A F" of the 2d group of
dynamic constructions)
Right of image: *Suprematizm v
arkhitekture Planity/doma/budushchego
Leningrada. Planit letchika* (Suprematism
in Architecture/Planits/houses/of the
future/for Leningrad. Pilot's planit)
Lower right corner: *N5*

Andersen 1970, no. 87

Collection, The Museum of Modern Art,
New York.

Exhibition
Berlin 1927(?) (see cat. 144)

161 Two Squares, 1920s(?)
Graphite pencil on paper
19 3/4 x 14 1/2 (50.2 x 36.8)
Verso in blue crayon: *16*
Andersen 1970, no. 89

Collection, The Museum of Modern Art,
New York.

Exhibition
Berlin 1927(?) (see cat. 144)

162 Circle, 1920s(?)
Graphite pencil on paper
18 1/2 x 14 1/2 (47 x 36.5)
Verso in blue crayon: *19*
Andersen 1970, no. 90

Collection, The Museum of Modern Art,
New York.

Exhibition
Berlin 1927(?) (see cat. 144)

163 Suprematist Drawing, before 1927
Black crayon on paper
13 7/8 x 8 5/8 (35 x 22)
Andersen 1970, no. 95

Stedelijk Museum, A7685. Acquired from
Hugo Häring, 1958.

Exhibition
Berlin 1927(?) (see cat. 144)

164 Suprematist Drawing, before 1927
Black crayon on paper
13 7/8 x 8 5/8 (35 x 22)
Andersen 1970, no. 96

Stedelijk Museum, A7686. Acquired from
Hugo Häring, 1958.

Exhibition
Berlin 1927(?) (see cat. 144)

165 Standing Figure, before 1927
Black crayon on paper
13 $^{15}/_{16}$ x 8 $^5/_8$ (35.5 x 22)
Andersen 1970, no. 97

Stedelijk Museum, A7687. Acquired from
Hugo Häring, 1958.

Exhibition
Berlin 1927(?) (see cat. 144)

166 Standing Figure, before 1927
Colored pencil on paper
13 $^{15}/_{16}$ x 8 $^{11}/_{16}$ (35.5 x 22.5)
Andersen 1970, no. 98

Stedelijk Museum, A7695. Acquired from
Hugo Häring, 1958.

Exhibition
Berlin 1927(?) (see cat. 144)

Arkhitektons

▪ **167 Alpha,** 1920
Plaster
13 x 14 $^7/_{16}$ x 33 $^1/_4$ (33 x 37 x 84.5)
Under small lateral element (incised):
K Malevich 1920
Scratched twice into plaster within body of
arkhitekton: *K. Malevich 1920.*

State Russian Museum, inv. no. Sk−2052.

Exhibitions
Moscow 1929 (typed list in Tretiakov
Gallery includes twenty-six arkhitektons,
nos. 66–91); Leningrad 1932–1933, no.
1228 ("Alpha, Beta, et al")

This arkhitekton was reassembled entirely
from original fragments, on the basis of
early photographs, by Bella Toporkova in
consultation with Evgenii Kovtun.

▪ **168 Beta,** original before 1926
Plaster cast, 1989
10 $^3/_4$ x 23 $^3/_8$ x 39 $^1/_{16}$ (27.3 x 59.5 x 99.3)

Musée national d'art moderne, Centre
Georges Pompidou.

Three plaster casts of *Beta, Gota* (cat.
169), and *Gota 2−A* (cat. 170) were made
directly from reconstructions of the original
arkhitektons, now in the collection of
the Musée national d'art moderne. The
reconstructions were made in Paris by
Poul Pedersen over a two-year period
(1978–1980), based on an exhaustive
collaborative study of existing documents,

photographs, and the artist's relevant
theoretical writings, undertaken first in the
context of a seminar conducted by Troels
Andersen. Pedersen's reconstructions
in each case were assembled in part from
original surviving fragments and, where
necessary, from newly cast elements. The
reconstruction of *Beta* incorporates 29
original elements and 40 new ones; of
Gota, 187 original elements and 56 new
ones; of *Gota 2−A,* 80 original elements
and 35 new ones. For extensive docu-
mentation of the reconstruction process
as well as discussion of many of the
issues raised by Malevich's arkhitektons,
see *Malévitch: Architectones, peintures,
dessins,* exh. cat. (Paris: Centre
Georges Pompidou, Musée national
d'art moderne, 1980).

▪ **169 Gota,** original plaster 1923(?)
Plaster cast, 1989
33 $^9/_{16}$ x 18 $^7/_8$ x 22 $^{13}/_{16}$ (85.2 x 48 x 58)

Musée national d'art moderne, Centre
Georges Pompidou.

▪ **170 Gota 2−A,** original plaster 1923–1927(?)
Plaster cast, 1989
22 $^7/_{16}$ x 10 $^1/_4$ x 14 $^3/_{16}$ (57 x 26 x 36)

Musée national d'art moderne, Centre
Georges Pompidou.

Translations and transliterations by
Troels Andersen, Michele A. Berdy, John
E. Bowlt, Caryl Emerson, Alla T. Hall,
Edward Kasinec, Melinda C. Mclean, and
Svetlana Makurenkova.

ENDNOTES

Berlin 1927

1 See K. Malevich, *Suprematismus. Die gegenstandlose Welt,* trans. Hans von Riesen (Cologne, 1962); *Avantgarde Osteuropas 1910–1930,* exh. cat. (Berlin, 1967), prefaces by Hans Richter, Hans von Riesen, Eberhard Roters.

Malevich and His Art, 1900–1930

1 See also Kazimir Malevich, *Suprematism. 34 risunka* (Vitebsk: Unovis, 1920), 1.
2 Ibid.
3 See Evgenii Kovtun, "K. Malevich, 'Pisma k M. V. Matiushinu,'" *Ezhegodnik rukopisnogo otdela Pushkinskoho doma na 1974* (Leningrad, 1976).
4 Ibid.

Malevich and the Energy of Language

1 For another version of the photograph with Pavel Filonov see Figure 6. Still another, with Iosif Shkolnik, is reproduced on the back dust jacket of Nicoletta Misler and John E. Bowlt, *Pavel Filonov: A Hero and His Fate* (Austin: Silvergirl, 1983).
2 Malevich to Matiushin, 14 February 1916. English translation in Troels Andersen, ed., *K. S. Malevich. The Artist, Infinity, Suprematism,* vol. 4 (Copenhagen: Borgen, 1978), 209.
 See Vasilii Kandinsky, "Soderzhanie i forma." In *Salon 2,* catalogue of an exhibition organized by Vladimir Izdebsky in Odessa, Jan. 1910–Dec. 1911, 14–16.
3 Malevich to Matiushin, summer 1913. Translated in Andersen, *K. S. Malevich,* vol. 4 (1978), 206; ibid, May 1914, 209.
4 Malevich, *Chelovek vsegda ozabochen.* Undated manuscript, collection of the Stedelijk Museum, Amsterdam, 24.
 In Matiushin's autobiography in TsGALI (Central State Archives of Literature and Art, Moscow), (f. 134, op. 2, ed. khr. 23), he mentions writing an article on contemporary music for the first issue of *Supremus* in 1918. Along with Popova, Rozanova, and others, Roslavets was a member of the Supremus group.
 See Catalogue 33 for the portrait of Matiushin. Khardzhiev refers to the sketch for another portrait by Malevich, this one of

Roslavets. See Nikolai Khardzhiev, *K istorii russkogo avangarda* (Stockholm: Almqvist and Wiksell, 1976), 127.
5 "Nikolai Roslavets the only friend that I acquired in Konotop." Malevich, "Avtobiografiia," in Khardzhiev, *K istorii,* 116.
6 Benedikt Livshits, *Polutoraglazyi strelets* (Leningrad: Izdatelstvo pisatelei, 1933), 202. Nikolai Kulbin wrote several essays on "free" and microtonal music. See his booklet *Svobodnaia muzyka* (St. Petersburg, 1909; French translation also 1909; second, enlarged Russian text, St. Petersburg, 1911); "Svobodnaia muzyka" in *Studiia impressionistov* (St. Petersburg, 1910), 15–26 (and the German variant in *Der blaue Reiter* [Munich: Piper, 1912], 69–73).
7 Benedikt Livshits, Artur Lure, et al.: *Nash otvet Marinetti* (1914). Poster reprinted in Livshits, *Polutoraglazyi strelets,* 249.
8 Malevich: "Kino, gramofon, radio i khudozhestvennaia kultura." Translated in Andersen, *K. S. Malevich,* vol. 4 (1978), 164.
9 "Nikolai Roslavets o sebe i o svoem tvorchestve," *Sovremennaia muzyka* (Moscow) (Nov.–Dec. 1923): 132–138. In the same year he contributed to the journal *K novym beregam* (no. 1), its cover designed by Popova. In 1924 he became editor of *Muzykalnaia kultura.* For information on Roslavets see Detlef Gojowy, *Neue sowjetische Musik der 20er Jahre* (Regensburg: Laaber, 1980).
10 Malevich to Matiushin, May 1914. Translated in Andersen, *K. S. Malevich,* vol. 4 (1978), 209. For other information on Malevich and transrational language see R. Ziegler, "Poetika A. E. Kruchenykh pori '41°,'" in Luigi Magarotto, Marzio Marzaduri, and Giovanni Pagani Cesa, eds., *L'avanguardia a Tiflis* (Venice: Quaderni dell' Seminario di Iranistica, Uralo-Altaistica e Caucasologia degli Università degli Studi di Venezia, 1982), 235–258.
11 Manuscript, collection of the Stedelijk Museum, Amsterdam, 19.
12 Malevich, "Autobiography," in *Malewitsch,* exh. cat. (Cologne: Galerie Gmurzynska, 1978), 11.
13 Malevich, "O Zangezi" (1922–1923). Translated in Andersen, *K. S. Malevich,* vol. 4 (1978), 95.
14 Malevich, "O poezii," *Izobrazitelnoe iskusstvo* (Petrograd), no. 1 (1919): 31.
15 Malevich, "V prirode sushchestvuet" (1916–1917). Translated in Andersen, *K. S. Malevich,* vol. 4 (1978), 31.
16 Malevich, "O poezii," 31, 34.
17 Malevich; *O novykh sistemakh v iskusstve* (1919), 5. Translated in Troels Andersen, ed., *K. S. Malevich. Essays on Art,* vol. 1 (Copenhagen: Borgen, 1968), 87.
18 *Vzorval* (St. Petersburg: EUY, 1913); *Li Dantiufaram* (Paris: 41 degrés, 1923); Vladimir Markov (Matvejs), *Printsipy novogo iskusstva. Faktura* (St. Petersburg: Soiuz molodehi, 1914), 18.

19 Alexei Kruchenykh, untitled leaflet published in Baku in 1921. Reprinted in Vladimir Markov, ed., *Manifesty i programmy russkikh futuristov* (Munich: Fink, 1967), 180.
20 For a reproduction of the drawing carrying the words "How brazen," see Jean-Claude Marcadé, ed., *Malévitch* (Lausanne: L'Age d'Homme, 1979), ill. 78; for the design carrying "Stupid," see Catalogue 115; for the fish signboard see Marcadé, ill. 74.
21 Malevich to Matiushin, 3 July 1913. Translated in Andersen, *K. S. Malevich,* vol. 4 (1978), 204.
22 "Pervyi Vserossiiskii sezd baiachei budushchego," *Zhurnal za sem dnei* (St. Petersburg), no. 28 (1913): 606.
23 The identities of the several poets who allegedly supported Larionov's Rayonist system remain a mystery, although it now seems fairly certain that Anton Lotov was the pseudonym of Konstantin Bolshakov. For commentary on Lotov and on Larionov's "mystifications," see Vladimir Markov, *Russian Futurism* (Los Angeles: University of California Press, 1968), 184–185, 403; Khardzhiev, 47, 80–81; Gerald Janecek, *The Look of Russian Literature* (Princeton: Princeton University Press, 1984), 150–154; Marzio Marzaduri; *Dada Russo* (Bologna: Il Cavaliere Azzurro, 1984), 55–61. I would like to thank Mark Konecny for fruitful discussion of this subject.
24 "Poeziia futuristov," *Teatr v karrikaturakh* (Moscow), no. 1 (8 Sept. 1913): 15. Anton Lotov, "Ulichnaia melodiia" *Teatr v karrikaturakh,* ibid. According to the anonymous prefatory statement to the Lotov poem printed here (another is a visual poem that begins with the lines "Povelika/Lika/Led/A/Kil/Great"), both poems come from Lotov's collection *Rekord,* which "appeared in a quantity of forty copies already sold out." No one has ever located a copy of this book.
25 L. Frank, "Vospominaniia," *Teatr v karrikaturakh* (Moscow), no. 6 (2 Feb. 1914): 7.
26 Much influenced by Velimir Khlebnikov, Pavel Filonov experimented with *zaum,* as is demonstrated by his long poem *Propeven o prorosli mirovoi* (Petrograd: Zhuravl, 1915). Olga Rozanova's experimental poetry, including *zaum,* was published in three of Kruchenykh's books: *Balos* (1917, with Rozanova), *Nestroche* (1917), and *Ozhirenie roz* (1918). See Tatiana Nikolskaia, "Igor Terentiev v Tiflise," in Magarotto et al. eds., *L'avanguardia a Tiflis,* 206. Rozanova's poems were also published in *Iskusstvo* (Moscow), no. 4 (1919): 1; and they have been reprinted, with a previously unpublished *zaum* poem by Nina Gurianova, in *Iskusstvo* (Moscow), no. 1 (1989): 30. Parts of several books of *zaum* graphic poetry by Varvara Stepanova have been reproduced in recent studies of Alexander Rodchenko and Stepanova. See *Die Kunstismen in Russland/The Isms of Art in Russia,* exh. cat. (Cologne: Galerie

Gmuryznska, 1977), 135–138; *Alexander Rodtschenko und Warwara Stepanowa,* exh. cat. (Duisburg: Wilhelm-Lehmbruck-Museum; Baden-Baden: Staatliche Kunsthalle, 1982–1983), 210–215; Alexander Lavrentiev, *Stepanova* (London: Thames and Hudson, 1988), 18–29.

27 Malevich, "O poezii," 31.

28 Malevich, *O novykh sistemakh v iskusstve,* 1; Malevich, "Kor re rezh. . . ." (ca. 1915). Translated in Andersen, *K. S. Malevich,* vol. 4 (1978), 27; Malevich, "O poezii," 35.

29 E. Lunev (pseud. Kruchenykh), *I. Terentiev, A Kruchenykh grandiozar* (Tiflis: Kuranty, 1919), 2. Quoted in Nikolskaia, "Igor Terentiev v Tiflise," 195.

30 Kruchenykh spoke of his "Vsemirnyi poeticheskii yazyk" in his *Zaumnyi yazyk.* See Markov, *Manifesty,* 18. Malevich published his lithograph *Vsemirnyi peizazh* in Kruchenykh's *Vzorval* (St. Petersburg: EUY, 1913) and *Stikhi Maiakovskogo* (St. Petersburg, 1914).

31 Malevich, "Autobiography," in *Malewitsch,* 11–12; Nikolai Kulbin, "Free Music," in Wassily Kandinsky and Franz Marc, eds., *The Blaue Reiter Almanac* (New York: Viking, 1974), 141

32 "2 doklada. Tema: Bespredmetnost.'" One-page, anonymous, undated manuscript, collection of the Stedelijk Museum, Amsterdam, numbered "page 2." The text lists various points made by Malevich and Terentiev in their lectures, presumably delivered at GINKhUK. Malevich, described here as a member of the State Academy of Artistic Sciences, speaks of Edison in point no. 9.

33 Mikhail Matiushin. Quoted in Alla Povelikhina, "Matyushin's Spatial System," *The Structurist* (Saskatoon), no. 2–3 (1975–1976): 65. See also Marzio Marzaduri, ed., *Igor Terentiev. Sobranie sochineii* (Bologna: San Francesco, 1988), especially 400–404.

34 Malevich to the Petrograd Board of Scientific Institutes, 1923. Translation in *Malewitsch,* 275. Also see Larisa Zhadova: "Gosudarstvennyi Institut khudozhestvennoi kultury." In Selim Khan-Magomedov, ed., *Problemy istorii sovetskoi arkhitektury,* vol. 4 (Moscow: Gosudarstvennyi komitet po grazhdanskomu stroitelstvu, 1978), 28.

35 Alexander Tufanov, *K zaumi. Fonicheskaia muzyka i funktsii soglasnykh fonem* (Petersburg: Izdanie avtora, 1924; reprinted in Konstantin Kuzminsky, Dzherald Yanechek, and Alexander Ocheretiansky, *Zabyti avangard. Rossiia. Pervaia tret XX stoletiia* [Vienna: Wiener Slawistischer Almanach, 1989]), 102–125; quotations, 108, 124.

36 Daniil Kharms, "Predmety i figury otkrytye Daniilom Ivanovichem Kharmsom" (1927). Translation and commentary in Ilya Levin, "The Fifth Meaning of the Motor-Car," *Soviet Union* (Tempe) 5, pt. 2 (1978): 287–300. This quotation, 293.

37 Malevich, *O novykh sistemakh v iskusstve* (1919). Translated in Andersen, *K. S. Malevich: Essays,* vol. 1 (1968), 118–119.

38 Malevich, "Suprematizm, kak chistoe neznanie," undated manuscript, collection of the Stedelijk Museum, Amsterdam; Malevich, "Belaia mysl. O boge" (1921), undated manuscript, collection of the Stedelijk Museum, Amsterdam. Kharms, in Levin, "Fifth Meaning," 293. According to Levin, 289, Kharms dedicated his poem "Iskushenie" (1927) to Malevich. He also wrote an obituary poem on Malevich's death in 1935. See *Malevich,* exh. cat. (Amsterdam: Stedelijk Museum, 1970), 16.

39 In his declaration on the fifth meaning of the object (Levin, "Fifth Meaning," 292, 300), Kharms uses the word "SENSE-LESS" to describe the effect of the fifth meaning but claims that what is nonsense "from the human point of view" is, in fact, the higher dimension of the object.

"I too am but a stair" attributed to Malevich in Larisa Zhadova, *Malevich* (London: Thames and Hudson, 1982), 41; Malevich, "Mir kak bespredmetnost" (before 1927), translated in Troels Andersen, ed., *K. S. Malevich. The World as Non-Objectvity,* vol. 3 (Copenhagen: Borgen, 1976), 292; Malevich titled five works in *Tram V* (Petrograd, 1915), "paintings the contents of which"; the last two statements illustrated in Marcadé, *Malévitch,* nos. 69, 70.

40 "The Oberiu Manifesto" (1928). Translated in George Gibian, ed., *Russia's Lost Literature of the Absurd* (Ithaca: Cornell University Press, 1971), 193.

A Study of Technique: Ten Paintings by Malevich in the Tretietov Gallery

1 Kazimir Malevich, *From Cézanne to Suprematism. A Critical Sketch* (1920), 3–4

2 Malevich, *From Cézanne,* 4.

3 Kazimir Malevich, *From Cubism and Futurism to Suprematism. The New Realism in Painting* (1916), 11.

4 Malevich, *From Cubism,* 11

5 Malevich, *From Cézanne,* 4.

6 Ibid., 8.

7 Malevich, *From Cubism,* 21.

8 Malevich, *From Cézanne,* 9.

9 Alexei Rybakov, *Tekhnika maslianoi zhivopisi* (Moscow and Leningrad, 1937), 197.

10 Malevich, *From Cézanne,* 8.

11 Ibid., 6, 8.

12 Ibid., 8.

13 Malevich, *From Cubism,* 26.

14 Ibid., 26.

15 Malevich, *From Cézanne,* 7.

16 Ibid., 7.

17 Malevich quoted by his student Kurlov. See S. Fomin and V. Tsoffka, "Uroki odnoi sud by," *Novye rubezhi,* no. 25 (15 February 1988): 11064.

18 Rybakov, *Tekhnika,* 197.

SELECTED BIBLIOGRAPHY

The centenary of Malevich's birth in 1978 generated a number of important exhibitions and publications that included detailed bio-bibliographical information, and there is no need to repeat that information here. Consequently, the primary emphasis of this bibliography is on the more recent Western-language publications that deal specifically with Malevich and that have made particularly valuable contributions to the study and appreciation of his work. The bibliography does not include numerous books, exhibition catalogues, and articles on the general history of the Russian avant-garde that have appeared in many languages, especially in the last decade. Ljilja Grubisic and Mark Konecny have rendered invaluable assistance in the compilation of this list.

A. Primary Sources

1. Andersen, Troels, ed. *K.S. Malevich: Essays on Art.* Copenhagen: Borgen, 1968–1978. 4 vols. Vol. 1, *1915–1928,* and vol. 2, *1928–1933,* trans. Xenia Glowacki-Prus and Arnold McMillin (1968); vol. 3, *The World as Non-Objectivity. Unpublished Writings, 1922–25,* trans. Xenia Glowacki-Prus and Edmund T. Little (1976); vol. 4, *The Artist, Infinity, Suprematism. Unpublished Writings, 1913–33,* trans. Xenia Glowacki-Prus (1978).
2. Andersen, Troels, comp. *Malevich. Catalogue Raisonné of the Berlin Exhibition, 1927, Including the Collection in the Stedelijk Museum, Amsterdam.* Amsterdam: Stedelijk Museum, 1970.
3. *Kazimir Malevich, 1878–1935,* exhibition catalogue. State Russian Museum, Leningrad, Stedelijk Museum, Amsterdam, and Tretiakov Gallery, Moscow, 1988–1989 (in English and Russian). Essays by W. A. L. Beeren, Nina Barabanova, Elena Basner, E. A. Ivanova, S. M. Ivanitsky, Joop M. Joosten, Dmitrii Sarabianov, Evgeny Kovtun, and Linda S. Boersma. Autobiographical notes (1923–1925) and notes on architecture (1924) by Malevich.

B. Main Collections of Writings by Malevich in Translation

1. Riesen, Alexander von, trans. *Kasimir Malewitsch: Die gegenstandlose Welt.* Munich: Langen, 1927. New edition with a foreword by Stephan von Wiese. Mainz and Berlin: Kupferberg, 1980.
2. Dearstyne, Howard, trans. *The Non-Objective World.* Chicago: Theobald, 1959.
3. Haftmann, Werner, ed., and Hans von Riesen, trans. *Kasimir Malewitsch.*

Suprematismus—Die gegenstandlose Welt. Cologne: DuMont, 1962. New edition with a foreword by Karl Ruhrberg. Stuttgart: Kunstwerk, 1980.
4. See A1.
5. Kovtun, Evgenii, ed. "K.S. Malevich. Pisma k M.V. Matiushinu," in *Ezhegodnik Rukopisnogo otedela Pushkinskogo doma na 1974 god.* Leningrad: Nauka, 1976, 177–195.
6. Marcadé, Jean-Claude, ed. *K. Malévitch.* Lausanne: L'Age d'Homme. 3 vols. Vol. 1, *De Cézanne au suprématisme,* trans. Jean-Claude Marcadé and Véronique Schiltz (1974); vol. 2, *Le miroir suprématiste,* trans. Jean-Claude Marcadé (1977); vol. 3, *La lumière et la couleur,* trans. Jean-Claude Marcadé and Sylviane Siger.
7. Nakov, Andrei, ed., and Andrée Robel, trans. *Malévitch. Ecrits.* Paris: Champ Libre, 1975. New edition, Paris: Lebovici, 1986. Italian edition, *Malevic. Scritti.* Milan: Feltrinelli, 1977.
8. Mijuskovic, Slobodan, ed. *Maljevic. Suprematizam—Bespredmetnost.* Belgrade: Studentski izdavacki centar UK SSO Beograda, 1980.
9. Kasimir Malevich Archive, Stedelijk Museum, Amsterdam. Collection of forty-six microfiches of Malevich manuscripts published by Inter Documentation Company, Zug, 1980.

C. Exhibition Catalogues of Malevich's Works

1. Karshan, Donald. *Malevich. The Graphic Work: 1913–1930.* Jerusalem: Israel Museum, 1975–1976.
2. Joosten, Joop. *Drawings, Graphics and Documents of K. S. Malevich.* Amsterdam: Stedelijk Museum, 1976.
3. *Suprématisme.* Paris: Galerie Jean Chauvelin, 1977. Essays by Miroslav Lamac, Jiri Padrta, Evgenii Kovtun, Yves-Alain Bois, Donald Karshan, John E. Bowlt, Emmanuel Martineau, and Jean-Claude Marcadé.
4. *Malevitch.* Paris: Centre Georges Pompidou, 1978. Essays by Pontus Hulten and Jean-Hubert Martin.
5. *Malewitsch.* Cologne: Galerie Gmurzynska, 1978. Essays by Szymon Bojko, Vasilii Rakitin, Anna Leporskaia, Valentine Marcadé, Miroslav Lamac, Jiri Padrta, Jean-Claude Marcadé, Evgenii Kovtun, John E. Bowlt, Donald Karshan, and Andrzei Szewczyk.
6. *Journey into Non-Objectivity.* Dallas: Dallas Museum of Fine Art, 1980. Essays by Harry S. Parker III, Jacqueline Gilliam, and John E. Bowlt.
7. *Kasimir Malewitsch (1878–1935). Werke aus sowjetischen Sammlungen.* Düsseldorf: Kunsthalle, 1980. Essays by Jürgen Harten, Jewgeni Kowtun, and Larissa Shadowa.
8. *Malévitch. Architectones, peintures, dessins.* Paris: Centre Georges Pompidou, 1980. Essays by Troels Andersen, Jean-Hubert Martin, Caroline Kealy, Jacques Ohayon,

Poul Pedersen, and Chantal Quirot.
9. *Malevich, Suetin, Chashnik.* New York: Leonard Hutton Galleries, 1983. Essays by Ingrid Hutton and Sarah Bodine.
10. See A3.
11. *Kazimir Maljevic.* Zagreb: Muzej suvremene umjetnosti, 1989–1990. Essays by Aleksandar Borovski, Jesa Denegri, Aleksandar Flaker, Evgenij Kovtun, and Marijan Susovski.

D. Books and Major Articles about Malevich

1. See A2.
2. Martineau, Emmanuel. *Malévitch et la philosophie.* Lausanne: L'Age d'Homme, 1977.
3. Bois, Yves-Alain. "Malévitch, le carré, le degré zéro," *Macula* (Paris), no. 1 (1978): 28–49.
4. Bowlt, John E., and Charlotte Douglas, eds. *Kazimir Malevich 1878–1935–1978.* Special issue of *Soviet Union* (Tempe) 5, pt. 2 (1978). Essays by John E. Bowlt, Charlotte Douglas, W. Sherwin Simmons, Linda Henderson, Margaret Betz, Jean-Claude Marcadé, Milka Bliznakov, Ilya Levin, Natalia Lianda, and Alik Rabinovich.
5. Couto, S. "Malevitch e los signos," *Colóquio: artes* (Lisbon) 36 (March 1978): 5–15.
6. Crone, Rainer. "Zum Suprematismus. Kazimir Malevic, Velimir Chlebnikov und Nicolai Lobacevskij," *Wallraf-Richartz-Jahrbuch* 40 (1978): 129–162.
7. Crone, Rainer. "Malevich and Khlebnikov: Suprematism Reinterpreted," *Artforum* (New York) 17, no. 4 (1978): 38–47.
8. Shadowa, Larissa A., *Suche und Experiment. Russische und sowjetische Kunst 1910 bis 1930.* Dresden: VEB Verlag der Kunst, 1978. English edition, *Malevich. Suprematism and Revolution in Russian Art 1910–1930.* London: Thames and Hudson, 1982. Polish edition, *Poszukiwanie i eksperymenty. Z dziejow sztuki rosyjskiej i radzieckiej lat 1910–1930.* Warsaw: Wydawnictwa Artystyczne i Filmowe, 1982.
9. Simmons, W. Sherwin. "Kasimir Malevich's 'Black Square': The Transformed Self, Parts I–III," *Arts Magazine* 53, nos. 2–4 (1978), (October) 116–125, (November) 130–141, (December) 126–134.
10. Kovtun, Jevgeni. "Kazimir Malevitsi Suprematismi Teooria," *Kunst* (Tallin), no. 55 (1979): 2–7.
11. Ingold, Felix Philipp. "Kunst und Oekonomie," *Wiener Slawistischer Almanach* (Vienna) 4 (1979): 153–193.
12. Marcadé, Jean-Claude, ed. *Malévitch. Colloque international Kazimir Malévitch.* Lausanne: L'Age d'Homme, 1979. Essays by Pontus Hulten, Jean-Claude Marcadé, Dora Vallier, Jean Clair, Jiri Padrta, Vassili Rakitine, Susan Compton, Emmanuel Martineau, Larissa Jadova, Troels Andersen, Xavier Deryng, Tadeusz Peiper, Nicolas Khardjiev, and Eugène Kovtoune.
13. Douglas, Charlotte. "Beyond Suprematism. Malevich: 1927–33," *Soviet Union*

(Tempe) 7, nos. 1–2 (1980): 214–227.

14. Douglas, Charlotte. *Swans of Other Worlds. Kazimir Malevich and the Origins of Abstraction in Russia.* Ann Arbor: University Microfilms, 1980.

15. Flaker, Aleksandar. "Kazimir Malevic u crnom kvadratu," *Start* (Zagreb), no. 325 (1981): 52–54.

16. Ingold, Felix Philipp. "Kasimir Malewitsch," *Neue Zürcher Zeitung* (Zurich), no. 25 (1981): 67.

17. Kovtun, Evgenii. "Malevich," *Art Journal* (New York) 41, no. 4 (1981): 345–346.

18. Simmons, W. Sherwin. *Kasimir Malevich's "Black Square" and the Genesis of Suprematism 1907–1915.* New York: Garland, 1981.

19. Dabrowski, Magdalena. "Malevich-Mondrian. Geometric Form as the Expression of the Absolute," *Nelson-Atkins Museum of Art Bulletin* (Kansas City) (October 1982): 19–34.

20. Sproccati, S. "Malevich: il corpo della pittura," *Rivista de estetica,* no. 10 (1982): 64–88.

21. Stapanian, Juliette R. "Vladimir Maiakovskii's 'From Street into Street' as Cubo-Futurist Canvas: A View through the Art of Kazimir Malevich," *Slavic Review* (Austin) 41, no. 4 (1982): 639–652.

22. Bojko, Szymon, Leszek Brogowski, and Mieczyslaw Kurewicz, eds. *Kazimierz Malewicz.* Gdansk: Zwiazek polskich artystow fotografikow, 1983.

23. Cardoza y Aragón, Luis. *Malevich. Apuntes sobre su aventura icárica.* Mexico City: Universidad Nacional Autónoma, 1983.

24. Grois, Boris. "Moscow Artists on Malevich," *A-Ja* (Paris), no. 5 (1983): 25–35.

25. Marcadé, Jean-Claude, ed. *Malévitch. Cahier I.* Lausanne: L'Age d'Homme, 1983. Essays by Valentine Marcadé, Vassili Rakitine, John E. Bowlt, Agnès Sola, Rainer Crone, Dora Vallier, Larissa Jadova, Krystyna Pomorska, N. Savéliéva, Jean-Claude Marcadé, Emmanuel Martineau, Jiri Padrta, Charlotte Douglas, and Donald Karshan.

26. Marcadé, Jean-Claude. "Le suprématisme de K.S. Malevic ou l'art comme réalisation de la vie," *Revue des études slaves* (Paris) 56, pt.1 (1984): 61–70.

27. Schwartz, Frederic. "Kasimir Malevich's 'Suprematist Composition, White on White,'" *Transactions of the Association of Russian-American Scholars in the USA* (New York) 18 (1985): 233–244.

28. Strauss, T. "Malewitschs Spätwerk," *Kunstwerk* 39 (April 1986): 20–28.

29. Günther, H. "Sieg über die Sonne," *Kunst* (1987), no. 10: 820–825; no. 11: 904–909; no. 12: 1012–1017.

30. Ingold, Felix Philipp. "Bildkunst und Wortkunst bei Kazimir Malevic," *Delfin* (Stuttgart), no. 10 (September 1988): 50–62.

31. Kovtun, Evgenii. "Kazimir Severinovich Malevich," *Ogonek* (Moscow), no. 33 (1988): 8 and unpaginated insert.

32. Tsoffka, Viktor. "Suprematist Kazimir Malevich," *Moscow News* (Moscow), no. 9 (1988): 16.

33. Chardjiev, Nikolaj. "Un eccezionale inedito: un appello di Malevic del 1919 agli artisti d'avanguardia d'Italia," *Il giornale dell'arte* (Turin), no. 68 (1989): 1–2.

34. Cooke, Catherine, ed. *Malevich. Paintings, Architektons, Writings, Suprematism and the Avant-Garde.* London: Art and Design, 1989. Essays by Catherine Cooke, Geoffrey Broadbent, Paul Crowther, Andrew Benjamin, Marcel Otakar, Valery Dudakov, and Minna Tarkka.

35. Crone, R., and D. Moos. "Subjectivity in Time: Kazimir Malevich," *Artforum* (New York) 27 (April 1989): 119–125.

36. Marcadé, Jean-Claude. "Malévitch le perturbateur," *Galleries* (Paris) (February 1989): 84–89.

37. Stachelhaus, Heiner. *Kasimir Malewitsch. Ein tragischer Konflikt.* Düsseldorf: Claassen, 1989.

PHOTOGRAPH CREDITS

Photographs for works in the exhibition were
provided by their owners.

The photograph for Figure 4 is from a private
archive; photographs for Figures 47–54
are from the Institute of Modern Russian Culture,
University of Southern California.
All others are from the archives of the
Dutch and Russian museums.

Kazimir Malevich 1 8 7 8 – 1 9 3 5

Designed by COY Los Angeles / Steven Rachwal
Production managed by Laurie Bennett
Text set in Helvetica with Helvetica Bold Condensed
Display type in TC Extension Extra Bold
set by Aldus Type Studio Limited, Los Angeles
Printed by Anderson Lithograph, Commerce, California,
on 100 lb Quintessence Dull Book
with 80 lb Strathmore Grandee Text endsheets
and 100 lb Quintessence Gloss Cover
Casebound edition in Iris 101 binding cloth
by Roswell Bookbinding, Phoenix, Arizona